DIGITAL PHOTOGRAPHY
THROUGH THE YEAR

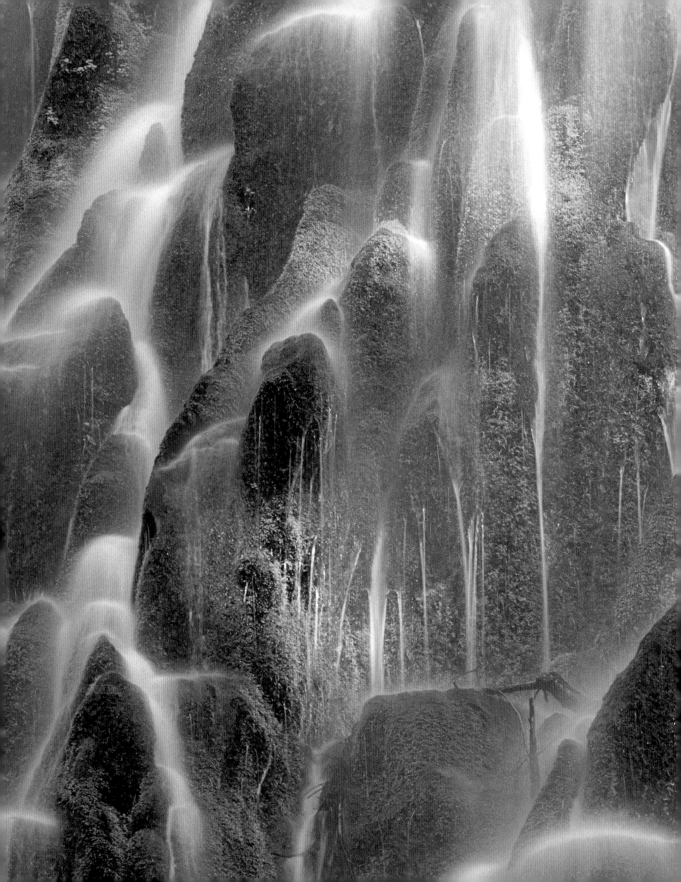

DIGITAL PHOTOGRAPHY
THROUGH
THE YEAR

TOMANG

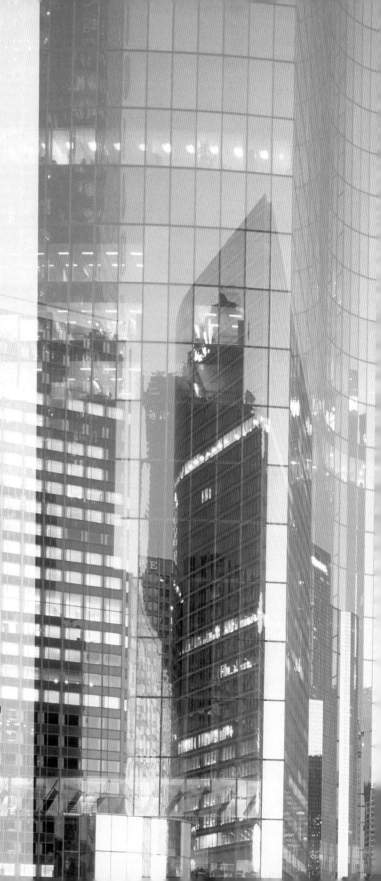

2020 EDITION

Jacket Design Development Manager	Sophia MTT
Jacket Designer	Tanya Mehrotra
DTP Designer	Bimlesh Tiwari
Pre-Production Manager	Balwant Singh
Senior Managing Art Editor	Lee Griffiths
Managing Editor	Gareth Jones
US Executive Editor	Lori Hand
Producer, Pre-production	Gillian Reid
Producer	Rachel Ng
Associate Publishing Director	Liz Wheeler
Art Director	Karen Self
Publishing Director	Jonathan Metcalf

PREVIOUS EDITION

Senior Editor	Nicky Munro
Designer	Joanne Clark
Editor	David Summers
US Senior Editor	Rebecca Warren
Managing Editor	Stephanie Farrow
Managing Art Editor	Lee Griffiths

This American Edition, 2020
First American Edition, 2012
Published in the United States by DK Publishing
1450 Broadway, Suite 801,
New York, NY 10018

A WORLD OF IDEAS:
SEE ALL THERE IS TO KNOW

www.dk.com

OCTOBER 2021

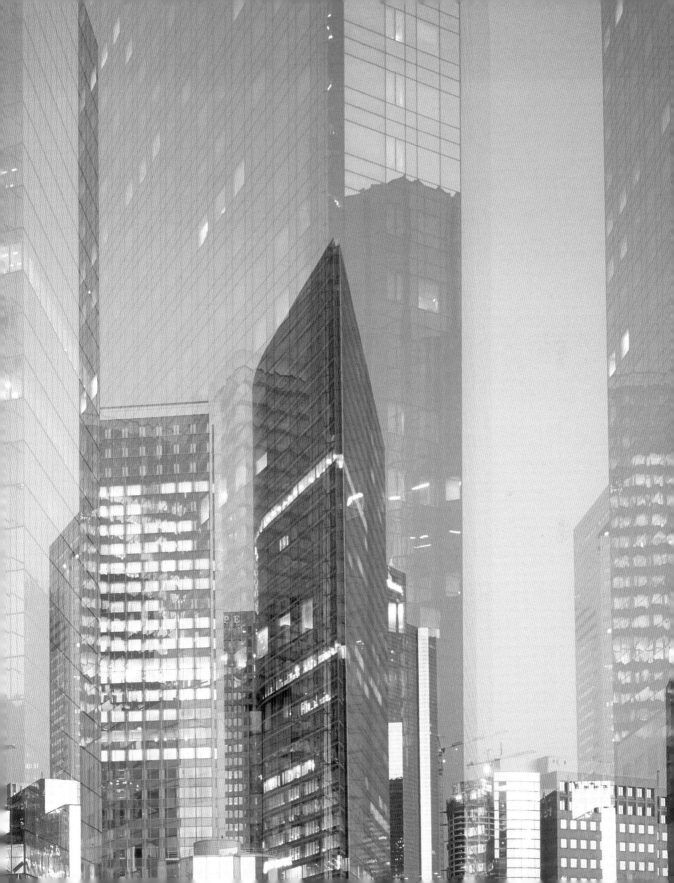

Contents

Introduction

Now that digital cameras are so capable and powerful yet affordable to a mass market, the question is no longer "how to shoot?" but "what to shoot?". Camera models regarded these days as "amateur" or "enthusiast" can resolve more detail, capture richer colors, shoot faster, and reach further than early models of professional-grade digital cameras. Your modern digital camera can take you to realms of photography that were beyond the dreams of the founding fathers: you can expose in near-total darkness, you can shoot with machine-gun rapidity, and you can capture thousands of images without interruption.

What's more, you don't even need to have the slightest idea how the camera works to obtain satisfying and even thrilling results. All this for a modest entry fee that is but a small fraction of the cost of early digital cameras.

So what do you do with all this amazing technology? There are innumerable books that tell you how to use your cameras, but few that help with what to do once your initial enthusiasm and obvious subjects are exhausted. This book gives you hundreds of ideas of what to aim your camera at.

Here we share ideas and inspiration with you. One of the most important lessons in photography is that all light is good light and all conditions are good conditions for photography. You simply have to figure out how to work with each situation, instead of fighting with it, sighing for sunny days with pretty clouds. It's a key purpose of this book to show you how conditions—such as a snowstorm or a gray and rainy day in the city—that don't at first appear promising are, in fact, treasure-troves of opportunity for invention and creativity.

Arranged by season, the book shows you that every season packs a basket of goodies ready for the photographer. You only have to unwrap each opportunity, with an investment of perhaps only a few minutes making the difference between an indifferent snap and an outstanding image.

What matters most of all is to approach each and any day with the knowledge that a fine image is possible: that's why we filled this book to the brim with outstanding images that show how lovely creations may be obtained from just about any situation under the sun, cloud, or moon. Success doesn't depend on using the latest camera or a model sprouting a super-zoom reaching 600mm. Success is measured entirely by using what you have on what you see to produce the best you can. If you can pre-visualize the picture you want instead of thinking that you need such-and-such a lens or camera, your photography will improve, instantly.

This book is designed to help you put pre-pictures in your mind: that's what inspiration is about. Looking for images is like looking for a lost object: if you don't know what you're looking for, how do you know when you've found it? We hope you this book fills your mind with images you want to look for.

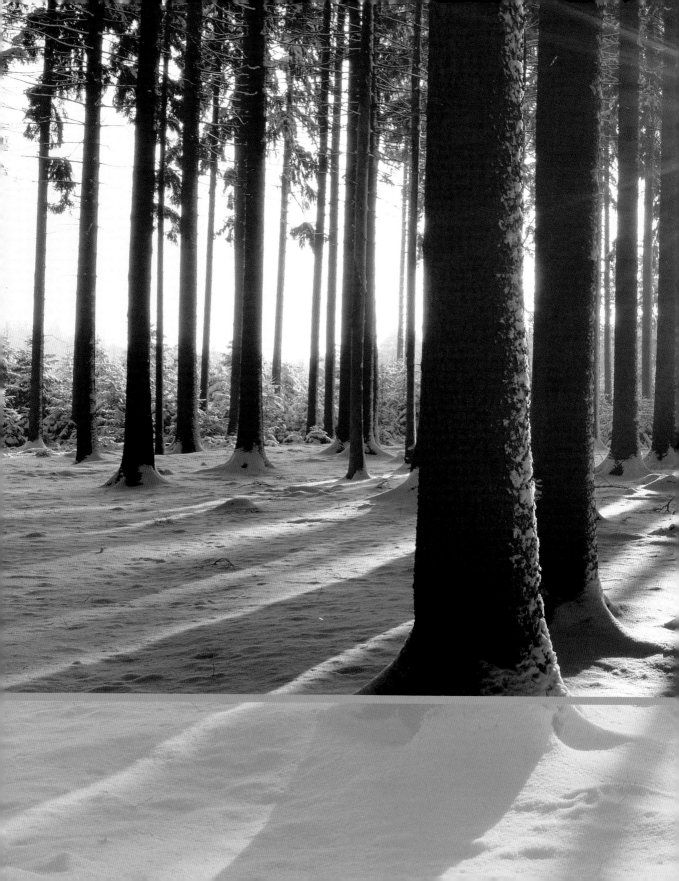

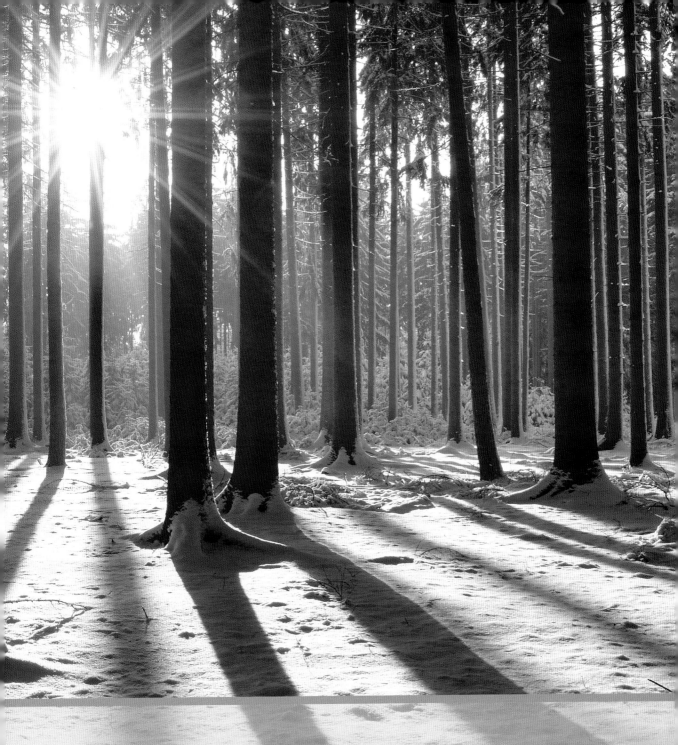

Midwinter

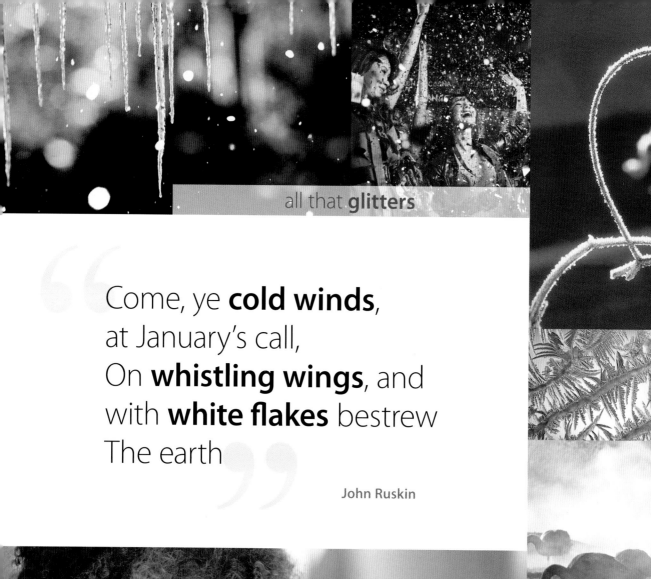

" Come, ye **cold winds**,
at January's call,
On **whistling wings**, and
with **white flakes** bestrew
The earth "

John Ruskin

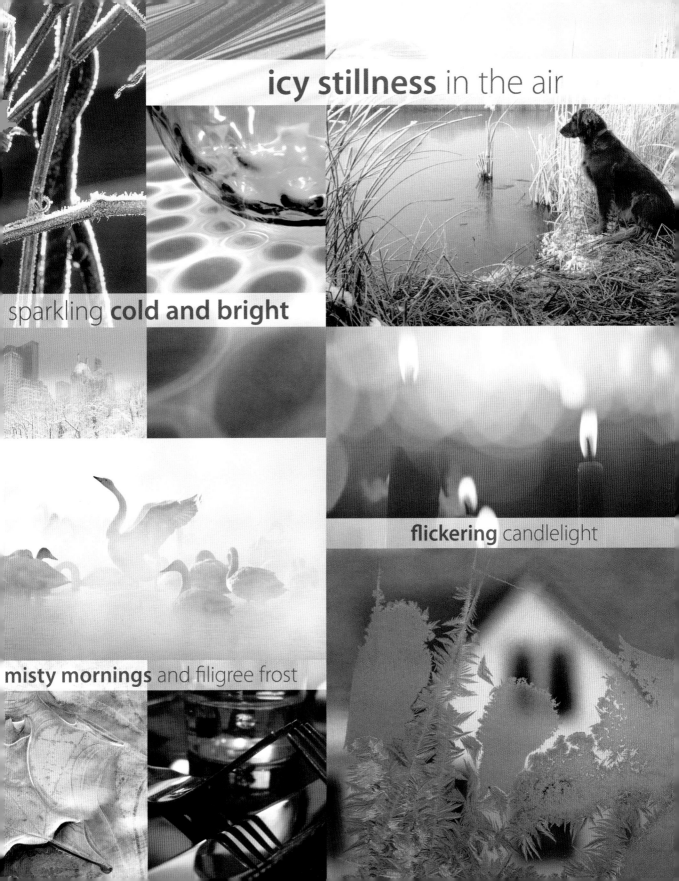

icy stillness in the air

sparkling cold and bright

flickering candlelight

misty mornings and filigree frost

Ice formations

Ice can have a wonderful, transforming effect on the environment—even the most everyday objects, such as leaves or pebbles, are defamiliarized and changed into magical frozen artifacts. Rough textures become smooth, while soft objects become brittle and hard, creating striking, almost abstract contrasts. Far from being flat, featureless, and lacking in color, ice can offer a wealth of patterns and subtle tones.

CAMERA MODE	LENS SETTING
Select **Landscape** mode or **Aperture Priority** and an aperture of f/4	Zoom to **moderate telephoto**

SENSOR/FILM SPEED	FLASH
Use a **low ISO** setting (e.g. ISO 100)	Shoot without **flash**

FOR THIS SHOT

This study of a leaf trapped in ice was made on an overcast day. Flat lighting avoids glare, reduces shadows, and helps to retain colors.

1 Close up
By zooming in from approximately an arm's length you can capture the leaf's structure and markings, and the fine, filigree patterns in the ice. It's best to avoid using Macro mode as the camera may be too close and cause shade.

2 Exposure
If your subject is mostly composed of lighter tones, use a modest amount of exposure correction to keep the image bright. Here, 1/3 to 2/3 stop has been used to prevent the ice from appearing dull.

3 ISO setting
A low ISO setting ensures the best image quality and pick up the subtle textures in the leaf, pebbles, and ice.

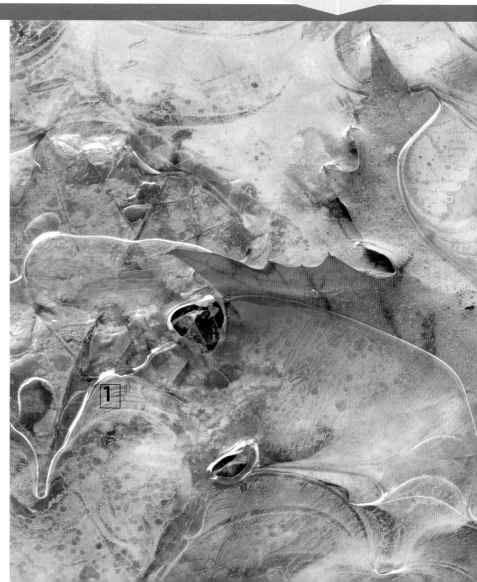

TRY THIS

As water freezes, melts, and refreezes, icicles form, creating sparkling, almost sculptural forms. The details of the grooves and ridges (right) are enhanced by shooting against the sun and including reflections of darker elements in the landscape. A dramatic effect can be achieved by using short shutter times to capture droplets falling from icicles as they melt (far right).

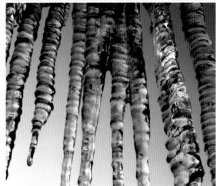

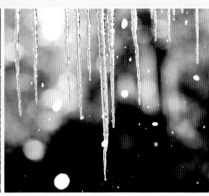

ALTERNATIVE APPROACHES

Shooting ice from up close will remove everyday context, resulting in images with a more abstract, graphic feel. Some are not even immediately identifiable as ice.

Air bubbles trapped in ice form unusual, ethereal shapes. Shoot from different angles and notice how the changes of light refraction and reflection affect each shot. Underexpose the image a little in order to darken the background.

When water droplets freeze slowly they can form shardlike crystals that grow from, and cling to, plants and pebbles. Use a tripod and medium depth of field to achieve the sharp focus that's needed to fully capture the delicate beauty of the structure.

See also: Frosty mornings pp.18–19, A walk in the park pp.22–23, In the winter garden pp.30–31, Exploring textures pp.114–15

Outdoor portraits

Although winter may not seem the obvious time for portrait photography, it can provide wonderful settings—gleaming snow and the bright light reflected from it—that add a sparkling quality to outdoor portraits. Make sure that you and your subjects are wrapped up warmly, then look around for good locations and props. Try to find unconventional or oblique ways in which to frame your shot, yet keep obvious the wintery season.

CAMERA MODE	LENS SETTING
Select **Portrait** mode or **Aperture Priority** and an aperture of f/5.6	Zoom to **moderate telephoto**
SENSOR/FILM SPEED	FLASH
Use a **low ISO** setting (e.g. ISO 100)	Shoot without **flash**

FOR THIS SHOT

The rear-view mirror of a motorcycle makes a fitting frame for an informal, fun portrait of a biking couple in the snow.

1 Positioning
Take your time setting up the shot. Here, the couple has been positioned so that they are perfectly framed, but you can't see the photographer in the mirror.

2 Exposure
It can be tricky to get the exposure right in scenes with a lot of snow. Use your camera's auto setting first, then try overexposing by 1/2 stop.

3 Focusing
When you're shooting reflections, make sure that the people themselves—rather than the mirror—are sharp. Keeping other details, such as the speedometer, in focus helps to add interest.

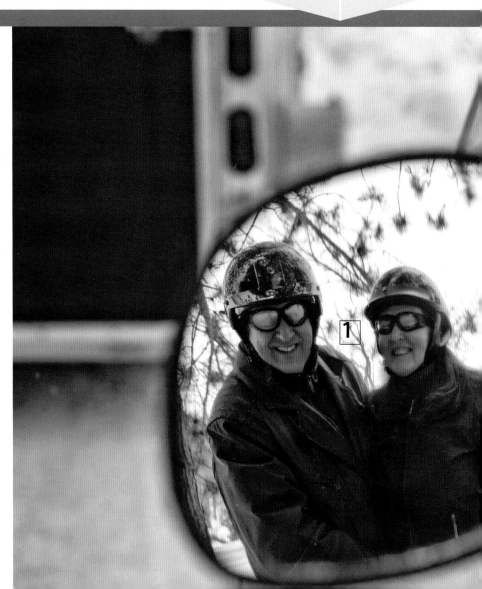

TAKE IT FURTHER
IN THE STYLE OF MAGRITTE

For a witty approach, set up a portrait that verges on the surreal. This businessman with his umbrella looks totally out of place, in a subtle reference to the paintings of Surrealist artist René Magritte. The dark figure of the man forms a striking contrast with the snowy scene behind him.

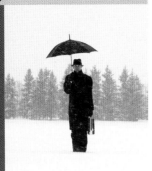

ALTERNATIVE APPROACHES

Think of ways in which you can use props to give your pictures a seasonal feel. Warm clothes, woolly hats, sleds, and frosty windows, for example, all indicate the time of year without any reference to snowy landscapes.

A close-up of a small detail, such as these cold-looking, characterful hands clasped around a hot drink, can make a revealing portrait. Ask your subject to adjust the position of his hands, and keep shooting. Posed hands rarely look natural

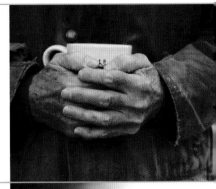

Make the most of a burst of winter sunshine to create a flattering, backlit portrait. Shooting toward the sun creates a little lens flare that makes a halo around your subject. Try altering the camera angle until you get the desired effect.

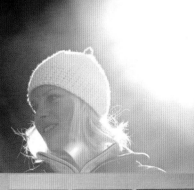

Windows provide an instant frame with which to compose a shot. These two children have been posed behind different window panes to create a humorous double portrait. Shoot square-on to keep the verticals straight.

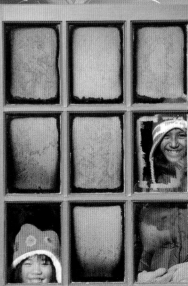

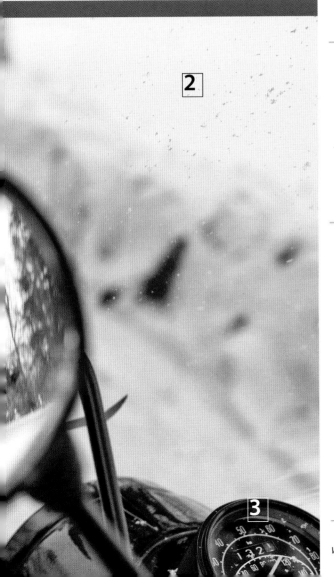

See also: Character portraits pp.82–83, Children outdoors pp.126–27, Winter sports pp.330–31, Fun in the snow pp.336–37, Posed portraits pp.342–43

Frosty mornings

Like snow, frost has a magical effect on the landscape, producing sparkling highlights and striking crystalline patterns. However, its effect is more delicate and subtle than that of snow, so a slightly different approach is required. Explore your surroundings, looking for small-scale details and objects that have taken on a covering of frost. Get out and about in the early morning before the frost is melted by the sun.

CAMERA MODE	LENS SETTING
Select **Macro** mode or **Aperture Priority** and an aperture of f/5.6	Zoom to **moderate wide angle**
SENSOR/FILM SPEED	**FLASH**
Use a **low ISO** setting (e.g. ISO 100)	Shoot without **flash**

FOR THIS SHOT

Frost creeping across a window pane creates an interesting foreground against an almost abstract view of the house opposite.

1 Exposure
Expose the photograph on the mid-tones of the image, to emphasize the highlights in the frost.

2 Using light
When shooting frost through a window, make sure all the light in the scene comes from outside. Any light in the room you're shooting from may reflect in the window and spoil the image.

3 Depth of field
The striking detail in the frost is clearly the main focus of this image. Using a medium-sized aperture and shooting from fairly close up has blurred the house in the background but ensured that it's still recognizable.

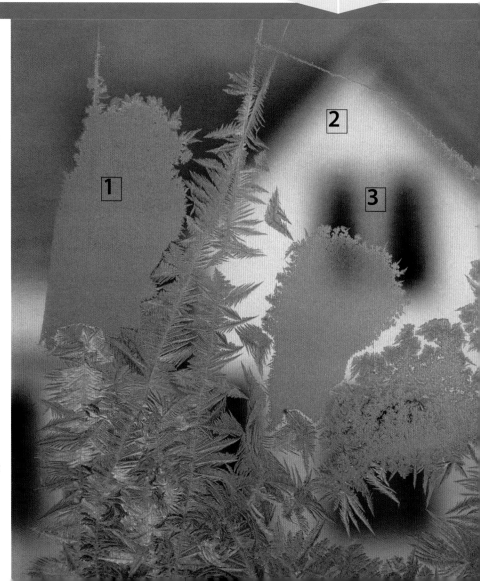

TAKE IT FURTHER
ULTRA CLOSE-UP

To capture ultra close-up pictures of ice crystals you'll need to use a camera and a macro lens, with a tripod to minimize movement. Backlighting will show up the finest details and refraction of the light may produce an attractive bluish tinge.

ALTERNATIVE APPROACHES

A veneer of frost, combined with the soft light of a winter morning, can transform even the most ordinary subjects. If you get up early you'll capture the purple hue infused into the ice by the morning twilight.

Frozen moisture can create elongated and spiky ice crystals. When the crystals form geometric patterns (on fencing, for example), and are shot against a dark background, their effect is made even more striking. For best results, keep the composition square-on.

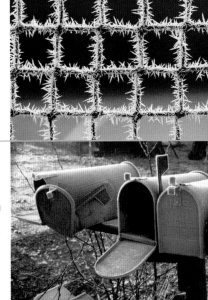

As frost builds up on surfaces it softens outlines and gives them a slightly furry texture, perfect for enhancing side lighting. You can also capture interesting color contrasts between the cold, blue shadows and the warmer, more amber-colored sunlight.

When frost is accompanied by mist, the landscape is drained of color and textures are softened, creating a hazy, dreamlike quality. Try overexposing by 1 stop to keep the scene bright.

When frost forms it can define details on objects that might otherwise go unnoticed. Look out for interesting leaf shapes that are normally camouflaged by their color. To avoid distortion when shooting objects on the ground, hold the camera straight and immediately overhead.

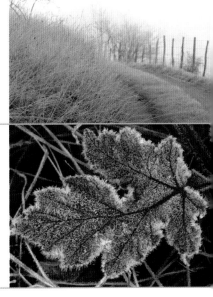

See also: Ice formations pp.14–15, A walk in the park pp.22–23, In the winter garden pp.30–31, Outdoor still life pp.46–47

Party people

The colors, textures, and movement created by throngs of people dancing under unconventional lighting make parties an exciting but tricky subject. You'll want to convey the energy and exuberance of the event, but take yourself out of the heart of the action now and then too. Capture candid gestures, quiet moments, and details to make your record of the evening more complete.

FOR THIS SHOT

As a party reaches its climax, revelers cheer and raise their arms, making this the perfect time to capture the essence of the occasion.

1 Lighting
At parties, the light varies from moment to moment. Exploit the color casts in the ambient lighting, and experiment with fill-in flash.

2 Focusing
Autofocus can struggle with moving objects like this falling glitter, so focus manually on the near- to mid-range before shooting.

3 Composition
Close framing directs our attention to the subjects' gestures, but the gaze of the woman on the left suggests a bigger picture we can't see.

CAMERA MODE

Select **Sports** mode or **Aperture Priority** and an aperture of f/2.8

SENSOR/FILM SPEED

Use a **high ISO** setting (e.g. ISO 1600)

LENS SETTING

Zoom to **moderate telephoto**

FLASH

Try shots with flash or fill-in flash and without **flash**

ON YOUR PHONE
ATMOSPHERIC SHOT

Many camera phones struggle to deliver high-quality shots in difficult lighting conditions. Make a virtue of your phone's limitations—prop it on a table (to limit shake) and shoot some atmospheric views. Motion blur will only add to the impact.

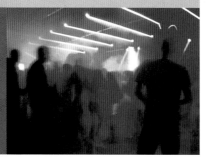

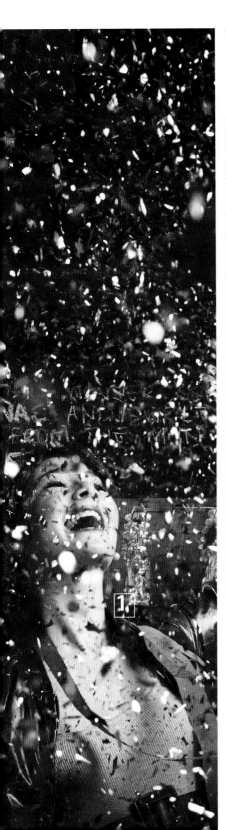

ALTERNATIVE APPROACHES

Look around a party and you'll find a lot to photograph away from the dance floor: friends exchanging stories, people enjoying the party food, outfits, and decorations, all are worthy subjects. Also, think about the mood you're trying to capture. Is it a collective celebration, or something more intimate and personal?

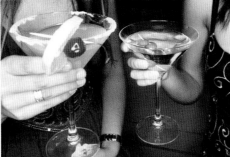

Intersperse your pictures of people with some close-up shots of details that tell the story of the evening. Focusing on these cocktails gives us an idea of the type of event these friends are attending. Ask people to pose for you and show them the pictures as you take them.

The unpredictable lighting in nightclubs means the use of flash is unavoidable when shooting portraits. However, try to soften the light by using a diffuser or by bouncing the flash off a wall. Here, flash has illuminated the main subject, while a long exposure allows ambient light to brighten her companions and the background.

For a shot with a head-spinning perspective, hold your camera low down in the middle of a group of dancers, point up and shoot. Try photographing with and without fill-in flash.

See also: Balancing color pp.36–37, Wedding day pp.146–47, Garden parties pp.216–17, Music festivals pp.224–25, Using flash pp.344–45

A walk in the park

Snowy city parks are excellent places to look for scenic inspiration. From the serene beauty of frost-coated trees and ice-glazed lakes to the cold, imposing facades of office buildings and frozen monuments, the juxtaposition of the natural and the man-made can create striking images. Try heading out at different times of day and during different weather conditions to capture the effects of varying light.

CAMERA MODE	LENS SETTING
Select **Landscape** mode or **Aperture Priority** and an aperture of f/8	Zoom to **moderate wide angle**

SENSOR/FILM SPEED	FLASH
Use a **low ISO** setting (e.g. ISO 100)	Try shots with and without **fill-in flash**

FOR THIS SHOT

City buildings, softened by snow, provide an eerie, incongruous backdrop to this nature scene.

1 Exposure
Light tones dominate this scene, enhancing the cold, wintry atmosphere. Increasing exposure by around 2/3 stop will preserve the brightness of the frost and snow.

2 Contrasts
The delicate frosted trees in the middle distance contrast with the flat foreground dotted with waterfowl and the bold geometry of the buildings in the background.

3 Foreground interest
The icy pond and the waterfowl provide dynamic foreground interest. They add depth and detail to the landscape.

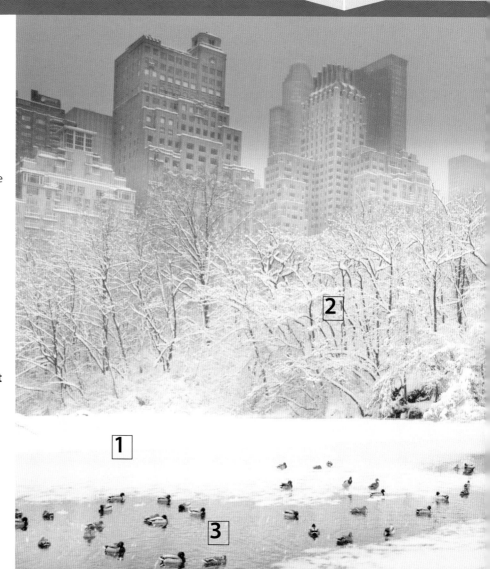

TAKE IT FURTHER
MORNING MISTS

The morning mist that forms over lakes in parks is the perfect subject for a meditative, atmospheric image. Set up your equipment as early as possible, so you're ready to start work as soon as it gets light. Shooting through the mist directly into the sun works to create strong contrasts between background and foreground (right) and can render subjects in dramatic partial silhouette (far right).

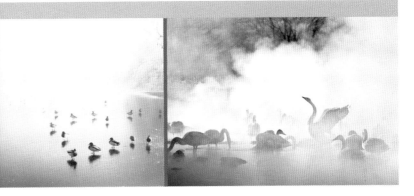

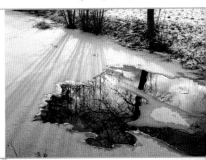

ALTERNATIVE APPROACHES

Wintry parks offer more than just scenic landscapes. Explore your surroundings and pay close attention to the details—they can present you with unusual and intriguing subjects.

Sunlight can transform even the most ordinary subject, like this shallow puddle on an icy path, into a beautiful composition. Long shadows soften the image and break up expanses of light tones, while the reflections add depth and interest.

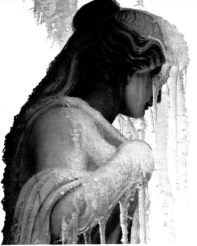

Sometimes, a covering of ice can embellish a sculpture or statue in a beautiful, unexpected way. Here, the image has been framed with a plain background so that the icicles can be seen clearly.

See also: Outdoor portraits pp.16–17, Woodland shadows pp.34–35, Wintry cityscapes pp.50–51, White on white pp.334–35

Indoor abstracts

Small-scale abstract photography is about creating dramatic images by concentrating on an object's shape, form, colors, and patterns. It invites us to look at even the most commonplace items in a new way and appreciate their aesthetic value. By capturing a subject in a non-literal way, abstract photography appeals to the viewer's emotional rather than logical side, and this can make the photographs all the more powerful.

CAMERA MODE	LENS SETTING
Select **Auto** mode or **Aperture Priority** and an aperture of f/8	Zoom to **normal focal length**

SENSOR/FILM SPEED	FLASH
Use a **low ISO** setting (e.g. ISO 100)	Shoot without **flash**

FOR THIS SHOT

Molded or cut glass produces captivating patterns as light shines through it. The result produced by the dispersed and refocused light is often more eye-catching than the object itself.

1 Focus
For shots like this, it doesn't really matter how much of the image is in focus, so feel free to experiment with depth of field.

2 Light source
Varying the position and direction of the light source creates a wide range of different effects.

3 Exposure
When working with light patterns, try to err on the side of underexposure. This will help to eliminate burned-out areas and produce stronger colors.

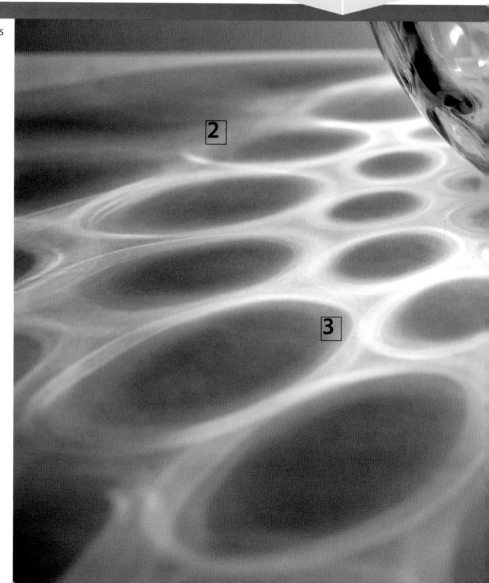

TRY THIS

Think of your dining table as a mini studio. Compact cameras can focus closely so zoom in on cutlery and table decorations, and explore them from unusual angles. Steady your camera on the table and experiment with candles and other light sources to vary the effects.

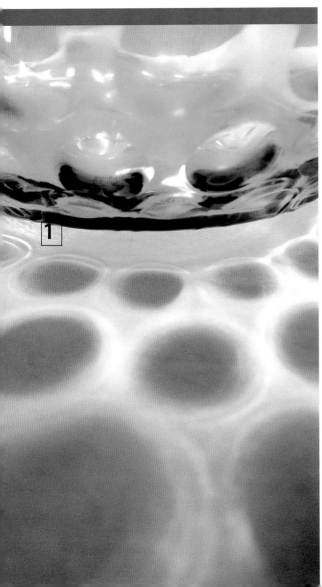

ALTERNATIVE APPROACHES

You don't need to go far to find inspiration, which makes abstract photography particularly useful for days when outdoor photo opportunities may be limited. Simply by looking—in a different way—around your home you should be able to find plenty of potential subjects.

Closets and shelves aren't usually considered subjects for creative photography, but with their repeating patterns and contrasting colors they lend themselves to abstract treatment. For best effect shoot face-on and crop in tightly.

When viewed from an unusual angle, ordinary household objects can take on abstract forms. Try shooting a small area taken out of context from a high vantage point and look for strong geometric shapes and striking compositions.

Try arranging everyday objects—here piles of paper napkins—to produce interesting patterns. Get in close to emphasize the pattern so that the objects themselves become secondary to the composition. Use a small aperture setting to make sure the whole image appears sharp.

See also: Camera modes pp.64–65, Light trails pp.88–89, Modern interiors pp.220–21, Abstract lights pp.328–29

Cozy interior

During the dark winter months, try to capture the cozy atmosphere of a warm and comfortable room. Exploit the soft glow of lamplight or the rich intensity of a fire, and look for situations that combine the hallmarks of a cozy, homely interior with the response of those enjoying it. To emphasize the contrast between inside and out, try juxtaposing the mellow colors indoors with the cold tones or darkness glimpsed through a window.

CAMERA MODE	LENS SETTING
Select **Sunset** mode or **Aperture Priority** and an aperture of f/2.8	Zoom to **normal focal length**

SENSOR/FILM SPEED	FLASH
Use a **medium ISO** setting (e.g. ISO 400)	Shoot without **flash**

FOR THIS SHOT

The glow from this fire reflected in the children's faces creates a heartwarming scene. It might be a clichéd interpretation, but that's part of its charm.

1 Composition
The subjects are positioned obliquely, so they're seen from the side, rather than the back, with the reflected light illuminating their profiles.

2 White balance
For a warm color cast, set your camera's white balance to Sunlight or Cloudy.

3 Exposure
Your camera's autoexposure system will overexpose dimly lit scenes like this, so underexpose by 1 to 1 1/3 stops, or set your exposure to a bright part of the scene.

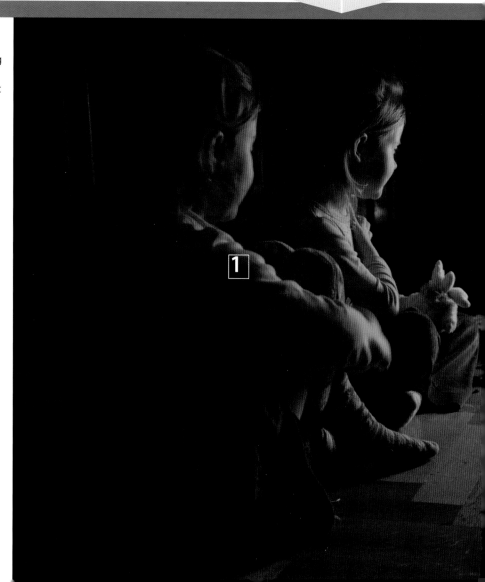

TRY THIS

The soft light from candles can create a warm, intimate feeling, especially if it's blurred. Shoot a cluster of candles using the maximum aperture, but focus on just one or two. This will produce a dreamlike haze of light.

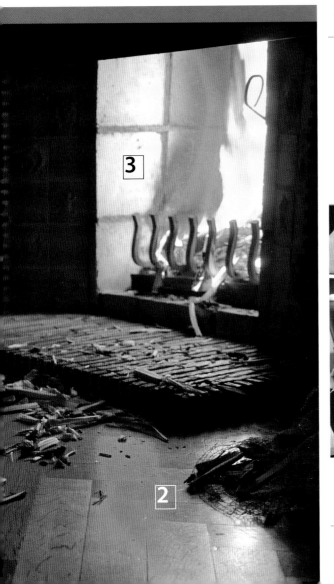

ALTERNATIVE APPROACHES

Not everyone's idea of coziness is the same, so look out for the idiosyncratic ways in which people—and pets—relax at home. When composing images, try to include symbolic elements that evoke winter days spent snuggled up indoors.

A sleeping dog epitomizes the feeling of comfort and contentment. The sidelighting bathes his face in a golden glow while the rest of the room remains in shadow, contrasting with the cool light outdoors. Use of a large aperture (for example f/2.8) has thrown the background into blur.

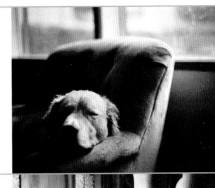

Even though we only get a glimpse of the person in this shot, the combination of the woolly socks, the hot drink, and the fire immediately conveys the theme. Blurring the fire helps to keep it in the background, while natural light picks out the foreground details well.

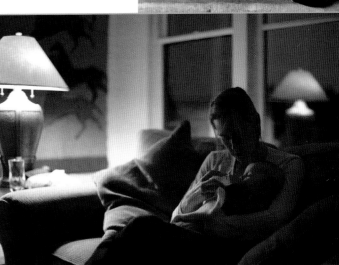

Using lamp lighting and even underexposing by up to 2/3 stop, can help to convey a mellow and relaxed atmosphere. Here the contrast between the warm tones inside and the cold blue outside enhances the effect.

*See also: Indoor child portraits pp.32–33, Working in low light pp.288–89
Around the house pp.296–97, Window-lit portraits pp.300–01*

Pets in snow

Snow can provoke interesting behavior in pets. Whether they're rolling around in it, chasing snowflakes, or picking their way gingerly through it, this dramatic change to their environment exaggerates their personalities. Have fun with your shots, be playful and experimental with your approach, and work with light and shadow to create expressive and characterful portraits.

CAMERA MODE	LENS SETTING
Select **Landscape** mode or **Aperture Priority** and an aperture of f/11	Zoom to **moderate telephoto**
SENSOR/FILM SPEED	FLASH
Use a **low ISO** setting (e.g. ISO 100)	Shoot without **flash**

FOR THIS SHOT

Placing the dog in the foreground, and framing him with the tunnel created by the trees bordering the path, makes this more than just a snow scene. The landscape is seen through the dog's eyes.

1 Pose
The dog's pose is crucial to the strength of this image. The angle of his head—turned to the side, as he takes in his surroundings—implies curiosity, and allows us to glimpse his features.

2 Contrast
To keep the contrast, tweak the white balance or shoot in black and white. This emphasizes the coal-black of the dog's coat, and the dark tangle of branches.

3 Flat lighting
A shot like this benefits from flat, overcast lighting that eliminates shadows and produces an almost monochrome image.

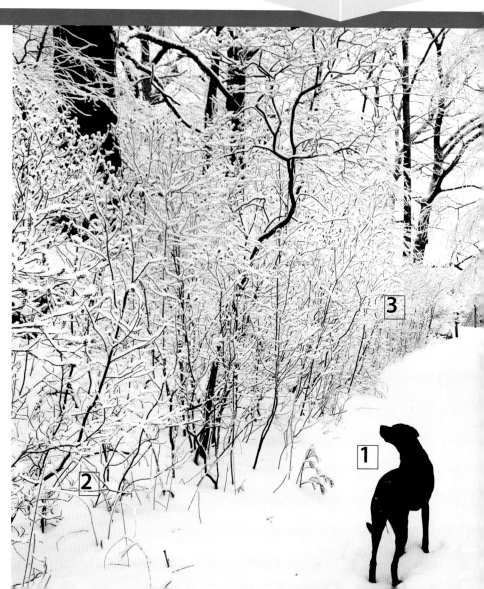

ON YOUR PHONE
ADD A VIGNETTE

Try using an app that adds a vignette, to help focus attention onto the main subject of your picture. This can be a useful way to improve a quick snapshot in which the setting is distracting, unphotogenic, or both.

TRY THIS

Overexposed portraits create a professional studio-shot feel. Overexposing by 1 stop renders the background snow as featureless, so the dog is the sole focus of the image. This touching pose, with the dog gazing up into the lens, is achieved with a high camera angle, while a moderate wide-angle lens setting gives him a plaintive, wide-eyed look.

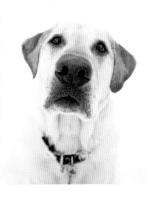

ALTERNATIVE APPROACHES

The effect of snow on pets is unpredictable but, whether they love it or hate it, their reactions can form the basis of some unusual portraits.

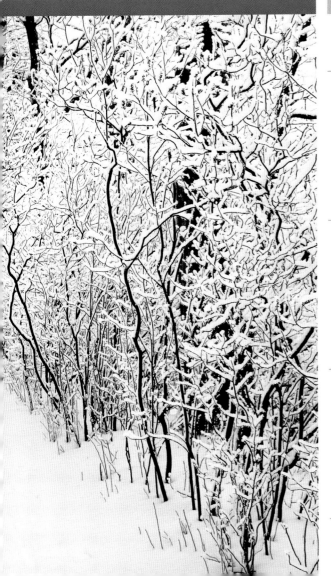

A dusting of snow automatically gives portraits a seasonal character. Here, a shallow depth of field focused on the cat's beautiful green eyes makes the image more striking.

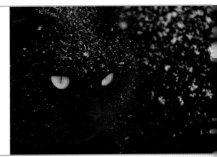

Include the wider scenery to create an unusual setting for a pet portrait. Here the dog appears thoughtful, perhaps confused by the changes to his environment. The strength of this image is its composition: the dog's gaze guides the eye across the landscape.

Capture your pet's playful behavior in snow by setting your camera to shutter priority and selecting a short exposure time, or use Action Scene mode with follow focus. Use modest (1/2 to 1 stop) overexposure to retain the brightness of the snow.

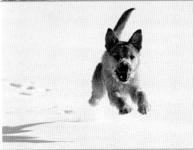

See also: Winter wildlife pp.48–49, Down on the farm pp.70–71, At the animal park pp.80–81, Pets in action pp.194–95

In the winter garden

What the winter garden lacks in brilliant blooms it makes up for in striking shapes and textures. From bulbous berries and spiky evergreens to frost-tipped shrubs and skeletal plants, look out for the eye-catching outlines that make gardens so visually stimulating during the winter months. But be careful not to breathe on the camera or lens when it's cold otherwise condensation will blur the image.

CAMERA MODE	LENS SETTING
Select **Macro** mode or **Aperture Priority** and an aperture of f/5.6	Zoom to **moderate telephoto**

SENSOR/FILM SPEED	FLASH
Use a **low ISO** setting (e.g. ISO 100)	Try shots with and without **fill-in flash**

FOR THIS SHOT

Not all plants lose their leaves in the winter. Look out for those that come into their full glory when the cold begins to bite.

1 Lighting
Light shining from the side can accentuate the form and colors of winter foliage. Here, the twinkling frost gives the edges of the leaves sharp definition.

2 Depth of field
Use a wide aperture setting to create a shallow depth of field that blurs the background, creating a sense of depth and making the main subject appear sharper.

3 Picture quality
By using the lowest possible ISO setting you can ensure optimum image quality. Unless you have very bright conditions you may need to use a tripod, as lower ISO settings demand longer shutter times.

TRY THIS

Animal tracks in the snow make simple, rather touching images. Keep the snow looking bright and white by increasing exposure by 1 or 2 stops. A similar effect can be achieved using your camera's snow scene mode.

ALTERNATIVE APPROACHES

Although the winter months are associated with darkness and gloom, the morning sunlight at this time of year can add sparkle, while overcast conditions are perfect for capturing soft, faded colors.

As well as highlighting detail, shooting toward the sun creates a soft, halo-like glow around the subject. A lens hood will prevent sunlight entering the lens directly, minimizing flare. If you don't have a lens hood, use your hand to create shade.

The delicate pastel colors of a faded winter garden are further subdued when they are lightly covered with frost. Use this to your advantage to create an image in which bold plant forms stand out against the muted palette.

TAKE IT FURTHER
OUTSIDE FROM INDOORS

If you're lucky enough to have wildlife visiting your garden, you can set up indoors and photograph it through a (clean) window. You'll need an SLR with a moderate-to-long telephoto lens to capture close-up images from a distance.

• Use a high ISO setting (around ISO 800) for short exposures, in order to capture fast-moving subjects clearly and sharply.

• Use a wide aperture to isolate the subject from its background.

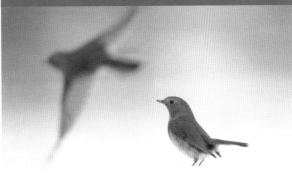

See also: Ice formations pp.14–15, Frosty mornings pp.18–19, A walk in the park pp.22–23, Snow-laden trees pp.54–55

Indoor child portraits

The key to shooting candid child portraits is getting your subject to forget you're there. In fact, children quickly become absorbed in what they are doing and it's at these times that you'll be presented with the best opportunities for natural portraits. Winter days, when children tend to spend more time indoors engaged in quiet pursuits—painting, reading, and playing games—are perfect for practicing your candid portraiture.

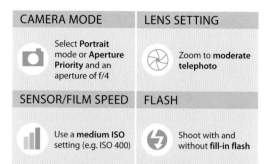

CAMERA MODE	LENS SETTING
Select **Portrait** mode or **Aperture Priority** and an aperture of f/4	Zoom to **moderate telephoto**

SENSOR/FILM SPEED	FLASH
Use a **medium ISO** setting (e.g. ISO 400)	Shoot with and without **fill-in flash**

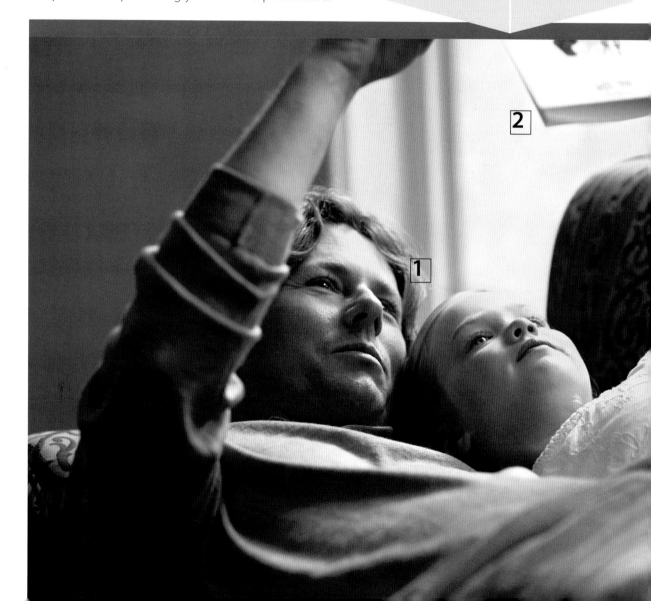

TRY THIS

You don't have to restrict portraits to faces. Other features can produce fun portraits. When a child is relaxed with an adult, or even asleep, you might shoot their hands or feet. Use a wide aperture, such as f/4, to restrict the focus, but frame the shot so that the child is recognizable.

ALTERNATIVE APPROACHES

Candid photographs of children engrossed in their favorite activity can really draw out their characters. For engaging shots, always get down on their level because an elevated viewpoint can make the viewer feel detached.

The concentration on the face of this child painting has been captured by zooming right in to exclude any distractions. A large aperture setting has created a narrow depth of field throwing all but the child's face and her artwork out of focus.

FOR THIS SHOT

This tender portrait of a father and his daughter sharing a quiet moment makes good use of available light and cleverly exploits an unusual framing device to draw the viewer into their world.

1 Shooting angle
Taking the photograph from a position level with the subjects' faces lends further intimacy to the feel of the image.

2 Framing
The arms of the subjects holding the book have created an effective framing device. The shallow depth of field also helps to make their faces the focal point of the image.

3 Natural lighting
Daylight diffused through a translucent blind provides very soft and warm lighting, but if shadows are too deep, consider using fill-in flash.

Shared participation in an activity, such as playing a video game, presents an opportunity for a candid portrait of siblings together. Taken from a position to the side of the television and zoomed in to capture their expressions, the only light in the image comes from the screen.

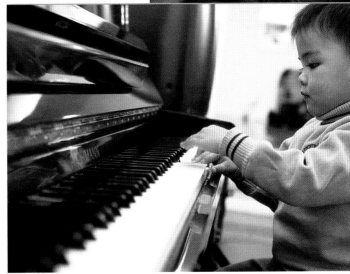

This young pianist's hands are the focus of his concentration and the main focal point of the picture. The framing draws your eye along the piano keys to the child's fingers.

See also: Character portraits pp.82–83, Baby portraits pp.140–41, Window-lit portraits pp.300–01, Posed portraits pp.342–43

Woodland shadows

Winter woodlands have a completely different character from woods in summer. The tree trunks become more dominant, as there are no distracting leaves, and you can see the framework of the bare branches clearly. Because the sun is low in the sky, immensely long shadows are cast across the woodland floor, providing interesting material for some bold, graphic images.

FOR THIS SHOT

This shot explores the contrast between vertical tree trunks and the diagonal lines of their shadows. Take care where you step—trampled snow will spoil the look of your image.

Side lighting
Bright sunlight shining from one side casts shadows of varying widths—many from trees that are out of shot.

Exposure
The dazzling snow may cause automatic exposure systems to underexpose. Increase exposure by 2/3 to 1 stop to preserve brightness.

Aperture
Use a small aperture setting to retain texture throughout your image.

CAMERA MODE

Select **Landscape** mode or **Aperture Priority** and an aperture of f/16

SENSOR/FILM SPEED

Use a **low ISO** setting (e.g. ISO 100)

LENS SETTING

Zoom to **telephoto**

FLASH

Shoot without **flash**

TRY THIS

Shadows on snow may look many different colors, as the Impressionist painters demonstrated. Sometimes they take on the intense blue of the sky. Set your color balance to Daylight mode, to create an image that's true to color.

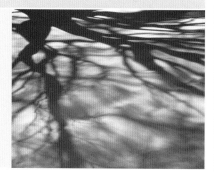

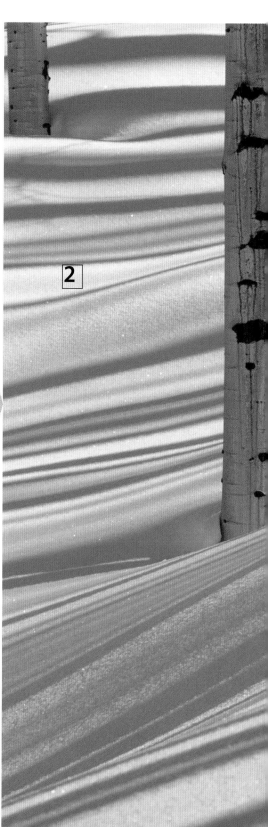

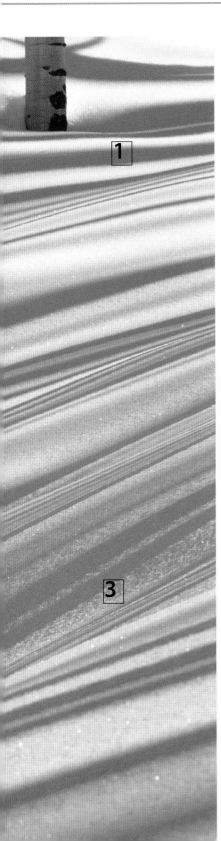

ALTERNATIVE APPROACHES

Snow is the perfect, unblemished canvas for shadows—as are smooth paths and walkways. When the sun is very low at the end of a winter's day, you'll be able to achieve some really sharp contrasts between light and shade. Try taking both wide landscape shots and cropping in closely to isolate unusual details.

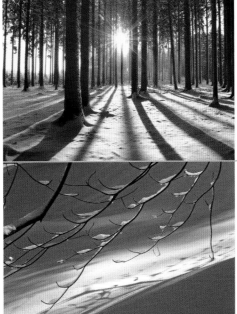

To capture long shadows that stretch from the foreground away into the background, it's best to shoot directly into the sunlight, rather than across it. The trees will stand out in silhouette. Here, a small aperture has been used to generate a sunburst effect.

Frame close-up details carefully to create an interesting composition. The diagonal sweep of these twigs from the top of the picture gives the image a sense of movement and there is a dramatic contrast between the inky twigs, the feathery edging of snow, and the soft, gray shadows beyond.

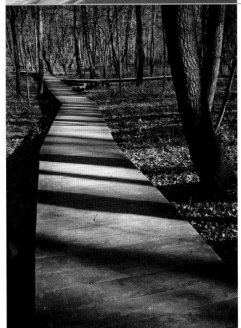

Woodland shadows can be just as striking without snow. Here, the image is given structure and interest by shooting along a raised wooden walkway that leads your eye into the distance. The sepia/brown tone of the image ensures that there are no distractions of color, instead directing the viewer to the contrast between the tone and form of the walkway and the shadows cast by bare trees.

See also: A walk in the park pp.22–23, Street shadows pp.52–53, Snow-laden trees pp.54–55, Shades of gray pp.254–55

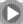

Balancing color

When we photograph a scene we expect the colors in the picture to be close, if not identical, to those we see with our eyes. However, we're often disappointed by the results. The human eye is so remarkably adept at automatically adjusting to a wide range of lighting types and conditions, that we don't notice the color casts produced by each. While cameras can't match the sophistication of this process, most come with a system that helps to compensate: white balance.

▶ WHITE BALANCE TYPES

Most digital cameras let you adjust the white balance setting so that colors are properly recorded under different types of lighting. It does this by removing, by varying degrees, any dominant color in the illuminating light until it approximates standard daylight. Typical settings include Daylight, Shade, Tungsten (traditional light bulbs), and Flash. Some cameras have more white balance settings than others and some even include an Underwater setting. The images below show the same scene shot using four different white balance settings.

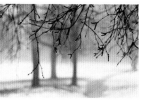

DAYLIGHT

FLASH

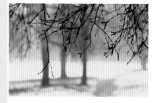

SHADE

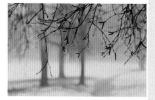

TUNGSTEN

▶ MANUAL WHITE BALANCE

Many digital cameras allow you to set the white balance manually for precise results when you're working under difficult or extreme lighting conditions.

To do this you'll need a sheet of white cardstock, if the light is poor, or gray cardstock, in bright conditions. Position the cardstock so that it's lit by the same light source as your scene, and make sure that it completely fills the camera's field of view. You can now set the white balance by either pressing the white balance button on your camera or selecting the manual white balance option from the system menu.

DID YOU KNOW?

ADDING WARMTH USING WHITE BALANCE

If you want to warm up your photos, set the color balance to cloudy, even if there's not a cloud in the sky. The camera will shift the picture's color balance to make it redder, which has the effect of strengthening the pinks and yellows.

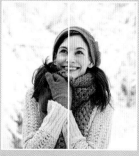

ORIGINAL **CLOUDY**

AUTO WHITE BALANCE

All digital cameras have an auto white balance setting, which is useful when you don't have time to properly assess color balance. However, this setting has its limitations and certain subjects and lighting conditions can cause problems. This is particularly the case in scenes with an excess of either warm or cold tones.

The auto white balance assumes that lighting conditions are standard and that the subject has a broad range of colors. If one color dominates, it assumes that this is a color cast and incorrectly compensates. In these shots of a sunset, the original scene has strong, warm tones, whereas the image shot using auto white balance is much less punchy.

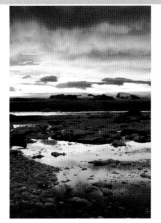 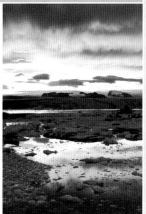

ORIGINAL AUTO WHITE BALANCE

CORRECTING COLOR CASTS

If you or your camera have used the wrong white balance setting, your photos may have taken on a color cast, which could be warm or cool, or tinted. That cast could be so minor as to be unnoticeable, but often it's very dramatic.

It's easy to correct color casts in post-processing using image manipulation software. The Auto Color command, featured in most packages, can sometimes be effective, but can also be fooled by a predominant color in a shot. You may find it more effective to use the Color Balance control to reduce the intensity of the color producing the cast.

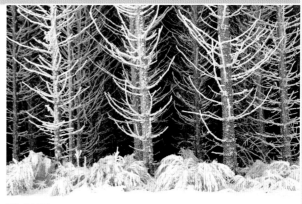

NO CAST

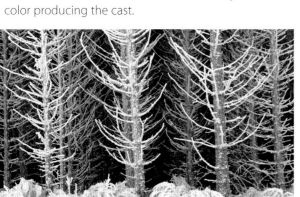

WARM CAST

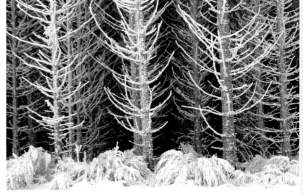

COOL CAST

Late Winter

ghostly trees and quiet calm

roads shining like rivers

a world transformed

bewitching twilight

"Why, what's the matter,
That you have such a **February** face,
So full of **frost**, of **storm**
and **cloudiness**?"

William Shakespeare

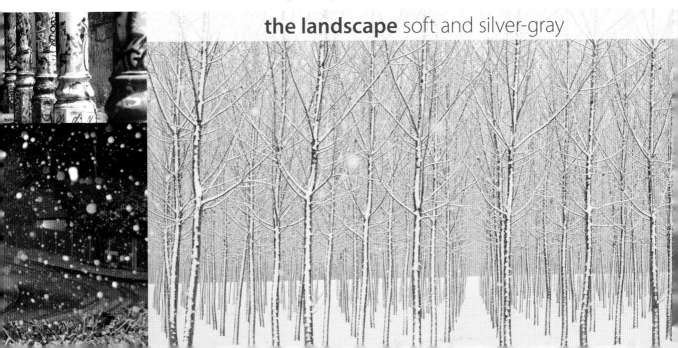

the landscape soft and silver-gray

Purple twilight

At twilight, the darkening blue of a clear sky can combine with the residual tones of sunset to bathe the landscape in a soft purple light. This color—ranging from rose pink to indigo—will blend with any artificial lighting to produce compelling scenes that are all the more beautiful for their transience. Find a vantage point that allows you to capture the full impact of this effect.

CAMERA MODE	LENS SETTING
Select **Landscape** mode or **Aperture Priority** and an aperture of f/5.6	Zoom to **moderate telephoto**

SENSOR/FILM SPEED	FLASH
Use a **medium ISO** setting (e.g. ISO 400)	Shoot without **flash**

FOR THIS SHOT

Reflecting the light from a twilight sky, even a gray cityscape has a magical quality it would lack in the daylight.

1 Perfect timing
Pick the time of your shot carefully to achieve a good balance between natural and artificial light.

2 Color balance
Artificial lighting provides a counterpoint to the purple tone in the image. Street lighting appears warmer (more red) than normal if the color balance is set at Auto.

3 Enhanced color
Underexposing by 1 stop or more produces more intense color and preserves the twilight brightness levels.

TRY THIS

A twilight sky filled with birds flocking together to return to their roost is a spectacular sight. With a high ISO sensitivity of around 1600 you'll achieve short exposure times and sharp images of the birds in flight.

ALTERNATIVE APPROACHES

To achieve the best results from your twilight images, get to your location in good time and plan your shot carefully. Try to anticipate how the light will change and work out the best angle from which to capture the scene.

Although transmission towers aren't always popular with photographers, they can be exploited to make an unusual landscape picture. Here, shot at telephoto and with a large depth of field, their linked silhouettes guide the eye toward the horizon.

The mist in the background of this scene creates a texture reminiscent of brushstrokes. Combined with the sharply silhouetted rushes, the image takes on the quality of a Romantic landscape painting.

The framing of scenes like this benefit hugely from time spent studying the way in which the light plays on the water. With this vertical framing, the dark rocks in the foreground provide a strong counterpoint to the soft, velvety texture of the sand and the glasslike smoothness of the sea beyond.

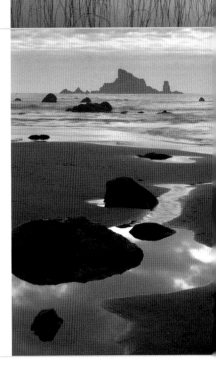

See also: Snowy sunsets pp.60–61, City lights pp.62–63, Changing skies pp.106–07, Glorious sunsets pp.250–51

Snowstorms

From gridlocked roads to impaired visibility, heavy snowfall can be inconvenient and sometimes dangerous. However, if you're prepared to venture out, a blizzard can provide an opportunity for making unique and evocative pictures. The snow envelops familiar objects and shrouds the landscape in a transforming veil, encouraging you to explore your environment in a different way.

CAMERA MODE	LENS SETTING
Select **Landscape** mode or **Aperture Priority** and an aperture of f/5.6	Zoom to **moderate telephoto**

SENSOR/FILM SPEED	FLASH
Use a **medium-to-high ISO** setting (e.g. ISO 400 to 800)	Shoot without **flash**

FOR THIS SHOT

To capture the full drama of a blizzard, focus on the background of the scene beyond the snowflakes. This creates a slightly abstract image—the snow remains the star of the show. If possible, use manual focus, as the autofocus might be confused.

1 Color and contrast
Photos of snowstorms don't have to be colorless. Look for bold background colors to provide a strong contrast with the snowflakes.

2 Exposure
For a touch of grittiness and texture, use a moderate-to-high ISO to allow for short exposures. This retains the circular shape of each snowflake, rather than rendering them as streaks.

3 Human interest
Here, the inclusion of the cars and the pedestrian hurrying through the snow stops the image from being completely abstract.

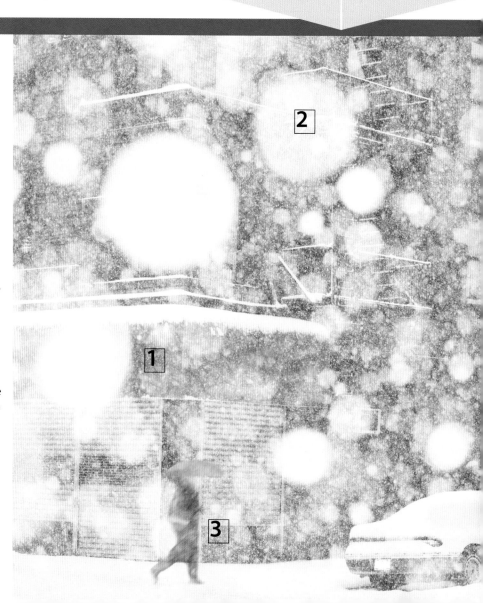

TRY THIS

For a striking, colorful image, try capturing the ambient glow given off by the snow-covered ground under street lighting. By using flash, the snow that's falling in the foreground has been rendered as white, bringing depth and contrast to the picture.

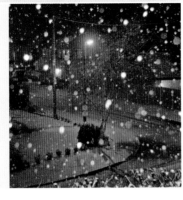

ALTERNATIVE APPROACHES

Falling snow lends a romantic, painterly quality to the most ordinary scenes, acting like a diffusing filter that softens busy compositions. Night scenes take on an otherworldly dimension, with car headlights and street lamps illuminating the landscape with an eerie glow.

Offset the muted tones of a snow scene by accentuating the more vibrant colors in the image. Partial blurring—which can be created by simply rubbing a streak of snow on the lens—can be used to reinforce, or even exaggerate, the severity of the weather.

When driving into falling snow, car headlights create a surreal tunnel effect. By setting a relatively long exposure time (around 1/30 sec), you can create the illusion that the snowflakes are streaming past you, enhancing the impression of speed.

To capture the sheer velocity of snowfall during a blizzard, it is best to set it against a dark background. Here, the diagonal snow streaks contrast nicely with the horizontal and vertical lines of the windows. An exposure time of around 1/4 sec has accentuated the movement of the snow.

See also: Working in low light pp.288–89, Exposure pp.316–17, White on white pp.334–35, Fun in the snow pp.336–37

Outdoor still life

Photography and still life are the perfect match. As your subject matter is static you can take your time, make as many adjustments as you need, and fine-tune the lighting until you're happy with the composition. What's more, you can create a still-life arrangement using absolutely anything that you have on hand. To create a seasonal image, look for objects that are associated with winter—the best ones are probably outdoors.

CAMERA MODE	LENS SETTING
Select **Auto** mode or **Aperture Priority** and an aperture of f/5.6	Zoom to **moderate telephoto**
SENSOR/FILM SPEED	**FLASH**
Use a **low ISO** setting (e.g. ISO 100)	Shoot without **flash**

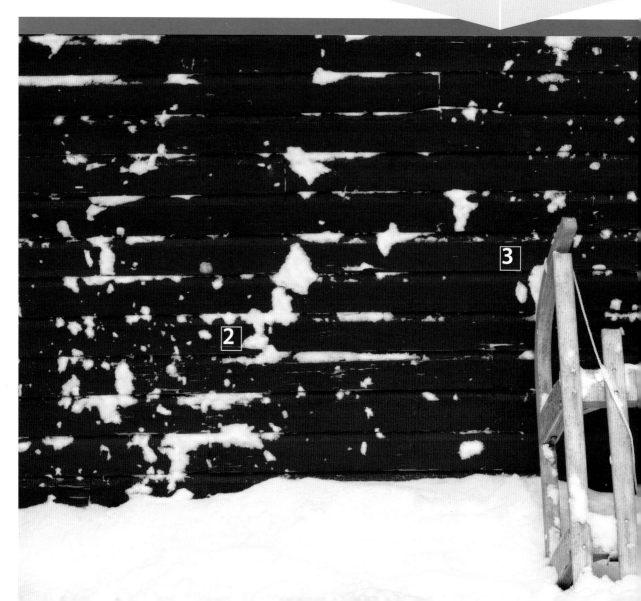

TRY THIS

To evoke the feel of a winter's day, try using filters that accentuate the contrast in a scene and give it soft, muted colors. Setting up in front of a window enables you to contrast still-life elements indoors with the wintry scene outside.

ALTERNATIVE APPROACHES

Still lifes are usually thought of as indoor arrangements, but there's no reason why they shouldn't be set up outdoors. Things you come across outside are often more redolent of winter and can make very striking compositions.

A still life doesn't have to be complicated. Simple things can just as effective and produce strong images. Look for objects that work well together because they are similar in color or texture, such as these fir cones in a wooden bowl.

FOR THIS SHOT

Sledges are, of course, associated with winter. In this shot, the seasonal look is emphasized by the scattered snow, dull light, and cool overall tone.

1 Color
Red is the dominant color in this image, yet its subdued character creates a cold feel. The subtle bluish tones on the snow also reflect the wintry mood.

2 Flat lighting
As the light is utterly shadowless, textures have been defined with broken patches of snow and contrasting boundaries between color patches.

3 Texture
The contrast of random snow patches with the regular, manmade shapes of the sledge and weatherboard enliven an otherwise flat image.

Choose things associated with winter, such as these ice skates, and try to arrange them in a way that looks natural. Try out various arrangements until you find one that looks pleasing, yet uncontrived.

Winter still lifes don't need to depict objects only associated with winter, but it's nice if they suggest the season in some way. Here, the coating of frost on the shears and the flower immediately tell you what time of year it is.

See also: Picture composition pp.260–61, Indoor still life pp.274–75,
Fallen leaves pp.306–07, Exposure pp.316–17

Winter wildlife

The colors and markings that provide many animals—large and small—with camouflage for most of the year cause them to stand out prominently against a backdrop of snow. This is a rare opportunity for you to make them the full focus of your photographs. Wrap up warm and—as with all wildlife photography—be prepared to wait for the shot you want. Your patience will be rewarded with a striking, uncluttered image.

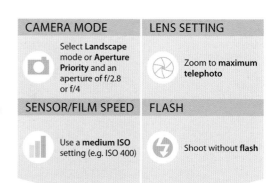

CAMERA MODE	LENS SETTING
Select **Landscape** mode or **Aperture Priority** and an aperture of f/2.8 or f/4	Zoom to **maximum telephoto**

SENSOR/FILM SPEED	FLASH
Use a **medium ISO** setting (e.g. ISO 400)	Shoot without **flash**

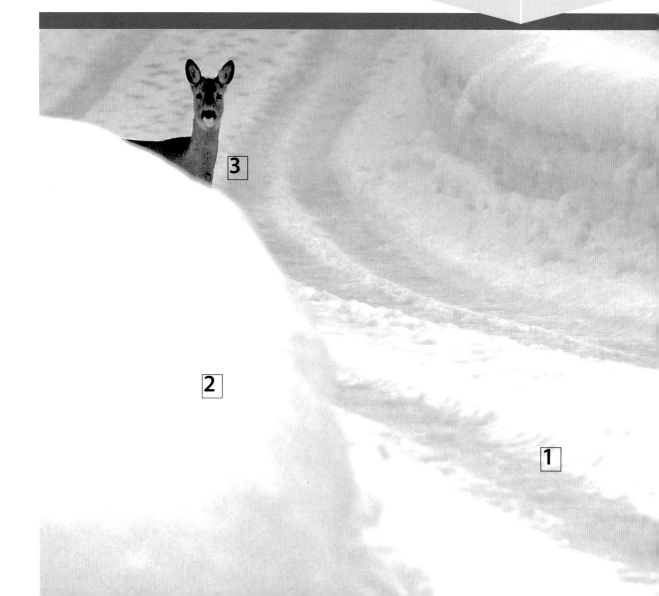

TRY THIS

Small creatures that don't hibernate or migrate for winter can be tempted into your yard with a regular supply of food and water. Set up a table visible from a window and have your camera ready to capture them in close-up when they visit.

ALTERNATIVE APPROACHES

Few animals can successfully conceal themselves in the snow-covered landscape. In addition to making them easier to locate, their markings, patterns, and colors add a richness and vibrancy to a snowy scene, bringing a different dimension to your images.

Spend some time watching the activity of birds in your yard and you'll notice that many tend to have favorite perches that they return to again and again. Set your camera up in advance, compose your shot, and wait.

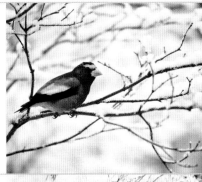

A reduced food supply in the winter makes the behavior of larger predators such as foxes bolder. Focused on hunting, they become slightly easier to photograph. To get close shots like this, keep your distance, remain still, and zoom in.

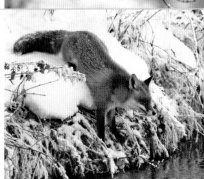

FOR THIS SHOT

The strength of this composition is its minimalism—the solitary deer stands out from its white background, without dominating the image.

1 Composition
Make use of any compositional aids you come across by chance. Here, the tire tracks provide texture and a suggestion of movement in a still scene.

2 Exposure
In full sun, you'll need to overexpose to retain the bright white tones of snow. Here, there is some shade, so a compensation of only around 1 stop is needed.

3 Framing
Overcoming the urge to place the deer at the center of the frame has resulted in a far more interesting image.

TAKE IT FURTHER

GETTING CLOSER

For wild animals, you'll need the reach of the longest telephoto lenses—but even if you can't fill the frame, you can still obtain satisfying images by including their environment.

See also: *Pets in snow pp.28–29, Down on the farm pp.70–71, At the animal park pp.80–81, Picture composition pp.260–61*

Wintry cityscapes

Snow has a transformative effect on places and people—colors become muted, shapes are softened, and lights are blurred, while pedestrians take on an amorphous appearance, hurrying through the streets wrapped in layers of clothing. The cityscape is changed beyond recognition, and those photographers who are prepared to brave the elements can take advantage of an abundance of picture-making opportunites.

CAMERA MODE	LENS SETTING
Select **Landscape** mode or **Aperture Priority** and an aperture of f/4	Zoom to **moderate telephoto**
SENSOR/FILM SPEED	FLASH
Use a **high ISO** setting (e.g. ISO 800)	Shoot without **flash**

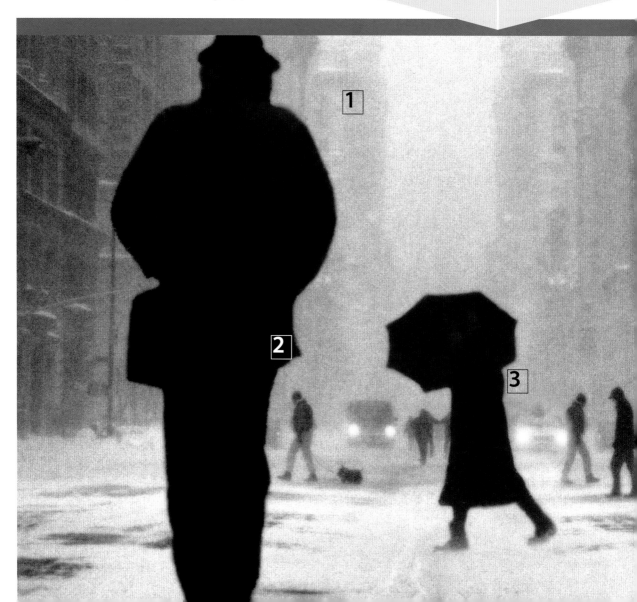

ON YOUR PHONE
FROM A MOVING VEHICLE

We spend many hours traveling in cars, but few people think to use that time to make pictures. Use your phone to capture the city from an unusual perspective. The view from the passenger seat offers many picture-making possibilities that are not available to pedestrians.

ALTERNATIVE APPROACHES

Blizzards howling through streets might be an obvious shorthand for representing a city in winter, but they're not your only option. The city provides endless opportunities to create distinctive images, from the scenic to the abstract, that capture the atmosphere of an urban winter.

A steamed-up or frosty window can be used as a frame through which to shoot the scene beyond. (You can breathe on the window to create a similar effect.) Focus on the distance to ensure the fogging in the foreground is softly blurred.

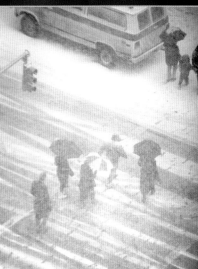

A high vantage point helps to create order in scenes that could be chaotic if shot from street level. Once you've found your spot, watch and wait until the activity below resolves into a pleasing composition. Increase exposure by 1 stop in order to keep the shot bright and to prevent the snow from looking gray.

FOR THIS SHOT

The main figure in this composition—the man in the hat, shoulders hunched, walking away from the camera—dominates this image, creating depth and filling the height of the frame.

1 ISO setting
The force of a blizzard can appear slightly diminished on camera. A high ISO setting results in more image noise, bringing graininess to the scene.

2 Low angle
Shooting from waist height and keeping the camera level makes the subjects of your picture—people or buildings—more imposing.

3 Lens setting
A moderate telephoto setting allows exact framing of the principal subjects. It also gives a slightly compressed perspective.

TRY THIS

A snow-covered road becomes a canvas for the tire treads of vehicles. A light dusting of snow produces strongly contrasting black-and-white patterns, which can make pleasing graphic images. Look out for eye-catching arrangements of footprints on pathways too.

See also: Ice formations pp.14–15, Outdoor portraits pp.16–17, Frosty mornings pp.18–19, Industrial landscapes pp.84–85

Street shadows

When the sky is clear, the low winter sun casts long shadows. In landscape shots, shadows are often used to enhance a composition, but you can also make them the primary focus of a scene to create intriguing and compelling images. Once you start looking, you'll discover how useful the presence of shadows can be for creating effective compositions.

FOR THIS SHOT

This image of a figure walking along a sunlit sidewalk is given a cinematic feel by the presence of the exaggerated shadow stretching out behind him.

1 **Timing**
The pedestrian has been captured walking into a patch of light, resulting in a well-defined silhouette and the longest possible shadow.

2 **Composition**
Including the row of posts in the left of the scene and balancing them with the wall on the right neatly frames the subject.

3 **Depth of field**
Using a large depth of field retains detail in the most distant objects as well as the foreground.

CAMERA MODE

 Select **Landscape** mode or **Aperture Priority** and an aperture of f/8

SENSOR/FILM SPEED

 Use a **low ISO** setting (e.g. ISO 100)

LENS SETTING

 Zoom to **wide angle**

FLASH

 Shoot without **flash**

TRY THIS

Getting good pictures of shadows isn't just about luck—you can make your own forms and shapes. This image has been inverted—so the shadow appears to be upright—and it's been cropped so the people making the shadow are not visible.

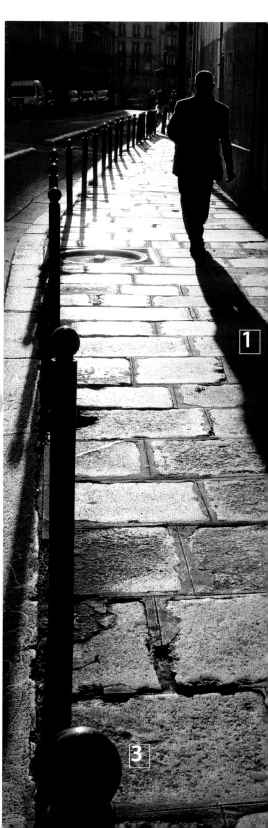

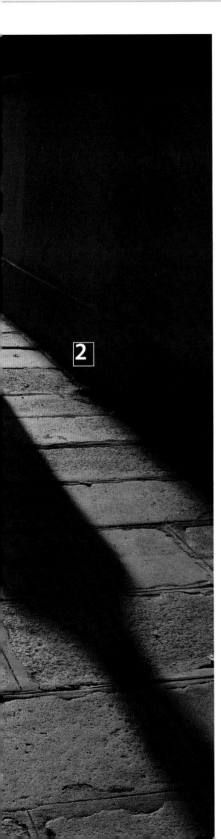

ALTERNATIVE APPROACHES

In photography, shadows can be used as props or as the main subject of the image. Whichever approach you choose you'll create images that are unusual and intriguing—even the most prosaic subject can take on a mysterious feel when captured as a shadow.

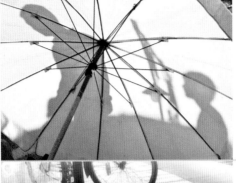

Don't just look for shadows on the ground. Other objects—such as a window blind or umbrella—can act as a screen for a shadow. As long as they're sufficiently translucent, they can be used to make candid shots of oblivious passers-by.

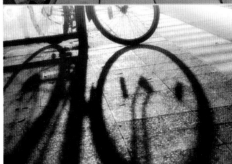

Shadows with fuzzy edges can be used to create a mellow, nostalgic image, especially when offset by gentle winter sunlight. Here, the sun's low angle distorts the bicycle's shadow, resulting in an image that combines the everyday with the abstract.

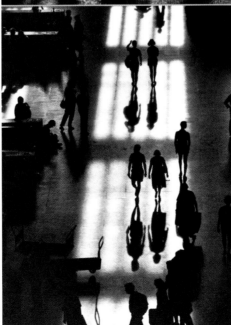

From a high vantage point, and shooting into the light, people and their shadows blend together. Emphasize these strange conjoined forms by making pictures in black and white. In this image, a large window frame casts a shadowy grid on the ground, and the subjects move in and out of the dark and light areas. For scenes with expansive shadowy areas, underexpose slightly to make the silhouetted figures darker.

See also: On the move pp.86–87, Silhouettes pp.202–03, Backlighting and silhouettes pp.204–05, Streetlights pp.304–05

Snow-laden trees

Don't allow the cold and inconvenience of snowfall to deter you from venturing out into the woods. Bare trees become stark silhouettes against the sparkling white landscape, the delicate tracery of their dark branches accentuated by an outline of snow. These contrasts present their own challenge—namely, how to strike the right balance between light and dark tones.

FOR THIS SHOT

Despite the semiabstract nature of this shot, it has been carefully composed to capture a pleasing balance between the heavy branches, the more dainty twigs, and the background.

1 Framing
The inclusion of part of the trunk on the right side of the image anchors the composition and provides a point of reference for scale and orientation.

2 Exposure
When shooting a combination of very dark tones and very light tones in a scene, experiment with exposure compensation to find the best effect.

3 Depth of field
Selecting a small aperture, but focusing on the middle distance, keeps sharpness throughout the image.

CAMERA MODE

Select **Landscape** mode or **Aperture Priority** and an aperture of f/11

SENSOR/FILM SPEED

Use a **low ISO** setting (e.g. ISO 100)

LENS SETTING

Zoom to **moderate telephoto**

FLASH

Shoot without **flash**

TRY THIS

You may not immediately think about shooting snow-laden trees at night, but the effect can be striking. Lit from behind by a street lamp, the snow on the branches reflects and diffuses the light to produce a soft and eerie glow. Position yourself so that the light source is obscured by the trees.

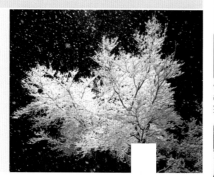

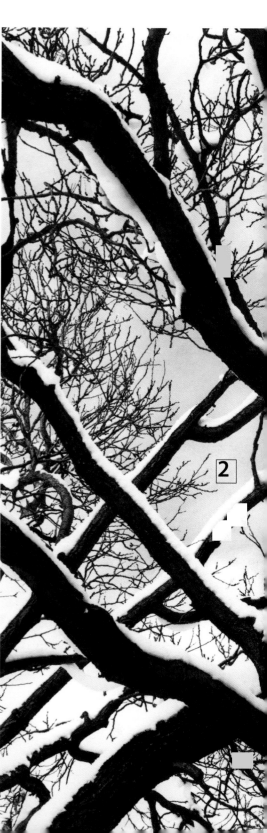

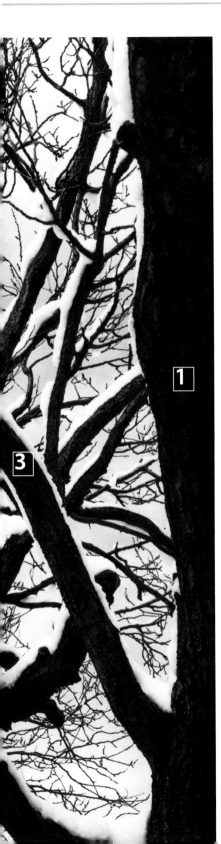

1

3

ALTERNATIVE APPROACHES

The monochromatic nature of shots of snowy trees means they follow similar rules to black-and-white photographs. Pattern and form, rather than color, dominate. Study the shapes and planting patterns of the trees, and the way the light interacts with the snow, to find the best approach.

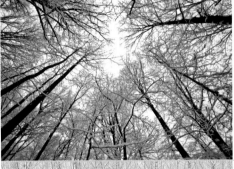

Looking directly up when in a wood or forest provides an entirely different, almost kaleidoscopic effect. The tree trunks (vertical and parallel when shot square-on) will converge to a point, and sunlight will add a soft halo to the snow-covered branches.

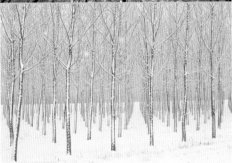

Trees and shrubs that are commercially grown are often planted in regimented, high-density rows. Snow makes the planting pattern of these trees emerge more clearly—move around to find the view that best captures the regularity of the planting and ensure that you keep the horizon straight.

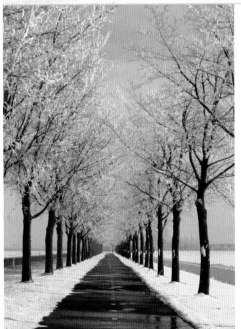

Shooting down a straight tree-lined avenue results in a symmetrical composition. This can be given a more interesting graphic feel by looking for additional lines of symmetry. Here, for example, the color and shape of the road converging in the distance is echoed by the tree trunks that line it. Shooting in Landscape mode deepens the colors.

See also: A walk in the park pp.22–23, Woodland shadows pp.34–35, Skeleton tree pp.312–13, White on white pp.334–35

Urban decay

Most large towns and cities have districts that are marked by signs of urban decay. Like a contemporary take on medieval ruins, vacated factories, homes, and commercial buildings are intriguing spaces that can be turned into a subject for highly atmospheric images. The style can be varied, from hard-hitting documentary pictures to more artistic interpretations that find beauty in the decay.

CAMERA MODE	LENS SETTING
Select **Landscape** mode or **Aperture Priority** and an aperture of f/8	Zoom to **telephoto**

SENSOR/FILM SPEED	FLASH
Use a **medium ISO** setting (e.g. ISO 400)	Shoot without **flash**

FOR THIS SHOT

The bright colors of this graffiti transform a rundown arcade into a piece of urban art.

1 Patterns
Shooting the line of pillars at an angle produces a repeating pattern of identical shapes, distinguished by the different graffiti.

2 Background
Shots like this work best without background distractions to upset the rhythm of the composition, so walk around your subject to find the best angle to shoot from.

3 Depth of field
To keep everything in focus, from the nearest pillar to the furthest, select Landscape mode or Aperture Priority and the smallest possible aperture.

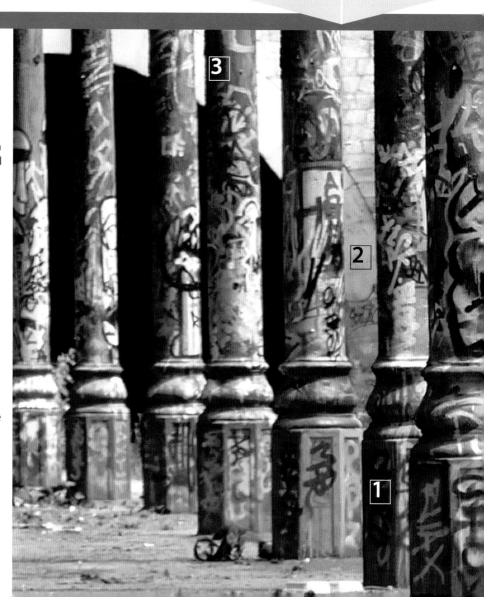

TAKE IT FURTHER
EMPHASIZE DECAY

Accentuate urban decay using image manipulation software. Reduce color saturation by 10–15 percent; apply a grain filter for a gritty texture. For deeper shadows, increase the contrast and reduce the brightness. Flashes of color can be boosted for an eye-catching effect.

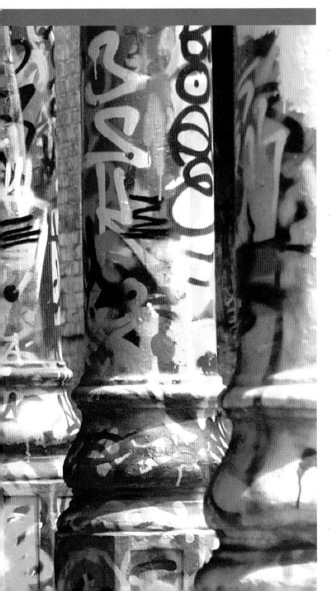

ALTERNATIVE APPROACHES

In most run-down neighborhoods, you'll be able to photograph different stages of deterioration as the lack of care and attention takes its toll on buildings. Be very careful when shooting inside abandoned or neglected buildings—they may not be completely safe.

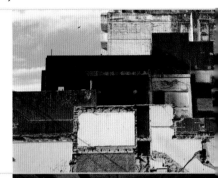

This carefully composed image of a partially demolished building is a fascinating patchwork of geometric shapes. The inclusion of a small area of blue sky provides context and a sense of scale.

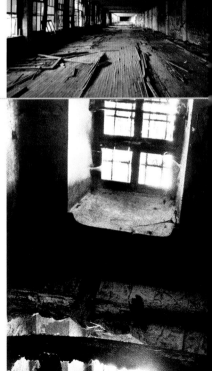

We rarely appreciate the size of work spaces when they're filled with machinery or office equipment but, stripped bare, the scale becomes obvious. Enhance the cavernous feeling by zooming out to capture long vistas.

Black and white is favored by reportage and documentary photographers and can be used to create powerful images of dilapidated buildings. Without the distraction of color, the viewer pays more attention to light and shadow, and the distressed fabric of the building. Using a high ISO setting has added noise to this image, which works well with the subject.

See also: *Modern architecture pp.74–75, Industrial landscapes pp.84–85, Romantic ruins pp.144–45, Spirit of place pp.238–39*

City bridges

From ancient Roman viaducts to monumental modern suspension structures, the size and style of bridges vary hugely. Spend a little time assessing the character of the bridge to determine the best viewpoint. Whether from a distance, close up, or from an unusual angle, try to uncover the most interesting option, looking at the way light and shadow interacts with the bridge and how it impacts on its surroundings.

CAMERA MODE	LENS SETTING
Select **Landscape** mode or **Aperture Priority** and an aperture of f/11	Zoom to **wide angle**

SENSOR/FILM SPEED	FLASH
Use a **medium ISO** setting (e.g. ISO 400)	Shoot without **flash**

FOR THIS SHOT

The combination of flood-lighting and the residual colors of a twilight sky add interest and enhance the sense of perspective to this modern steel structure.

1 Composition
Choose your viewpoint to emphasize the most notable aspect of the bridge and decide whether to include the wider scenery. This view along the walkway emphasizes the graphic repetition of the girders.

2 Time of day
Shoot at different times of day for images with very different qualities. Here, the floodlighting adds subtle shades of silver that would be absent in the day.

3 Exposure
When working in half-light, increase the exposure slightly to retain detail in the darker areas. Here, the exposure has been increased by 2/3 stop so you can see right to the end of the bridge.

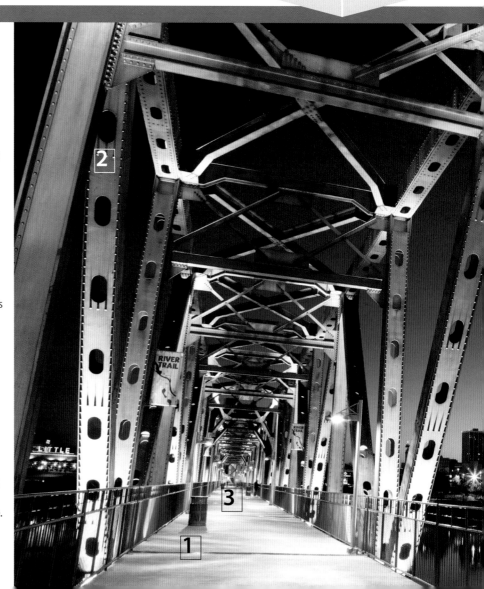

SELECTIVE FOCUS

Use selective focus to draw attention to a detail of a scene without losing the context. Here, using a long telephoto lens to reduce the depth of field has isolated the ornate ironwork of a bench, but the shot is composed to lead the eye down the pier.

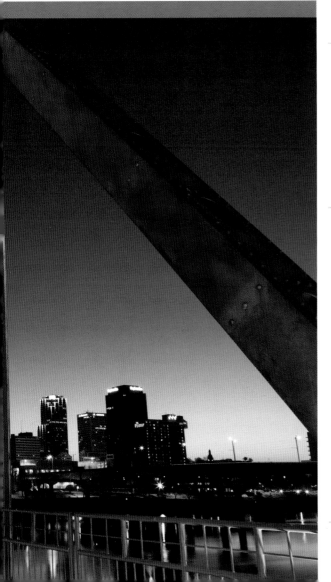

ALTERNATIVE APPROACHES

Whether they're quaint and picturesque, brutally utilitarian, or elegant feats of engineering, most bridges have something in common—bold geometric shapes and revealing details. When planning your shot, look at the bridge's idiosyncracies, the features that make it unique, as well as wider views.

To fully exploit the dynamic, sweeping shapes of intertwining road bridges at major intersections, position yourself safely between the roads and then zoom out as wide as possible.

When assessing the photographic possibilities of a bridge, pay attention to the surroundings as well as the bridge itself. Here, the arch of this bridge has been used as a frame for the scene beyond.

Close examination of a bridge reveals the methods of construction. Make use of strong side-lighting to turn details, such as the elongated shadows cast by these rivets, into an eye-catching feature. Shooting from a low angle draws attention to the scale of this monumental structure.

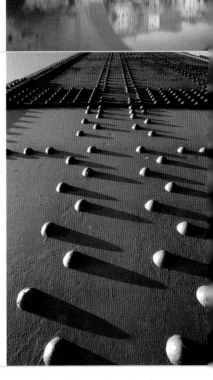

See also: Modern architecture pp.74–75, Railway stations pp.76–77, Architectural details pp.78–79, Shades of gray pp.254–55

Snowy sunsets

Clear winter skies at dusk are a perenially popular subject for photography—from the soft golden colors to the way in which the low angle of the sun enhances the textures of the landscape. If you're heading off the beaten track in harsh conditions, make sure you're properly dressed—when the sun goes down the temperature drops rapidly. Tell someone where you're going, and when you expect to return.

CAMERA MODE	LENS SETTING
Select **Landscape** mode or **Aperture Priority** and an aperture of f/11	Zoom to **moderate wide angle**

SENSOR/FILM SPEED	FLASH
Use a **low ISO** setting (e.g. ISO 100)	Shoot without **flash**

FOR THIS SHOT

Here, the colors of a glorious winter sunset are reflected by a snow-covered field. A modest amount of underexposure helps to intensify the colors.

1 **Composition**
A barbed wire fence becomes a thing of beauty when softened by snow and bathed in glowing light. Use man-made features in the landscape to give structure and rhythm to compositions.

2 **Lighting**
With the sun just out of frame, subtle variations in color are preserved.

3 **Camera angle**
A low camera angle makes the beautifully lit frosted twigs and undulating foreground snow the main focus of this image.

TAKE IT FURTHER
COLOR TINTING

Images of sunsets don't have to be all about color—converting a picture into black and white draws attention to the interaction of light and shadow. You can desaturate the color (right) or give it a color tint (far right) using image manipulation software.

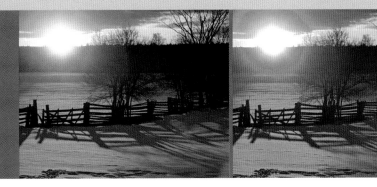

ALTERNATIVE APPROACHES

Rather than pointing your camera directly at a sunset, try experimenting with the varied effects produced by diffused and reflected sunlight.

Shooting a sunset through a semitranslucent fabric helps to diffuse the strong light. Here photographing through a linen window blind has given the snowy sunset outside a textured, painterly feel.

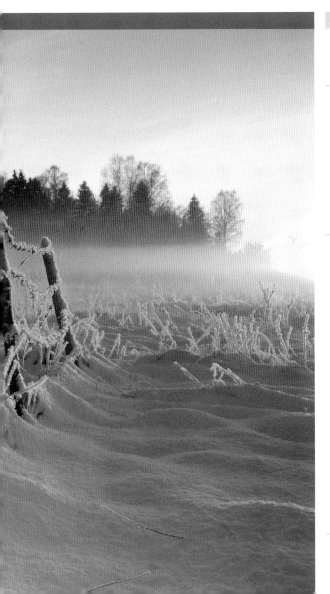

In this striking image of a partially frozen lake, the golden reflections of the setting sun contrast beautifully with the purple shadows of the ice floes. Zooming in from a distance has compressed the perspective and given the picture a more graphic feel. Slight underexposure has made the colors richer.

See also: Woodland shadows pp.34–35, Purple twilight pp.42–43, Glorious sunsets pp.250–51, Working in low light pp.288–89

City lights

Big cities are transformed at night. The streets are enlivened by brightly-lit windows, floodlit buildings, and illuminated signs and advertising billboards. This presents photographers with both challenges and opportunities. Making successful images featuring areas of intense light and color, often against dark backgrounds, involves mastering your camera's exposure settings and experimenting with focus.

CAMERA MODE	LENS SETTING
Select **Night Scene** mode or **Aperture Priority** and an aperture of f/11	Zoom to **moderate telephoto**
SENSOR/FILM SPEED	FLASH
Use a **medium ISO** setting (e.g. ISO 400)	Shoot without **flash**

FOR THIS SHOT

This image features an overlapping composition that exploits vertical structural elements to bring order and balance to an otherwise chaotic street scene.

1 Keep it level
If you are going to use strong vertical or horizontal elements in your images, make sure your camera is level and that the elements are correctly aligned.

2 Framing
Stand back and zoom in to compress the perspective and include more detail. Placing bold linear shapes at the edge of the image will help to frame the scene.

3 Exposure
Select the Night Scene exposure mode. If you're using Aperture Priority, underexpose by 1 stop to preserve the darker tones and keep the colors rich.

TAKE IT FURTHER
THE DYNAMIC CITY

A bird's-eye view of the city at night offers a dynamic snapshot of the activity at street level and above. Using a wide-angle lens exaggerates the way the vertical lines of the buildings converge at street level.

ALTERNATIVE APPROACHES

While shooting at night can put a fresh spin on images of iconic landmarks, the transformative effect of street lighting can completely change the aesthetic of more unassuming areas of the city, too. It will also force you to be more experimental with your approach.

Not all parts of the city are bright and bustling at night—some have a sparse, mysterious feel. To capture this mood try shooting from street level with a wide angle setting. Soft lamp light and reflections off wet ground become even more evocative in black and white.

By using unusual angles and imaginative framing you can add fresh interest to even the most well-known subject. Here, shooting from below and at a skewed angle has placed the illuminated subway sign center stage—as if it's pushing the iconic clock tower out of the way.

A high vantage point offers you the chance to look down on adjacent high-rise buildings and the surrounding landscape. Experiment with exposure to capture light trails from passing cars and vehicles on nearby roads.

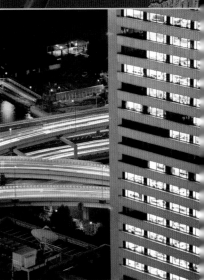

See also: Purple twilight pp.42–43, Camera modes pp.64-65, Light trails pp.88–89, Working in low light pp.288–89

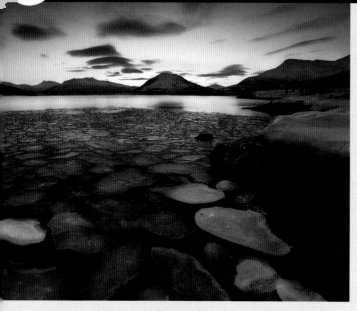

Camera modes

Digital cameras feature a selection of modes that are designed to help you to configure your camera for different subjects and situations. The most basic compact cameras may have only a fully automatic mode, and this will produce pleasing results in many cases. More advanced cameras offer a choice of modes that give various levels of control over the parameters of an exposure—aperture size, shutter time, and ISO sensitivity—including a fully manual setting.

 APERTURE PRIORITY

The Aperture Priority mode, sometimes denoted by Av (for Aperture value) or simply A, lets you set the size of the lens aperture, while the camera calculates and sets the corresponding shutter time for an accurate exposure.

You would usually select this mode if you wanted to control the depth of field: a small aperture delivers an extensive depth of field, while a wide aperture produces a shallow depth of field. You might use a shallow depth of field, for example, to isolate a portrait subject from its background (see pp.120–21).

SHALLOW DEPTH OF FIELD

SHUTTER PRIORITY

The Shutter Priority mode, denoted on some cameras by Tv (for Time value) and on others simply by S, allows the photographer to set the exposure time and lets the camera calculate and set an appropriate aperture size.

This mode is popular with sports and wildlife photographers as it allows them to use short shutter times to freeze fast-moving action. It's also used by landscape photographers who, by using a long exposure time, can render moving water—in waterfalls, rivers, and the sea—as silky and smooth.

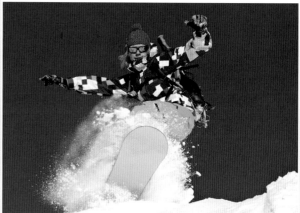

SHORT SHUTTER TIME

SCENE MODES

Scene modes are essentially short cuts—camera modes that, when selected, configure the camera to optimize its functions to suit particular scenes or subjects.

When you set a scene mode the camera automatically sets the size of the lens aperture, the exposure time, and also, depending on the mode, white balance settings and even the flash. For example, selecting Portrait mode sets a wide aperture for a shallow depth of field and a lower color saturation for attractive skin tones. Conversely, Landscape mode sets a narrow aperture for an extensive depth of field and a high color saturation for strong colors.

Some cameras feature a larger selection of scene modes than others. Depending on your camera, you can set the scene modes from the exposure dial or control menus.

PORTRAIT

LANDSCAPE

SPORTS/ACTION

BACKLIGHT

NIGHT SCENE

CLOSE-UP/MACRO

PROGRAM MODE

Most cameras have an Auto mode, where every setting is made automatically—you just press the shutter button. Some also feature a Program mode (P) that offers you a little extra control. For example, you can activate the flash, alter the white balance, or change the ISO sensitivity, and the camera will compensate by automatically configuring the other settings.

You might choose the Program mode if you want to force the camera to use the flash, for example, but bear in mind that this will affect the other settings.

MANUAL MODE

Switch to Manual mode (M) and you have full control over your camera. You can now set the aperture and shutter time at will, along with the ISO sensitivity, white balance, or flash mode. Manual mode is the best choice when you need to configure your camera for shots that demand settings that the semiautomatic modes will not accommodate.

The downside to using the manual mode is that you need to know what settings are required, and most photographers tend to stick with a priority mode, or one of the scene modes.

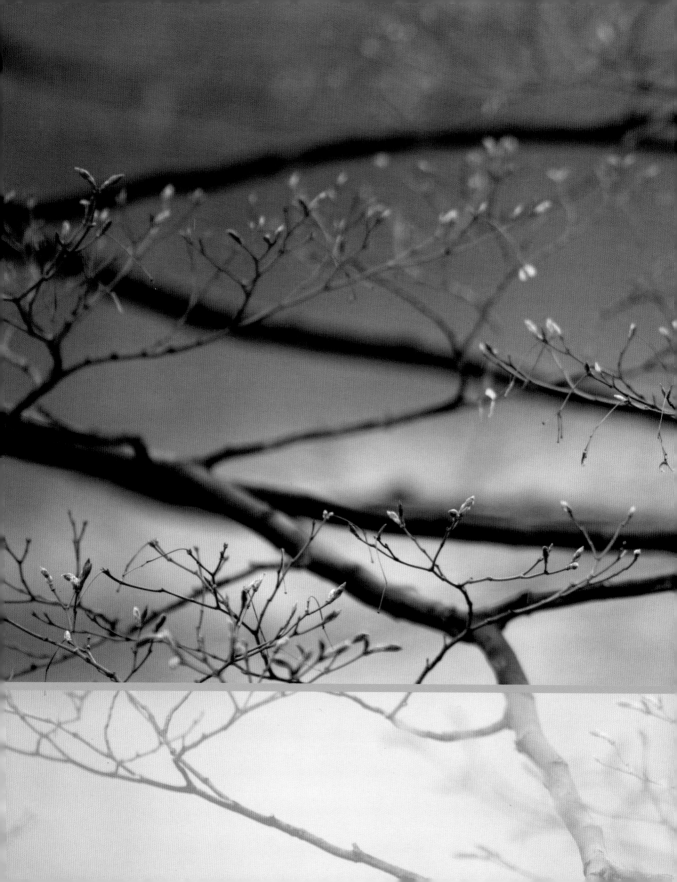

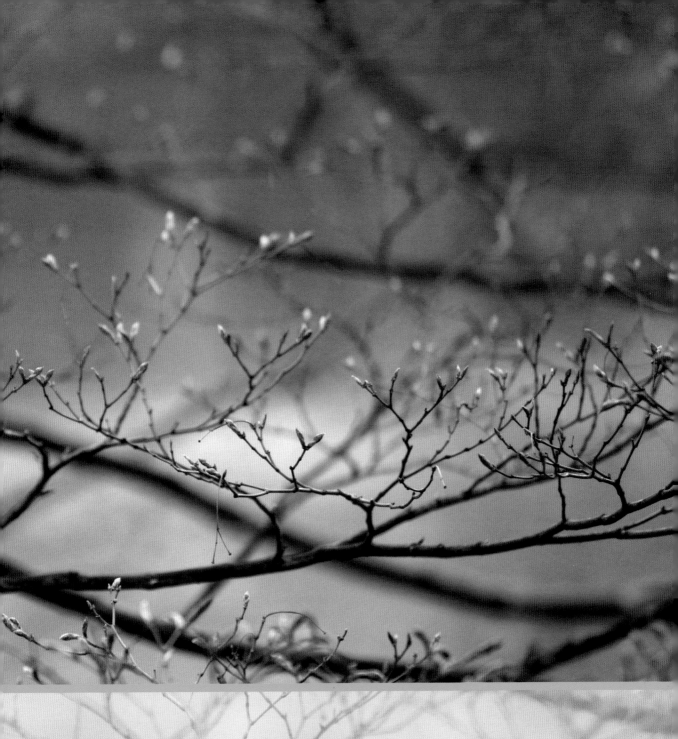

Early Spring

bathed in liquid gold

"It was one of those **March** days when the **sun shines** hot and the **wind blows cold**: when it is summer in the **light** and winter in the **shade**"

Charles Dickens

the world rushing by **in a blur**

highlights and shadows

silhouettes against the sky

a glorious moment of color and light

every seed awakened

Down on the farm

Visiting a farm in spring can offer the chance to create heart-warming images that communicate the vitality of the season—the landscape is coming back to life and the animals are freed from the confines of sheds and barns. As always when photographing animals, sensitivity and respect are key. Never venture into fields or enclosures without first seeking the permission of the farmer or landowner.

CAMERA MODE	LENS SETTING
Select **Landscape** mode or **Aperture Priority** and an aperture of f/5.6	Zoom to **moderate telephoto**

SENSOR/FILM SPEED	FLASH
Use a **low to medium ISO** setting (e.g. ISO 100 to 400)	Shoot without **flash**

MONTAGING IMAGES

Here a rusting vintage tractor has been made into the subject of a farm-themed montage. A side view of the tractor has been merged with a solarized shot of an arable field. A texture filter brings both layers together.

ALTERNATIVE APPROACHES

Farms can present a curious mix of tranquility and activity. Shots of animals grazing in the fields have a mellow quality that conforms to the traditional view of country life. However, working farms are also businesses, and from a photographer's perspective, this side of agricultural life is worth investigating too.

Many farmyard animals are indifferent to distractions. Take advantage of this to get close-up shots of livestock that are full of character. Set your camera's lens to a wide angle and get low down so that the subject fills the frame.

FOR THIS SHOT

From the intrigued sheep in the foreground to the characterful barn in the background, this shot has a timeless feel.

1 Depth of field
This image could have been all about the photogenic barn. However, to keep the sheep as the main focus of the shot, a large lens aperture was used to throw the background out of focus.

2 Composition
Here, part of the appeal is the low camera angle, which puts you at eye level with the sheep. Attract the animals' attention with a gentle noise.

3 Lighting
On a bright day, it's worth waiting for clouds to diffuse the light to avoid contrasts of light and shade.

Use your imagination to escape the clichéd image of spring lambs frolicking. This picture, with beautiful golden light falling on to the rear view of two lambs, communicates their sense of wonder. The colors have been made stronger by slight underexposure.

The attitude of a farmer toward his livestock—simultaneously caring and businesslike—can be used as the subject of an unusual character portrait. Here, tight cropping focuses on their faces and invites a comparison between the two.

See also: At the animal park pp.80–81, Character portraits pp.82–83, Equine portraits pp.104–05, Harvest time pp.248–49

Modes of transportation

Cars are an obvious source of photographic inspiration with their sleek lines and shiny surfaces. However, there are many other forms of transportation you can explore to create a variety of striking images. Unless you're taking a straightforward shot for an auction website or similar, look for unusual angles and viewpoints, fill the frame with detail, or pull back to show outline.

FOR THIS SHOT

Shooting the reflection of a motorcycle framed in the chrome detail of a similar vintage model is a novel way of depicting a classic bike event.

1 Sharpness
Use a small aperture to ensure both the close-up details and the reflected image appear sharp.

2 Lens setting
Stand back and use a moderate telephoto setting: the curvature of a chromed tank acts like a wide-angle lens and provides a wide view.

3 Focus
Make your camera focus past the reflective surface into the reflected scene. Point it to the scene outside the reflection and hold the focus point.

CAMERA MODE

Select **Landscape** mode or **Aperture Priority** and an aperture of f/16

SENSOR/FILM SPEED

Use a **low ISO** setting (e.g. ISO 100)

LENS SETTING

Zoom to **moderate telephoto**

FLASH

Shoot without **flash**

ON YOUR PHONE
ALL ABOARD!

Camera phones are useful because they are discreet and, on public transportation, ubiquitous. Use one to shoot everyday scenes from your daily commute, but do so using perspectives that emphasize symmetry, shape, or interesting colors.

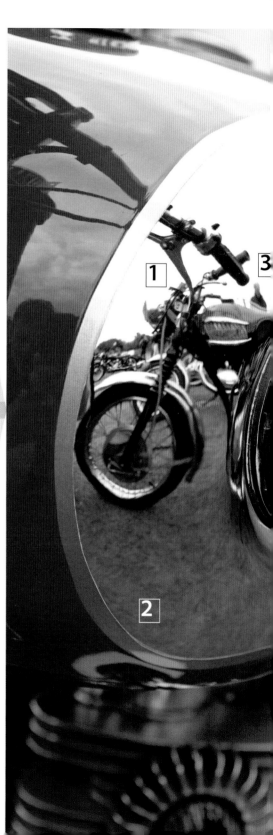

ALTERNATIVE APPROACHES

Look at each form of transportation and ask yourself what are the most significant attributes of the vehicle—is it a powerful machine, is it ubiquitous in its environment, is it sleek and modern, or romantic and historical? These factors could determine your approach.

Zoom in from a distance to compress the planes of the scene in front of you, making the view appear more congested. The slightly elevated position flattens perspective so the boats look as if they're on top of each other on the same plane. As a result, the image is more textural and abstract.

Look for repeated patterns: trains waiting at platforms, new cars in a delivery pound, or buses lined up. Shoot at an oblique angle to create a dynamic perspective with the repeating shapes receding into the distance.

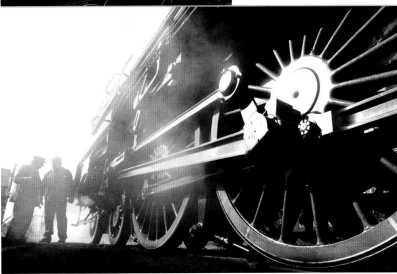

The size and power of this steam train is emphasized by the way its wheels dominate the image and it towers over the figures in the background. The low oblique angle further increases this effect and adds drama to the shot.

See also: Railway stations pp.76–77, On two wheels pp.188–89,
Using color pp.232–33, Composition pp.260–61

Modern architecture

Its clean lines and innovative use of materials make modern architecture an inspiring subject. The often extreme forms and the large-scale use of glass and curves are an invitation to use the architect's vision to create dynamic images of your own. The beauty is often in the detail, so as well as taking wide-angle pictures, zoom in to focus on details and look for ways to create abstract images from contrasts of shapes and patterns.

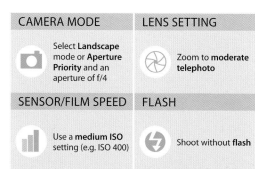

CAMERA MODE	LENS SETTING
Select **Landscape** mode or **Aperture Priority** and an aperture of f/4	Zoom to **moderate telephoto**

SENSOR/FILM SPEED	FLASH
Use a **medium ISO** setting (e.g. ISO 400)	Shoot without **flash**

FOR THIS SHOT

Reflected in the still water of the lake, the titanium and glass dome of the Beijing Opera House looks as though it's been lifted straight from a science-fiction film.

1 Lighting
Shooting at dusk enables you to exploit reflections of the rich colors of the sky. Here, the golden glow of sunset is nicely balanced by the artificial lights inside the building.

2 Composition
By zooming in on one side of a symmetrical structure you can sometimes reveal more than you could with a full portrait. In this shot, the reflected light helps describe the building's surface detail and curves.

3 Exposure
Use a large aperture to compensate for relatively low light levels without needing a tripod. Because you are at a distance, depth of field should be sufficient.

ON YOUR PHONE
A TUNNEL OF LIGHT

High-rise buildings can look stunning when shot from unusual angles. Enhance the perspective produced by converging verticals by shooting toward the sun and using an app with a vignette filter to produce a tunnel-of-light effect.

ALTERNATIVE APPROACHES

The diversity of form in modern architecture can mean that normal rules of composition are less easily applied. Although this may give you a freer hand, don't lose sight of the importance of perspective, balance, and harmony.

Experiment with wide-angle views and shoot at skewed angles to emphasize the extreme perspective effects. Explore unusual alignments that would be less successful when photographing more traditional buildings.

Modern buildings often have an ambivalent relationship with their surroundings. They may echo the forms of the landscape and feature harmonious colors, or strike deliberate contrasts. Shoot from a distance that lets you capture the building in its setting.

Stark and severe architecture demands a similarly bold photographic approach. Zooming in to eliminate any features that give a sense of scale prompts the viewer to speculate about the size, function, and general appearance of the building. Emphasize bold forms and colors with equally bold underexposure, or set the camera to give images with higher-than-normal contrast.

See also: Architectural details pp.78–79, Romantic ruins pp.144–45, Public sculpture pp.166–67, Modern interiors pp.220–21

Railway stations

A visit to a railway station can be a source of inspiration for a diverse range of photographs, from the frenzy of a commuter hub at rush hour to the romance of a great rail journey. Trains can introduce movement and elegant lines to an image, while the architecture of stations themselves—whether they're ornate reminders of Victorian splendor or ontemporary streamlined structures—are often highly photogenic.

CAMERA MODE	LENS SETTING
Select **Landscape** mode or **Aperture Priority** and an aperture of f/5.6	Zoom to **wide angle**

SENSOR/FILM SPEED	FLASH
Use a **high ISO** setting (e.g. ISO 1000)	Shoot without **flash**

FOR THIS SHOT

This deserted station platform, illuminated by stark overhead lighting, has an almost ghostly feel.

1 Converging lines
A train standing at a platform is a useful opportunity to experiment with bold compositions that use converging lines to great effect.

2 Muted color
This particular shot makes a virtue of the lack of color in the scene. The subdued gray palette says something about the character of an empty subway station at night.

3 Lighting
Here, the strong, cool artificial lighting adds to the bleakness of the scene. You could adjust the white balance on your camera to compensate for this effect.

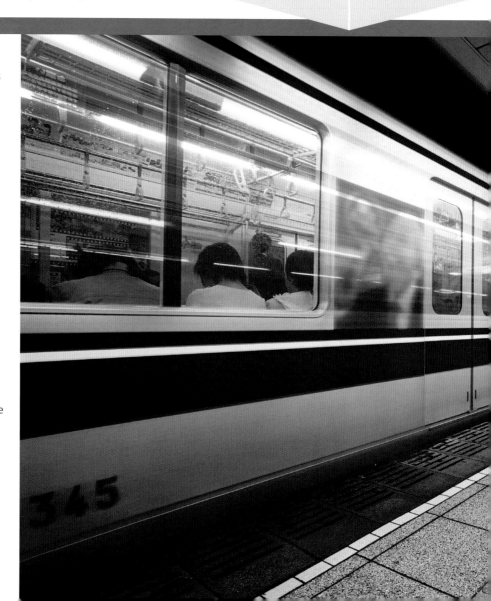

TAKE IT FURTHER
RUSHING TRAVELERS

To capture the frenzy of a major station during rush hour, find a raised vantage point, use a low ISO setting (100) and small aperture (f/22) for exposures of around 1 sec. This will blur people as they rush past. Anybody standing still will be in focus.

ALTERNATIVE APPROACHES

Studying the ways in which people move around railway stations and react to their environment can yield diverse and interesting results. Experiment with the effects of both artificial and natural lighting.

Find a vantage point from which to juxtapose the grandiose and confident architecture of a major station with the often frantic, transient activity of the travelers dwarfed by its cavernous spaces. Experiment with motion blur to increase the sense of activity.

For a poetic depiction of train travel, look for intriguing shadows of passengers. Images like these have a cinematic quality that evokes the golden age of railway travel. Underexpose slightly to boost the colors and darken the shadows.

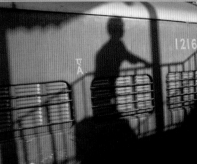

Sunlight flooding into the railway station can be used to dramatic effect. Shoot into the light to render the passengers and railway workers as silhouettes. Set your exposure to the brightest part of the shot, then recompose your image.

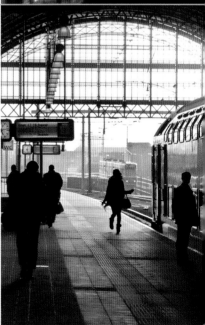

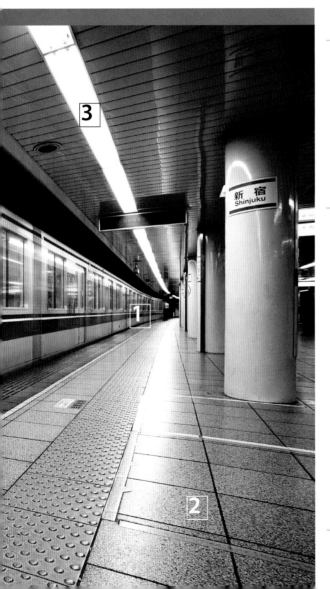

See also: On the move pp.86–87, Street photography pp.160–61, On the tourist trail pp.226–27, Shops and shoppers pp.324–25

Architectural details

When we photograph buildings, it's tempting to focus on structures that seem noteworthy: prominent landmarks or those that are historic or ultra-modern. More utilitarian buildings tend never to get a second glance. Look more closely, however, and even the most outwardly drab buildings feature details that are worth investigating with your camera.

FOR THIS SHOT

This image effectively contrasts the elegant and the industrial. The inclusion of a reflection lends it an abstract quality.

1 Background
A neutral background—here, an overcast sky—focuses attention on the relationship between the spiral fire escape and the linear window frames.

2 Reflection
Careful positioning allows both the staircase and its reflection to appear in the shot, creating symmetry and a visual puzzle.

3 Keep it straight
By shooting from a distance and zooming in you can ensure that you're square-on to the subject, which keeps vertical lines upright and parallel.

CAMERA MODE

Select **Landscape** mode or **Aperture Priority** and an aperture of f/5.6

SENSOR/FILM SPEED

Use a **low ISO** setting (e.g. ISO 100)

LENS SETTING

Zoom to **telephoto**

FLASH

Shoot without **flash**

ON YOUR PHONE
BOOSTING MOOD

This statue looks menacingly over the city below. Its sinister effect has been enhanced by the use of an app that converted it to monochrome and boosted the contrast.

ALTERNATIVE APPROACHES

Architects are often obsessed with detail, so, in theory, you should be able to find photogenic elements in most buildings. Whether you're in familiar surroundings or exploring a new location, look at buildings with a degree of detachment to find interesting combinations of color, shape, and shadow.

Look out for the way light can reveal—or enhance—the slightest architectural detail, and zoom in. Here, the sunlight is just grazing the wall, causing projecting fixtures and fittings to cast disproportionately long, angled shadows. Together with the bold color scheme they produce an arresting, if transient, pattern.

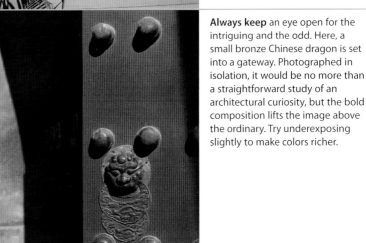

It's the contrast in shapes that makes this picture work, with a cool white balance producing a limited color palette. In the background is a rustic weatherboard house, complete with faded shutters. The colors are soft and the lines rectilinear. In the foreground is the contrasting natural sweep of a palm frond.

Always keep an eye open for the intriguing and the odd. Here, a small bronze Chinese dragon is set into a gateway. Photographed in isolation, it would be no more than a straightforward study of an architectural curiosity, but the bold composition lifts the image above the ordinary. Try underexposing slightly to make colors richer.

See also: City bridges pp.58–59, Modern architecture pp.74–75, Exploring textures pp.114–15, Heritage architecture pp.258–59

At the animal park

A day out at a zoo or animal park presents an excellent opportunity for you to practice your wildlife photography. However, fences or glass enclosures may obscure your view or spoil your photographs. With some deft camera work you can create the illusion that you're face to face with exotic animals. Alternatively, you may want to include the signs of captivity, to give a more realistic depiction of the animals' environment.

CAMERA MODE	LENS SETTING
Select **Sports** mode or **Aperture Priority** and an aperture of f/5.6	Zoom to **telephoto**
SENSOR/FILM SPEED	FLASH
Use a **medium ISO** setting (e.g. ISO 400)	Shoot without **flash**

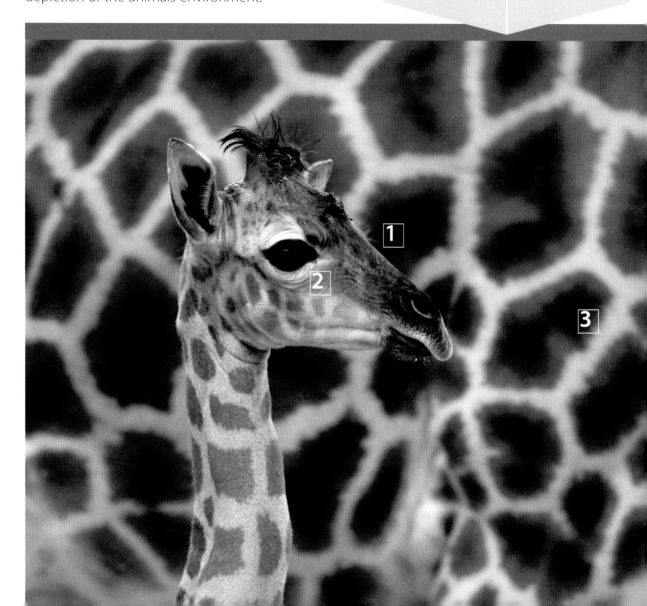

TRY THIS

People don't visit wildlife parks just to look at the animals; sometimes they can interact with them in the most subtle and touching ways. Look for opportunities to capture candid shots like this one of child and a gorilla—a moment of tenderness, even though it is taking place through a sheet of glass.

ALTERNATIVE APPROACHES

Try experimenting with different styles of shot to reflect the characters of the different animal species, from long-range pictures of groups interacting to intimate, close-up portraits of individuals.

FOR THIS SHOT

This image uses an adult giraffe's markings as a background to communicate a sense of scale—you can tell how small the baby is and how huge the adult must be.

1 Timing
In a front-on image, the head of the baby giraffe would be lost against the bold patterning of the adult. Patiently waiting for a profile has improved the clarity of the subject.

2 Focus
In any portrait, the eyes always draw attention. Here, the eye of the young giraffe is in sharp focus—without this, the image would almost be abstract.

3 Depth of field
To ensure that a detailed background—such as the markings on the adult giraffe's coat—is slightly blurred but still clear, use a medium aperture.

Zoos have a serious—if sometimes controversial—role in animal welfare and conservation, but can also provide plenty of entertaining moments. The best action shots are the result of careful preparation. Observe the animals' behavior and plan your composition in advance.

If there's a drawback to wildlife parks, it's that the surroundings are unlikely to resemble the animal's natural habitat. You can add a touch of realism by including some blurred foliage in the foreground of your image. If the animal is in a caged enclosure, using a large aperture will help blur out the bars.

Wildlife parks give us opportunities to make pictures that would be difficult—if not impossible—anywhere else, such as this dramatic shot of a polar bear swimming directly toward the camera. Remember, never use a flash when photographing an animal through glass—your picture will be overwhelmed by flare and you may distress the animal.

See also: Down on the farm pp.70–71, Equine portraits pp.104–05, Garden safari pp.172–73, At the aquarium pp.302–03

Character portraits

Making a successful character portrait is all about capturing the personality of the person you're photographing, but the best portraits also reveal something more about the sitter. The location you choose, such as their home or workplace, the street, or even a studio setting can also convey much about their personality. Ideally your portraits will have an appeal beyond the subject's friends and family.

CAMERA MODE	LENS SETTING
Select **Portrait** mode or **Aperture Priority** and an aperture of f/5.6	Zoom to **moderate wide angle**

SENSOR/FILM SPEED	FLASH
Use a **low ISO** setting (e.g. ISO 100)	Shoot without **flash**

FOR THIS SHOT

The strength of this portrait comes from the interaction between the subject and his surroundings—he almost seems to blend in with them.

1 Composition
Position your subject in a way that reveals his or her mood. Here, the old man's glance toward the unseen window suggests a contemplative frame of mind.

2 Exposure
The limited natural lighting in this image picks out and isolates the man's features. To create this effect, expose the image for the brightest part of the subject's face or reduce the overall exposure by 1 to 2 stops.

3 Aperture
To keep the subject sharp and avoid losing too much background definition, select a small aperture (such as f/5.6) rather than the wider aperture normally used for portrait shots.

TAKE IT FURTHER
STRONG SIDELIGHTING

With a little effort you can create a dramatic, studio-style portrait. A single source of light directed at the side of the face helps to create an image full of contrast. For the best effect position your subject by a window and use natural light. Expose for the bright side of your subject's face to throw the other side into shadow.

ALTERNATIVE APPROACHES

A character portrait may be formally staged but engaging composition can sometimes occur spontaneously. Regardless, the strength of your shot will often depend on the rapport and communication between you and your subject. Try to engage them in conversation and make them feel that they are part of a collaboration by asking for their input and showing them pictures as you take them.

Some people—especially groups—can discover an extrovert side when faced with a camera, and require very little encouragement to pose. Here, the girls' quirky clothing is all-important, so take key details into account when framing your image.

Attire and setting are good ways of communicating your subject's occupation or interests. The fisherman is very much the focus of this image, but the wide angle has captured his environment. A medium aperture has been used to blur the boat in the background while keeping it recognizable.

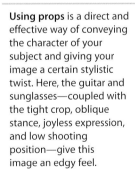

Using props is a direct and effective way of conveying the character of your subject and giving your image a certain stylistic twist. Here, the guitar and sunglasses—coupled with the tight crop, oblique stance, joyless expression, and low shooting position—give this image an edgy feel.

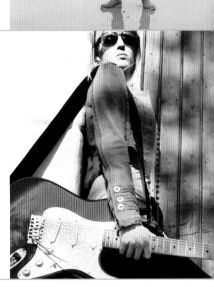

See also: Indoor child portraits pp.32–33, Baby portraits pp.140–41, Vacation portraits pp.212–13, Posed portraits pp.342–43

Industrial landscapes

Although they may not be considered conventionally beautiful, industrial sites—from the angular colossus of a power station or factory to the inky silhouettes of towering cranes along a dock—often have a stark grandeur that can create immensely powerful images. The massive buildings and the complex detail of busy construction sites present plenty of opportunities to create strikingly graphic pictures.

CAMERA MODE	LENS SETTING
Select **Landscape** mode or **Aperture Priority** and an aperture of f/4	Zoom to **telephoto**

SENSOR/FILM SPEED	FLASH
Use a **medium ISO** setting (e.g. ISO 400)	Shoot without **flash**

FOR THIS SHOT

The blanket of steam constantly billowing around this processing plant gives the image visual interest it might otherwise have lacked.

1 Contrasts
Make the most of unusual contrasts within a landscape. Here, the shot has been framed to include a church spire—a touching relic of a preindustrial world.

2 Composition
Balancing different areas of your image creates a dynamic composition. Here, the processing plant is set against the landscape beyond and its outlines are softened by clouds of steam.

3 Timing
When photographing scenes that are constantly changing, you need to time your shot well. Too much steam in this picture, for example, could easily have obscured some of the details of this intricate building.

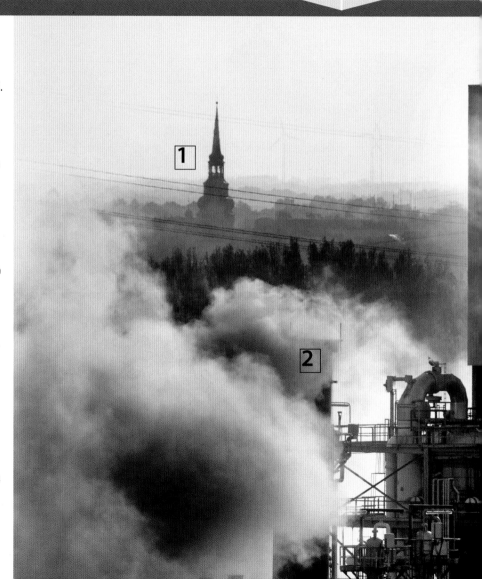

TAKE IT FURTHER
DISTRESSED SCENES

Industrial landscapes are often described as grimy or gritty. You can enhance this effect by using a phone app to give your pictures a distressed, worn appearance—most evident here in the patchy, grainy look of the sky.

ALTERNATIVE APPROACHES

Obviously, all industrial sites have been created for function rather than beauty. To create a strong image, look for what is striking in the scene before you—the graphic outlines of the structures perhaps, or the texture of a detail.

Apply the principles of conventional landscape photography to industrial scenes. Cranes can take on the appearance of delicate fretwork when captured in silhouette against the glow of a setting sun.

Look for ways in which elements in industrial environments can help you compose your shots. Try using objects, structures, and machinery as a frame, or to lead the eye into the scene. For a shot like this, expose for the brightest area to avoid overexposure.

Exploring contrasts can result in interesting shots. Here, the structure of the factory in the background contrasts with the simple girders in the foreground. A moderate wide-angle lens setting helps capture a wide scene from close quarters.

See also: Wintry cityscapes pp.50–51, City bridges pp.58–59, Urban decay pp.56–57, Shades of gray pp.254–55

On the move

Whatever they're doing and wherever they're going, images of people on the move present an interesting snapshot of daily life. One of the most effective ways to portray the relentless surge of human traffic that characterizes much of city life is through the use of blur. As well as conveying motion, blurring lends an almost painterly, abstract quality to the most familiar everyday scenes.

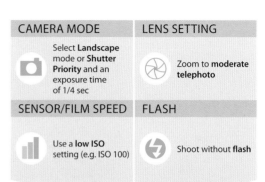

CAMERA MODE	LENS SETTING
Select **Landscape** mode or **Shutter Priority** and an exposure time of 1/4 sec	Zoom to **moderate telephoto**

SENSOR/FILM SPEED	FLASH
Use a **low ISO** setting (e.g. ISO 100)	Shoot without **flash**

FOR THIS SHOT

The blurring in this image graphically captures the frantic energy of rush hour. Getting the right volume of people is essential in a shot like this—too many might clutter the shot, too few would be ineffective.

1 **Shutter time**
Experiment with shutter times and try to decide just how much blur produces the effect you're looking for. A good starting point is 1/4 sec.

2 **Depth of field**
To capture the whole scene in focus, use a small aperture. With the exception of the motion blurring effect, the people will still be rendered sharply.

3 **Composition**
Seek out a vantage point that enables you to use strong compositional elements like the black-and-white road markings in this image.

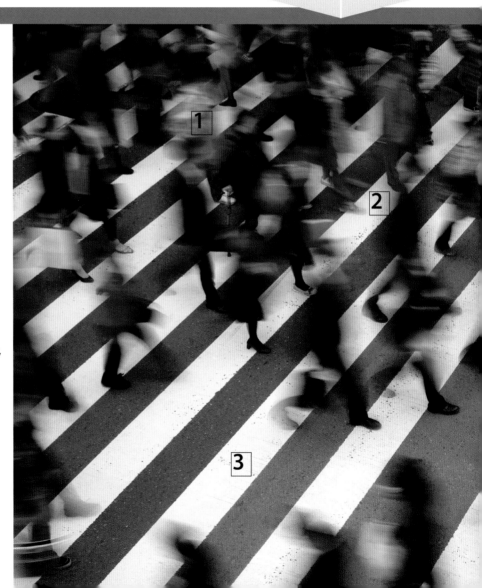

TRY THIS

Panning the camera—moving it smoothly to follow a subject—works well with shots like this, where you want the subject to be in focus while the background is blurred. It's a very effective way of representing speed and movement while still keeping the subject of the shot recognizable.

ALTERNATIVE APPROACHES

Experimenting with motion blur is fun. The relative motion of your subject and its surroundings, camera movement, and exposure times all produce varying amounts of blur. Don't overlook the angle and composition of your shots though.

People moving against a background that's also on the move creates an interesting effect. This image of pedestrians walking past a slow-moving bus would be quite different if the bus was stationary.

When taking photos through the window of a moving vehicle, the amount of blur will vary according to the proximity of the objects outside. With a similar exposure time, nearby traffic will appear more blurred than traffic that's further away.

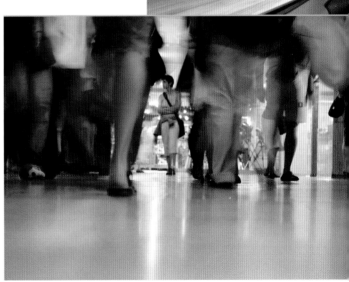

For an unusual perspective, try placing your camera on a polished floor to capture the sense of the footfall that moves through a public space. From this low position the foreground picks up the reflections of the lights and passersby.

See also: Depth of field pp.120–21, Marathon runners pp.246–47, Café life pp.256–57, Shops and shoppers pp.324–25

Light trails

In the dark, the movement of just about any light source—vehicle headlights, flashlights, even stars—can be captured as trails on camera. Experiment with long exposure times to vary the effects of blurring, and take every opportunity to practice the technique. Try controlling the light source yourself to create unique and intriguing images.

FOR THIS SHOT

Although light trails can be used to make beautiful abstract images, this picture, with a welder sending up sparks at its center has a gritty, documentary feel.

 Focus point
This is ostensibly a portrait shot, so, as the eyes are obscured, the visor is the point of focus. A small aperture ensures much of the scene is in focus.

 Exposure
In situations like this, it's hard to predict the exposure setting you'll require. Start with 1/30 sec at f/11, but be prepared to experiment.

 Low angle
To record a more spectacular cascade of sparks in the foreground, this image was shot from a position just below the subject.

CAMERA MODE

Select **Manual** mode or **Shutter Priority** and an exposure time of 1/30 sec

SENSOR/FILM SPEED

Zoom to **telephoto**

LENS SETTING

Use a **low ISO** setting (e.g. ISO 100)

FLASH

Shoot without **flash**

TRY THIS

A moving camera will produce light trails from fixed sources of light. This fun but quite unpredictable technique involves overexposing by 1 sec or more, pressing the shutter button, then (with the strap firmly around your wrist) throwing the camera into the air with a rotating action.

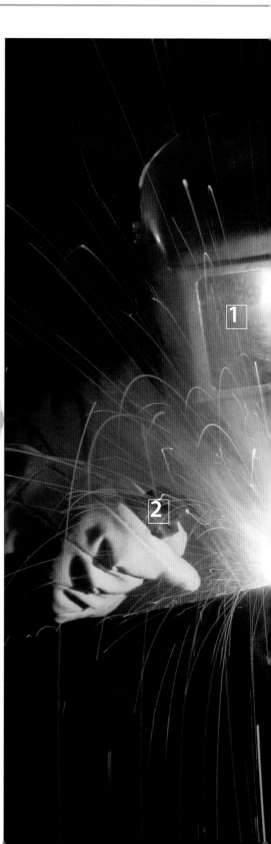

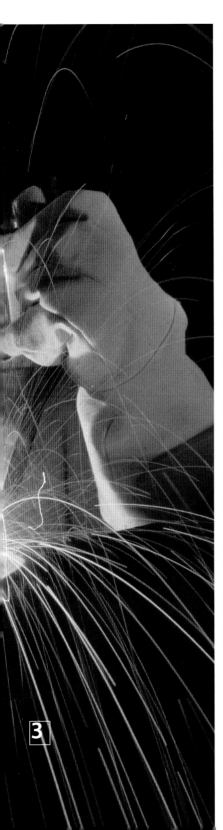

3

ALTERNATIVE APPROACHES

Selecting longer exposure times—of several seconds or more—allows you to create dramatic images using light sources from vehicles and flashlights. Try this at night, or late twilight if you want to include a little color in the sky, to achieve the maximum effect from the trails.

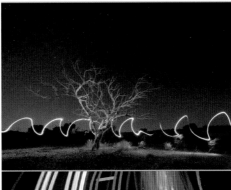

You can use a flashlight to paint in light across a scene. Set your camera on a tripod and walk around with the flashlight, drawing shapes in the landscape. Here, the person holding the light is barely visible as they are in darkness and constantly moving. The tree and some areas of the ground have been flashed separately.

To create really bright and dynamic light trails set up your camera and tripod on a bridge and direct your camera at the traffic below (avoiding bright street lights). Shoot at f/8 for around 30 seconds with a low ISO sensitivity. Vary the exposure duration to alter the length of the trails.

TAKE IT FURTHER
STAR TRAILS

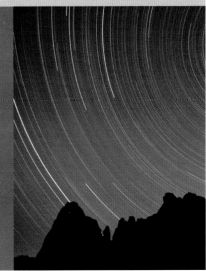

As the Earth rotates, stars describe arcs in the sky as they appear to move around the celestial poles. Star trails are not hard to record if you follow a few basic tips:
- Choose a very dark location with little light pollution. For the same reason, avoid shooting star trails for a few days either side of a full moon.
- Use a tripod or other support to allow for very long exposures.
- Use an exposure of 20 minutes or longer with a wide aperture.
- For the most dramatic trails, point your camera toward the celestial polar region.
- Keep an eye on your camera's battery consumption: long exposures can drain batteries very quickly.

See also: City lights pp.62–63, Camera modes pp.64–65, Exposure pp.316–17, Fireworks pp.340–41

New growth

Each year, new plant growth heralds the coming of spring. As the greening of the landscape begins, take the time to investigate the small-scale participants in the process. Get up close to tiny buds and unfurling leaves, and experiment with framing, composition, and the effects of different lighting. In all your images, try to evoke a sense of renewal and the return of life.

FOR THIS SHOT

This photograph of the fractal spiral of a uncurling frond reveals the minute detailing that is only visible for a brief time in the plant's life.

1 **Focusing**
Close-ups usually have a very limited depth of field, so make sure you focus on the most important feature.

2 **Framing**
A close framing concentrates attention on the frond tip, and cropping at the edges creates a sense of the coiled frond bursting out of the frame.

3 **Use a tripod**
Movement is the bane of macro photography. Use a tripod to prevent camera movement and shoot when there is a minimum of breeze.

CAMERA MODE

 Select **Macro** mode or **Aperture Priority** and an aperture of f/8

SENSOR/FILM SPEED

 Use a **low ISO** setting (e.g. ISO 100)

LENS SETTING

 Zoom to **moderate telephoto**

FLASH

 Shoot without **flash**

TRY THIS

If you have access to a light box, arrange translucent seedlings across it to create ethereal backlit images. You can make your own table-top light box by placing a piece of frosted glass over a fluorescent bulb using a simple wooden frame.

1

3

ALTERNATIVE APPROACHES

New growth in plants appears in different ways, and each presents a different photo opportunity. Capture the moment that new buds of trees and shrubs burst from the otherwise bare branches, and look for emerging seedlings as they erupt miraculously from the soil.

The grid-like pattern of seedlings in a tray provides an interesting contrast with the irregular shapes of the plants themselves. Select the orientation and a point of view that you think works best, then choose an area of the image to keep sharp.

Look out for the subtle pastel colors of early blossoms as fruit trees come to life. In this image the buds contrast nicely with the dark branches, and the narrow depth of field has emphasized the flecks of bright color. Photographing them under flat lighting and with a neutral gray background has given them maximum impact.

TAKE IT FURTHER
BACKLIGHTING

Using natural backlighting to illuminate new plant growth can create a nice effect, but controlling exposure and working with lens flare takes some practice. To ensure that you expose your subject correctly, and pick up the rim lighting, you may need to increase exposure by at least 1 stop. Use a lens hood to limit flare and frame your subject so that any flare falls in a way that enhances the image.

See also: Close-up and macro pp.92–93, Spring blossom pp.118–19, Spring dew pp.128–29, Flowers in close-up pp.190–91

Close-up and macro

Taking close-up photographs of very small subjects and details is easy with digital cameras. Most have lenses that are capable of close focusing, and a Macro scene mode that configures the camera appropriately. Strictly, "macro" refers to shooting small subjects that are reproduced at their true scale on the image sensor, but recently it has been used to describe any close-up photography.

▶ FOCAL LENGTH AND WORKING DISTANCE

The lenses of many compact cameras have short focal lengths, which means that the camera needs to be positioned very close to the subject when shooting close-ups. For some subjects this can be problematic. Small animals may be scared off as you approach them, and there is the added risk that you or the camera will shade the subject and prevent a good exposure. For these reasons many photographers who become interested in macro work invest in SLRs.

Lenses with a focal length of 50–60mm are often compact and light, and offer good value, but still require you to be quite close to your subject. These are best used to photograph subjects that won't be disturbed. Lenses with a focal length range of 150–200mm are bulky and can be costly but allow you to put greater distance between you and the subject. Depth of field is also proportionately shallower with longer lenses, making it easier to isolate your subject from its surroundings. In practice, most photographers will go for a macro lens of around 100mm, which offers a good compromise in terms of working distance and depth of field.

LONG FOCAL LENGTH

SHORT FOCAL LENGTH

▶ REDUCED DEPTH OF FIELD

Even the most basic compact digital cameras often have a Macro mode that will allow you to fill the frame with objects as small as $^1/_2$in (15mm) across from just a few inches in front of the lens. Although this is useful, in most cases the depth of field is disappointingly limited when using macro settings.

To overcome this you can try setting the smallest practicable aperture on your camera—f/16 or even f/22. This will demand a longer exposure time so it's essential that the camera is firmly mounted on a tripod or other support. It also means that you can only shoot subjects that won't move noticeably during the exposure. To reduce the exposure time, you can increase the camera's ISO sensitivity. Another option, which isn't suitable for every subject, is to light it with flash.

Alternatively, you can use the limited depth of field to help isolate the subject—or part of the subject—from the rest of the scene. For example, you can focus on a small insect on a leaf and render the plant and the background blurred. Or you can try to line up your subject to use what depth of field is available. For example, show the length of an insect instead of approaching it head-on.

EXTENSIVE DEPTH OF FIELD

SHALLOW DEPTH OF FIELD

▶ MACRO LENSES

A dedicated macro lens that's designed to reproduce subjects at up to full size is the best possible option for close-up photography. Most are "prime" lenses, with a fixed focal length, and these are some of the best quality lenses available. They allow close focusing without the distortion that other lenses would produce, but they can also focus to infinity, which means they are an excellent option for general photography.

WATER DROPLETS

DECORATIVE DETAIL

HUMAN EYE

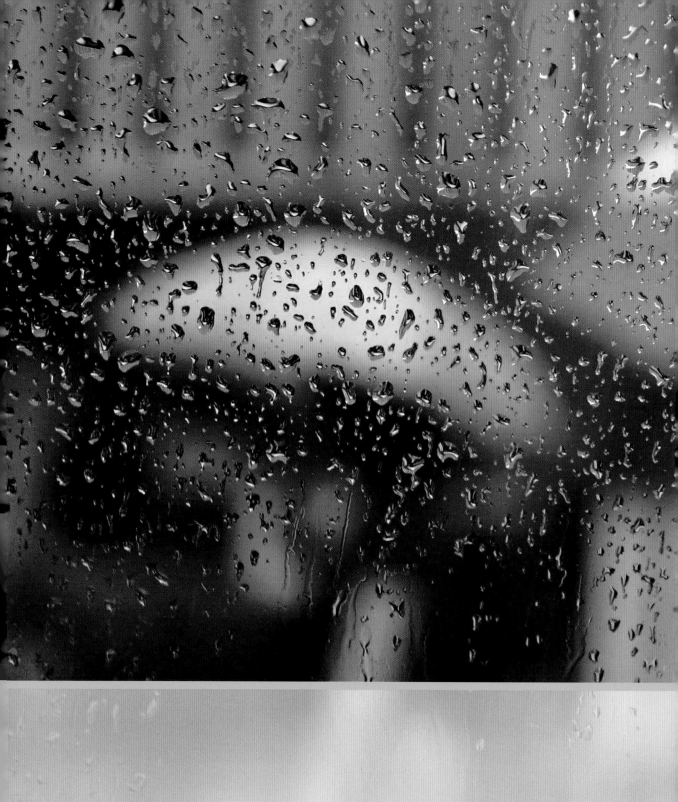

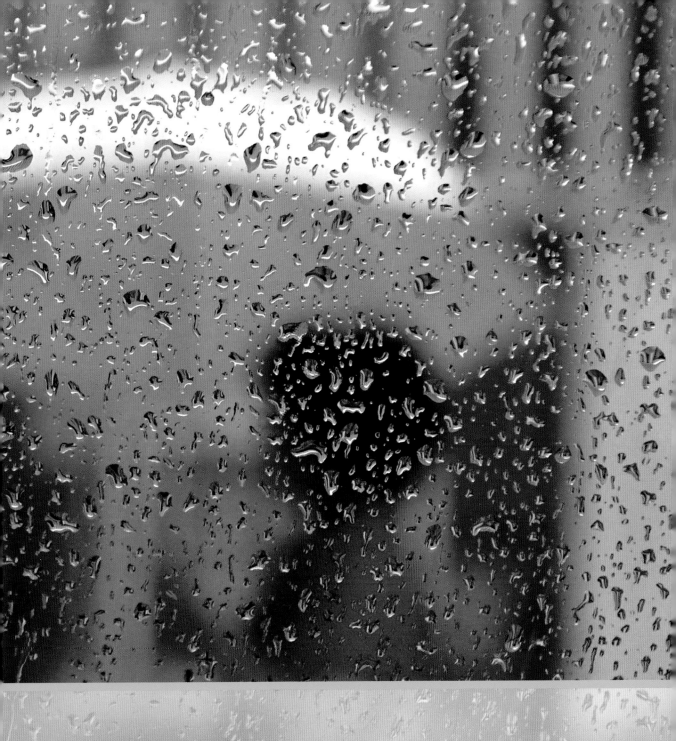

Mid-Spring

high days and **holidays**

spring blossom as delicate as snowflakes

watching the sun go down

colors bleeding **in the rain**

"A lovely **spring night**
suddenly vanished while
we viewed **cherry blossoms**"

Matsu Basho

scudding clouds **and stormy skies**

Rainy day

It may be tempting to stow away your camera when the skies threaten stormy weather, but rain actually presents a photographic opportunity. The light during a rain shower has a special quality to it—soft and diffused—while the rain itself can lend a gloss to sidewalks and roads, turning them into reflective surfaces that you can use to create depth and interest.

FOR THIS SHOT

The romantic feel of this wet, late-afternoon scene is a result of the magical effect created by the play of light on the rain-soaked sidewalk.

1 Straighten up
Care should be taken with vertical alignment so as not to distract from the long reflections in the foreground.

2 Exposure
This scene has been purposely underexposed for the highlighted areas to ensure accurate color rendition and to create the silhouettes.

3 Image stabilization
A long exposure will produce movement blur in the people, adding to the Impressionistic effect. Use a tripod or rest your camera on a table to keep it steady.

CAMERA MODE

 Select **Landscape** mode or **Aperture Priority** and an aperture of f/8

SENSOR/FILM SPEED

 Zoom to **moderate telephoto**

LENS SETTING

 Use a **medium ISO** setting (e.g. ISO 400)

FLASH

 Shoot without **flash**

TRY THIS

Shooting through a rain-lashed windshield blurs the scene through the glass, creating a watercolor-style abstract. You'll have to be quick to beat the wipers, but don't forget about composition and framing. Here, the road markings and headlights add depth and perspective to the image.

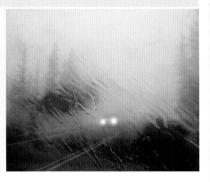

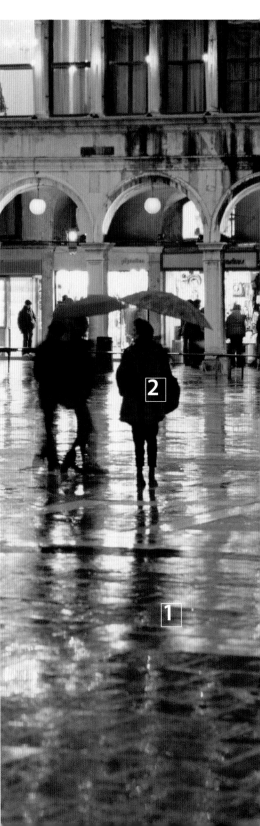

ALTERNATIVE APPROACHES

Like snow and ice, rain can completely transform the environment—the landscape changes and so does the behavior of the people who inhabit it. Umbrellas appear with the first drops of rain, and their distinctive shape and often bright colors make them useful visual props.

It's actually quite difficult to capture falling rain in a photograph. One way to represent the effect of a downpour is to shoot through rain-spattered glass. Although the scene beyond the window is important, focus on the droplets and use a shallow depth of field to make them stand out.

At any event affected by the weather, the atmosphere can quickly change, so turn your focus on the crowds sheltering from the downpour. Zooming in from a distance will flatten perspective and emphasize the density of the crowd.

Rainy days tend to be characterized by muted tones. As a result, vibrant colors stand out more than usual. Make a feature of this to create a quirky shot in which splashes of color provide the prominent focal point. An elevated viewpoint will help you to identify and frame likely subjects.

See also: Snowstorms pp.44–45, Splash! pp.102–03, Using color pp.232–33, Wild outdoors pp.308–09, Abstract lights pp.328–29

Along the riverbank

Riverbanks are the perfect location for making tranquil nature pictures. They are fascinating ecosystems, populated by an incredible variety of wildlife and flora. The atmosphere of your pictures will change according to the time of day, the weather, and the season, but it's in the springtime when a riverbank truly comes to life, so take advantage of warmer temperatures and sunlight and spend a day exploring this rewarding environment.

CAMERA MODE	LENS SETTING
Select **Portrait** mode or **Aperture Priority** and an aperture of f/4	Zoom to **long telephoto**

SENSOR/FILM SPEED	FLASH
Use a **low ISO** setting (e.g. ISO 100)	Shoot without **flash**

FOR THIS SHOT

A striking riverbank scene such as this waterfowl with its young, is surprisingly easy to achieve.

1 Positioning
Find a clear, uninterrupted view of the river with a pleasing background and be prepared to wait for wildlife to pass by.

2 Be sensitive
Even animals that are used to human activity are protective of their young, so try not to draw attention to yourself.

3 Reflections
If you're including a reflection, make sure you get it all in shot, otherwise your image will look unbalanced. You can always crop it out later if you decide to change the composition.

TAKE IT FURTHER
TIMID WILDLIFE

If you want to capture shots of the more elusive inhabitants of the riverbank, you'll need to understand their behavior. You may need to visit the same stretch again and again before you finally get the shot you're looking for.

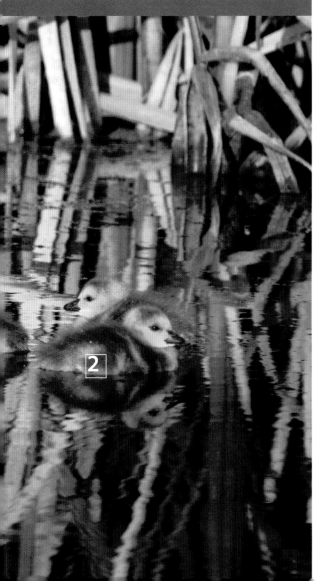

ALTERNATIVE APPROACHES

Riverbanks are varied landscapes providing opportunities to experiment with different photographic styles. So whether your interest lies in landscape, natural history, still life, or more graphic images, you'll find plenty to keep you busy.

Sunsets can be enlivened by including characteristic elements of the river and its bank. Here the grasses and reeds are thrown into silhouette by the setting sun and its reflection. A large aperture has allowed a narrow depth of field for effective blurring.

Look at the way the riverbank and its reflection work together. Simple, regular plant growth can produce bold patterning with almost perfect symmetry. There's no obvious subject here—the power of the image is its strong graphic style.

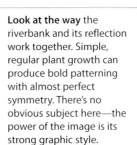

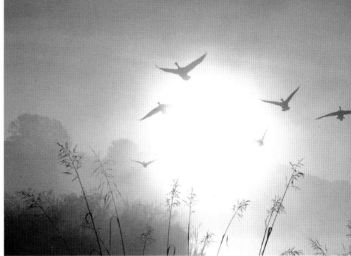

Early morning is a great time to explore the riverbank. If conditions are right, mists forming over the river will give the scene an ethereal feel. Shooting into the sun can render foreground subjects in dramatic silhouette.

See also: Winter wildlife pp.48–49, Pond life pp.132–33, Reflected city pp.184–85, Fall wildlife pp.280–81

Splash!

From sudden heavy showers to standing puddles and shallow streams at the side of the road, water is in plentiful supply at this time of year. Make the most of all this water to create humorous, vibrant images that really convey a sense of the season. For maximum impact, you'll want to keep the droplets as sharp as possible so use a brief exposure time to create the illusion that they're hanging in mid-air.

CAMERA MODE	LENS SETTING
Select **Auto** mode or **Shutter Priority** and an exposure time of 1/250 sec	Zoom to **moderate telephoto**

SENSOR/FILM SPEED	FLASH
Use a **medium ISO** setting (e.g. ISO 400)	Shoot without **flash**

FOR THIS SHOT

An unlucky passerby, already trying to shelter himself from the rain, is drenched by spray from a passing car. This shot is the result of perfect timing—and a little luck.

1 Timing
Shots like this require anticipation, quick reactions, or both. Preset your camera to Auto (or Shutter Priority) so you can respond to any unforeseen opportunities.

2 Depth of field
Select a medium aperture to give sufficient depth of field in order to retain focus on the main elements of the scene.

3 Exposure
To freeze the moment and keep the water spray sharp, you need a short exposure time of around 1/250 sec.

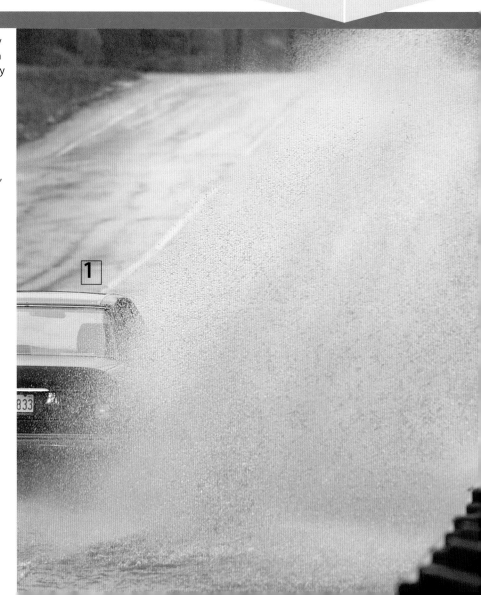

TRY THIS

It's easy to create a shot like this using a large baking sheet (or other metal sheet) and a hose or a cup of water. To aid the composition, mount your camera on a tripod and run a gentle stream of water onto the tray. Use short exposure times and experiment with fill-in flash.

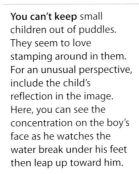

ALTERNATIVE APPROACHES

When making pictures of water splashes experiment with distance and angle—getting in close or low will give your photograph a different feel. After a downpour you'll find a variety of photo opportunities, from wildlife shots to informal portraits of children.

Birds don't just drink from puddles—they enjoy splashing around in them, too. To avoid disturbing them stand at a distance and zoom in if you require a close-up.

The splash from a modest puddle can look dramatic if you're near enough to it. This picture has been shot close-in, with the camera held right down at ground level. If you are intending to get this close to the water, ensure your camera is protected.

You can't keep small children out of puddles. They seem to love stamping around in them. For an unusual perspective, include the child's reflection in the image. Here, you can see the concentration on the boy's face as he watches the water break under his feet then leap up toward him.

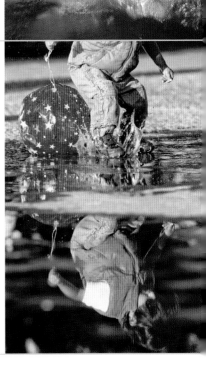

See also: Waterfalls pp.134–35, People under water pp.174–75, Watersports pp.182–83, At the poolside pp.200–01

Equine portrait

Their elegant forms, graceful movements, and variety of moods—from determined to serene—make horses a hugely rewarding subject. However, their sheer size means it can be surprisingly tricky to capture a successful portrait—you might need to come up with creative ways to convey the spirit of these magnificent animals. Certainly, the more you learn about horse behavior, the easier you'll find it to photograph them.

CAMERA MODE	LENS SETTING
Select **Portrait** mode or **Aperture Priority** and an aperture of f/8	Zoom to **moderate telephoto**

SENSOR/FILM SPEED	FLASH
Use a **medium ISO** setting (e.g. ISO 400)	Shoot without **flash**

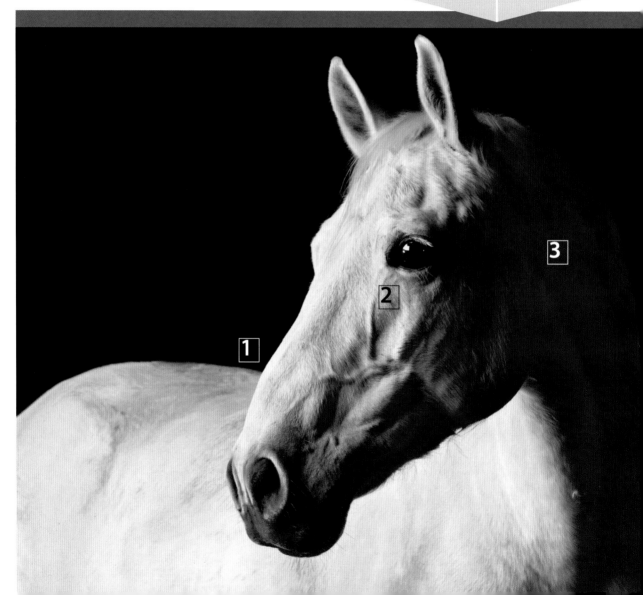

TRY THIS

For a humorous caricature, get in close with the lens at its widest setting to exaggerate the size of the horse's muzzle. Use a wide aperture to create a shallow depth of field to emphasize the length of its face, too. A compact or a camera phone is less likely to alarm a skittish horse than a larger camera.

FOR THIS SHOT

For an intimate portrait like this, take your time and gain the animal's confidence. You'll get a better shot if it's relaxed in your presence.

1 Lighting
The use of strong natural side lighting from an open barn door has produced beautiful detailing in the horse's face. Setting it against a dark interior has focused all attention on the horse.

2 Focusing
For formal horse portraits, always focus on the eyes—or eye, in this case. Set your camera to a medium aperture to ensure that all of the horse's head is sharp, but its body is slightly blurred.

3 Exposure
Photographing a white horse against a dark background requires careful exposure control. This image has been exposed on the mid-shadows to retain some detail in the shaded areas.

ALTERNATIVE APPROACHES

An enclosure provides an opportunity for formal portraits, but for more spontaneous or action-filled pictures, get outdoors and capture horses against a variety of backdrops and in different lighting conditions.

The silhouettes of horses are beautiful and unmistakable. Position yourself at a distance, so you don't disturb them, and underexpose strongly—by 2 stops or more—to produce a well defined silhouette against an intense sky.

Take advantage of the low sun to make a back-lit portrait of your subject. If possible, use golden rim lighting to define its profile. When shooting toward the sun, shade your camera lens to prevent flare.

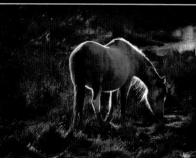

Tight framing has created an unconventional picture of a pair of horses out on a gallop. Although this picture shows little of either horse, the movement of the image—produced by the flowing manes of both creatures—suggests speed and power.

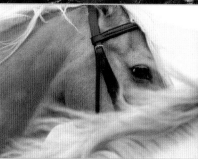

TAKE IT FURTHER
TELLING DETAIL

Stand well back and use a camera with a long telephoto lens to isolate a horse's eye. Viewed close-up it's not immediately obvious that this is the eye of a horse, but it is remarkably expressive and suggests a sensitive animal.

See also: *At the animal park pp.80–81, Pets in action pp.194–95, Backlighting and silhouettes pp.204–05, Working in low light pp.288–89*

Changing skies

This is the time of year when the weather can be at its most changeable. For photographers this means that not only can you shoot the same scene in different light in a single day, but there's a chance of catching one of those fleeting moments as the sky changes from bright to dark or from stormy to calm. Seek out a promising location, check the forecast, and make sure both you and your camera are properly prepared for stormy weather.

CAMERA MODE	LENS SETTING
Select **Landscape** mode or **Aperture Priority** and an aperture of f/11	Zoom to **moderate wide angle**

SENSOR/FILM SPEED	FLASH
Use a **medium ISO** setting (eg. ISO 400)	Shoot without **fill-in flash**

FOR THIS SHOT

This remote cottage, bathed in eerie light, is captured moments before it's swallowed up by the storm that's gathering overhead.

1 Composition
By filling the top two-thirds of the frame with sky, the menacing clouds have become the dominant feature of this scene. Placing the cottage to one side reveals the emptiness of the surrounding area and adds to its sense of vulnerability.

2 Exposure
Exposing for the bright foreground has made the stormy sky appear even darker and more threatening.

3 Wide angle
Getting fairly close to the subject and then zooming to wide angle captures a wide sky with a dramatic perspective as the storm clouds surge over the landscape.

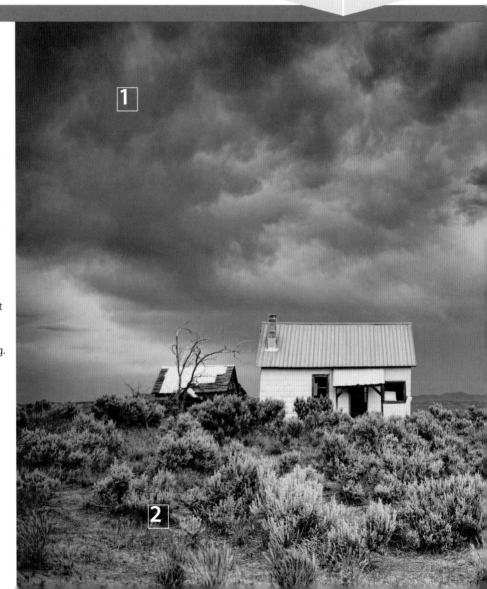

TAKE IT FURTHER
LIGHTNING

With forward planning, to determine when and where to get the best results in safety, it's possible to take impressive pictures of lightning storms. Set your camera for a long exposure, up to 30 seconds, at an aperture of f/8. Including landscape can add to the drama of the composition.

3

ALTERNATIVE APPROACHES

Weather changes all the time—sometimes dramatically, sometimes more subtly. Keep your photographer's eye open not only for the vagaries in the weather itself but also for the way those changes affect the environment. Look out too for more transient weather phenomena that can create strong, atmospheric images.

With the sun behind you and rain in front, there's a good chance of a rainbow appearing against the backdrop of a dark sky. Try underexposing slightly to boost the colors in the rainbow.

During very changeable weather, storms will alternate with brighter periods. Torrential downpours can be rendered in ominous silhouette shot against the brighter sky beyond. Underexpose by 2/3 stop to darken the falling rain and boost the color.

When you have contrasting patterns in different sections of the sky, look for interesting ways to bring them together in a single shot. This could be done using reflections in a window, lake, or puddle, for example. Large reflective surfaces, like those on glazed buildings, can be particularly effective.

See also: Purple twilight pp.42–43, Seascapes pp.116–17, Mountain scenery pp.162–63, Picture composition pp.260–61

Birthday parties

Children's parties are often chaotic and disorderly events. They are also packed with color, high emotion, energy, and excitement. Capturing successful images can be a challenge, but with a little forward planning it will be rewarding and lots of fun. Make sure that you know the party plan so that you can position yourself in good time, and when you start to take photos get down low to capture the children's perspective.

CAMERA MODE	LENS SETTING
Select **Auto** mode or **Aperture Priority** and an aperture of f/8	Zoom to **moderate wide angle**

SENSOR/FILM SPEED	FLASH
Use a **medium to high ISO** setting (e.g. ISO 400 to 800)	Shoot without **flash**

FOR THIS SHOT

When the children sit down to eat, a semblance of order is introduced. This presents a good chance for you to take some group photos, and also pictures of the colorful food.

1 Focal point
Shoot along the length of the table to include the maximum number of guests in the frame and direct the gaze toward the birthday girl at the head of the table.

2 Lighting
If possible, use the ambient room lighting for the best results. Increase ISO sensitivity for a suitably brief exposure time of around 1/125 sec. If you need to use flash, diffuse it to soften the effect by placing some white tissue paper over it.

3 Capture details
Try to get a good variety of pictures, including those that focus solely on the food and decorations. It might be easier to shoot these before the guests arrive.

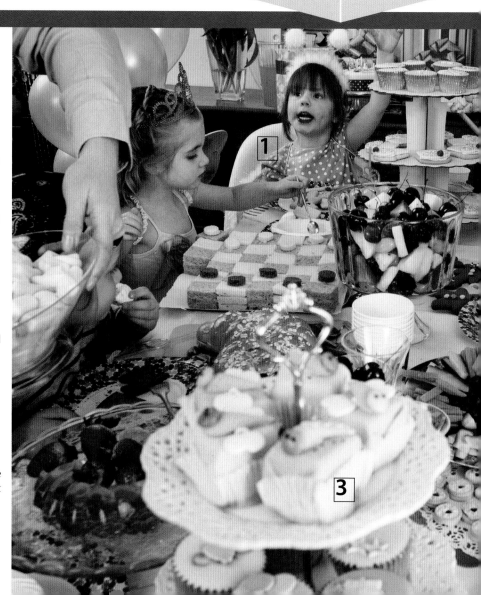

TRY THIS

Games are a staple of children's parties. Use your camera's flash to freeze the action, and try to capture the children against a plain, uncluttered background. Take lots of pictures so you can choose the best later.

ALTERNATIVE APPROACHES

All children's parties have some activities that simply demand to be photographed—blowing out the candles on a cake, for example. However, memorable images can also be created from quieter moments.

Parties aren't all about fun and games. The time will come when a few of the guests tire and seek refuge in a quiet room. Exploit these tranquil moments for more posed portraits, or shoot candidly to capture their changing mood.

For a dramatic image, light the shot using only the glow from the candles. Zoom in close and set your exposure to the child's face, increasing the ISO sensitivity if necessary.

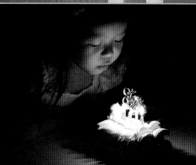

In addition to portraiture, children's parties provide plenty of opportunities for shots in which color and pattern dominate. Birthday presents wrapped in glossy paper bring bold shapes and vibrant colors to the proceedings. Here, a narrow depth of field has been used to ensure that the child's face remains the main focus of the shot.

See also: Party people pp.20–21, Children outdoors pp.126–27, Garden parties pp.216–17, Picture composition pp.260–61

Flower fields

A view of a spring meadow in full flower is so inherently appealing that almost any approach will result in a pleasing photograph. Therefore, the main challenge is to create images with a difference that stand out from the crowd. Experiment with different compositions and perspectives, try varying the depth of field, and use light in different ways to capture the freshness and vibrancy of these scenes.

CAMERA MODE	LENS SETTING
Select **Landscape mode** or **Aperture Priority** and an aperture of f/11	Zoom to **maximum wide angle**

SENSOR/FILM SPEED	FLASH
Use a **low ISO** setting (e.g. ISO 100)	Shoot without **flash**

FOR THIS SHOT

The success of this wide-angle image lies in its unusual perspective. The back-lit flowers are perfectly set off by the stunning backdrop of the clear blue sky.

1 Lighting
If your camera has a flip-out screen it will be fairly easy to position the sun behind a flower head. Stopping the sun affecting the exposure prevents the flowers from being rendered as silhouettes. Try using fill-in flash if getting the correct exposure proves difficult.

2 Focusing
Before placing your camera on the ground, set the focus to manual and focus on an object at a distance similar to the height of the flowers.

3 Backdrop
Choose a cloudless day so that small wildflowers can be seen clearly against a plain background.

TRY THIS

To create an Impressionistic effect, which emphasizes shape and color above detail, try capturing some movement in your image. On a day with a light breeze, mount your camera on a tripod and set a shutter time of up to 1 sec. Or hand-hold your camera and move it deliberately and steadily during exposure. Here you see the result of a vertical movement.

ALTERNATIVE APPROACHES

Try a variety of approaches to capture the beauty of spring flowers. Get in close to make them the sole focus of your shot, include them as part of a wider landscape view, or use them to create a colorful textured background.

To capture a bank of flowers from a bug's-eye view, get down among the blooms and shoot at their level. Don't worry about keeping every flower in focus—unfocused flowers will create depth in the scene. To capture the translucence of the petals, shoot toward the sun.

The strength of this image lies in its bold composition. The frame is dominated by a mass of bright flowers in the foreground, which occupies more than half the frame. The color palette is very pleasing too—yellow, green, and blue work well together.

Look for contrasts in the flowering landscape. Here, the delicate and transient spring flowers contrast well with a stark barbed wire fence. Focusing on the fence emphasizes its form, while effectively blurring the flowers.

See also: New growth pp.90–91, Spring blossom pp.118–19, Flowers in close-up pp.190–91, Crop fields pp.192–93

Family days out

Whether it's a boat trip, a picnic in the park, or a visit to a museum, pictures of a family outing are all about capturing a sense of fun and adventure. Try to use a combination of different subjects and treatments to tell the story of the day. Take a mixture of candid and posed portraits, and group pictures showing interaction between family members. Family days out are usually relaxed and informal, so your photos should be too.

CAMERA MODE	LENS SETTING
Select **Portrait** mode or **Aperture Priority** and an aperture of f/8	Zoom to **moderate wide angle**
SENSOR/FILM SPEED	FLASH
Use a **low ISO** setting (e.g. ISO 100)	Shoot without **flash**

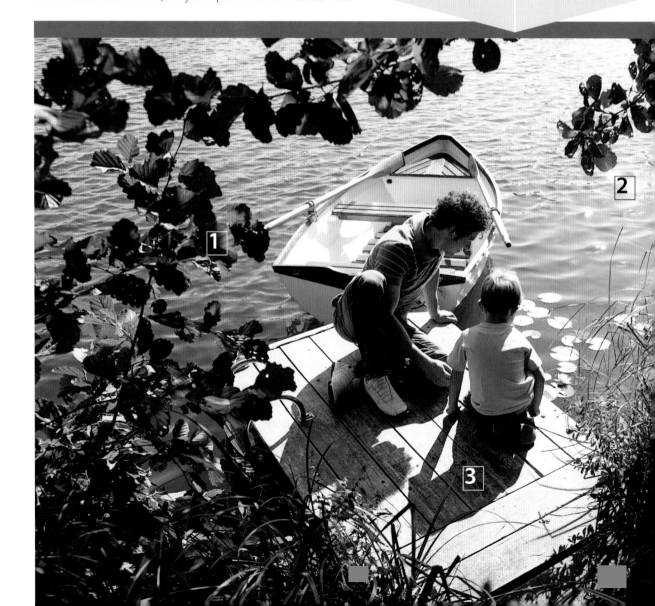

TRY THIS

Humorous group portraits of your friends and family really capture the fun of a day out. Position them in front of an appropriate backdrop and encourage them to get animated. Use your camera's burst mode, if it has one, and shoot lots of pictures in quick succession.

ALTERNATIVE APPROACHES

Family excursions are often crammed with new and different experiences. Capture this overload of the senses with a variety of shots, from candid pictures taken from a distance to close-up images of evocative details.

When documenting your day, include some pictures that set the scene for the sequence that follows. The jaunty angle of these ice cream cones makes for a more dynamic shot than would be the case if they were aligned horizontally.

FOR THIS SHOT

Absorbed in a world of their own, a father and son have been captured by zooming in from a modest distance, so as not to disturb the scene or spoil the atmosphere.

1 Framing
A framing device, such as the foliage in this picture, fills the image to the edges and draws the viewer into the scene, increasing the feeling of intimacy.

2 Highlights
The idyllic nature of this scene is enhanced by the golden highlights of sun glinting on the surface of the river. Overexpose slightly to bring out these bright tones.

3 Point of view
Taking the photograph from an elevated position aids the composition by eliminating any background distractions and limiting the perspective.

As well as capturing the focus of your day out, also photograph the activities that surround it, including eating and traveling. The tight framing of this candid image has given it a nice balance and focus.

For interior shots, such as this museum display, set your white balance to Tungsten to help tone down the warm color cast.

See also: *Birthday parties pp.108–09, Children outdoors pp.126–27, Eating al fresco pp.154–55, Camping vacations pp.196–97*

Exploring textures

For semiabstract, graphic images with a tactile appeal, try emphasizing the texture of your subjects. Finding interesting textures to photograph isn't difficult—wherever you live, an afternoon spent exploring your neighborhood will reveal plenty of prospective subjects, from brick walls to flower heads. Zoom in, focusing on the detail—the more detail you capture, the more textured your picture will appear.

CAMERA MODE	LENS SETTING
Select **Landscape** mode or **Aperture Priority** and an aperture of f/5.6	Zoom to **moderate telephoto**

SENSOR/FILM SPEED	FLASH
Use a **low ISO** setting (e.g. ISO 100)	Shoot without **flash**

FOR THIS SHOT

Corrugated metal, ragged paper, old stonework, and flaking paint combine to produce an image that is highly textured.

1 Lighting
Lighting is crucial to bringing out texture: shadows are at their most pronounced close to the plane of the subject, highlighting every surface imperfection.

2 Zoom in
You'll get the best results by shooting a scene like this from a modest distance and zooming in. Close-up, wide-angle views may distort any vertical lines.

3 Framing
Frame your shot to include contrasting textures but be careful—too many contrasts may dilute the strength of the image.

TAKE IT FURTHER
APPLYING TEXTURES

Apply a texture effect to another image to give the appearance of it being printed on fabric or textured paper. These effects can be found in image manipulation applications, but it's more fun to shoot your own texture in close up, then position it behind your primary photo. Ensure any effects you apply add something intriguing your image, rather than distracting from it.

ALTERNATIVE APPROACHES

Look closely and you'll find interesting patterns and textures in both natural and man-made objects. Although we tend to think of texture as something seen from up close, tight framing can isolate textures from a wider scene.

This shot of an office block is intriguingly ambiguous, thanks to the absence of any obvious reference points, such as other buildings or sky.

Though sharp, directional lighting can enhance textures, don't ignore the opportunities offered by softer light. Here, it helps contrast the lichen-spotted tree bark—a popular subject for texture photos—and the more pronounced stems of the creeper clinging to it.

See also: Urban decay pp.56–57, Architectural details pp.78–79, Basic image adjustments pp.148–49, Lost and abandoned pp.244–45

Seascapes

The coast offers a limitless range of photo opportunities, whatever the weather. Our appreciation of seascapes has much to do with movement, whether stimulating or soothing; the play of light on rippling water, the changing colors, or the violent energy of breaking waves. The trick is to capture something of this dynamism in a single shot. Watch the cycle and rhythm of the waves to decide when they'll be at their most photogenic.

CAMERA MODE	LENS SETTING
Select **Landscape** mode or **Shutter Priority** and an exposure time of 1/125 to 1/1250 sec	Zoom to **long telephoto**

SENSOR/FILM SPEED	FLASH
Use a **medium ISO** setting (e.g. ISO 400)	Shoot without **flash**

FOR THIS SHOT

There are few more awesome sights than a storm-driven wave crashing over a breakwater. Here, the waves and lighthouse are lit by a burst of sunlight that accentuates the contrast between the foaming water and the dark sky.

1 Timing
Observation is key to capturing dramatic waves. Watch the the waves to work out when they'll be at their most spectacular, and depress the shutter just before the peak of the action.

2 Shutter time
To freeze the moment select a moderately short shutter time of around 1/125 to 1/250 sec.

3 Exposure
Automatic exposure may result in whites being overexposed. Underexpose by 2/3 to 1 stop to preserve the detail.

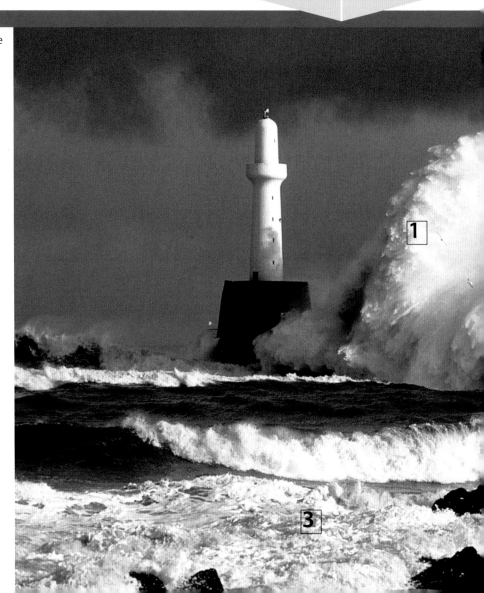

TAKE IT FURTHER
HEIGHTENING MOOD

Add to the drama of a stormy seascape by using software to boost the contrast. Use a contrast control, also adjusting the brightness if necessary. You could also apply a monochrome tint (as here).

ALTERNATIVE APPROACHES

To get the most from a trip to the sea, fully explore your location. Look for different angles and positions that give interesting perspectives and make the best use of the weather conditions.

Weather plays a large part in determining the atmosphere of seascapes. Sunlight breaking through dark clouds suggests a feeling of calm before, or after, the storm. Set your camera's white balance to Daylight to ensure the moody colors are retained.

Cliff-top shots give a different perspective on a seascape, looking down on—rather than across at—the breaking waves. Include a little foreground to enhance the perspective.

From a low vantage point on a boat or ferry, even a modest swell of the waves can look impressive—zooming in will exaggerate this effect. Without the seagulls, this shot—with its monochrome palette and fog—would feel even more abstract.

See also: Changing skies pp.106–07, Fishing harbors pp.210–11, On the beach pp.214–15, Shades of gray pp.254–55

Spring blossom

For centuries, images of spring blossom have been an artistic shorthand for the end of winter and a symbol of brighter, warmer, and more colorful days to come. The delicate petals and sprays of tiny buds look gorgeous in close up, but this does present some challenges. Pay particular attention to composition and focus, as the fragile beauty of the subject will only highlight any mistakes.

CAMERA MODE	LENS SETTING
Select **Macro** mode or **Aperture Priority** and an aperture of f/4	Zoom to **moderate telephoto**

SENSOR/FILM SPEED	FLASH
Use a **low to medium ISO** setting (e.g. ISO 100 to 400)	Shoot without **flash**

FOR THIS SHOT

This blossom has been chosen for its well-grouped, pleasing shape. Dead or damaged flowers have been carefully removed.

1 Exposure
When shooting pale flowers against a light background overexpose by around 1 1/3 stop to keep the shot bright and airy.

2 Lighting
The best time of day to photograph blossom is in the soft light of early morning. Bright sunshine can lead to blown-out highlights, so choose a cloudy day.

3 Depth of field
A limited depth of field has kept only the closest flowers in sharp focus while those behind are progressively blurred.

TAKE IT FURTHER
INDOOR STUDY

With a little effort and experimentation you can create beautiful blossom portraits at home. To make a dark background, place a black piece of card stock behind, block out all light from the room, and illuminate the blossom with a lamp.

ALTERNATIVE APPROACHES

Inevitably, your photos of blossom will be largely dictated by the weather—a spell of wind or frost can cause flowers to fall, while a change in the light will alter the atmosphere completely. Be ready to adapt your projects to the weather and plan alternative shots before you set out.

Here, fallen blossom shot at wide-angle and with large depth of field has created a carpet of color. The low angle, which crops off the top of the trees, ensures that the blossom on the ground is the focus of the image. The dappled shadows from the branches above add texture.

A neutral background can add a surprising amount of interest to an image. Here, a whitewashed, sunlit wall behind a blossom-laden tree creates interaction between the blossoms and their shadows.

For an unusual take on the subject, look for contrasts in color and light. In this image the soft-colored blossoms are juxtaposed with gaudy lights that spill out from behind the branches and are reflected in the wet walkway. You can enhance colors by underexposing the scene, while experimenting with white balance will produce different effects.

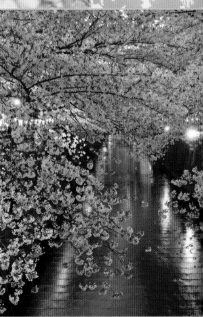

See also: *Snow-laden trees pp.54–55, Close-up and macro pp.92–93, Flower fields pp.110–11, Flowers in close-up pp.190–91*

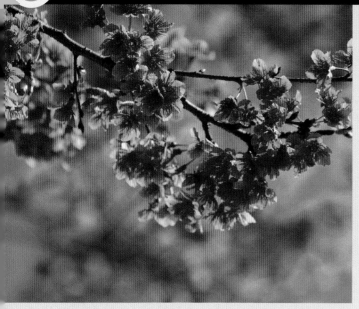

Depth of field

Depth of field describes the space in front of and behind the plane of focus in which an object appears acceptably sharp. When this distance is shallow, the foreground and background are rendered blurred. This is ideal for portraiture, where you want to concentrate attention on the subject. When the depth of field is large almost everything in a scene can be sharp. This is the preferred setting for landscapes, when you want to see detail in every part of the scene.

 PLANE OF FOCUS

The weight of an image can be said to be carried on the plane of sharpest focus. By controlling depth of field and varying the plane of focus you can make your pictures much more interesting and effective.

By using a depth of field that's smaller than the distance between key elements, you can keep one element in focus, while the other is thrown strongly into blur. It's the contrast between the two that enhances the power of the image. If an image is completely blurred it is hard to make it work, while pictures that are perfectly sharp all over are often dull.

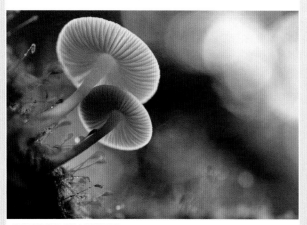

SELECTIVE SHARPNESS

 CONTROLLING DEPTH OF FIELD

Varying the lens aperture is the principal method of controlling depth of field. Generally, when the lens aperture is reduced the depth of field becomes larger, and vice versa. For example, with a lens set at f/2.8 only a very small section of an image will be sharp, but when closed down to f/22 the depth of field will be very large with every part of the picture sharp.

Depth of field also varies with lens focal length and focusing distance: when you shoot a subject at a telephoto setting, the depth of field is smaller than when you zoom out to wide-angle. For a given aperture and focal length, the closer you get to your subject, the smaller the depth of field will become. A very limited depth of field is an issue for close-up photography.

DID YOU KNOW?

BLUR AND BOKEH

The aesthetic quality of blur in an image is called "bokeh." Bokeh is usually considered good when the blur transitions smoothly between pin sharp and completely indistinct. An abrupt or stepped transition suggests detail and so is considered undesirable. Good bokeh is created by lenses highly corrected for aberrations and perfectly circular apertures.

 USING APERTURE

The effect that varying the aperture size has on depth of field can be illustrated by comparing pictures shot at different f/number settings. In each of these photos the focus was locked on the blue boots in the foreground. At the widest setting (f/4) only the blue boots appear sharp; at the mid setting (f/11) there is extra definition in the mid-ground and background; at the smallest aperture (f/22) every part of the scene is equally sharp.

f/4

f/11

f/22

 USING DEPTH OF FIELD

Once you have learned how to control depth of field, you can use it to produce different effects in a wide variety of situations.

An extensive depth of field is commonly used in the following types of subject:
• Landscapes, such as wide-angle, general views.
• Architecture, when you want to show detail throughout a structure in a single shot.
• Interiors, to include nearby furniture or other objects and far off windows and similar features.

A shallow depth of field is often used for the following:
• Portraiture, to help concentrate the viewer's attention.
• To isolate a subject from the distracting visual clutter of its surroundings, or to reduce the distraction from elements that can't be removed.
• For artistic effect.

PORTRAITURE

ARCHITECTURE

ISOLATING A SUBJECT

LANDSCAPES

ARTISTIC EFFECT

INTERIORS

Late Spring

inky ripples and reflections

enchanted emerald forest

magical evening light

the romance of ruins

sparkling dewdrops

"Sweet May hath come to love us,
Flowers, trees, their blossoms don;
And through the blue heavens above us
The very clouds move on"

Heinrich Heine

Children outdoors

The best child portraits are informal and uncontrived, and there's nowhere better to capture their sense of fun, curiosity, and exuberance than the great outdoors. If you want to make some collaborative pictures it's best to do this at the start of the photo session, then just let them do their own thing. Once they're happily entertaining themselves, they'll forget you're there and give you a chance to make some lovely natural images.

CAMERA MODE	LENS SETTING
Select **Portrait** mode or **Aperture Priority** and an aperture of f/4	Zoom to **telephoto**

SENSOR/FILM SPEED	FLASH
Use a **low ISO** setting (e.g. ISO 100)	Shoot without **flash**

FOR THIS SHOT

A lone child heads off to explore a colorful garden. Absorbed in his own world, he seems oblivious to the photographer.

1 Shooting angle
Although it's unusual in portraiture, in some situations a back view can work well. Stance, rather than facial expression conveys emotion. Here, you can sense the child's hesitation as he sets off on his little adventure.

2 Depth of field
Use a wide aperture to create a shallow depth of field. Here, the blurred foreground and mid-ground create a dreamy atmosphere.

3 Composition
Including the out-of-focus foliage in the picture's foreground frames the child and adds depth.

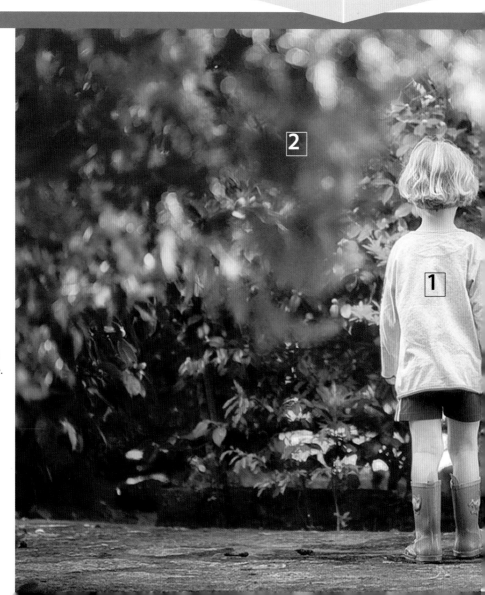

TRY THIS

Next time you take your child to the playground, join in the fun to create some active shots. To convey the movement of a merry-go-round use a slow shutter time of around 1/8 sec to produce effective motion blur.

ALTERNATIVE APPROACHES

Children will often be happy to perform for the camera, and this can bring out their character. However, even if your subjects won't fully cooperate you can still capture engaging images.

Occasionally even the most accommodating children become camera shy. Instead of coaxing and cajoling, take some pictures anyway. Here, the posture of the children, who are clearly delighting in teasing the photographer, has produced a charming double portrait.

For a dynamic group shot, put yourself in the middle of the action and shoot from a low angle. Select a wide-angle view and shoot in burst mode if you have it (or at least take several consecutive shots) to improve your chances.

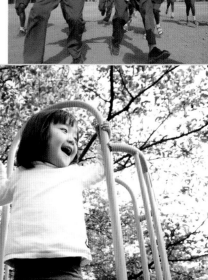

When photographing children, it's usually best to get down to their eye level, or lower. This gives a child's eye view of their world. When shooting in bright sunlight, use a little fill-in flash to avoid harsh shadows.

See also: Indoor child portraits pp.32–33, Birthday parties pp.108–09, Family days out pp.112–13, Garden parties pp.216–17

Spring dew

For the briefest time when the weather conditions are right, a layer of dew settles over the morning landscape. It clings to the most delicate of natural structures, adorning them with jewellike droplets. Dew coats fields and lawns with a transient silky texture and softens their color. It most commonly forms under clear skies, giving you the opportunity to exploit the warm early morning sunlight in your shots.

CAMERA MODE	LENS SETTING
Select **Landscape** mode or **Aperture Priority** and an aperture of f/8	Zoom to **moderate wide angle**

SENSOR/FILM SPEED	FLASH
Use a **low ISO** setting (e.g. ISO 100)	Shoot without **flash**

FOR THIS SHOT

As the sun rises it picks out this spider's web sagging under the weight of the morning dew.

1 Lighting
Arranging the shot with an oblique angle between the spider's web and the sun produces bright highlights, making the web sparkle.

2 Composition
Zoom out to include the surrounding landscape, but get close to the web to make it really dominate the frame. A small aperture setting will keep most of the scene sharp.

3 Watch out for wind
Even a hint of breeze will ruin shots of delicate dew formations on fragile structures like webs and grasses. Shoot when the air is still or stand to one side to create a barrier.

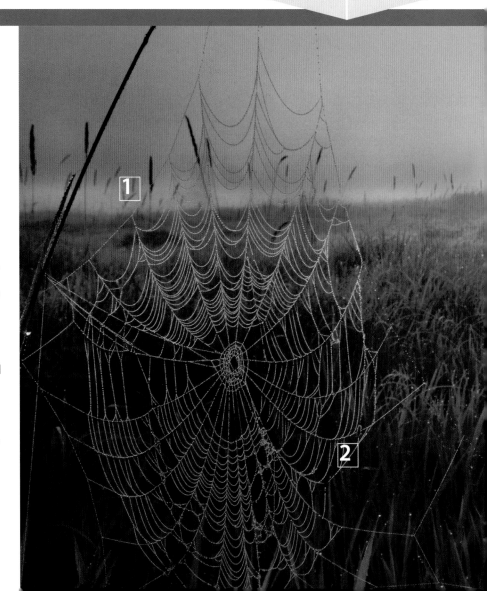

TAKE IT FURTHER
THE WORLD IN A DROPLET

Get in close enough and a single drop of dew can act like a wide-angle lens, reproducing the scene beyond (albeit in inverted form). To capture this you'll need to be really close and use a macro lens to focus on an individual droplet. Adjust your position to show an interesting scene in the droplet and use a wide aperture to blur the background.

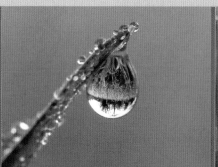
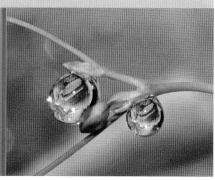

ALTERNATIVE APPROACHES

In the most subtle of ways dew can transform every detail in the landscape, giving you the opportunity to photograph familiar scenes and objects in striking new ways.

On smooth surfaces dew forms in distinctive patterns. The low sunlight raking across this car hood gives the dew drops a very graphic feel. In such harsh light, experiment with different exposures.

Explore different materials and notice the way the formation of the droplets changes on different textures. When using a Macro setting, take care to avoid casting a dark shadow (from you or the camera) on your subject.

3

See also: A walk in the park pp.22–23, Woodland shadows pp.34-35, Flowers in close-up pp.190–91, Golden sunrise pp.322–23

Working the land

The scale of human impact on the environment is perhaps best illustrated by the extent that agriculture has transformed the natural landscape—from patchwork fields to regimental rows of trees. However, capturing human interest in your photographs will give them an extra dimension, whether you're documenting people's working lives or trying to communicate the relationship between farmers and their land.

CAMERA MODE	LENS SETTING
Select **Landscape** mode or **Aperture Priority** and an aperture of f/16	Zoom to **maximum wide angle**

SENSOR/FILM SPEED	FLASH
Use a **low ISO** setting (e.g. ISO 100)	Shoot without **flash**

FOR THIS SHOT

This photo captures the range and intensity of Asian paddy field farming. Including the workers in the picture gives the viewer a sense of the scale of their task.

1 Wide angle
Zoom out as wide as possible to include as much foreground detail and distant landscape as you can.

2 Depth of field
The way the channels wrap around the contours of the hillside has created a striking rhythmic pattern. A small aperture setting has been used to ensure that the full extent of the terracing appears sharp.

3 Framing
The framing of this shot nicely captures the terraces' dramatic lines as they sweep across the scene. It also gives us a detailed glimpse of the crops in the foreground.

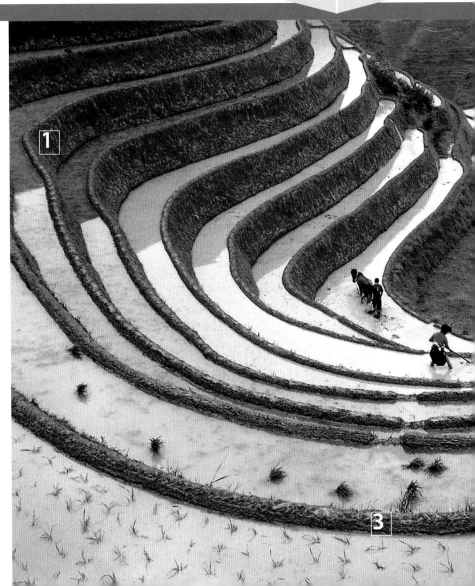

TRY THIS

Set your camera to portrait mode and take photos of people working from a modest distance. Using portrait mode will render the foreground blurred, which both frames the subject and picks her out in sharp detail.

ALTERNATIVE APPROACHES

As well as wider views that take in the impact of agricultural activity on the landscape, try to capture the hard-working spirit of agricultural workers as they engage in their day-to-day tasks.

An unusual viewpoint will give you a very different perspective on your subject. If possible, try photographing them from directly above to focus on the individual and their immediate environment, rather than the wider landscape around them.

Working the land is a hands-on activity, and this can be interpreted literally with some close-up shots. Here, the tight framing and low angle of the picture isolates the job in hand.

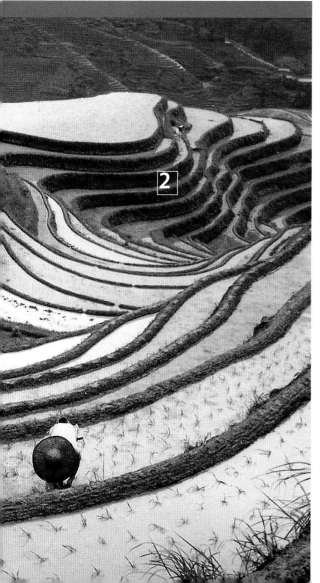

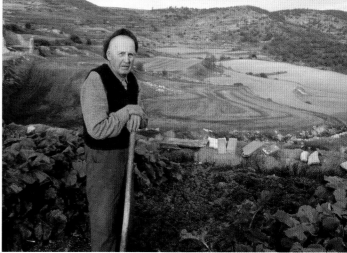

Pictures of people working the land need not always show them toiling away. A moment's respite is a good opportunity to shoot a considered portrait. By placing this farmer off-center, the viewer's focus is split between him and his land.

See also: Down on the farm pp.70–71, Flower fields pp.110–11, Crop fields pp.192–93, Harvest time pp.248–49

Pond life

Healthy ponds are thriving ecosystems that teem with life. Water plants provide necessary shade and oxygenation for fish, insects, and amphibians, which in turn attract birds and other predators. Ponds present photographic challenges— such as reflections or ripples on the surface of the water—but if you can overcome these difficulties, you'll be rewarded with some striking shots of the natural world.

CAMERA MODE	LENS SETTING
Select **Landscape** mode or **Aperture Priority** and an aperture of f/8	Zoom to **moderate telephoto**
SENSOR/FILM SPEED	**FLASH**
Use a **medium ISO** setting (e.g. ISO 400)	Shoot with **full flash**

FOR THIS SHOT

This image of a koi carp has the sparse yet highly decorative appeal of a Japanese silk painting.

1 Exposure
In this image there is a strong contrast between the inky water and brightly colored fish. By using an underexposure of 1 stop the water remains dark but the fish is correctly exposed.

2 Flash
Full flash has been used to produce the very bold highlights on the ripples. Shooting at an oblique angle limits direct reflections and avoids glare.

3 Composition
By placing the fish off-center and limiting its size in the frame, more emphasis is given to the dazzling effect of the water ripples.

TRY THIS

Although the build-up of algae in a pond may be undesirable, if you study it closely it has all the tone and pattern of a miniature landscape. Zoom right in to isolate a pleasing area and shoot at an oblique angle to limit the amount of unwanted reflection.

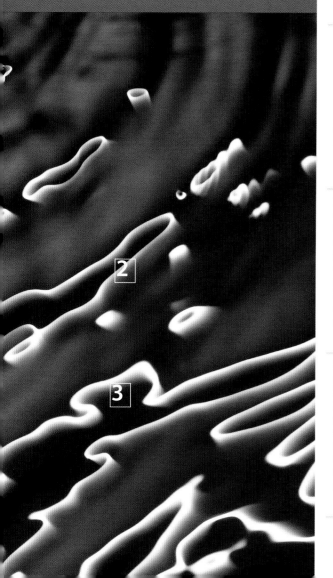

ALTERNATIVE APPROACHES

A lot of activity takes place on, in, and around ponds, albeit on a small scale. Some of this activity is obvious, while some needs to be discovered. A day spent by a pond is an exercise in patient observation, but is well worth the time and effort.

Use reflections from surrounding foliage and the clear or cloudy sky to create bold shapes, patterns, and colors that will add depth and interest to your pictures.

When photographing amphibians, try to place them in the context of their environment. Use a wide depth of field to include as much detail as possible. Try an overhead view to make the most of strong shapes, such as lily pads.

Predators are frequently drawn to garden ponds. In a moment of calmness the elegant outline of this egret is captured against the dark water. But be prepared to set your camera to Shutter Priority and select a brief exposure time to freeze the action when the bird strikes.

Use a waterproof camera or housing to capture pond life from beneath the water. Zoom to wide-angle and set the camera to Auto white-balance. Taking care not to disturb any sediment, reach toward the bottom of the pond and point the camera toward the surface.

See also: Underwater photography pp.176–77, Reflected city pp.184–85, Exposure pp.316–17, At the aquarium pp.302–03, Using flash pp.344–45

Waterfalls

One of the most rewarding of all landscape subjects, waterfalls are endlessly inspiring for photographers. However, lighting conditions can be tricky—the best are often tucked away in glens and ravines—so it pays to take time to work out how best to use the available light. Where you have deep shadows and bright highlights, the high dynamic range (HDR) or tone-mapping features on some cameras are very effective.

CAMERA MODE	LENS SETTING
Select **Landscape** mode or **Shutter Priority** and an exposure time of 1 sec	Zoom to **moderate telephoto**

SENSOR/FILM SPEED	FLASH
Use a **low ISO** setting (e.g. ISO 100)	Shoot without **flash**

FOR THIS SHOT

The tight framing of this image focuses the eye on the texture of the falling water and vibrant color of the moss-covered rocks.

1 Exposure time
Experiment with exposure times to capture the water in different ways. Here, a long exposure has blurred it—the faster the flow the more milky it appears. A short exposure would have produced sharply defined water droplets.

2 ISO setting
The long exposure times necessary for water blur will accommodate a low ISO sensitivity, giving the highest image quality.

3 Lighting
Be prepared to wait for sunlight to break through the trees to highlight some areas of the waterfall, leaving others in the shade.

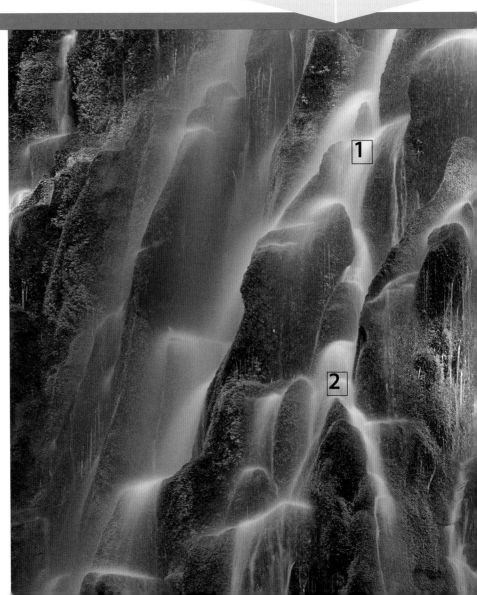

TRY THIS

By zooming in and concentrating on a small section of a waterfall you can create abstract images that highlight texture, pattern, and color. Use reflections of the sky and surrounding trees and varying degrees of motion blur to introduce extra color and dynamism.

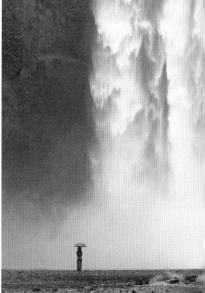

ALTERNATIVE APPROACHES

As well as mastering the varied effects you can achieve with different exposure times, experiment with other variables, such as lighting and focal length.

The force of a waterfall breaking on rocks or gathering in a pool can produce a fine mist above the water. If you're able to position yourself between this mist and the sun you may be rewarded with a rainbow.

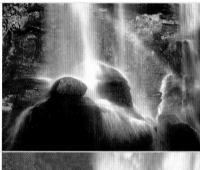

Flowing water can look much the same from near or far, so it can be difficult to communicate the size of a waterfall in a photograph. Shooting from a distance and including a person, tree, or other familiar object for reference provides a sense of scale.

See also: Camera modes pp.64–65, Exploring textures pp.114–15, Seascapes pp.116–17, Exposure pp.316–17

Cats and dogs

Capturing your beloved cat's or dog's character and quirky behavior in photographs can be as entertaining as it is challenging. As with small children, the key to success is having your camera on hand so that you can fire off a sequence of quick shots when something catches your eye. In this way, you should be able to make some spontaneous, natural-looking portraits.

FOR THIS SHOT

Hunters by nature, cats love to look out at the world from a secret hiding place. Here, the curtains form a frame for the small furry face peeping through them.

1 Eye contact
Get your camera ready and prefocus, then gently call your cat's name, to make her look straight at you.

2 Timing
Pets don't stay still for long, so take your shots quickly. Hesitation can mean the difference between a good shot and a shot with no cat at all.

3 Background
The plain, neutral curtains help to focus attention on the cat's face—especially her striking, green eyes and her whiskers, picked out by the light.

CAMERA MODE

Select **Portrait** mode or **Aperture Priority** and an aperture of f/2 or f/2.8

SENSOR/FILM SPEED

Use a **high ISO** setting (e.g. ISO 1000)

LENS SETTING

Zoom to **moderate telephoto**

FLASH

Shoot without **flash**

TRY THIS

Cats and dogs love to bask in a warm, sunny spot. Rather than photographing them in full sun—which might make them squint—try to catch them in dappled shade, such as under a tree or beneath a blind. Both will cast an interesting pattern of shadows on both your pet and the background.

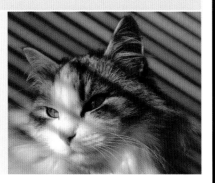

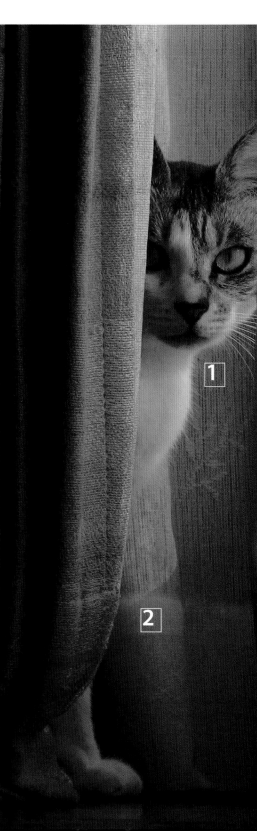

ALTERNATIVE APPROACHES

You know your pet's habits and how it reacts in different situations, so you may be able to set up some characterful shots with the help of a friend or family member. For more relaxed shots, it's worth taking advantage of the fact that your pet probably spends a great deal of time asleep, recovering from its busy day.

Traditional cat and dog portraits often mimic conventional portrait techniques and adopt the head-and-shoulder format. Enlist someone to talk to your pet and engage his attention so that you can take some more natural-looking profile shots.

Pets are, of course, at their most relaxed when fast asleep. Get down low on the ground and zoom in close to get an intimate shot of your pet's face that fills the frame. Use Portrait mode to keep the background soft and focus attention entirely on the face.

A close-up can sometimes produce a more expressive picture than one that includes the whole face. Rather than getting up too close, zoom in from a moderate distance. As long as the eye is in focus, it doesn't matter if other elements are a little soft. Crop the image further to finesse the framing, if needed, and try converting to black and white for added impact.

See also: Pets in snow pp.28–29, Down on the farm pp.70–71, Equine portraits pp.104–05, Pets in action pp.194–95

Lush greenery

As spring advances and leaves begin to unfurl, trees and plants turn the brightest of lush greens. Before the leaves fully mature, sunlight can still penetrate deep into woodland. Exploit the dappled light filtering through the leaves to create images sparkling with vibrant highlights. You'll need to experiment with exposure to get the right balance of light and shade and to capture all the subtle variations of color.

CAMERA MODE	LENS SETTING
Select **Landscape** mode or **Aperture Priority** and an aperture of f/8	Zoom to **moderate** or **maximum wide angle**

SENSOR/FILM SPEED	FLASH
Use a **low ISO** setting (e.g. ISO 100)	Shoot without **fill-in flash**

FOR THIS SHOT

This viewpoint—lying on the ground gazing up through the branches—evokes the feeling of peace and tranquility you can experience on a sunny spring day in the woods.

1 Wide view
For maximum impact, zoom out as wide as possible, emphasizing the giddying convergence of the tree trunks.

2 Exposure
When shooting a tree canopy against a bright sky, set your exposure to the leaves. The sky will be overexposed, but the bright greens of the foliage will be preserved.

3 Vary settings
Bracket exposure and experiment with different orientations, as small alterations in aim can make a significant difference with wide-angle shots.

TRY THIS

In addition to making young green leaves appear more vivid, you can use backlighting to pick up detail, such as the leaf's skeletal structure and any variations in color. Use a Macro setting and fill the frame.

ALTERNATIVE APPROACHES

Wander through a woodland in the spring and you'll find gorgeous views at every turn. Whether you're photographing close-ups or exploring wider views, crop in tightly to exclude the sky and focus all attention on the lush greenery.

Zooming in from a distance has created a shallow depth of field in this image of sunlight filtering through trees. If your camera has a Vivid Color mode, use it to enhance color saturation.

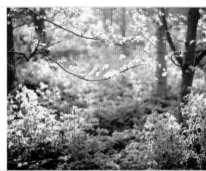

Look for layers of new growth against old to find repeating patterns in contrasting shades of green. Use a Macro setting to get in really close to the smaller leaves and fronds and shoot square-on.

A relatively thin cover of deciduous foliage allows light to spill onto the forest floor, lighting up the verdant mosses. Get in close enough to examine the texture and detail, but try framing the shot to show the way they blanket the woodland floor.

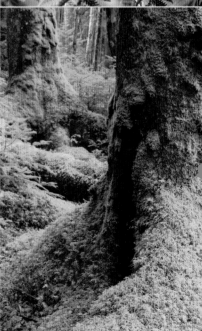

See also: New growth pp.90–91, Close-up and macro pp.92–93
Spring blossom pp.118–19, In the forest pp.270–71

Baby portraits

The best baby portraits either capture something of the new arrival's character or reveal the close bond between parent and child. Although it's relatively easy to pose shots, effective framing, lighting, and creative use of depth of field can really make a difference. By isolating a baby's tiny features, you can create images that emphasize their vulnerability.

FOR THIS SHOT

This tender portrait conveys the special relationship between a mother and her newborn baby. Tight framing eliminates unwanted evidence of the hospital room.

1 **Framing**
Getting in close—either literally or by using a zoom lens—increases the sense of intimacy and focuses attention on the bond between the subjects.

2 **Black and white**
Making the image black and white removes any color distractions and evens the newborn's skin tones.

3 **Lighting**
Position your subjects carefully to take advantage of soft natural lighting from a window. Use the fall of the light to draw attention to the baby and highlight its features.

CAMERA MODE

Select **Portrait** mode or **Aperture Priority** and an aperture of f/4

SENSOR/FILM SPEED

Use a **low ISO** setting (e.g. ISO 100)

LENS SETTING

Zoom to **moderate telephoto**

FLASH

Shoot without **flash**

ON YOUR PHONE
SNAP AND SEND

Because it is always with you, a camera phone is perfect for catching those fleeting but memorable expressions. You can then quickly share your images with family and friends as email attachments or multimedia messages. You can even upload them directly to your favorite social media site or post them on an online album.

3

2

ALTERNATIVE APPROACHES

Baby photographs are among our most cherished possessions. Keeping a camera handy will not only help you to record key stages and events in your baby's life, but also those everyday moments that might easily be forgotten. Take lots of photos, but try to be disciplined when it comes to editing them.

Tender moments, when a parent's smiles and kisses are reciprocated by a baby, make wonderfully expressive portraits. Use a plain background or shallow depth of field to isolate your subjects, then zoom in as close as you can to catch the expressions on both faces.

A play gym with colorful toys is ideal for catching a baby's interest and can stimulate a wealth of charming expressions. In this picture, shooting through the gym with a shallow depth of field has created an appealing foreground that frames the baby's face well.

TRY THIS

For a different approach, experiment with images that focus on one part of the baby, or are symbolic in some way. This shot emphasizes how tiny the baby's feet are, and the heart shape of the hands expresses the love felt by the parent.

See also: Indoor child portraits pp.32–33, Character portraits pp.82–83, Window-lit portraits pp.300–01, Posed portraits pp.342–43

In the night garden

By night, a garden can be gloomy and uninviting or, with the judicious placement of just a few lights, something quite magical. Views that by day are dominated by color and flowing planting, at night may be superseded by more dramatic and theatrical scenes. Night lighting can transform any garden, drawing attention to photogenic areas and throwing distractions into shadow.

CAMERA MODE	LENS SETTING
Select **Landscape** mode or **Aperture Priority** and an aperture of f/11	Zoom to **moderate wide angle**

SENSOR/FILM SPEED	FLASH
Use a **medium to high ISO** setting (e.g. ISO 400 to 800)	Shoot without **flash**

FOR THIS SHOT

Shot at dusk, ornamental lighting has brought this Japanese garden to life. It has harmonized the structural and living elements and produced a layering effect that gives the image depth.

1 Natural light
Night shots often work best when there's still a little light in the sky. This adds some color and interest to the background.

2 Reflections
When light is limited, exploit the ability of water to produce glowing reflections that enliven the scene.

3 Depth of field
Use a small aperture setting to ensure that you have the maximum depth of field. Make the most of both foreground elements and the distant landscape to further create a feeling of depth.

TAKE IT FURTHER
AN ENIGMATIC PORTRAIT

Using portable lights and a few props—which you may already have—you can stage intriguing garden portraits. Carefully position the lights to impart a surreal or romantic feel. Underexpose by around 2/3 stop to preserve the dark tones and atmosphere.

ALTERNATIVE APPROACHES

Capturing the essence of a garden at night need not involve just shooting wide, all-embracing views. Focusing on details can result in unusual and evocative images. Use any garden lighting that's available but also try experimenting with flash and combining the two.

Use flash in the garden at night to render plants brightly lit against a dark background. The flash will light the foreground but not beyond. Underexpose by 1 to 2 stops to retain detail in the plant and to prevent it from appearing washed out.

Exploit low light levels at night to take long exposures of illuminated water features, blurring them to produce a silken cascade. Using a tripod or nearby stable surface, try shots at 1/2 sec or 1 sec.

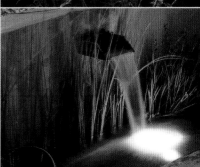

Make a feature of attractive light sources, such as these paper lanterns. Depending on their output, and your exposure time, they may illuminate the garden around them. Alternatively, use a burst of fill-in flash to gently light the scene.

2

See also: Purple twilight pp.42–43, City lights pp.62–63, Formal gardens pp.156–57, Working in low light pp.288–89

Romantic ruins

A popular destination for days out in Victorian times, romantic ruins became a common subject in the early days of photography. To this day, both magnificent historic ruins with architectural merit and more prosaic tumble-down buildings have much to offer. Interesting perspectives and framing devices, good natural light, and rough textures of crumbling stone can all be used to evoke the atmosphere of lost worlds.

CAMERA MODE	LENS SETTING
Select **Landscape** mode or **Aperture Priority** and an aperture of f/16	Zoom to **moderate wide angle**

SENSOR/FILM SPEED	FLASH
Use a **low ISO** setting (e.g. ISO 100)	Shoot without **flash**

FOR THIS SHOT

This photo exploits the contrast between the solidity of the columns in deep shadow and the intricate windows in the sunlight.

1 Exposure
When shooting a scene that contains shadow and bright light, ensure that you balance the exposure to prevent the shadows from becoming too deep or the highlights being burned out.

2 Composition
When composing your shot, exploit the structure of the ruin. Look for strong lines and alignments that will help to enhance the depth of the scene.

3 Use a tripod
To obtain a wide depth of field use a small aperture setting. To achieve a sharp image, especially at a low ISO sensitivity, you may need to use a tripod.

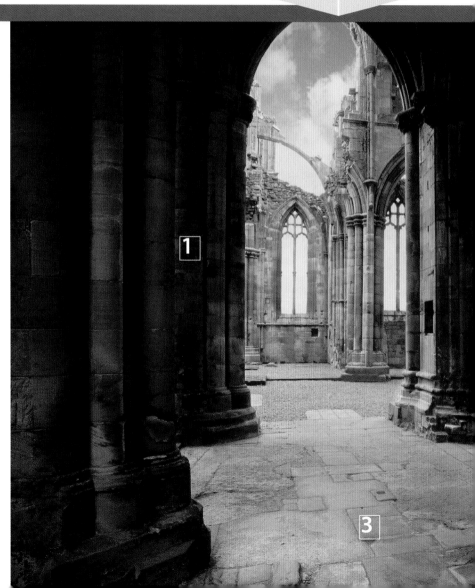

TRY THIS

To draw attention to the dramatic lines and shadows of a ruined building, try shooting in black and white. This will create a strong graphic image, with good contrast, that might not be as effective if shot in color.

ALTERNATIVE APPROACHES

Whether it rises up dramatically from a barren landscape, or is partially obscured by undergrowth, much of the drama of a ruined building is created by its setting. Stand back and observe how it interacts with its surroundings.

The warm lighting of the golden hour—the hour before sunset or after sunrise—casts a soft glow over landscapes and ruins. For a strong composition that conveys the isolation of the location, position the ruin off-center, leaving room in the frame for an expanse of wilderness.

Next time you take a walk in the woods, keep your eyes open for buildings being overwhelmed by the trees and shrubs. Here, the white of the cottage is being displaced by the emerald green of the undergrowth, which unifies the picture.

A ruin needn't dominate a shot to be its main focal point. Get down low to create a composition in which the distant ruin is balanced by the foreground landscape. For best results, zoom out to a wide-angle lens setting and use a very small aperture to keep the whole image sharp.

See also: Urban decay pp.56–57, Architectural details pp.78–79, Spirit of place pp.238–39, Heritage architecture pp.258–59

Wedding day

A celebration of life and love, a wedding day is a beguiling blend of tradition and personal moments, creating plenty of photo opportunities. Whereas the official photographer will have a formal shooting brief, you can take a free approach to the spirit of the event and concentrate on capturing informal scenes. As well as photographing the bride, groom, and attendants, focus on the details of dresses, flowers, and decorations.

CAMERA MODE	LENS SETTING
Select **Sports** mode or **Shutter Priority** set to 1/250 sec	Zoom to **moderate wide angle**

SENSOR/FILM SPEED	FLASH
Use a **low ISO** setting (e.g. ISO 100)	Shoot without **flash**

FOR THIS SHOT

This shot shows the brides and grooms at a Chinese collective wedding tossing lucky silk ribbons around a tree. The spontaneity and happy atmosphere are reflected in the informal nature of the picture.

1 Get up close
Once the formalities are over and the key players have started to relax, zoom out wide and move in close to the action, but make sure you don't get in the way.

2 Exposure
Don't be afraid to use the autoexposure mode when people are moving around. It's a good idea to take as many pictures as you can, and review them during quiet moments so that you don't miss anything.

3 Sharpness
Use a short exposure time to capture crisp images of fast-moving action.

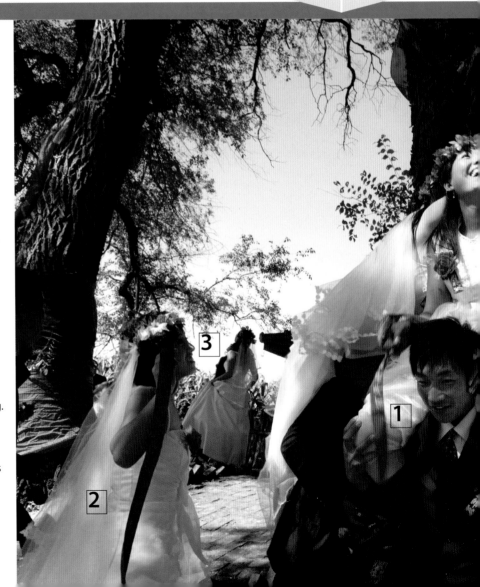

ON YOUR PHONE
SELECTIVE COLOR

Black and white is a classic look for wedding photos. Give a few images a twist by using a selective color app. This will transform an image to black and white, then let you add colors where you choose, to create eye-catching highlights.

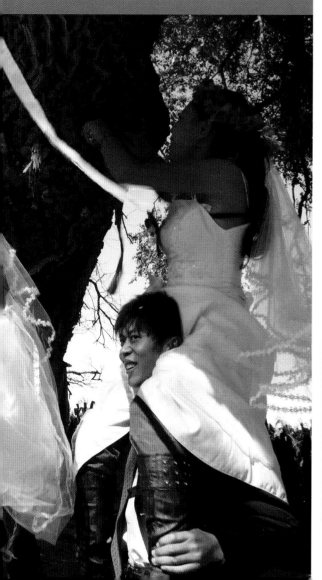

ALTERNATIVE APPROACHES

It's best to leave formal group photos to the professionals and focus instead on more personal pictures of the bride, groom, and guests. Keep an eye open for humorous moments too—there are always a few at a wedding.

The pairing of hands is symbolic of the whole wedding and makes a striking image. This colorful shot is packed with intricate detail and contrasting patterns. Using the portrait mode has blurred the background a little so the hands stand out sharply.

The preparations and the activities behind the scenes at a wedding present some of the best photo opportunities. This candid shot, which cleverly incorporates a reflection of the scene beyond, captures a rare quiet moment in a busy day, which would otherwise have gone unnoticed.

TAKE IT FURTHER
ULTRA WIDE ANGLE

You may need to use an ultra wide-angle lens to take in the whole scene at key moments in the ceremony. Although there may be some distortion, such images create a dramatic impact.

See also: Party people pp.20–21, Indoor child portraits pp.32–33, Birthday parties pp.108–09, Garden parties pp.216–17

Basic image adjustments

Many professionals advise that if you take a photograph correctly you'll have little need to manipulate it on your computer later. In practice, most images benefit from a little enhancement. This might involve tweaking the composition, adjusting the contrast, or boosting the colors, for example. Here are five key adjustments you can make using virtually any image editing application.

 CROPPING

Although it's a very basic adjustment, cropping a photograph can have a dramatic effect on its impact. You can crop to remove distractions from the edges of photographs, enlarge or reposition the main subject, and change the overall image format to match that of a frame or print.

With the cropping tool selected, you simply define the top left hand corner of the desired crop and drag to the bottom right. You can then use the corner "handles" to fine-tune the final crop.

CORRECTING LEVELS

The Adjust Levels control lets you adjust the tones in a photograph to ensure that it contains a full range, from deep blacks to bright whites. Most programs use a graphical representation called a histogram.

Adjust the levels by dragging the sliders under the histogram. As you move them, observe the effect this has on the image. For best results, drag the sliders to meet the start and end points of the histogram curve. The Auto Levels command is a useful shortcut, automatically adjusting levels for the best distribution.

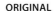

CROPPED IMAGE WITH ORIGINAL

ORIGINAL

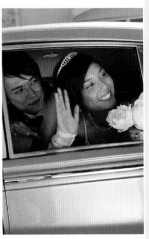

LEVELS ADJUSTED

COLOR BALANCE AND SATURATION

Use the Color Balance or Hue controls to correct unwanted color casts (see pp.36–37). The Color Balance control changes the primary and secondary hues in an image (red/cyan, green/magenta, blue/yellow), whereas the Hue control shifts the entire range of colors by an equal amount.

To give colors an extra boost, or to reduce their impact, use the Saturation control. When increasing saturation, be careful not to overdo it—an increase of between 5 and 8 percent is usually sufficient.

ORIGINAL INCREASED SATURATION

SHADOWS AND HIGHLIGHTS

To brighten areas of shadow in your images and to stop bright highlights becoming featureless, use the Shadow/Highlight tool. Move the respective sliders until you are happy with the results. A light touch—with adjustments kept under 10 percent—is best.

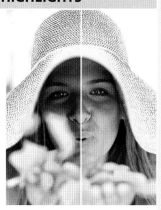

ORIGINAL BRIGHTENED

DID YOU KNOW?
IMAGE SIZE

When making any image adjustments it's best to use the original image as it was downloaded from your camera. Many changes can be applied more subtly on a larger image. If you later need a smaller image file, say for web use, change the size using the Image Size command. However, it's a good idea to keep a copy of the original too, just in case you need the best-quality image again.

REMOVING DISTRACTIONS

Whether it's a speck of dust, a conspicuous road sign, or even a post appearing to grow out of your subject's head, some distractions really need to be removed. The Clone (or Rubber Stamp) tool conceals any mark or flaw by simply copying pixels from another part of the image. It takes a little practice—particularly in choosing the best place from which to copy—to get perfect results, but the reward is usually well worth the effort.

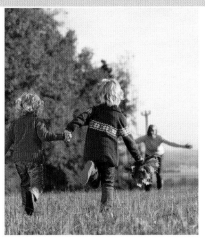

ORIGINAL

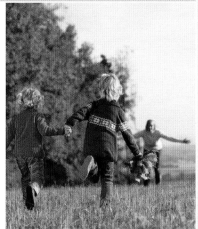

DISTRACTION REMOVED

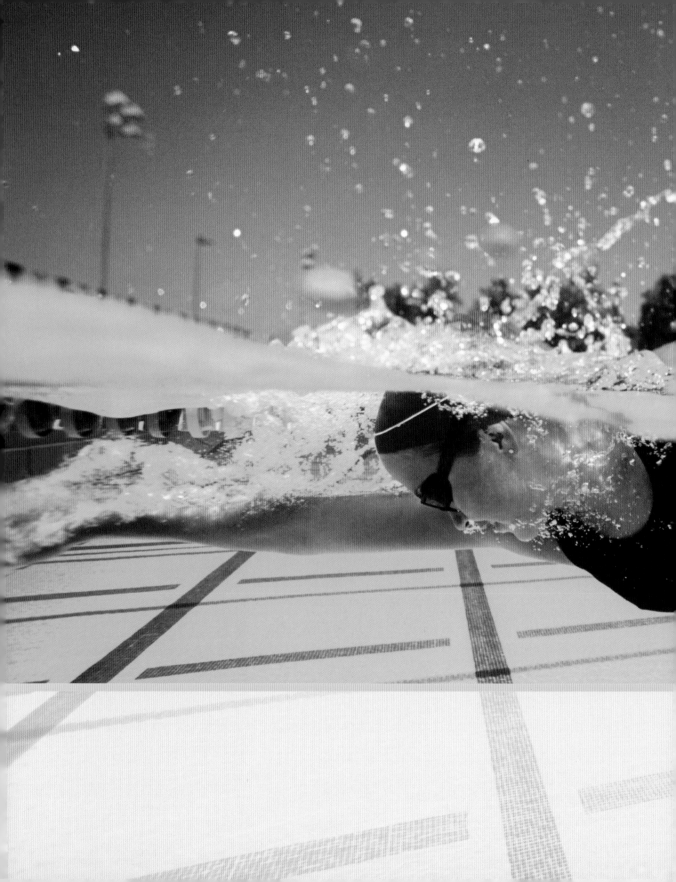

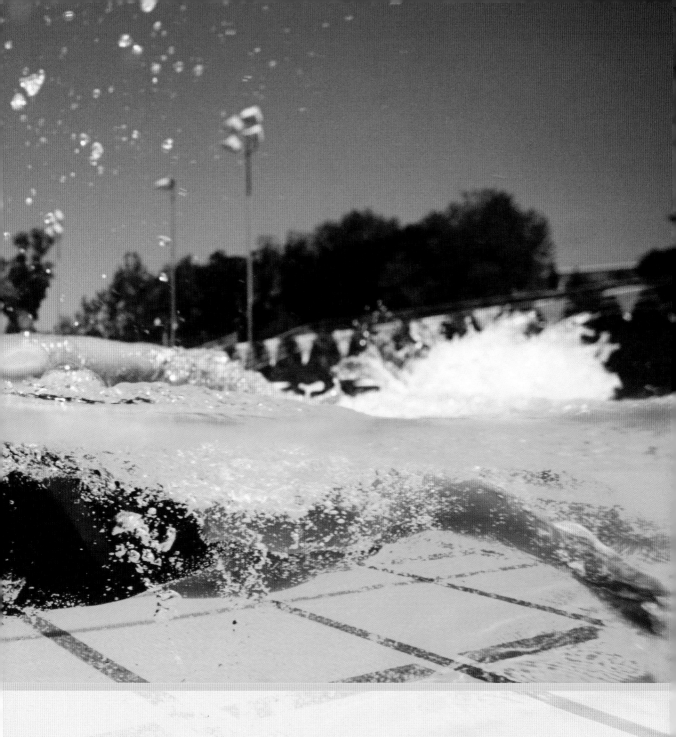

Early Summer

shimmering iridescence

> "**Summer** afternoon—summer **afternoon…** the two most **beautiful words** in the English language"
>
> Henry James

the drowsy **hum of bees**

turquoise pool of light

all the fun of **the fair**

mist-shrouded mountains

Eating al fresco

When the days are warm and the evenings are long, few people need much of an excuse to dine al fresco. Whether it's a barbecue or a simple picnic, outdoor dining tends to be a relaxed affair, making it an ideal setting for fun-filled pictures of friends and family enjoying themselves. Al fresco meals also offer the opportunity for some candid portraits as well as still-life photos of food.

CAMERA MODE	LENS SETTING
Select **Portrait** mode or **Aperture Priority** and an aperture of f/2.8	Zoom to **moderate telephoto**

SENSOR/FILM SPEED	FLASH
Use a **low ISO** setting (e.g. ISO 100)	Shoot without **flash**

FOR THIS SHOT

This lovely scene captures everything that is good about al fresco dining, from the food in the foreground to the expectant faces of the children.

1 Composition
The close framing on the barbecue food and the children's faces gives this shot clear focus. The fork entering from above is a quirky compositional element that directs the eye.

2 Depth of field
A wide aperture has been used to create a narrow depth of field, drawing our attention to the food. The children have been blurred nicely but we can still recognize their expressions.

3 Exposure
As the main subjects have been shot against a bright background, the picture has been slightly overexposed to retain detail and avoid silhouetting.

TRY THIS

For an image with an unusual perspective and an interesting framing device, photograph people dining outdoors from inside the house. Set your exposure to the outdoor scene, which will silhouette the interior, then experiment with fill-in flash to pick out some interior details without distracting from the main subject.

ALTERNATIVE APPROACHES

Whether captured individually or together, both of the focal points of al fresco dining—the food and the company—have plenty of photographic potential.

An appetizing spread, laid out for a picnic, is the perfect subject for a still-life photo. If it helps the composition, reposition the food, paying attention to contrasting textures and complementary colors.

Step back from a picnic and take some candid group shots. From a moderate distance you'll need to zoom in to get a tight composition that fills the frame. The unusual framing of this shot has emphasized the relaxed and casual atmosphere.

Shooting from directly overhead puts a fresh, graphic twist on picnic photos. Stand on a chair and zoom out to capture the patterns created by the food and people. The shapes and colors of this image are reminiscent of a kaleidoscope.

See also: Birthday parties pp.108–09, Children outdoors pp.126–27, Wedding day pp.146–47, Garden parties pp.216–17, Café life pp.256–57

Formal garden

Although formal gardens are designed to be visually impressive year-round, they tend to be at their peak in the summer months. Often designed on a grand scale, they are usually architectural in structure, and rely on features such as avenues, paths, flights of steps, or clipped hedging to create a framework for the plants. Take advantage of the landscaping to create images of both sweeping vistas and intriguing details.

CAMERA MODE	LENS SETTING
Select **Landscape** mode or **Aperture Priority** and an aperture of f/16	Zoom to **moderate wide angle**

SENSOR/FILM SPEED	FLASH
Use a **low ISO** setting (e.g. ISO 100)	Shoot without **flash**

FOR THIS SHOT

This wide-angle view makes a feature of one ornamental element of the garden, while also including the palace beyond and the magnificent natural setting.

1 Composition
The stone urn in the foreground helps to structure the image and lead your eye down the steps to the palace. The tall hedges on either side create a strong sense of perspective.

2 Depth of field
Use a small aperture setting to maximize depth of field in order to keep everything from the urn to the distant landscape as sharp as possible.

3 Lighting
When the light is coming from one side, it creates strong shadows. This side-lighting helps define features such as the relief in the stone urn, conferring a rounded volume to it.

TRY THIS

In some gardens it's the hard landscaping more than the planting that creates the most striking point of interest. Look for areas where contrast of light and shade emphasizes patterns and textures and zoom in close to eliminate distractions.

ALTERNATIVE APPROACHES

Just because a garden is grand in scale, it doesn't mean your pictures must be too, so think about taking a more intimate approach. Look at the garden in terms of form, color, and texture—as if it were a work of art.

Clipped box hedges and topiary are typical features of many formal gardens. Look for viewpoints that make the most of the modeling effect of light and shadow to accentuate the contrast between their geometric shapes and the more informal planting.

Here, the arches of a rose tunnel draw your eye into the distance, with splashes of red providing a lively counterpoint to the dominant green of the image. In high contrast scenes, experiment with position and exposure times to find a pleasing balance between areas of light and shade.

See also: Depth of field pp.120–21, Lush greenery pp.138–39, In the night garden pp.142–43, In the forest pp.270–71

At the carnival

Old-fashioned fairgrounds, with their dizzying rides, gaudy colors, and blaring music, overwhelm you with sensations that take you straight back to childhood. The best way to capture the giddy fun is to get into the thick of the action. Try to capture the hustle and bustle of the environment as well individual rides and revelers. With so much movement and color, a carnival is the ideal place to experiment with exposure times too.

CAMERA MODE	LENS SETTING
Select **Action/sports** mode or **Shutter Priority** and an exposure time of 1/4 sec	Zoom to **moderate wide angle**

SENSOR/FILM SPEED	FLASH
Use an **medium ISO** setting (e.g. ISO 400)	Shoot without **flash**

FOR THIS SHOT

The sensation of speed and excitement on this whirling carousel are evocatively conveyed by the rakish angle of the shot and the strong blurring.

1 Wide-angle setting
Include both the carousel and riders by shooting as wide as you can from a low viewpoint.

2 Exposure
Overexposing by 2/3 to 1 stop has given this shot an airy feel, retaining the blue of the sky as well as the color and detail in the shadowed area of the carousel.

3 Shutter time
To capture motion blur while keeping the subject recognizable, experiment with an exposure time from 1/30 sec to 1/4 sec.

TRY THIS

By their very nature, fairgrounds are rather unruly and boisterous places. Take advantage of the bubbly mood to make some silly, fun pictures of friends and family. The weird distortions of a Hall of Mirrors is guaranteed to have everyone laughing—get as close as you can and keep shooting while the others move around.

ALTERNATIVE APPROACHES

For all the clamor and color, there's something nostalgic about the fairground atmosphere too. Try to capture the spirit of tradition as well as the dazzling frenzy of the fair.

A ride on the rollercoaster or ferris wheel will give you an overview of the site. You won't be able to move around much to compose your shot, of course, but try to include as many people as possible and use the colorful awnings to introduce some structure to the scene.

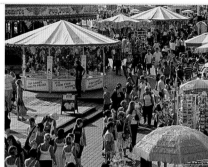

Carnivals come alive at night. Set your camera on a tripod and experiment with long exposures to capture the blur of the spinning lights. Try using your flash too, for images that combine sharpness and blur.

Without the distraction of color, all attention is focused on the child's smiling face. This treatment also lends the image a charming, timeless quality.

The twisted poles and painted horses of traditional carousels are fascinating examples of craftsmanship. Choose a place where the horses are well lit and zoom in if necessary. If the carousel is moving, use a short exposure time to freeze the movement or longer ones for blur.

See also: Camera modes pp.64–65, On the move pp.86–87, Music festivals pp.224–25, Exposure pp.316–17

Street photography

The strength of street photography lies in the spontaneity of the images, and the variety of subjects and possible interpretations. Whether simply capturing a snapshot of life or taking a more idiosyncratic approach and commenting on the scene in front of you, there are opportunities everywhere. Sometimes you have to walk the streets to find them, sometimes you just need to stand and wait for them to emerge.

CAMERA MODE	LENS SETTING
Select **Sports** mode or **Aperture Priority** and an aperture of f/11	Zoom to **moderate wide angle**

SENSOR/FILM SPEED	FLASH
Use a **low to medium ISO** setting (e.g. ISO 100 to 400)	Shoot without **flash**

FOR THIS SHOT

This picture sums up the opportunism required for successful street photography. The billboard image lends a surreal cut-and-paste quality to the busy urban street scene.

1 Depth of field
A very small aperture setting ensures that everything in the scene—from the close-up portrait to the buildings in the background—is in focus.

2 Contrasts
The difference in scale between the woman in the foreground and the people behind is matched by the contrast between her glamour and the urban clamor.

3 Composition
While the billboard provides a strong vertical division, the inclusion of the strip of street scene on the left ensures that this doesn't become an image of two disparate halves.

ON YOUR PHONE
SEIZING THE MOMENT

A camera phone comes in handy for capturing those unexpected moments. The curious juxtaposition of the women in head scarves with the mannequin legs presents a quirky image, spotted and snapped in an instant.

ALTERNATIVE APPROACHES

The key to effective street photography is spotting photo opportunities developing. Once you start looking, you'll begin to recognize and anticipate many intriguing, amusing, and telling moments all around you.

Street photography doesn't have to be candid: eye contact can help to provide a strong visual link between the subject and the viewer. But this picture is also about the hands. Repeated gestures add rhythm and an element of humor to an image.

Keeping an ever watchful eye will lead you to more opportunities. This dog, spotted sitting in the driver's seat of his owner's van, has transformed an everyday scene into something amusing and, at the same time, rather touching.

Many street photographers prefer to use black and white, believing that color is distracting. In this image, thoughtful composition has given an otherwise unremarkable scene a reportage feel that demands a closer look.

See also: *On the move pp.86–87, Depth of field pp.120–21, Street performers pp.170–71, Picture composition pp.260–61*

Mountain scenery

The combination of open spaces, dramatic skies, and superb views make mountain landscapes a photographer's paradise. In such breathtaking surroundings, take time to set up your shots carefully in order to do them justice. Mountain landscapes have inspired artists and writers for centuries, but present some serious challenges—the weather can change quickly, so check the forecast and be prepared.

CAMERA MODE	LENS SETTING
Select **Landscape** mode or **Aperture Priority** and an aperture of f/8	Zoom to **moderate telephoto**

SENSOR/FILM SPEED	FLASH
Use a **low ISO** setting (e.g. ISO 100)	Shoot without **flash**

FOR THIS SHOT

This image—a view of a Himalayan mountain—successfully contrasts the dazzling and majestic snowy peak in the distance with the modest stupa and wind-torn prayer flags close by.

1 Exposure
To retain brightness in the snowcapped mountains and clouds, overexpose by 2/3 stop.

2 Composition
Include a point of interest in your foreground—here, the moss-covered rock and stupa—to balance the more distant elements and provide context.

3 Depth of field
To ensure that the entire scene appears sharp, from the texture of the foreground rocks to the jagged peaks beyond, select landscape mode or a small aperture setting.

TAKE IT FURTHER
TEMPERATURE INVERSION

A temperature-inversion layer—in which air becomes warmer, rather than colder, as you move upward—produces low altitude clouds that often fill mountain valleys. You may have to wait for the right conditions, but you'll be rewarded with an intriguing image, with clouds helping to define the distant ridges.

2

ALTERNATIVE APPROACHES

Almost by definition, mountain photography is large-scale. However, there's more to shooting mountain landscapes than towering peaks and sweeping vistas—where possible, try to incorporate a human element into your images, too.

People live and work in even the most extreme and inhospitable mountain ranges. Approached with sensitivity, candid pictures—using the mountain landscape as a backdrop—can provide a powerful portrait of these people in their environment.

At sunrise, lakes are more likely to be flat and calm, providing mirrorlike reflections of their surroundings. Here, the mountain itself isn't in shot, but its reflection shows its peak bathed in clear morning light. The boat provides context in an image that would otherwise feel abstract.

TRY THIS

Vary your perspective when photographing expansive landscapes. Here, the plants in the foreground, and the lush hills at the sides of the scene, frame the frosted peaks in the middle of the image.

See also: Snowy sunsets pp.60–61, Changing skies pp.106–07, Picture composition pp.260–61, Exposure pp.316–17

Bird life

From the extravagantly colored exotic species to the ubiquitous garden varieties, birds are a fascinating subject for photography. Although getting close to birds can be a problem, bringing them within range can be as easy as setting up a bird feeder in your yard or feeding the ducks at your local park. Get to know the birds' habits so that you can predict their behavior, and seek out unusual viewpoints that depict bird life in new ways.

CAMERA MODE	LENS SETTING
Select **Action** mode or **Shutter Priority** and an exposure time of 1/125 sec	Zoom to **telephoto**
SENSOR/FILM SPEED	FLASH
Use a **medium to high ISO** setting (e.g. ISO 400 to 800)	Shoot without **flash**

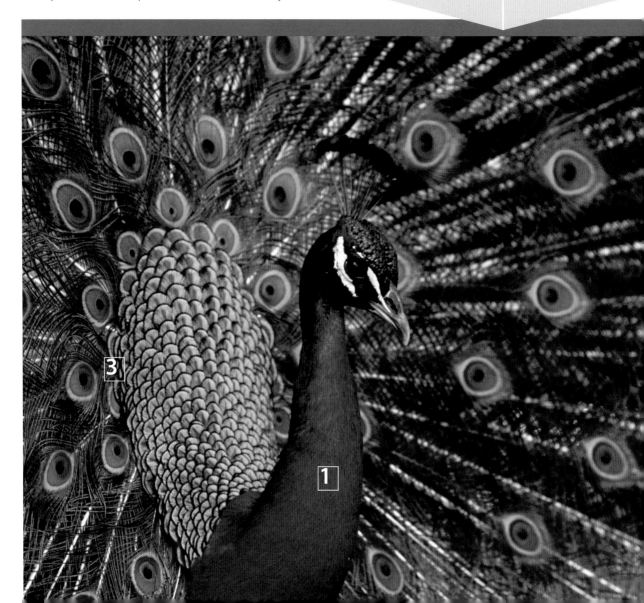

TAKE IT FURTHER
CAUGHT IN FLIGHT

Capturing sharp and well-exposed images of birds in flight is a real challenge. For the best results you'll need to use a camera with a focus tracking function. Set the metering mode to Center weighted to achieve a good exposure of your subject.

FOR THIS SHOT

Peacocks are confident as well as colorful, which means it's usually easy to get close-up images of their iridescent colors as they show off their plumage.

1 Composition
Positioning the peacock's head and neck to one side and filling the rest of the frame with feathers emphasizes the scale and impact of its plumage.

2 Framing
Don't always try to accommodate the whole bird in your picture. Here, a tight framing has been used to block out any background distractions.

3 ISO setting
To make the most of the dazzling colors and elaborate eye patterns of a peacock's feathers, increase the ISO sensitivity for brief exposures, freezing any movement to create a pin-sharp image.

ALTERNATIVE APPROACHES

Tame birds may give you your best chance for making successful portraits, but you'll need a different approach for wild birds. Try creating artistic images of groups of perched birds, or capture their movement in flight using motion blur.

As evening falls many bird species gather in flocks on wires, rooftops, or pylons, and this is a good time to capture them en masse, in silhouette. Underexpose to darken the silhouettes and boost the color of the twilight sky.

This unusual image of a flock of birds in flight has taken on an almost abstract quality. Capture motion blur by setting an exposure time of 1/30 to 1/15 sec, and pan with the birds to blur the background too.

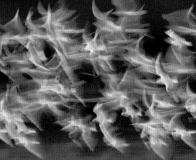

It's possible to make intriguing pictures of the most ordinary subjects by using an unusual viewpoint. It takes a moment or two to work out that this image is a group of pigeons on a store awning, taken from below.

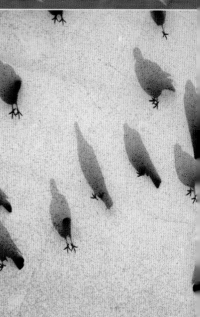

See also: A walk in the park pp.22–23, Along the riverbank pp.100–01, Garden safari pp.172–73, Exposure pp.316–17

Public sculpture

All cities have some kind of public sculpture, ranging from the classical and ancient to the abstract and modern. Look at the sculpture from all angles before you start taking photographs to make sure you get the best view. Rather than just documenting it, try to find ways to express your own vision. Capture the whole sculpture and its surroundings as well as looking at details that give a feel of the style of the piece.

CAMERA MODE	LENS SETTING
Select **Landscape** mode or **Aperture Priority** and an aperture of f/8	Zoom to **moderate wide angle**

SENSOR/FILM SPEED	FLASH
Use a **medium ISO** setting (e.g. ISO 400)	Shoot without **flash**

FOR THIS SHOT

This unorthodox view of a well-known site successfully establishes its monumental scale by including the janitor in the frame.

1 Composition
The columns in deep shadow place the sculpture within its context and frame both the sculpture itself and the tiny figure at its feet.

2 Timing
An early start is essential if you want to explore your subject in depth and capture an atmospheric shot without hordes of tourists.

3 Exposure
In scenes with areas of deep shadow, set your exposure for the main subject so that it's not overexposed.

TRY THIS

Turn a public sculpture into a personal project. Shoot it from a range of viewpoints and at different times of day. Show how it relates to its environment—whether it complements or contrasts with surrounding architecture. Explore how forms and textures appear different depending on how close or far away you are.

ALTERNATIVE APPROACHES

Public sculptures may be somber or frivolous and situated in grand or commonplace settings. The tone of the piece, and its location, can help determine your approach.

A tight crop can be more effective than trying to capture the entire sculpture. Zoom in to fill the frame with the subject. For varying results, revisit the scene through the day to see how light and shadows affect it.

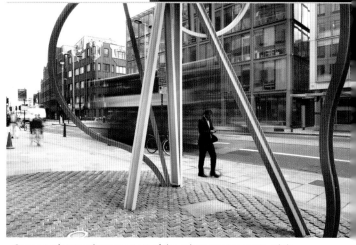

Some sculptures become part of the urban environment, while others seem to invite the viewer to interact. Here passers-by accept this incongruous structure without reacting to it—both they and the city itself seem to become part of the artwork.

See also: *On the tourist trail pp.226–27, Street signs pp.230–31, Heritage architecture pp.258–59, Picture composition pp.260–61*

Travel portrait

Traveling is all about meeting new people and gaining new experiences—you don't have to go very far from home to find notable differences in culture, clothes, and customs. Although candid images can be effective, the best travel portraits are often made with your subject's collaboration. Always make eye-contact, smile, and exchange a few words—or gestures—to let someone know that you'd like to photograph them.

CAMERA MODE	LENS SETTING
Select **Sports** mode or **Aperture Priority** and an aperture of f/4	Zoom to **moderate wide angle**

SENSOR/FILM SPEED	FLASH
Use a **low ISO** setting (e.g. ISO 100)	Shoot with **fill-in flash**

FOR THIS SHOT

If you're lucky enough to find subjects as willing as these young monks, make the most of it. This lively, fun-filled portrait is a real team effort and perfectly captures the boys' amusement at being photographed.

1 Use of color
Red can be distracting when used as a highlight in a picture, but the strong red that dominates this image provides coherence, creating a balanced yet dynamic shot.

2 Wide angle
A wide-angle lens setting allows all the subjects to appear in the shot without crowding together. Use this setting with care—if you get too close, the faces at the edge of the picture will become distorted.

3 Fill-in flash
The use of fill-in flash gives bright, even-toned lighting. The flash needs to be balanced so that it appears natural and doesn't overpower the ambient light.

TRY THIS

If the location is great but your subjects are awkward and self-conscious, make the situation work to your advantage. Here, a formal approach contributes to the impact of the image because it captures the pride the subjects feel for their treasured collection, and what it represents.

ALTERNATIVE APPROACHES

All successful portraits reveal something of the character of the subject. Most travel portraits will be informal and usually include elements of the environment.

Candid shots are generally more expressive than formal portraits, even when they are posed. Here the girl was asked to move into the doorway and glance away from the camera. The result is a well-balanced, natural-looking portrait.

A posed portrait doesn't always mean a formal portrait. This shot is staged, but the sitter is relaxed in his own environment. Shooting at wide angle has opened up the interior of the taxi and revealed interesting details.

Gorgeous lighting gives portraits an atmospheric, painterly feel. Use oblique lighting (from a window to the side in this case), gauge the exposure based on the lightest side of the subject's face, and compensate for skin color—reducing it for darker tones. Focus on the nearest eye, then everything else can be unsharp.

See also: Vacation portraits pp.212–13, On the tourist trail pp.226–27, Using color pp.232–33, Using flash pp.344–45

Street performers

During the summer months, the streets and squares of towns and cities become open-air auditoriums for performers to entertain tourists and shoppers with a variety of acts—from mime and magic to music and dance. A street show is an opportunity to make images of performers that would be impossible—and very likely prohibited—in a theater. If you're taking pictures, always put some money in the collection bowl.

CAMERA MODE	LENS SETTING
Select **Sports** mode or **Aperture Priority** and an aperture of f/4	Zoom to **moderate telephoto**

SENSOR/FILM SPEED	FLASH
Use a **low ISO** setting (e.g. ISO 100)	Shoot without **flash**

FOR THIS SHOT

Have your camera ready at all times. This saxophonist has just begun to play and a crowd hasn't yet gathered, giving the impression of a private performance.

1 Composition
If the performer is casting an eye-catching shadow, position yourself to make the most of it, while avoiding including your own shadow in the picture.

2 Background
Even though the performer is the main point of interest he doesn't have to fill the frame. Here, the backdrop has the symmetry and elegance of a stage set.

3 Atmosphere
It is worth waiting for an expressive pose or gesture from your subject. Here, the saxophonist's soulful stance, and the solitude of his setting, conveys the feeling of him being lost in his music.

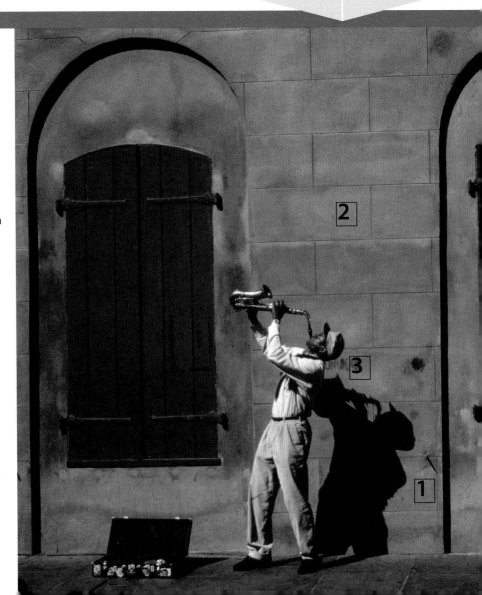

TRY THIS

Try capturing the essence of a performer by zooming in on important details. The gnarled knuckles and toughened skin on this guitarist's hand encourage the viewer to use their imagination to speculate about his general appearance, and the content of his act.

ALTERNATIVE APPROACHES

To convey the full feeling of a street performance, try to include more than just the routine itself. Details of costume, setting, and the audience's reaction to the show will all serve to make your images more telling.

Shooting from a low angle to focus on the billowing, colorful dresses of these flamboyant dancers conveys the upbeat mood of their performance. Freeze rapid movements by using a short exposure time of around 1/125 sec or shorter.

Capture both the performer and his environment by getting in close and shooting with your zoom set to a wide view. Don't worry if your subject isn't a magnet for attention—indifferent passersby are just as much a part of his experience as large, enthusiastic crowds.

TAKE IT FURTHER

PLAYING WITH PERSPECTIVE

Shooting from low down with a wide-angle lens distorts the perspective of this image. It exaggerates the height of the stilt-walkers, making them look as tall as the buildings.

See also: Character portraits pp.82–83, Street photography pp.160–61, People at work pp.186–87, Picture composition pp.260–61

Garden safari

You might be surprised by the number of beautiful photo opportunities that present themselves in your own back yard. Focus on the detail—when you get up close the colors and textures of common plants and tiny insects can take on a bold, vivid quality. The perfect conditions for close-up photography in this type of environment are a windless day with bright, diffused light.

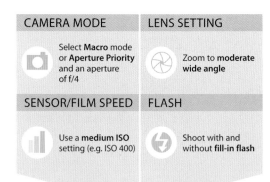

CAMERA MODE	LENS SETTING
Select **Macro** mode or **Aperture Priority** and an aperture of f/4	Zoom to **moderate wide angle**

SENSOR/FILM SPEED	FLASH
Use a **medium ISO** setting (e.g. ISO 400)	Shoot with and without **fill-in flash**

ON YOUR PHONE
ABSTRACT WALLPAPER

To create a striking wallpaper for your phone, try shooting through a magnifying glass to capture one of the patterns in nature found all around us. Here, the arrangement of tiny platelets on the surface of a butterfly's wing makes a beautiful abstract image.

ALTERNATIVE APPROACHES

A garden filled with summer color and buzzing with life may seem chaotic and overwhelming, but wait a while and you'll identify patterns of insect behavior and the best places to set up your camera.

This grasshopper clinging to a stem of grass has been nicely isolated by using a large aperture to create a very narrow depth of field. The way that the grasshopper is partially obscured gives an insect's-eye view effect.

The radiating petals on this flower draw the eye to its center, where a bee is foraging for nectar. In situations like this, bees are generally single-minded and won't be disturbed by your camera, even if you get very close to them.

Look closely for unusual subjects like this. Backlighting intensifies color, particularly against dark backgrounds. The alien-like shadow of this damselfly resting on a leaf makes an unconventional, eye-catching image.

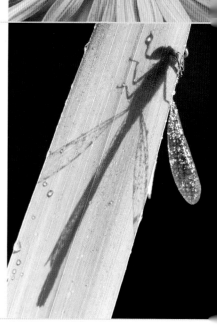

FOR THIS SHOT

With their brilliant colors and symmetical markings, butterflies are rewarding subjects for close-up photography, especially when set against a floral background of complementary colors.

1 Exposure
If you're shooting dominant dark tones, like those on this butterfly's wings, meter from the background to prevent overexposure.

2 Focal length
Use the longest focal length to allow adequate distance between you and your subject. Select Macro mode at short focal lengths, but take care not to cast a shadow on your subject.

3 Fill-in flash
Experiment by shooting with and without fill-in flash to find the best way to capture iridescent colors like these.

See also: Close-up and macro pp.92–93, Pond life pp.132–33, Flowers in close-up pp.190–91, Using flash pp.344–45

People under water

You don't need sophisticated or expensive equipment to photograph people under water. Some compact cameras are waterproof to a modest depth, while others can be fitted with an underwater housing or protected with purpose-made waterproof bags. Experiment with subject and atmosphere—from groups of people to individuals and from the lively and energetic to the serene.

CAMERA MODE	LENS SETTING
Select **Portrait** mode or **Aperture Priority** and an aperture of f/11	Zoom to **moderate wide angle**

SENSOR/FILM SPEED	FLASH
Use a **medium ISO** setting (e.g. ISO 400)	Shoot without **flash**

FOR THIS SHOT

This vibrant shot, with its bubbles, bright colors, and smiling subject, captures the exhilaration of splashing around in the water.

1 Wide angle
Shooting under water reduces the field of view by approximately a third. Use a wide-angle lens setting to counteract this effect.

2 Distortions
When shooting in the shallows, the surface of the water will reflect and distort your subject, creating the kind of fragmented pattern seen here.

3 White balance
When shooting near the surface, use Auto or Daylight settings. However, if you're shooting deeper underwater, you'll need to alter the white balance or use your camera's underwater settings to prevent your subjects from taking on the blue-green hue of the water.

TRY THIS

Get your friends to sit on the edge of the pool with their feet in the water and photograph them from below. This creates quirky images with a skewed, elongated perspective—the reverse of the truncated effect that happens when a person is standing in water and you photograph them from dry land.

ALTERNATIVE APPROACHES

Thanks to the proliferation of affordable equipment, it's never been easier to take lighthearted, entertaining pictures of people having fun under water. Embrace the liberating effect that the unfamiliar aquatic environment has on you and your subjects.

Of course it's hard for subjects to pose under water—keeping a group together and within your frame is especially difficult. However, these problems can result in shots that are more spontaneous than other portraits.

You can create a stunning image with an ethereal feel by working underwater with a subject wearing a translucent, floaty fabric such as chiffon or silk. Ask your subject to strike some balletic poses, and frame the shot so you include the broken reflection of the fabric on the surface of the water.

TAKE IT FURTHER
THE AQUATIC SPIRIT

Split-field shots that show the surface of the water as well as the subject below it, seem to straddle two worlds. You'll need an SLR fitted with a wide-angle lens and housed in a plastic box with a dome. The dome corrects the magnification of underwater images.

See also: Underwater photography pp.176–77, Watersports pp.182–83, At the poolside pp.200–01, Vacation portraits pp.212–13

Underwater photography

Whether you're an avid diver, an occasional snorkeler, or someone who just enjoys family vacations by the swimming pool, underwater photography opens up a new world of opportunities. Even absolute beginners can take some surprisingly effective images and, unless you intend to become a serious underwater photographer, it's not necessary to invest in costly equipment.

▶ EQUIPMENT

When it comes to taking a camera under water, you have the following general options, in order of increasing cost: a waterproof camera bag; a purpose-made waterproof compact; a dedicated underwater camera housing; and a specialized underwater camera. The best option depends on how serious you want to become. For casual use, a simple waterproof compact camera will give you pleasing results, but for more intensive use, the dedicated solutions that incorporate high quality cameras and let you add accessories like underwater flash units are best.

UNDERWATER HOUSING

▶ TAKING BETTER PHOTOS

Whatever equipment set-up you opt for, the following tips will help you to face the challenges of underwater photography and ensure that you get the best results:

• Familiarize yourself with your equipment before you get into the water; make sure that you know how to change the settings easily.

• Before you get into the open water, practice taking photos in the safe environment of a swimming pool.

• Get in close to your subject so that color, contrast, and sharpness aren't reduced by the water.

• The quality of light—and therefore colors and contrast—are better close to the surface.

• Use both hands to keep the camera steady.

• Use flash to improve exposure and color.

• Shoot horizontally or upward, rather than down on the subject, for better compositions and lighting.

• Try to ensure that the eyes of your subject are sharp.

• Use the sun to backlight your subject—this is very effective as the water creates striking rays of light.

• Set the white balance to the underwater setting if your camera has one.

• You will usually need to boost the contrast and color of your underwater photos in post-production on your computer, so shoot in the RAW image format, if possible, to create large unprocessed images.

▶ SAFETY FIRST

It's easy to get carried away by the lure of great underwater photographs. But entering any body of water can present dangers for the photographer.

Even if you plan to do nothing more than fire off a few shots in a hotel swimming pool, you need to be confident in the water and mindful of any local safety restrictions. In open water, whether you're scuba diving or snorkeling, you need to have good knowledge of your location and the environment. It's important that you're constantly aware of what's happening around you, and that you never get so engrossed in taking photos that you overlook potential threats to your safety.

▶ SPLIT SHOTS

For photos in which the top half of the frame is above the water, shoot in calm, clear water using a dome housing (see p.175). Use a wide-angle setting, and a small aperture to create a wide depth of field. Take your exposure from the top half of the image but focus on your underwater subject.

HALF AND HALF

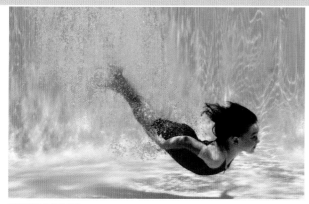

FAMILY ACTION

CLOSE-UP DETAIL

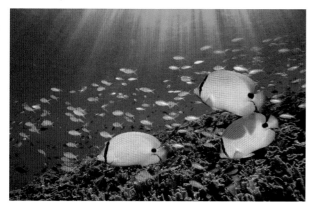

SUNLIGHT AND FLASH

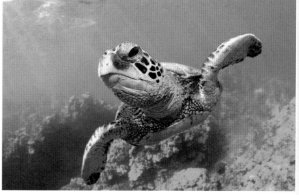

FACE TO FACE

Midsummer

flowers in full bloom

cutting through **the ocean waves**

sapphire skies and swimming pools

splashing about

Clouds come **floating** into my life,
no longer to carry rain or usher storm,
but to add **color** to my **sunset sky**

Rabindranath Tagore

exploring **new horizons**

Watersports

In the summer months, watersports enthusiasts head for the beach to pursue their passion. Whether or not you're taking part, the subject offers the opportunity to capture some really high-energy, high-impact shots. If you're going out on the water it's a good idea to use a waterproof camera or casing. Take plenty of shots before, during, and after the action.

FOR THIS SHOT

For images like this, you'll need to get onto the water yourself, either on a boat or an inflatable.

1 **Water droplets**
Although splashes on the lens are usually to be avoided, here they convey a feeling of being right in the middle of the action.

2 **Lens flare**
Shooting into the sun has resulted in a bright burst of lens flare that reinforces the exuberant energy of the shot.

3 **Framing**
The framing imparts a sense of speed and movement, with the windsurfer entering the shot from one side and moving toward the center.

CAMERA MODE

 Select **Sports** mode or **Aperture Priority** and an aperture of f/8

SENSOR/FILM SPEED

 Use a **high ISO** setting (e.g. ISO 1000)

LENS SETTING

 Zoom to **telephoto**

FLASH

 Shoot without **flash**

TRY THIS

Shooting watersports photos from beneath the waves creates a very different perspective. You'll need a bright day, clear water, and a camera that's waterproof to the required depth. Plan carefully so that you avoid coming into contact with your subject.

2

ALTERNATIVE APPROACHES

Your approach to shooting watersports will largely be determined by how involved—and how wet—you're willing to get. It's possible to shoot some events, sailing regattas for example, by zooming in from a distance—even from the shore. For others, however, you'll want to be close to the action. Remember that variety is key to creating interest, so try making more reflective images too.

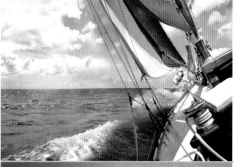

Shooting from the point of view of a crew member on a boat can yield some spectacular pictures. The drama will be enhanced if—regardless of the pitch of the boat—you keep the horizon level. A wide-angle setting will help you to capture all the action. In bright conditions, fill-in flash may be useful for reducing harsh shadows.

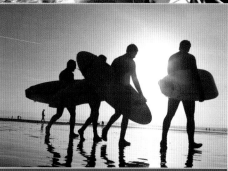

Watersports photography needn't be confined to moments of activity. The preparations, equipment, or reactions of spectators are all interesting alternative shots. This monochrome image, with the sun low in the sky, captures the quiet satisfaction experienced at the end of a successful day on the waves.

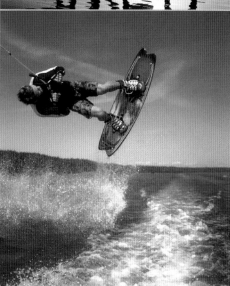

Position yourself on the back of a towing boat for some action-packed shots of waterskiers and wake boarders. Zoom in and pan the camera to follow your subject and keep him or her in sharp focus. Selecting a medium-to-high ISO sensitivity such as ISO 400 to 800, will also help reduce blur, allowing for shorter exposure times, which will retain sharpness in the churning water.

See also: On the move pp.86–87, People under water pp.174–75, On two wheels pp.188–89, Backlighting and silhouettes pp.204–05

Reflected city

The urban landscape is full of reflective surfaces, and each one offers an alternative view of what's in front of you. Spend some time actively seeking out reflections in glass, water, mirrors, and paintwork and you'll find endless new ways of getting more light, color, and depth into your photographs. Reflections interpret subjects in a way that's sometimes direct, often abstract, but always intriguing.

CAMERA MODE	LENS SETTING
Select **Landscape** mode or **Aperture Priority** and an aperture of f/8	Zoom to **moderate telephoto**

SENSOR/FILM SPEED	FLASH
Use a **low ISO** setting (e.g. ISO 100)	Shoot without **flash**

FOR THIS SHOT

Rivers are at the heart of many cities, offering the opportunity to depict buildings and landmarks in different ways. Here, a reflected view of a bridge and skyscrapers has been rotated, adding another surprising twist to the view.

1 Depth of field
A small aperture has been used to ensure that everything—from foreground ripples through to the building reflections—appears sharp.

2 Composition
When composing your image, experiment with different angles and vantage points and look for strong structural elements.

3 Distortion
Here, ripples become more pronounced toward the bridge, causing exaggerated distortions. Watch and wait for interesting patterns to emerge.

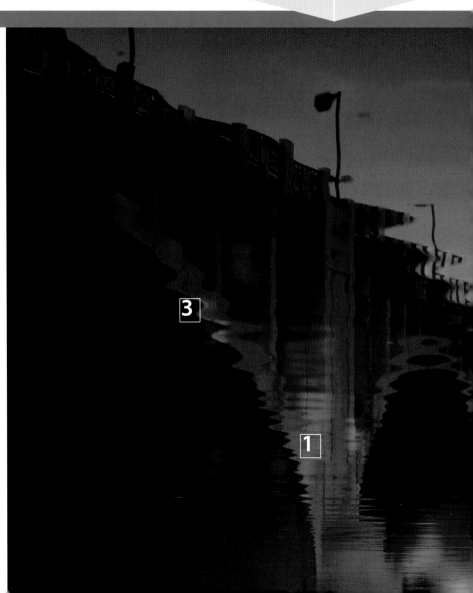

TAKE IT FURTHER
USING A LETTERBOX CROP

Images featuring multiple layers of reflections can sometimes be so complex that they're almost unintelligible. However, their abstract qualities can make beautiful images, and using a nonconventional format can be very effective. Here, a standard format photograph has been given a letterbox crop to concentrate attention on the overlapping reflections.

2

ALTERNATIVE APPROACHES

Look beyond major bodies of water for reflective surfaces that are common in cities. Glass, metal, and even puddles all reflect their surroundings in interesting ways.

The paintwork and glass of vehicles can produce reflections with radical distortions that follow the lines of the bodywork. Shoot from different angles to get the best effect from these distortions, but try to keep a wide depth of field.

Puddles produce reflections that are semitransparent, so it's often possible to glimpse the texture of the ground beneath. Use a puddle's broken edges as a quirky compositional device.

For bold, graphic images capture reflections in glass-clad buildings. The flat surface produces a faithful reflection of the sky but imprints its own texture and form. The even proportion of sky and building gives this image balance.

See also: Modern architecture pp.74–75, Street photography pp.160–61, Modern interiors pp.220–21, Abstract lights pp.328–29

People at work

Skilled people at work are inspiring to watch and photograph. Your subjects will be relaxed in their everyday environment and engaged in an activity that reveals something of their working lives and their personalities. Portraits of this type can vary from posed character studies to informal, observational shots of people absorbed in their work or interacting with colleagues or customers.

CAMERA MODE	LENS SETTING
Select **Portrait** mode or **Aperture Priority** and an aperture of f/5.6	Zoom to **moderate telephoto**

SENSOR/FILM SPEED	FLASH
Use a **medium ISO** setting (e.g. ISO 400)	Shoot without **flash**

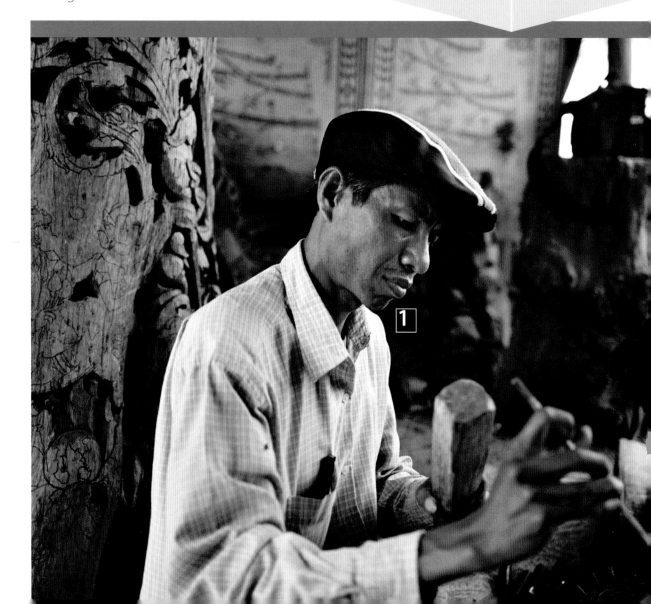

TRY THIS

In modern office environments there are opportunities to capture workers in unexpected ways. Here, glass obscures the faces of the subjects so their body language becomes the focus of the picture.

ALTERNATIVE APPROACHES

A candid approach is perfect for capturing, reportage style, the way people work. If you know, or get to know, the people you're interested in photographing, you may have a chance to experiment with more posed portraits, too.

Look for unusual ways to photograph people at work, even if they're not directly visible. Tools of the trade, clothing, and the subject's pose all provide clues about their work. With a little encouragement, some workers may be willing to help you craft a more intriguing image.

Don't shy away from asking people's permission to photograph them. For posed pictures with a natural feel, engage your subject in conversation, building a rapport before you start.

FOR THIS SHOT

Artisan workshops that are open to the public provide a wonderful opportunity to get close to craftspeople engrossed in their labors.

1 Approach
Think carefully about how you wish to portray your subject. Here, the composition hints at the nature of the work, but the artisan's expression of intense concentration takes precedence.

2 Available light
Lighting conditions in the workplace are often crucial to the atmosphere, so try to resist using flash, if possible. You may need to underexpose in dark settings and increase ISO sensitivity.

3 Be discreet
In this type of environment people are used to being photographed, so take time to compose your shot—but show respect and try not to get in the way.

If you get up early you may capture spontaneous images of workers going about their business while most people are still in bed. Make use of the morning light to imbue ordinary scenes with atmosphere and give a sense of the early hour.

See also: Character portraits pp.82–83, Working the land pp.130–31, Travel portraits pp.168–69, Picture composition pp.260–61

On two wheels

Whether you're a cyclist or simply a spectator, cycling offers lots of opportunities for dynamic action shots. You can experiment with exposure times to create motion blur, and with a little ingenuity make point-of-view shots from your own bike. But it's not only the activity itself that's of interest, bicycles are wonderfully photogenic machines—symbolic of freedom and progress and possessing an instantly recognizable silhouette.

CAMERA MODE	LENS SETTING
Select **Action/Sports** mode or **Shutter Priority** and an exposure time of 1/4 sec	Zoom to **moderate telephoto**

SENSOR/FILM SPEED	FLASH
Use a **low ISO** setting (e.g. ISO 100)	Shoot without **flash**

FOR THIS SHOT

This image captures the determination of the cyclist and the speed at which he's traveling. Motion blur in the background was created by panning with the cyclist at a relatively long exposure.

1 Exposure
Try shooting with different exposure times to achieve varying amounts of blur. Set an exposure of 1/4 sec as a starting point.

2 Focusing
Autofocus will struggle with a fast-moving subject, so set your camera to manual and prefocus on a point along the track. Press the shutter when the cyclist reaches that point.

3 Composition
It's difficult to compose an image while panning, so it may be best to crop the image later. Here, the cyclist is just entering the left third of the frame, suggesting that he's about to speed out of view.

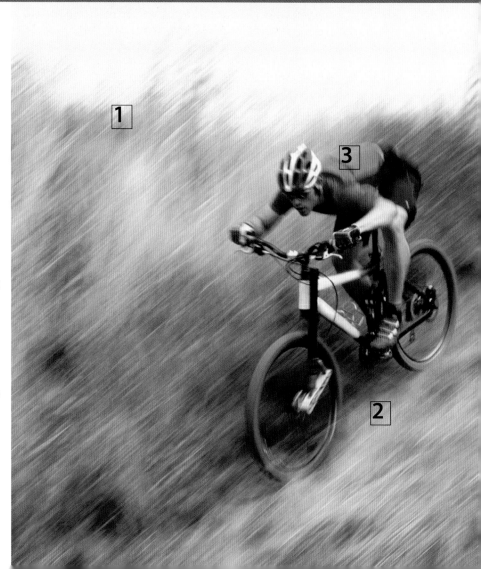

Strap your camera to your chest, your helmet, or even the frame of your bike for some impressive point-of-view shots. Wherever you mount the camera, wide-angle shots will work best as they'll feature more of the bike and the landscape sweeping past. For images like these, with both hands in the shots, you'll need to set your camera to the self-timer mode or use a remote control.

ALTERNATIVE APPROACHES

Bicycles make an interesting subject for more artistic images too. Try shooting them against a dramatic backdrop to create arresting images of their distinctive geometry.

Clear, sharp silhouettes have been created by setting the exposure for the glorious sunset. Shooting from a low angle and zooming in close produces a dynamic image that fills the frame.

Shot from above, the long shadows of the bicycles and their riders are the main subject of this picture. They form a graphic contrast with the strong horizontals in the picture—the railings and their shadow, the edge of the sidewalk, and the road markings.

See also: On the move pp.86–87, Watersports pp.182–83, Outdoor sports pp.298–99, Exposure pp.316–17, Winter sports pp.330–31

Flowers in close-up

Gorgeous pictures of flowers in full bloom are richly evocative of summer. For close-ups, you'll need a tripod and you can use the self-timer on your camera to further reduce the risk of camera movement. Pick a still day and, if possible, shoot while the sky is overcast, as very bright light washes out even the most vibrant colors. It's generally best to look for an uncluttered background, so it doesn't compete with your main subject.

CAMERA MODE	LENS SETTING
Select **Macro** mode or **Aperture Priority** and an aperture of f/8	Zoom to **moderate telephoto**

SENSOR/FILM SPEED	FLASH
Use a **low ISO** setting (e.g. ISO 100)	Shoot without **flash**

FOR THIS SHOT

A close-up, partial shot of a sunflower draws attention to the variation in colors and texture in the flower head.

1 Lighting
Position yourself so the light is coming from behind the flower, bringing out the color in the translucent petals and highlighting the fine hairs on the flower's bract and leaves.

2 Depth of field
Macro settings provide a very limited depth of field. Shoot from the side to get more of the characteristic parts of the flower in focus.

3 Picture quality
Choose a flower with no visible damage (unless that's the look you're after). Choose a low ISO setting and medium aperture to get the sharpest image and best color reproduction.

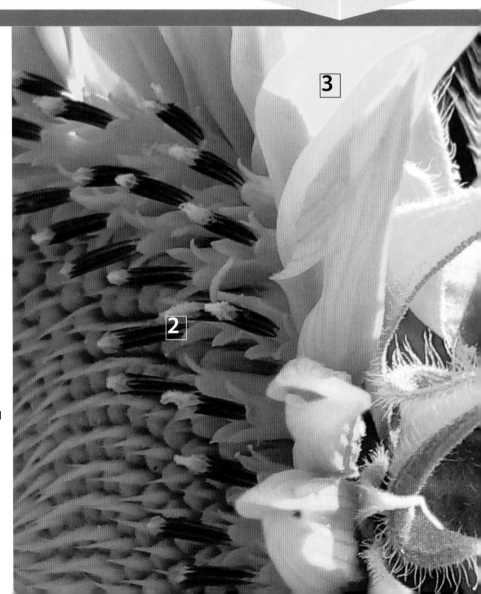

ON YOUR PHONE
APPLYING COLOR TINTS

Make your camera phone photographs of flowers in black and white, then explore apps that apply a tint to your images. Use discretion though: as with most special effects, tinting is most effective when used sparingly.

ALTERNATIVE APPROACHES

As with all portraits, it pays to think about how best to capture the essence of your subject. Flowers have a diverse range of characteristics—from showy to simple, gaudy to delicate, sturdy to fragile—so consider different approaches to suit the type of flower you're photographing.

Very strong elements of symmetry and repeating patterns have been captured in this image, which would not have been apparent from another angle.

Try shooting in black and white in order to place emphasis on the beautiful shape of flower petals. This works especially well with soft light and low contrast.

Instead of throwing a distracting natural background out of focus, try shooting flowers against a white backdrop. Use a sheet of white paper and experiment with angle to avoid shadows.

See also: In the winter garden pp.30–31, Close-up and macro pp.92–93, Flower fields pp.110–11, Spring blossom pp.118–19

Crop fields

An understanding of the way that lines lead the eye through a scene is important for any photographer. The summer landscape is full of lines formed by crop fields reaching maturity. For farmers, planting in orderly rows is a method of crop management. For photographers, these characteristic landscapes offer endless opportunities to experiment with composition.

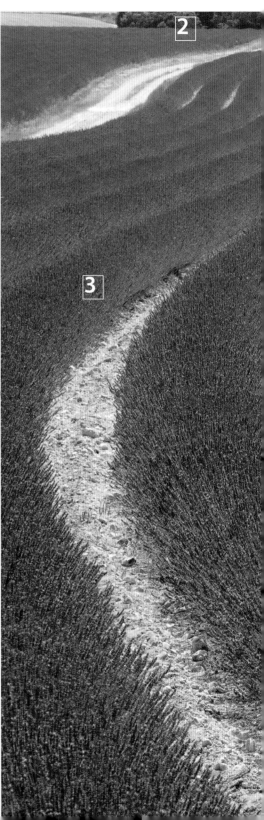

FOR THIS SHOT

Lavender fields, with their rounded contours and gorgeous colors, are perennially popular subjects, so it's well worth spending some time searching for a really stunning view.

 Framing
Here, the sweeping curves begin in the corner of the frame and lead the eye into the scene. The contrast between the lavender and the baked earth enhances the sense of movement.

 Horizon
Including even a tiny sliver of the view beyond the field gives a sense of scale and proportion.

 Depth of field
Using a small aperture for an extensive depth of field ensures that the whole scene appears sharp.

CAMERA MODE

Select **Landscape** mode or **Aperture Priority** and an aperture of f/16

SENSOR/FILM SPEED

Use a **low ISO** setting (e.g. ISO 100)

LENS SETTING

Zoom to **moderate telephoto**

FLASH

Shoot without **flash**

TRY THIS

In summer the low evening sun lights the tips of crops, leaving the rest in shadow. This enhances contrast and makes colors more vibrant. Allow a little lens flare into the scene to accentuate the golden light bathing the hills in the background.

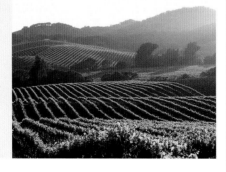

1

ALTERNATIVE APPROACHES

The regularity of crop lines always draws attention as they cross the rural landscape and their geometric patterns and block colors can be used to create unusual, almost abstract images. As well as images of converging lines stretching to the horizon, look for other strong, graphic compositions.

Position yourself so the landscape is being lit from the side. Strong side-lighting increases the contrast between the crop lines and the separating furrows, producing a bolder composition than would be achieved with backlighting.

Horizontal line compositions can have just as much impact as diagonal or converging lines. Use these lines to divide your photo into distinct sections. This image of managed sugar cane crops has the appearance of being split into four parts—the blue sky, new and old leaf growth, and the striped stems.

Tight framing on field boundaries can turn an agricultural landscape into something more abstract, making shape and color predominate. Zooming in flattens space and gives the impression that all areas of the picture are on the same (or a similar) plane.

See also: Depth of field pp.120–21, Lush greenery pp.138–39, Barren landscapes pp.228–29, Using color pp.232–33, In the forest pp.270–71

Pets in action

Pictures of pets in action are all about capturing a moment of spontaneity, so you'll need to use your knowledge of your pet's habits and character to anticipate promising photo opportunities. Their single-minded enthusiasm for whatever they're doing will provide you with a constant supply of energetic, action-filled images that capture their playful nature.

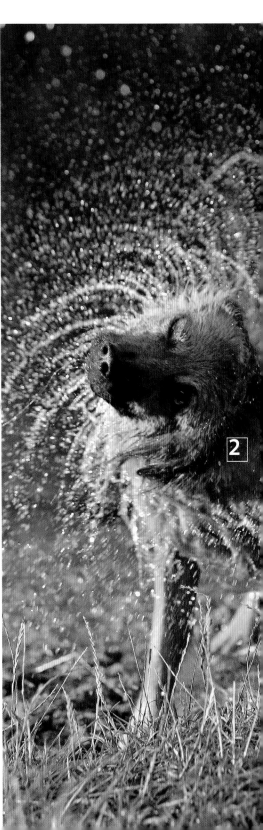

FOR THIS SHOT

The classic shot of a dog shaking itself dry is quite tricky to achieve. Take as many pictures as you can and if your camera has multi-shot mode, use that.

 Freeze the action
To capture a fleeting moment, use a short exposure time (1/500 sec or less) to freeze the droplets of water.

 Zoom in
For maximum impact, zoom in to fill the frame with the dog and the swirling water.

 Lighting
To make the water droplets sparkle, shoot the subject in sunlight. A dark background will make them stand out.

CAMERA MODE

Select **Portrait** mode or **Shutter Priority** and an exposure time of 1/500 sec

SENSOR/FILM SPEED

Use a **medium ISO** setting (e.g. ISO 400)

LENS SETTING

Zoom to **moderate telephoto**

FLASH

Shoot without **flash**

TRY THIS

A dog leaping high into the air to catch a ball, stick, or Frisbee, can make a memorable image. Shooting upward, from a position on the ground, makes the leap look more impressive. If possible, prefocus manually.

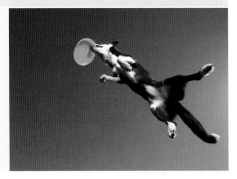

ALTERNATIVE APPROACHES

Some pets are happy to perform while you photograph them. Others may be more lazy, and so you'll need to encourage them into action with a favorite treat or a toy. As with any portrait, think about framing and background as well as the animal's pose.

For pictures that communicate an intimate sense of your pet's world, get down to their level and go close up, keeping as wide an angle as possible. For a shot like this, get someone else to amuse them so you can concentrate on framing.

Capture an image of your pet running directly toward you by prefocusing your camera and setting a wide aperture to provide a shallow depth of field. Increase the chances of a perfectly focused and framed shot by using your camera's burst (or multi-shot) mode, if it has one.

Puppies and kittens—and other pets too—enjoy fighting. Although this fighting is usually playful, there is a single-minded intensity to it that makes it the perfect subject for shots like this. The animals will be so absorbed with their activity, they'll be completely oblivious to you and your camera.

There is a humorous energy to the spectacle of a rodent running in its wheel. Photograph it at roughly 1/30 sec and you'll get a sharp shot of the rodent, but the wheel itself will be just a blur.

See also: Pets in snow pp.28–29, At the animal park pp.80–81, Equine portraits pp.104–05, Cats and dogs pp.136–37

Camping vacations

While a camping vacation offers an excellent chance to take some traditional landscape photographs, you can capture more quirky pictures with a strong human interest by turning your focus on the trip itself. Shots of your fellow vacationers interacting with nature can showcase the fun and freedom of a camping trip. Tailor your exposure settings to accommodate the inevitable variations in natural light you'll experience.

CAMERA MODE	LENS SETTING
Select **Landscape** mode or **Aperture Priority** and an aperture of f/8	Zoom to **maximum wide angle**
SENSOR/FILM SPEED	FLASH
Use a **low ISO** setting (e.g. ISO 100)	Shoot without **flash**

FOR THIS SHOT

The unforced vibrancy of this image seems to epitomize the essence of a camping trip. Shooting through the tent directly into the sun produces a glowing, highly atmospheric image.

1 Wide angle
Zoom out to the widest angle possible to include as much of the immediate surroundings—here the tent and the friends looking out—as you can.

2 Composition
Be creative with your composition. Having two subjects face away from the camera helps with the framing and draws the viewer into the image.

3 Exposure
If you're shooting into bright light, overexposing by 1 stop will retain the detail in your subjects, and prevent them from appearing as silhouettes.

TRY THIS

Tell the story of your trip by documenting all its events and details, even those you might not regard as particularly photogenic. The fun of cooking outdoors—whatever the weather—is a key aspect of the camping experience so take the opportunity to create some images that are evocative of the everyday, but equally significant moments.

ALTERNATIVE APPROACHES

Make the most of time spent outdoors to explore the interaction between people and the natural world—the time of day, the environment, and the weather.

Shooting at dusk allows you to make the most of the play between light and dark. For best effects, set your white balance for the ambient light which is bluish, making the artificial light in the tent more red.

Shooting a hike from ground level puts you and your camera in the heart of the adventure. It can also make ascents appear more dramatic. Use a small aperture setting to obtain a large depth of field.

Take a break from helping to set up camp to take photographs of the process. Make the shot as wide as you can to include as much of the landscape as possible. In this image, shooting from a low angle has captured the maximum amount of sky and tent.

See also: Family days out pp.112–13, Children outdoors pp.126–27, Eating al fresco pp.154–55, Music festivals pp.224–25

Pictures from a plane

The views from the window of a plane can be breathtaking, so next time you book a flight try to get a window seat and take advantage of the chance to make some stunning and unusual pictures. To achieve the best shots, make sure your window is clean and, if possible, reserve a seat toward the nose of the plane in front of the engine to avoid the jet stream.

FOR THIS SHOT

Including glimpses of the plane, such as a wing or window, gives context to the shot and can be used to frame the expanse of sky.

 Depth of field
Select a small aperture to ensure that everything in the image, from the window frame in the foreground to the distant clouds, appear sharp.

 Focus
Shooting through multiple layers of a window can cause problems for your autofocus system, so make sure you focus on an area of high contrast.

 Exposure
To ensure that you retain detail in the clouds and capture the rich color of the sky, you might need to underexpose by up to 1 stop.

CAMERA MODE

 Select **Portrait** mode or **Aperture Priority** and an aperture of f/16

SENSOR/FILM SPEED

Use a **medium ISO** setting (e.g. ISO 400)

LENS SETTING

Zoom to **moderate wide angle**

FLASH

Shoot without **flash**

ON YOUR PHONE
LANDING LIGHTS

From the air at night, airports—and the cities they serve—look like carpets of multicolored lights. As you come in to land, use a long exposure app to record the landscape below as a chaotic tangle of light trails.

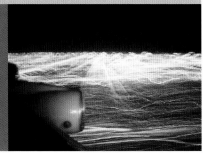

1

ALTERNATIVE APPROACHES

Watch the sky throughout your flight and you'll see a variety of magical cloudscapes. As the lighting conditions change, you'll also be rewarded with a view of gorgeous shifting colors. Clear skies provide an opportunity for bird's-eye view images of the landscape below.

A low sun, partially illuminating the cloud layer in a darkening sky, is an impressive sight. Ice crystals forming on multilayer aircraft windows can cause the light to scatter, creating a radiant sunburst effect like this.

You can make a portrait of the plane you're traveling in by catching its shadow as it passes over the landscape below. Keep a look out for an area of ground that will make an effective canvas for the shadow of the plane—an expanse of a single, relatively light color is ideal.

Summer in the tropics is the perfect time of year for capturing dappled clouds like these, and the well-defined shadows they cast on the landscape. If you experience increased vibration as you come in to land, stabilize your camera by resting your little fingers on the window.

See also: Changing skies pp.106–07, Mountain scenery pp.162–63, Glorious sunsets pp.250–51, Picture composition pp.260–61

At the poolside

Swimming pools should be a perfect backdrop for lively vacation pictures that capture the happy atmosphere of carefree days in the sun. Successful poolside photos strike a balance between the satisfying composition of a posed shot and the informality and energy of a candid picture. In addition to pictures of your vacation companions, experiment with making images of the way the light interplays with the water.

CAMERA MODE	LENS SETTING
Select **Sports** mode or **Shutter Priority** set to 1/125 sec	Zoom to **moderate wide angle**

SENSOR/FILM SPEED	FLASH
Use a **low ISO** setting (e.g. ISO 100)	Try shots with and without **fill-in flash**

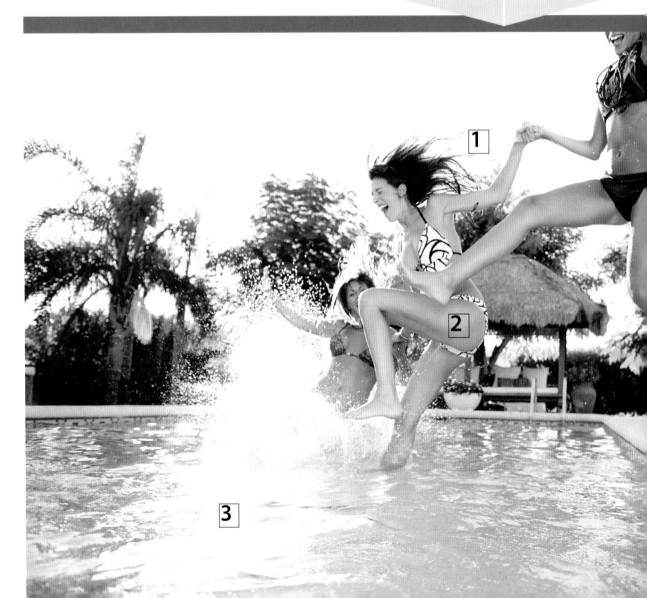

1

2

3

TRY THIS

In an empty, still pool the light and shadow from underwater lighting can be used to create striking abstract images. Use a high ISO setting for hand-held shots that allow you to move freely to experiment with angles and framing.

FOR THIS SHOT

This pool photo is partly staged; the subjects are prompted into action by the photographer but the result is spontaneous and fun.

1 Freezing the action
To freeze the action and ensure the whole image appears sharp, use a short exposure time (1/500 sec).

2 Fill-in flash
Set your camera's flash to fill-in mode. This will give sufficient flash to illuminate the subjects and stop them appearing in shadow.

3 Exposure
When shooting into the sun, increase the aperture by 1 stop to prevent the foreground from being underexposed.

ALTERNATIVE APPROACHES

As well as a backdrop for portraits and action shots of family and friends enjoying themselves, the swimming pool can be used as a location for more atmospheric or artistic shots. Although pools are at their busiest during the day, don't neglect the evening—an illuminated pool is a good subject for more tranquil images.

A portrait in which the subject looks directly at the camera can be given a dynamic twist by photographing the subject as they burst through the surface of the water. Zoom in to fill the frame, prefocusing if necessary.

An artificially lit pool provides an opportunity for unusual portraits, such as this silhouette. Use a medium ISO setting (around 400) and set the exposure for the bright water. Rest your camera on a poolside table to allow for the longer exposure time required.

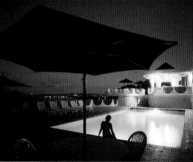

Poolside photos can capture the vacation atmosphere, even if they don't feature people. A simple still-life shot—such as these flip-flops at the edge of a pool—provides a relaxed contrast to other more energetic shots.

See also: People under water pp.174–75, Watersports pp.182–83, Vacation portraits pp.212–13, On the beach pp.214–15,

Silhouettes

Shooting silhouettes is a simple way to create strikingly graphic images. The contrast of dark and light focuses attention on the subject's form, rather than on any detail, and can be used to convey an atmosphere of mystery and drama. The basic method for shooting silhouettes is straightforward—place your subject in front of a light source, on which you base the exposure, while making sure that the subject is not directly lit.

CAMERA MODE	LENS SETTING
Select **Landscape** mode or **Aperture Priority** and an aperture of f/2.8	Zoom to **moderate wide angle**

SENSOR/FILM SPEED	FLASH
Use a **low ISO** setting (e.g. ISO 100)	Shoot without **flash**

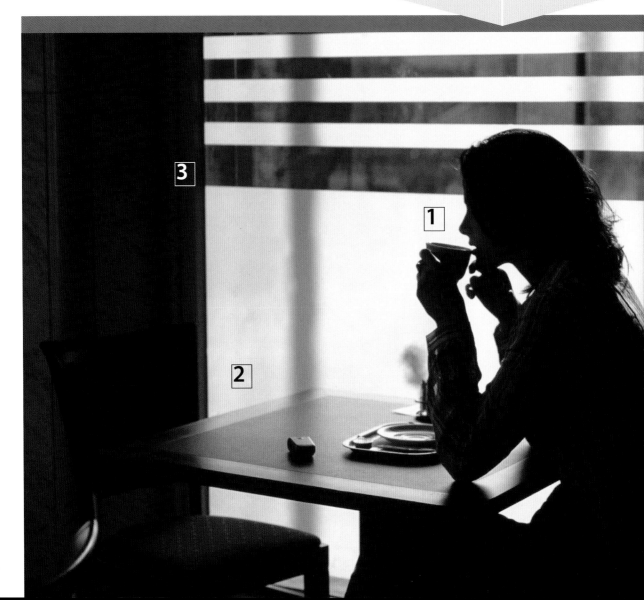

TRY THIS

Silhouettes can be used to create very bold compositions. Here, the woman is framed within the concentric partial silhouettes of two giant pipes. Your eye is drawn to her because she has been positioned at the brightest point where the sun has just set.

FOR THIS SHOT

The contemplative mood of this woman sipping coffee in front of a frosted, backlit window is conveyed more convincingly by a silhouette than it would have been in a more conventional portrait.

1 Subject
Choose a subject that has a strong, recognizable shape—one that doesn't depend on color or texture to make it work.

2 Lighting
Turn off your camera's flash if it's likely to trigger automatically when presented with a dark scene. Expose the shot for the bright background.

3 Composition
Look for framing devices that add interest and structure to the shot without detracting from the main subject.

ALTERNATIVE APPROACHES

The most successful photographs of silhouettes tend either to feature simple shapes set against colorful or detailed backgrounds, or more complex silhouettes placed against plain backgrounds. Try experimenting with both.

A bright scene, rather than a plain source of light, can form the backdrop to a simple silhouette. For an unusual scene like this, use a small aperture, such as f/16, to keep both the silhouette and background sharp. Use a wider aperture, such as f/8, if you just want the background sharp.

Sheer fabrics don't create true silhouettes, as light diffracts around the fine strands of the fabric and carries their color with it. For a romantic, ethereal image, drape sheer fabric around a silhouetted figure to soften the outline and add a hint of color.

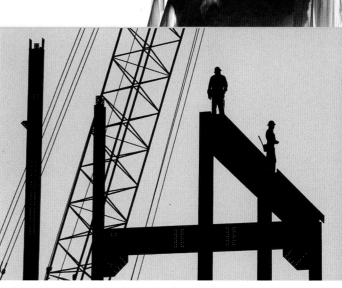

This construction site has been turned into a silhouette by taking exposure from the bright sky. The result is a highly graphic, two-tone image in which dramatic geometric forms provide a counterpoint to the rather vulnerable-looking human figures.

See also: Wintry cityscapes pp.50–51, Street shadows pp.52–53, Backlighting and silhouettes pp.204–05, Café life pp.256–57

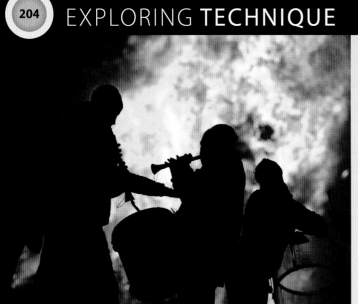

Backlighting and silhouettes

Backlighting offers many opportunities for lively interplay between subject, surroundings, and lighting in which you can exploit effects such as lens flare and internal reflections. The most challenging aspects of photographing backlit subjects are ensuring you have the correct exposure and controlling lens flare. To achieve good results, follow these simple guidelines and experiment freely.

▶ VISUAL IMPACT

Effective backlighting can result in shots that are full of drama, emotion, and impact. For example, whether you use natural or artificial light, it can give an attractive rim lighting effect to hair and profiles, bringing a light, delicate touch to portraits. Backlighting can also be used to boost the color of translucent objects, such as leaves and petals, while effective use of lens flare can really transform your images. By taking it further and creating silhouettes, you can accentuate the shape and outline of a subject and set it against a colorful or moody background.

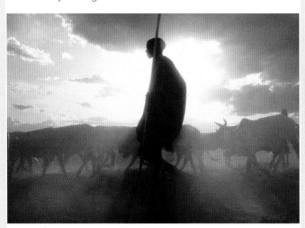

BACKLIGHTING ENHANCES MOOD

▶ CORRECT EXPOSURE

Shooting backlit subjects requires very precise metering to achieve the required exposure. If you use your camera's default meter settings, there's a good chance that your main subject will be underexposed. To lighten your subject, and to bring out details and colors, you'll need to increase the exposure by extending the exposure time or opening the lens aperture. Set your camera to Backlighting, if available, or take the exposure from the shadow side of your subject. To avoid a washed-out background, try to compose the shot without lots of bright sky.

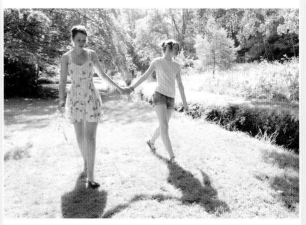

CORRECTLY EXPOSED SUBJECTS

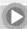 SHOOTING SILHOUETTES

Silhouettes turn conventional photo composition on its head. The aim is to make the foreground subjects as dark as possible while keeping the background nicely exposed. To do this you need to expose for the bright background. If necessary, you can darken silhouettes and enhance colors by reducing the exposure by 1 stop or more.

Sunrise and sunset provide ideal conditions for shooting silhouettes, but any setting with a bright background will work. For best results you need to ensure that the foreground subjects and background work together and don't compete for attention.

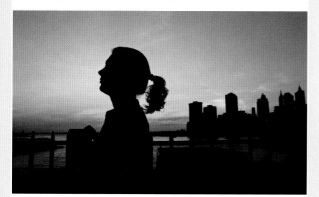

SILHOUETTE AT SUNSET

WORKING WITH LENS FLARE

Lens flare is created by non-image-forming light entering a lens and hitting the sensor. In photos it appears as bright circular or polygonal spots, streaks of light, or general haze. Conventionally, photographers have gone to great lengths to avoid, or at least minimize, lens flare. Using a lens hood or simply shading the lens with your hand can prevent it, as can careful positioning of your subject and your camera in relation to the light. But you can also use lens flare creatively. Spread evenly across an image it gives a soft dreamy look, or used more directly it can give a summery and sun-drenched feel.

SUN-DRENCHED FEEL

FILL-IN FLASH

Ensuring that backlit subjects are correctly exposed works up to a point, but there are situations when increasing the exposure completely burns out the background. The way around this is to use your camera's fill-in flash mode. This emits a modest flash, sufficient to light up shadowy areas but not strong enough to dominate. The exposure will be set for the background, so both the subject and background are well exposed.

WITHOUT FILL-IN FLASH

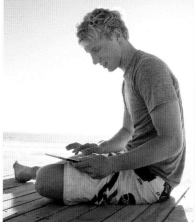

WITH FILL-IN FLASH

Late Summer

glinting and gleaming

> Whilst **August** yet wears her golden crown,
> Ripening fields **lush-bright** with promise;
> **Summer** waxes long, then wanes, quietly passing
> Her fading **green glory** on to riotous Autumn

Michelle L. Thieme

along the seashore

children at play

shimmering heat

lazy days outdoors

Fishing harbor

From small fleets of crabbers to bustling ports full of trawlers, fishing harbors are wonderful places to explore with your camera. As well as the colorful boats and crates of fish, there's masses of fascinating paraphernalia to photograph—winches, crab pots, coiled ropes, giant crates, tractors, and mounds of nets. Get to the harbor early in the morning to watch the boats head out to sea, or find out when the catch comes in.

CAMERA MODE	LENS SETTING
Select **Landscape** mode or **Aperture Priority** and an aperture of f/11	Zoom to **moderate wide angle**

SENSOR/FILM SPEED	FLASH
Use a **medium ISO** setting (e.g. ISO 400)	Shoot without **flash**

FOR THIS SHOT

Although devoid of people, this scene, shot from low on the quayside, is bursting with color and bristling with intriguing detail.

1 Timing
Shot very early in the morning, before the bustle begins, the harbor is a picture of tranquility as the early morning haze starts to lift and the sun breaks through.

2 Framing
The image is divided into three areas: the fishing gear in the foreground and the town in the background frame the fishing boats lined up in between.

3 Color contrasts
The composition makes the most of the contrast between the vivid oranges and reds of the fishing gear, the corresponding but muted tones of the buildings, and the blue of the sea and sky.

TRY THIS

Go to the dockside or the fish market to see what the fishermen have caught. Zoom in closely to create images with an abstract—almost surrealist—quality, or include the fishermen as they sort the gleaming fish in their baskets.

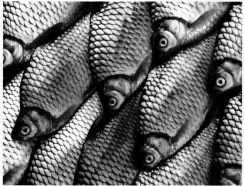

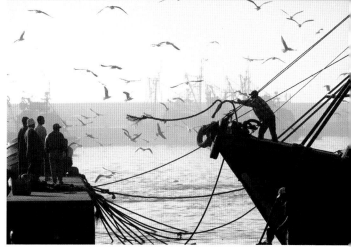

ALTERNATIVE APPROACHES

Look for where the fishermen store their nets, pots, and ropes, and experiment with some still life shots, or wait at the quayside to photograph the boats as they return.

Once you have found some interesting objects, study their patterns and texture. Try photographing them at different scales, with and without color contrasts. Keep your camera parallel to your subject so the pattern in the image is flat.

Try out some action shots. Here, shooting into hazy sunshine as a boat docks has desaturated the colors, making the fishermen, ropes, and the boat itself stand out in silhouette.

See also: Exploring textures pp.114–15, Seascapes pp.116–17, City river pp.242–43, Spirit of place pp.238–39, Shades of gray pp.254–55

Vacation portraits

A change of scenery provides many wonderful subjects for photography, but don't forget to take plenty of pictures of your companions. The juxtaposition of familiar faces with vacation locations gives you a constant stream of opportunities to create natural-looking portraits. These will animate the locations and reveal the personalities of your friends at their most relaxed and happy.

FOR THIS SHOT

Celebrating a successful climb, this charming portrait also manages to convey a strong sense of place.

1 Composition
Even with informal portraits, composition is still important. Positioning the girls off-center and on a diagonal is more interesting than a straight on, side-by-side shot.

2 Focus
Experiment with depth of field when shooting two people. Here, Portrait mode has been used to focus on the girl in the foreground.

3 Framing
Cropping in on your subjects creates a more dynamic picture. You only need to show enough background to give a flavor of the landscape.

CAMERA MODE

 Select **Portrait** mode or **Aperture Priority** and an aperture of f/4

SENSOR/FILM SPEED

 Use a **low ISO** setting (e.g. ISO 100)

LENS SETTING

 Zoom to **medium telephoto**

FLASH

 Shoot with **fill-in flash**

TAKE IT FURTHER
CHARACTER PORTRAIT

Shooting portraits in black and white, without the distraction of a colorful background, can focus attention on your subject's expression. If you want a warmer image, you can apply a tone using image manipulation software.

2

3

ALTERNATIVE APPROACHES

Most vacations are fun and informal, and your portraits should reflect this. Take a relaxed approach and let your subjects express themselves. Spontaneous shots are often the best for capturing the vacation atmosphere—you just have to watch and wait until the right moment presents itself.

When shooting into the sun, use fill-in flash to balance the backlighting in the scene and to prevent unattractive shadows. To achieve an evocative sunburst effect, position yourself so that your subject partly blocks the sun.

Try to evoke a sense of place in your vacation portraits, as well as your subject's personality. This shot catches the subject in pensive mood as he watches the sun set. Framing the shot so that he's off center shows more of the location, and allows you to follow his gaze to the sea.

A feeling of freedom is what vacations are all about. Take every opportunity to capture the laughter and sheer joy of time spent away from the constraints of work and everyday responsibilities. For many people, larking about in water is a big part of the vacation experience. For a shot like this, positioning yourself to face the sun will make the water droplets sparkle.

See also: Character portraits pp.82–83, Family days out pp.112–13, Travel portraits pp.168–69, Camping vacations pp.196–97, At the poolside pp.200–01, On the beach pp.214–15

On the beach

The beach—sun, sea, and golden sands—sums up many people's idea of the perfect vacation destination. It also provides a stunning backdrop for photography, not only for quick vacation snaps, but also for more considered compositions that make the most of the setting and gorgeous light. Experiment with different camera settings and the effects they create, but take great care not to get sand anywhere near your camera.

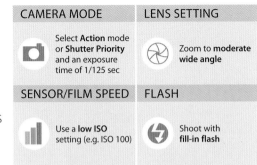

CAMERA MODE	LENS SETTING
Select **Action** mode or **Shutter Priority** and an exposure time of 1/125 sec	Zoom to **moderate wide angle**

SENSOR/FILM SPEED	FLASH
Use a **low ISO** setting (e.g. ISO 100)	Shoot with **fill-in flash**

FOR THIS SHOT

In this wonderfully atmospheric image of a busy beach at the end of the day, silhouettes stand out against the soft haze of a low sun.

1 Composition
The scene is divided into two horizontally. The people walking onto the beach and away from it create a sense of movement.

2 Exposure
Dramatic silhouettes have been created by exposing for the bright sky.

3 Perspective
Long shadows lead your eye from the soccer players in the foreground to the scene beyond. These and the lines formed by the beach and sea converge on the hills in the background.

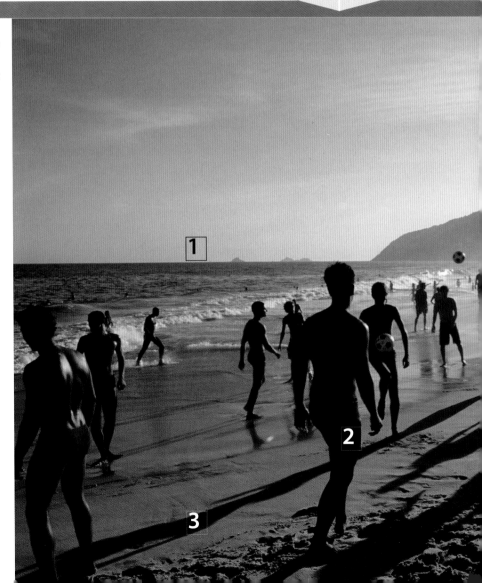

ON YOUR PHONE
USE VINTAGE EFFECTS

You may not want to take your camera to the beach, but you'll probably still have your camera phone. The beach is a good place to try the Hipstamatic app. Here, it picks up the blue and green tones of the sea and gives images a retro feel.

ALTERNATIVE APPROACHES

Although family snaps are great, documentary-style shots of scenes you observe on vacation can be just as evocative. Images of things you saw every day, or just glimpsed by chance, can bring the memories flooding back.

Take a picture of the view from your table while you're waiting for lunch. Including all the key elements in a single shot will give you rich, multilayered images. To achieve this effect, use a wide-angle lens setting and a small aperture to keep everything sharp.

Keep your camera close to you so you can take shots the moment something interesting catches your eye. Compose your image so that the frame is nicely balanced, then try bracketing your exposures to see what works best.

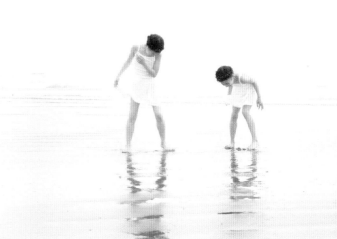

Experiment with your camera controls to capture the essence of a scene. Try generous extra exposure—1 1/2 stops or more—to heighten the sense of brilliant light and its reflections in the wet sand.

See also: On the move pp.86–87, Splash! pp.102–03, Silhouettes pp.202–03, Vacation portraits pp.212–13, Vacation postcards pp.218–19

Garden parties

Photographically, a garden is an excellent setting for a party: there's a lot of natural light, plenty of color, and a variety of background options. Also, people usually behave in a relaxed and spontaneous way when having fun outside and are likely to be ready with a smile. For images with an element of humor or surprise, take yourself out of the party to shoot candidly from the viewpoint of a detached observer.

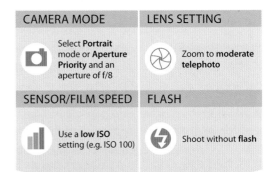

CAMERA MODE	LENS SETTING
Select **Portrait** mode or **Aperture Priority** and an aperture of f/8	Zoom to **moderate telephoto**

SENSOR/FILM SPEED	FLASH
Use a **low ISO** setting (e.g. ISO 100)	Shoot without **flash**

TRY THIS

Pictures of children at play sometimes fail to convey their energy. For a shot that captures lively rhythm and movement, find a raised vantage point, switch to Shutter Priority, and use an exposure time of 1/8 to 1/4 sec. Keep the camera as steady as possible.

ALTERNATIVE APPROACHES

From children's afternoon parties to more grown-up evening events, outdoor gatherings present a diverse range of photo opportunities. Vary styles, from conventional group shots to more abstract and unusual compositions.

Combine warm artificial lighting with the last natural light of the day. Keep your camera's white balance set to daylight and position your subjects so their faces are nicely lit.

FOR THIS SHOT

The image takes advantage of the layout of the garden—with its distinct sections—and successfully exploits changes in light conditions between different areas.

1 Exposure
All the action is at the rear of this scene. When you're shooting into brighter light from shade, set your exposure to the background, to prevent blown highlights.

2 Distance
To capture children at their least self-conscious, keep your distance and zoom in.

3 Framing
Use the landscape of the garden as a framework. Here, the expanse of foliage either side draws your eye to the toddler standing in a little oasis of light and color and the activity beyond.

For a more abstract group portrait, get down low and shoot the feet of people sitting around a table. The long shadows and warm highlights convey the lazy atmosphere of long summer days stretching into evening.

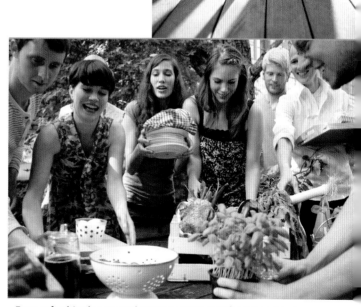

For a refreshingly unposed group portrait, wait for your subjects to move together naturally. The moment when the food is served is a good time to capture relaxed, informal pictures.

See also: Birthday parties pp.108–09, Children outdoors pp.126–27, Eating al fresco pp.154–55, Café life pp.256–57

Vacation postcards

There are many types of vacation photograph—from portraits of locals and the atmospheric images that say something about your own experience of the location, to snapshots of your companions enjoying themselves or posing by famous landmarks. Postcard shots, however, are slightly different—they need to rise above the purely personal and carry a much wider appeal.

FOR THIS SHOT

This photograph captures all that's best about a beach first thing in the morning—from the absence of people to the pristine sand and beautiful light.

1 Composition
Symmetrical compositions almost always produce strong images—here, the two boats mirror each other on either side of the jetty.

2 Depth of field
Ensure the most extensive depth of field by selecting a small aperture (f/16 or f/22) and focusing on a point in the middle distance.

3 Color saturation
To make the most of the scene's rich colors select a low ISO setting, for example ISO 50 or ISO 100.

CAMERA MODE

Select **Landscape** mode or **Aperture Priority** and an aperture of f/11

SENSOR/FILM SPEED

Use a **low ISO** setting (e.g. ISO 100)

LENS SETTING

Zoom to **maximum wide angle**

FLASH

Shoot without **flash**

TRY THIS

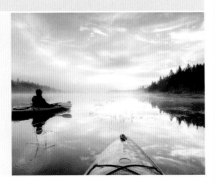

In this point-of-view shot, the beautiful light and gauzy clouds reflected in the lake perfectly capture the feel of a languid day spent on the water. Shooting into the sun has thrown the occupant of the other boat into silhouette, making the image less personal and giving it a wider appeal.

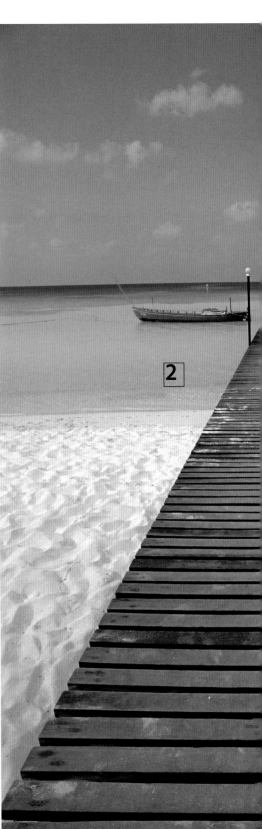

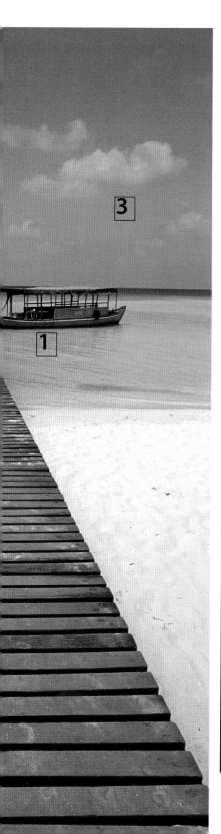

3

1

ALTERNATIVE APPROACHES

Postcard pictures are simply about recording in the best way possible the distinctive and representative aspects of your vacation destination. Look beyond conventional landscape shots and seek out other idiosyncratic images, from vernacular art to iconic modes of transportation.

Dramatic landscapes usually present so many photographic opportunities that it becomes difficult to decide what to zero in on. Take a moment to look carefully at the scene, assessing alternative shooting positions and using your camera's zoom to find the most striking framing.

Bright colors assume added vibrancy under clear blue skies, while juxtaposing primary colors creates images with a strong, graphic quality. Here, the identity of the vibrant red objects—some safety flags stacked on the beach—isn't immediately obvious, encouraging the viewer to spend time studying the image.

Make the most of the weather—good or bad. Mist or rain can be turned to your advantage to create moody, evocative shots that show a different side of your location. These views can sometimes say more about your destination than those taken in brighter conditions.

See also: Travel portraits pp.168–69, Fishing harbors pp.210–11, On the beach pp.214–15, Heritage architecture pp.258–59

Modern interiors

The interiors of many contemporary buildings are as dramatic as stage sets, making them excellent subjects for creative interpretation. Unlike traditional interiors, which generally demand a more classic approach, modern interiors can be used to make striking images that exploit extreme angles and perspectives. Try to convey the use of space, light, and unusual materials in your photos.

CAMERA MODE	LENS SETTING
Select **Landscape** mode or **Aperture Priority** and an aperture of f/16	Zoom to **maximum wide angle**

SENSOR/FILM SPEED	FLASH
Use a **low ISO** setting (e.g. ISO 100)	Shoot without **flash**

FOR THIS SHOT

This contemporary interior combines matte and polished surfaces with a palette of neutral and warm tones. The soft light has been filtered through translucent panels.

1 Composition
This composition is about exploiting the geometric shapes and reflections created by the space. Including the whole of a reflection creates balance.

2 Lighting
Use the available light wherever possible to preserve the mood. Using a flash gives a flat result and may not light the extremities of the space.

3 Depth of field
To make the most of the repeating lines and shapes in this image, the whole scene needs to appear sharp. Select a small aperture (f/16) and focus on the middle distance.

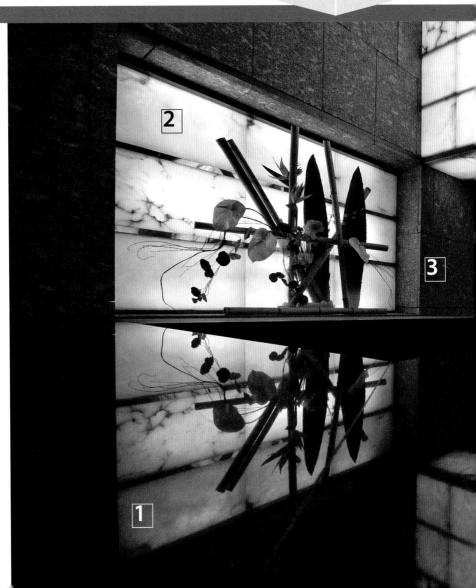

TRY THIS

An unusual perspective can completely reimagine elements of functional public buildings such as train stations or airport terminals. Here, the converging lines and series of reflections in the gap between two escalators are exploited to intriguing effect.

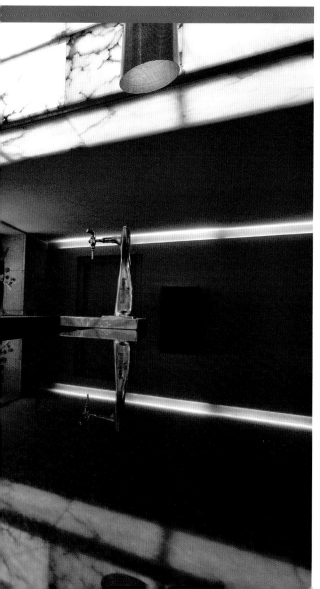

ALTERNATIVE APPROACHES

There are opportunities to photograph modern interiors all around, both in public buildings and private settings. Explore the scale of modern interiors—from the intimate to the grand, and look for the unusual textures of new materials, or for traditional materials used in novel ways.

Architects of modern interiors are adept at using color in new and exciting ways. Colored surfaces or lighting often define and differentiate spaces. In mixed lighting, set your camera's white balance to Auto, and underexpose strongly to intensify colors.

Modern construction techniques and materials give architects a free rein to create interiors that would have been impossible a few decades ago. Spend time investigating viewpoints to find the best way to communicate the dynamism and energy of the space.

Even the most prosaic of contemporary interiors, such as this sports center, can produce striking photographs when shot from an unusual angle. Create abstract images by concentrating on color and line and zoom in to crop out any distracting elements.

See also: Indoor abstracts pp.24–25, Modern architecture pp.74–75, Architectural details pp.78–79, Around the house pp.296–97

Dazzling sunlight

If you followed conventional wisdom you'd never venture out with your camera in bright sunlight. Direct sun creates harsh contrasts between highlights and shadows that tend to be unflattering, especially in portraits. However, while it can be problematic, you can make a virtue of strong contrasts and use these factors to your advantage to create some dramatic images.

FOR THIS SHOT

This image, shot in the blazing midday sun, makes good use of the strong light, which saturates the colors and makes the shadows deeper.

1 Exposure
To avoid blown highlights and washed out colors, expose for the mid-tones and recompose if necessary.

2 Shadows
Move around to find the best combination of light and shadow. Here the gates' shadows draw the eye through the gate toward the sea.

3 Shade your camera
Unless you want to include lens flare in your image, shoot from the shade if you can, or use your hand or a piece of paper to block the sun.

CAMERA MODE

 Select **Landscape** mode or **Aperture Priority** and an aperture of f/16

SENSOR/FILM SPEED

 Use a **low ISO** setting (e.g. ISO 100)

LENS SETTING

 Zoom to **wide angle**

FLASH

 Shoot without **flash**

TRY THIS

Use Macro mode to get some sun-filled close ups, such as this image of sparkling bubbles clinging to a slice of lemon in a cold drink. Get in really close so for an almost abstract look. To preserve the appearance of brilliant sunlight, overexpose by 1 stop.

ALTERNATIVE APPROACHES

Although many people avoid taking photographs in the midday sun, there are advantages to this approach if you're prepared to experiment and are looking for more unorthodox images. In hot climates atmospheric phenomena can also add to the effects you're able to achieve.

Rather than shading your camera from the sun, try shooting toward it and flood your image with sunlight. Here, shooting into the sun and through a window has produced a bold and dazzling portrait, full of refracted light and lens flare.

The heat of the midday sun can produce mirages, particularly over areas of tarmac and concrete, which heat up rapidly. They tend to appear in the middle and far distance, so zoom in. The watery illusion captured in this picture perfectly conveys the shimmering heat of a summer's day.

Bold, clearly defined shadows are characteristic of shots taken in bright sun. Explore ways of using them creatively. They can be seen like silhouettes, showing the shape of an object but not the detail.

See also: Street shadows pp.52–53, Vacation postcards pp.218–19, Barren landscapes pp.228–29, Glorious sunsets pp.250–51, Golden sunrise pp.322–23

Music festivals

Summer music festivals aren't just about listening to great music—the enthusiastic spectators, eclectic range of weird and wonderful activities, colorful tents, and even the litter all combine to create a vibrant, theatrical visual experience and a wealth of photo opportunities. Whether you're there to shoot the bands, the fans, or everything else that is going on, remember to stock up on memory cards and spare batteries before you leave.

CAMERA MODE	LENS SETTING
Select **Landscape** mode or **Aperture Priority** and an aperture of f/11	Zoom to **wide angle**

SENSOR/FILM SPEED	FLASH
Use a **medium ISO** setting (e.g. ISO 400)	Shoot without **flash**

FOR THIS SHOT

Tents are an integral part of the summer music festival. This image encapsulates the lively color and carnival atmosphere as fans wait for the shows to start.

1 Wide angle
When shooting from under a canopy, zoom to wide angle to fill the frame with both the scene beneath it and the view beyond.

2 Exposure
In high-contrast scenes, set your exposure to an area of moderate brightness, or take a reading from a shaded area. Increase exposure by 1 stop and recompose.

3 Lighting
Shield your lens from direct sunlight in order to retain the bright colors of the backlit hammocks and banners.

TRY THIS

The headline acts usually appear on stage after dark. You won't be able to get good close-ups of the bands unless you have a press pass or a super-zoom lens. Turn your camera's flash off—it won't successfully light the stage—and shoot using the ambient lighting. Zoom in for moderate close-ups or zoom out to include silhouettes of revelers dancing in the foreground.

ALTERNATIVE APPROACHES

The character of a festival is often best revealed away from the main stages and headline acts. For more quirky images, try turning your camera toward the festivalgoers.

Thousands of people tramping across wet grass transform the fields into seas of mud. This provides ample material for some humorous shots of classic festival attire—party and summer clothes combined with wellington boots.

Litter forms a significant part of the festival experience. This image is carefully framed to set the mounds of trash in the foreground against the carefree frolics of the festivalgoers behind.

For a spectacular view, get as close to the stage as possible, then turn your camera on the audience. Here, the light picks out the water bottles held up high. At night, you'd be more likely to see the winking lights of people's phones and cameras.

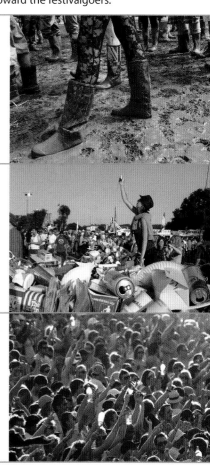

See also: Eating al fresco pp.154–55, At the carnival pp.158–59 Camping vacations pp.196–97, Marathon runners pp.246–47

On the tourist trail

If you find yourself swept along with a tide of tourists, it can be hard to take photographs of popular sites without the crowds. Why not try adopting an approach that's partly reportage, and explore the relationship between the tourists and the location, so that tourism itself becomes the subject of your shots? It's best to work discreetly and, when possible, ask permission before including people as the main focus of your images.

CAMERA MODE	LENS SETTING
Select **Landscape** mode or **Aperture Priority** and an aperture of f/8	Zoom to **extreme wide angle**

SENSOR/FILM SPEED	FLASH
Use a **medium to high ISO** setting (e.g. ISO 400 to 800)	Shoot without **flash**

FOR THIS SHOT

A grand spiral staircase makes a striking image in its own right, but it becomes even more interesting if you include tourists wending their way down it.

1 Wide angle
Set your lens to its widest setting to get the perspective that best enhances the spiral form.

2 Depth of field
To keep all the elements in the image sharp, choose a medium to high ISO setting that allows you to use a small aperture and short shutter time.

3 Lighting
When taking pictures like this inside a building, check that the source of light from above is strong enough. Oblique lighting tends to make the lower levels very heavily shaded, so detail will be lost.

TRY THIS

Popular sites are invariably awash with tourist souvenirs. Photographs that juxtapose these with the buildings or objects that they commemorate provide a witty comment on the tourist trade. Focus on the foreground and use a medium aperture (say f/5.6 or f/8). This blurs the landmarks in the background, but keeps them clearly recognizable.

1

ALTERNATIVE APPROACHES

Making your fellow travelers a key element of your pictures provides an interesting perspective on your trip. Look for new and intriguing ways to include both tourists and location.

A close-up of a visitor's sunglasses reflects the scene that he's looking at, creating an impression of the tourist experience. A wide-angle lens setting has been used close to the subject, with the focus locked on the reflected image.

If you're on a group trek, look for opportunities to shoot your fellow trekkers from unexpected angles. You can use them to emphasize a vertiginous climb or how far there still is to go. Use a wide-angle lens setting with the largest possible depth of field.

Groups of people sitting down for a leisurely lunch create an evocative scene. If the dappled light cast across this square makes it difficult to get the correct exposure, bracket your exposures and check later.

See also: Depth of field pp.120–21, Travel portraits pp.168–69, Spirit of place pp.238–39, Heritage architecture pp.258–59

Barren landscapes

The strong lines and contrasting colors and shapes of a barren landscape offer scope for creating bold compositions. But capturing the character of such a place can be tricky—there are few reference points and the conventional rules of composition don't apply. You'll need an eye for detail and the way that light—and shadows—can enhance an image.

FOR THIS SHOT

Landscapes like this have an expansive quality. Using a wide-angle setting enhances the effect of the baked earth stretching far into the distance.

1 Composition
Minimal landscapes are all about contrasts. Here the horizon divides the scene, emphasizing the differences between elements of the composition.

2 Focusing
To keep the view sharp throughout, select a small aperture (such as f/11) and focus on a point in the middle foreground.

3 Texture
A low camera angle and shadows from a low sun accentuate the texture of the dry lake bed.

CAMERA MODE

Select **Landscape** mode or **Aperture Priority** and an aperture of f/11

SENSOR/FILM SPEED

Use a **low ISO** setting (e.g. ISO 100)

LENS SETTING

Zoom to **maximum wide angle**

FLASH

Shoot without **flash**

TRY THIS

In barren landscapes, contrasts—such as these tiny flowers growing out of the parched earth—are exaggerated. The cracks in the ground can be used as a compositional aid, dividing the image into sections. When the light is too soft for a wider view, pictures that focus on detail are a useful alternative.

ALTERNATIVE APPROACHES

Although it's almost instinctive to do so, shooting landscapes by zooming out to wide-angle isn't always the best option. Sometimes it's better to zoom in and concentrate on one element of the scene. The inclusion of detail—an animal or plants and trees—can add interest and provide a sense of scale.

Zoom in close on the details in an otherwise featureless landscape, while remembering to keep an eye on the composition as a whole. Here, keeping the animals in the lower half of the frame helps to emphasize the stark expanse of the scene behind them.

Using the branches of a tree to frame another similar tree creates a slightly surreal feeling, in keeping with the otherworldly landscape. Pay careful attention to the background. Here, the shot has been composed in such a way that the background is divided into three distinct blocks of color.

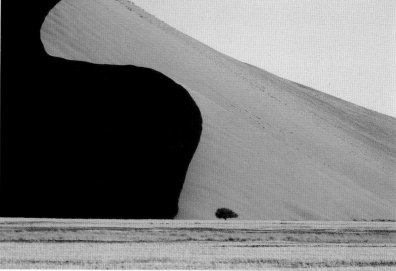

It can be hard to determine scale in a desert landscape. Use easily identifiable objects, such as the tree here, to give a sense of size. Exploit the harsh, directional lighting to create dramatic shapes from shadows.

See also: *Exploring textures pp.114–15, Depth of field pp.120–21, Dazzling sunlight pp.222–23, Picture composition pp.260–61*

Street signs

An intrinsic part of the urban experience, street signs not only serve a practical purpose, some are design icons in their own right. Next time you're out with your camera look at the signage around you from a pictorial perspective, paying attention to its particular aesthetic as well as its relationship with the surrounding urban architecture.

FOR THIS SHOT

A sign for a world-famous street is the perfect scene-setter for a set of vacation photos. Thanks to the angle and framing this image also stands on its own merits.

 Composition
Setting the building and the signpost at a skewed angle imparts a giddy dynamism that reflects the vibrant character of a major city.

 Framing
The building in the background completely fills the frame. This emphasizes the imposing urban feel and the scale of the buildings.

 Positioning
For an image that shows height and grand scale, get in close, set your lens wide, and shoot upward.

CAMERA MODE

Select **Landscape** mode or **Aperture Priority** and an aperture of f/16

SENSOR/FILM SPEED

Use a **low ISO** setting (eg. ISO 100)

LENS SETTING

Zoom to **moderate wide angle**

FLASH

Shoot without **flash**

TRY THIS

The bold shapes, clean lines, and highly contrasting tones and colors of street signage make them a striking subject for a set of themed images. Underexpose and boost saturation for best effects.

ALTERNATIVE APPROACHES

Photographers tend to regard excessive signage as a curse, blocking or adversely affecting views of historic or interesting buildings, and generally cluttering the place up. However, looked at another way, they contribute to, and in some ways define the character of a modern metropolis.

The strip of bold curbside markings that divides this image in two provides a strong repeating pattern of rectangles that's echoed in the rectangular shapes of the road, the bench, and, particularly, the railings. An exposure taken from the gray tones on the wall ensures that the white areas are not burned out.

Straight streets with regular intersections are bristling with signage. Here, the vertical shop signs with the horizontal lights and road signs suspended against the neutral background of the sky make a strong composition. A small aperture has produced a large depth of field, and the lens was set to a moderate zoom.

You don't necessarily have to include street signs themselves to make eye-catching images. The shadows they produce are unmistakable and can make an interesting foil for less formal street features, such as posters or graffiti. Here a slight underexposure has darkened the shadow and deepened the colors.

See also: City lights pp.62–63; Architectural details pp.78–79, Street photography pp.160–61, Café life pp.256–57, Picture composition pp.260–61

Using color

Color is an integral part of our experience of a picture, helping to determine the emotional content of the scene. You can use color as a compositional tool by separating it from the subject matter and treating it as a form of communication in its own right. By using a particular color scheme you can establish the entire mood of a shot, while you can combine contrasting and complementary colors to create feelings of dynamism or harmony, or imply relationships between subject elements.

▶ THE COLOR WHEEL

A color wheel like this clearly shows the way different hues and saturations relate to each other. Colors toward the edge are more saturated—have the most vibrant color—and those in the middle are less so.

This arrangement of colors is useful because it reveals that the relationship between colors corresponds to their relative positions. For example, colors opposite each other on the wheel, such as blues and yellows are perceived as being opposites.

▶ COLOR RELATIONSHIPS

Images consisting of colors that are adjacent to each other on the color wheel often possess visual coherence and harmony, particularly if they are similar in brightness and saturation. Combining colors that are well separated on the color wheel can be impactful, but this is only effective with simple color schemes and minimal subject elements.

Colors that are directly opposite each other on the color wheel, such as red and green and blue and orange, are said to be complementary: when placed next to each other they both appear more vibrant.

RED AND GREEN

BLUE AND ORANGE

▶ MOOD AND EMOTION

Colors in a picture immediately evoke mood and emotion. For example, reds and oranges give a feeling of energy and vitality, while blues and purples are calm and relaxing. Saturation and brightness also play a role: strong, bright colors have a "liveliness" that pale, dim colors lack. It's interesting to imagine a scene or subject in a different hue—it makes you realize how much its colors contribute to the mood.

ENERGETIC COLORS

CALM COLORS

▶ COMPOSING IMAGES

Try using color in the following ways to enhance the composition of your photographs:

• Create balance and harmony by giving equal weighting to complementary colors.

• Use a color accent—or splash of color—in an otherwise monochromatic picture.

• Use color to isolate elements; for example, pick out a warm element within an otherwise cool scene.

• Lead the eye by featuring the same color on different elements within an image.

• Enhance perspective by using warm, impactful colors toward the front of the scene and cool, recessive colors toward the back.

• Limit the range of colors by shooting monochromatic images that evoke mood and also emphasize shape and form.

BALANCED COLORS

SPLASH OF COLOR

ISOLATED ELEMENT

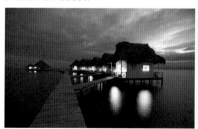

LEADING THE EYE

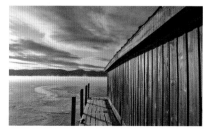

ENHANCED PERSPECTIVE

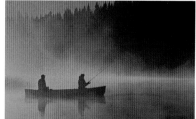

LIMITED COLORS

Early Fall

nature's bounty

exhilarating architecture

off the beaten track

Grown
Radish
$2

FRESH
BEETROOT
$2.50

long shadows in the city

> **September** days are here,
> With **summer's** best of **weather**
> And **autumn's** best of **cheer**

Helen Hunt Jackson

shafts of sunlight pierce the gloom

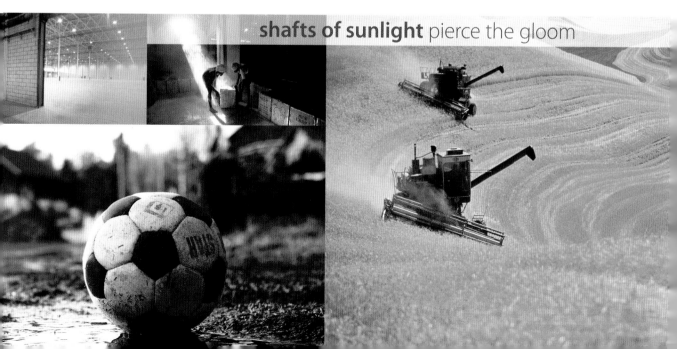

Spirit of place

Capturing the spirit of place means conveying its very essence in a photograph. These compositions are usually detached from your own experience of that place as they show the reality of it rather than your own view. Try to be selective in your approach. Carefully seeking out one shot that captures the soul of a place is more rewarding and has greater impact than making a lot of less meaningful images.

CAMERA MODE	LENS SETTING
Select **Landscape** mode or **Aperture Priority** and an aperture of f/5.6	Zoom to **telephoto**

SENSOR/FILM SPEED	FLASH
Use a **low ISO** setting (e.g. ISO 100)	Shoot without **flash**

FOR THIS SHOT

This village street photographed in the misty early morning light has a timeless feel—there's a sense that this scene has been enacted for centuries.

1 Composition
Zoom in to produce a tight composition. Enclosing the space gives a feeling of greater intimacy.

2 Perspective
The slightly raised viewpoint gives the viewer a feeling of observing the scene without intruding. The hazy morning light adds a sense of depth and greater perspective as objects in the distance are less clear and lower in contrast to those in the foreground.

3 Low light
Experiment with the preset values for lighting conditions on your camera to get the most accurate color balance. Use a long exposure and a higher ISO when you're working in low light.

TAKE IT FURTHER
A MUTED WORLD

Taking a photo in black and white is an excellent way of conveying a haunting atmosphere and works well for night shots. Zooming in with a telephoto lens using a shallow depth of field (with an aperture of f/4 or f/5.6) helps draw attention to the subject without compromising the mood.

ALTERNATIVE APPROACHES

Seek out views that capture the distinctive characteristics of a place. Particular landscapes, colors, architecture, and weather conditions all contribute to the pervading atmosphere of a location and can be used to make compelling images. In other places the people and their customs may be your inspiration.

Some locations are dominated by the sky, and there's nothing wrong with allowing the sky to dominate your image. Including just a narrow strip of land exaggerates the sense of open space.

Markets are a rich source of imagery and are full of activity and local color. Capturing a bird's-eye view gives a different sense of a market compared to photos shot at the same level as the goods.

The spirit of this harbor is captured in the colors of the faded paint on the buildings that butt up to the water's edge and their lively reflections in the water. By cropping out the sky above and focusing on the colors, the image takes on a painterly appearance.

See also: Travel portraits pp.168–69, People at work pp.186–87, On the tourist trail pp.226–27, Picture composition pp.260–61

Shafts of light

Even in the cleanest environment the air is full of tiny motes of dust that, when illuminated by the sun or another bright light source, seem to make an even brighter shaft of light. At their brightest they can resemble the rays of sunlight that radiate from behind clouds during stormy weather. In fact, any dark space where light penetrates can produce similarly striking rays that you can use as a feature in your photography.

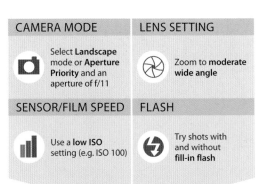

CAMERA MODE	LENS SETTING
Select **Landscape** mode or **Aperture Priority** and an aperture of f/11	Zoom to **moderate wide angle**
SENSOR/FILM SPEED	FLASH
Use a **low ISO** setting (e.g. ISO 100)	Try shots with and without **fill-in flash**

FOR THIS SHOT

A combination of fine fretwork on the window and the dusty atmosphere in this mausoleum chamber represents the perfect conditions for an intricate weave of fine shafts of light.

1 Viewpoint
Using a wide-angle lens setting and shooting from a low angle will enhance the shaft of light and make individual beams diverge more clearly.

2 Framing
Where possible frame your shot so that other key elements in the scene are positioned in the path of the light. Also try to include the patterns that are projected on the floor.

3 Exposure
When photographing scenes with high contrast, expose for the mid-tones so that you retain detail in the shadowy areas.

TRY THIS

Direct the light from a desk lamp onto an object and use a water spray to enhance the shaft of light. For a stronger effect increase the amount of mist, and for better contrast use a dark background. You can create a pattern of light on the surface of the object by placing different shaped cut-outs in front of the light source.

ALTERNATIVE APPROACHES

Shafts of light may appear most dramatic in an area where there is no other light, but this may prove difficult for your camera's metering system. Experiment by allowing some ambient light in, but resist flash, which will ruin the effect.

Light falling onto a staircase produces a strong interplay of light and dark as the striations fall on the treads and risers of the steps. Try shooting from different angles: low angles may produce disjointed patterns, while higher angles may produce rhythmic patterns.

In subterranean worlds—from subways to medieval vaults and cellars—daylight streaming through skylights casts soft pools of light on the floor below. Use a wide-angle setting to capture the contrast of light and shadows in the scene.

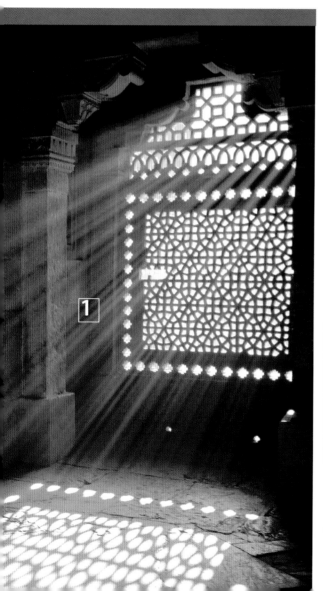

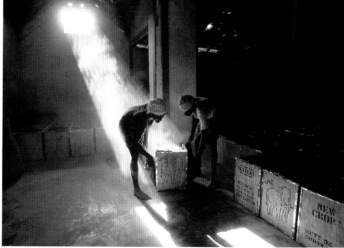

Whether through design or good fortune, photographing a subject or activity taking place at the base of a shaft of light has the effect of a theatrical spotlight, drawing attention to the subject. Use bracketing exposures to give you the most options.

See also: Silhouettes pp.202–03, Backlighting and silhouettes pp.204–05, Picture composition pp.260–61, Working in low light pp.288–89

City rivers

While they might provide an escape from the bustle of the streets, city rivers are often important thoroughfares in their own right, teeming with tourist boats and commercial shipping. All this activity provides plenty of scope for exploring a variety of images, from those that concentrate on shapes and textures, to more documentary-style shots that set the life of the river against the urban backdrop.

CAMERA MODE	LENS SETTING
Select **Landscape** mode or **Aperture Priority** and an aperture of f/4	Zoom to **telephoto**

SENSOR/FILM SPEED	FLASH
Use a **medium ISO** setting (e.g. ISO 400)	Shoot without **flash**

FOR THIS SHOT

The incongruous sight of a large cargo vessel set against the backdrop of a residential area or park perfectly captures the essence of an urban river.

1 Zoom in
A wide-angle view of a busy river scene can lead to an image that feels frenetic and unfocused. Zooming in allows you to reveal shapes and patterns that might otherwise go unnoticed.

2 Depth
The principal subjects of this image—the two boats and the machinery floating on the water—occupy different planes. The smog enhances this layered effect, with each plane becoming increasingly hazy.

3 Time of day
Shooting at different times of day will have a huge impact on the feel of your image—here, the setting sun infuses the waves with golden highlights.

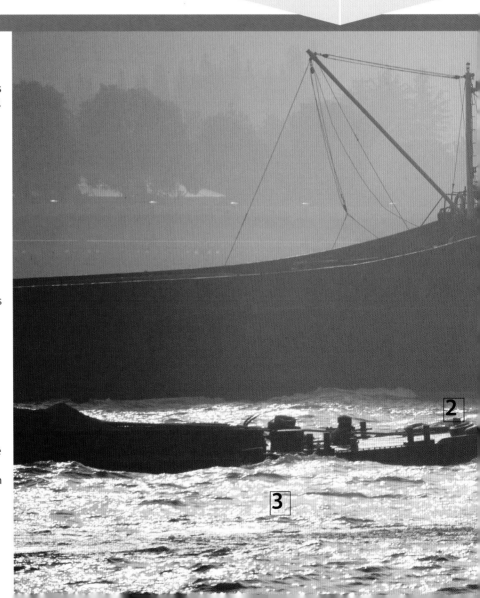

TAKE IT FURTHER
PERFECT PANORAMAS

Create a panorama of a wide river view by taking several shots from a high vantage point, ensuring each picture overlaps the previous one by a third. Use a tripod to ensure each shot is aligned exactly. Once you have captured the view, blend the sections into a panorama using image manipulation software.

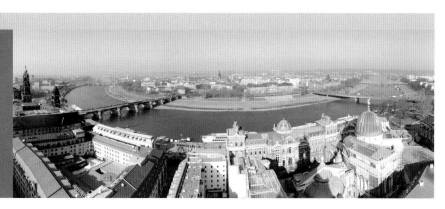

ALTERNATIVE APPROACHES

The character of a city river changes along its course and according to the time of day. To create a rounded portrait, explore different parts of the river and visit it at night too.

At night, reflections from the buildings that line its banks turn a city river into canvas for an atmospheric play of light and color. Use a medium aperture— around f/8—and keep your camera firmly supported to avoid blurring.

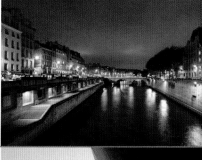

Crafts of all shapes and sizes navigate city rivers. Zoom in as much as possible then crop in further, if necessary, to create a dramatic composition that shows the variety of river traffic.

See also: Industrial landscapes pp.84–85, Reflected city pp.184–85, Silhouettes pp.202–03, Fishing harbors pp.210–11

Lost and abandoned

Discarded objects are usually regarded as worthless. Things that once belonged but are now abandoned, however, can evoke feelings of melancholy and nostalgia. Try to forget their original function, instead look at the broken shapes, faded colors, and fraying edges—and study how they fit into their new environments. Exploring the contrast between object and setting can lead to some really poignant images.

CAMERA MODE
Select **Portrait** mode or **Aperture Priority** and an aperture of f/8

LENS SETTING
Zoom to **moderate telephoto**

SENSOR/FILM SPEED
Use a **medium ISO** setting (e.g. ISO 400)

FLASH
Shoot without **flash**

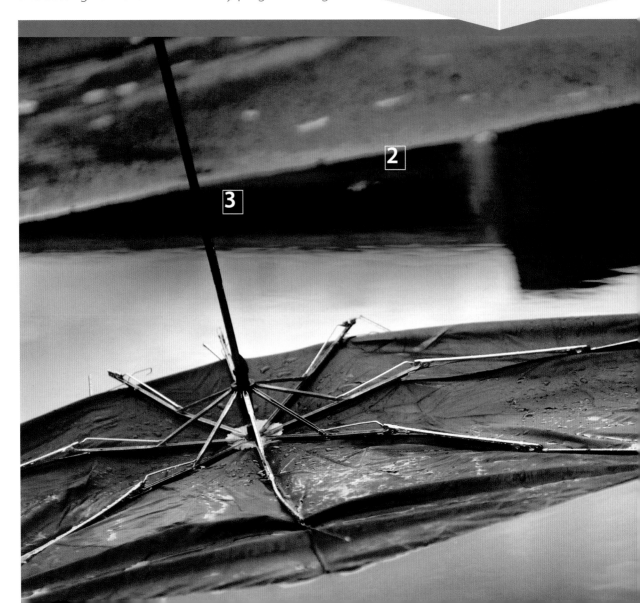

TRY THIS

Make a series of images that record how litter becomes part of the landscape. Zoom in close to reveal textures, and treat the litter as you would a still life. Compose your shots to highlight the contrast between man-made objects and the natural world.

FOR THIS SHOT

The bat-like form of this broken umbrella lying upside down in a puddle forms a striking image of a once-useful object reduced to urban detritus.

1 Lighting
The shape of the umbrella stands out against the light reflected in the puddle. Where colors are muted, shooting in, or converting to, black and white can help enhance form.

2 Composition
Look for features in the surroundings that will make your composition stronger. Here, the slope of the ground and the shadow above the umbrella help to anchor the elements of the composition.

3 Camera angle
Tilting the camera can produce a more dramatic image. The umbrella and the ground above it are both on a diagonal here, linked by the handle of the umbrella.

ALTERNATIVE APPROACHES

Look for ways to convey a sense of story in your images. You can frame your shots to crop in tightly on the object, or include its setting to emphasize the sense of abandonment.

A wet day gives abandoned belongings a dejected look. Shooting this old soccer ball from a very low viewpoint has made it dominant in the scene and given it a stronger sense of identity. Cameras that have flip-out screens are useful for low shots like this.

This shot has been tightly framed to show the contrast in shapes, colors, and texture between a forgotten farm cart and the exuberant young plants growing over it.

See also: Urban decay pp.56–57, Exploring textures pp.114–15, Forlorn gardens pp.276–77, Out of season pp.284–85

Marathon runners

Photographing marathons and fun runs is all about capturing the energy and scale of the event, as well as the way it interacts with, and fleetingly transforms, the urban environment. In a city, it's generally easy to find excellent vantage points to shoot from: along roadsides, on bridges, and—if you have permission— from buildings along the route.

FOR THIS SHOT

A snapshot of a group of runners is like a montage of miniature portraits, each one conveying a different emotion, from misery to elation.

1 **Composition**
Zooming in on a section of the runners crowds the frame and compresses the perspective to emphasize the feeling of density.

2 **Exposure time**
Use a short exposure time to ensure there is no motion blur, and a small aperture so that all participants appear sharp.

3 **Position**
Research the route and arrive early to secure a good spot. Shooting from an elevated position accentuates the space between individuals.

CAMERA MODE

 Select **Landscape** mode or **Aperture Priority** and an aperture of f/11

SENSOR/FILM SPEED

 Use a **low ISO** setting (e.g. ISO 100)

LENS SETTING

 Zoom to **telephoto**

FLASH

 Shoot without **flash**

TRY THIS

Runners often describe the latter stages of a marathon as a blur. You can convey a sense of this by creating a hazy, blurred image in which the runners are almost entirely abstracted. Lock your camera's focus on a close object (perhaps using Macro mode) and then recompose on the runners.

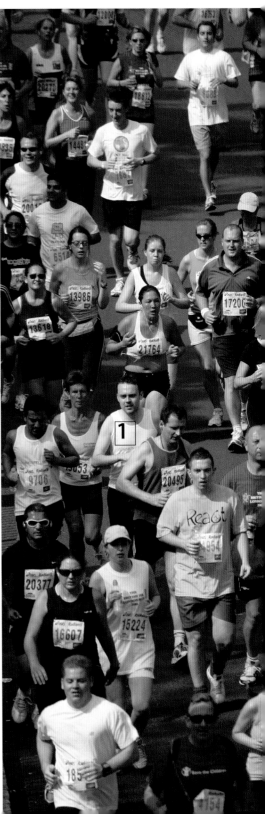

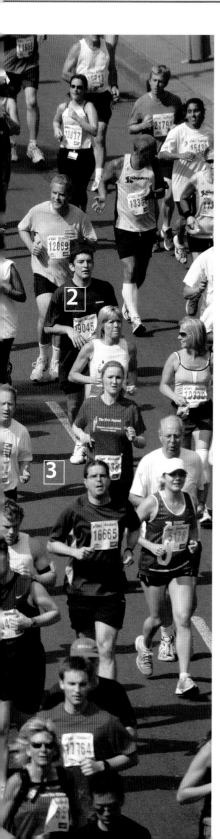

ALTERNATIVE APPROACHES

As well as taking general crowd shots or recording the progress of a group or an individual, search out opportunities for more quirky views of the race. Try to include features of the city that have no bearing on the marathon, and capture the way in which they're transformed by the presence of the event.

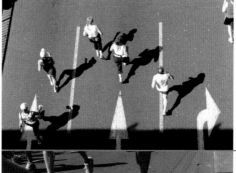

For a different perspective, find a high vantage point such as a building or bridge, and shoot from directly overhead. Give your image a humorous twist by capturing your subjects running along road markings intended for vehicles. Here, the arrows seem to point the way for the runners.

Create unconventional micro-portraits of runners by getting low down and taking close-up shots of their feet as they pass. Here, the inclusion of a shadow reveals a little more information about the subject. For an image that's rich in detail, zoom in to capture the texture of the ground.

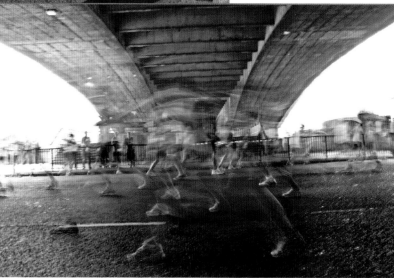

Mount your camera on a tripod to allow greater flexibility, then set an exposure of 1/2 sec or longer to capture the runners as ghostly apparitions. Only their feet—when in contact with the ground—will be captured sharply. Decrease ISO sensitivity to around 50 and select a small aperture for long exposure times.

See also: *On the move pp.86–87, Street photography pp.160–61, Music festivals pp.224–25, Picture composition pp.260–61, Shops and shoppers pp.324–25*

Harvest time

At harvest time farms are hives of activity, providing an opportunity to depict the reality of a working agricultural community. The colors of the landscape at this time of year—the vibrant reds and golds of woodland and the softer tones of arable farmland—will allow you to create interesting contrasts. Remember that farms are potentially hazardous places, so always put safety ahead of photography.

CAMERA MODE	LENS SETTING
Select **Landscape** mode or **Aperture Priority** and an aperture of f/16	Zoom to **maximum wide angle**

SENSOR/FILM SPEED	FLASH
Use a **medium ISO** setting (e.g. ISO 400)	Shoot without **flash**

FOR THIS SHOT

From the farm machinery to the muted color palette and expansive setting, this scene perfectly communicates the feel of a working farm in fall. You'll need the farmer's permission for close-up, documentary-style shots like this.

1 Wide-angle view
Keep the view as wide as possible to include as much of the harvester in your shot as you can.

2 Framing
Positioning the action slightly off-center—to the left of the shot—shows the field extending into the distance to the right, creating a feeling of space.

3 Composition
The two red bars in the foreground of the shot act as a frame for the grain arm, directing the gaze toward it.

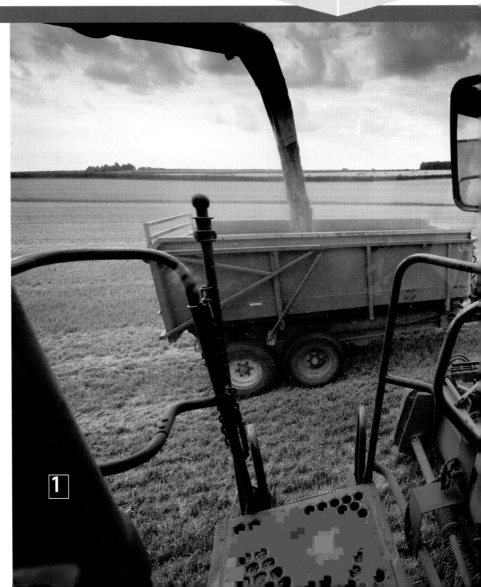

TRY THIS

Unusual compositions and lighting can bring an aesthetic beauty to farm labor. The intense color of the sky and the flare of the sun behind the grain lend a drama and romance to this scene. Underexposing by 1 stop has created a bolder silhouette.

ALTERNATIVE APPROACHES

Even large fields can be harvested in a few hours, meaning it's possible to document the whole process from start to finish. A project like this can produce many different types of image—begin with shots of ripe crops, progress through the harvesting, and finish with bare fields dotted with baled waste.

Images of harvesters in a large field convey the enormity of their task. To give a sense of the relentless toil involved, shoot them heading toward you, with their tracks receding into the distance.

Illustrate the progress of the harvest with a before and after shot, showing the demarcation between harvested and unharvested crops. Select a wide aperture—f/4, for example—to enhance the contrast, keeping the unharvested crops in focus.

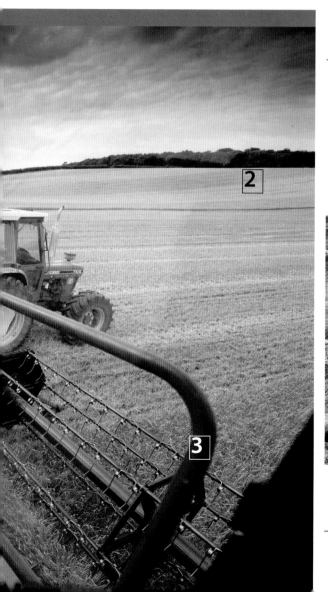

An arable landscape is transformed following the harvest. Be on the lookout for new patterns appearing as the harvesters leave behind razed fields. You can accentuate the patterning by zooming in on the fields and eliminating the sky and foreground.

See also: Down on the farm pp.70–71, Working the land pp.130–31, Crop fields pp.192–93, Colors of fall pp.266–67

Glorious sunsets

We all love a beautiful sunset, when the sky bursts into a magnificent, if brief, display of color. But photographing a sunset can be technically challenging. The wide range of light levels can confuse metering systems, while the color palette can have a similar effect on the white balance. The best sunset shots usually contain either foreground interest or a lovely landscape, so always keep a look out for suitable locations.

CAMERA MODE	LENS SETTING
Select **Sunset** mode or **Aperture Priority** and an aperture of f/8	Zoom to **telephoto**

SENSOR/FILM SPEED	FLASH
Use a **low ISO** setting (e.g. ISO 100)	Shoot without **flash**

FOR THIS SHOT

The contrast between the horizontal layers of cloud and the vertical wind turbines silhouetted against the landscape gives this picture added dynamism and drama.

1 White balance
When photographing sunsets don't use the Auto white balance mode, as this may reduce the warm tones of the light. Instead, set the white balance to Cloudy or Shade.

2 Lighting
Wait for haze or high cloud to diffuse the strength of the sun. This will result in a lower contrast, allowing you to capture details in the landscape.

3 Exposure
Experiment with exposures until you are happy with the result. You'll find that underexposing produces stronger colors and bolder silhouettes.

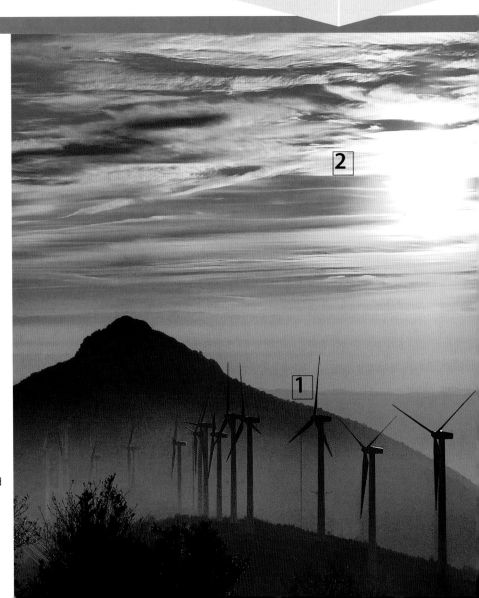

TRY THIS

For gorgeous backlit shots like this, carefully position a translucent object in front of the setting sun. Make sure that you focus on the object—rather than the distant landscape—and underexpose slightly (1/3 to 2/3 stop) to enhance color.

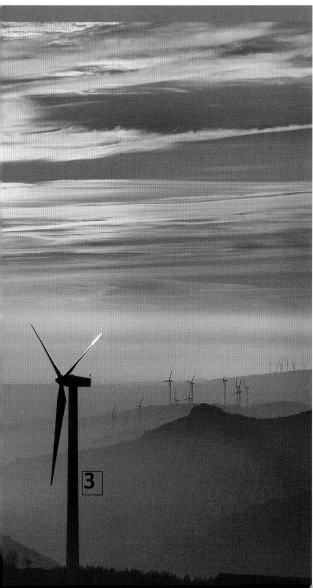

ALTERNATIVE APPROACHES

Though you're photographing a sunset, the sun doesn't have to feature directly in your shot at all. Sunsets affect the whole sky, burnishing the landscape, and infusing reflective surfaces with a warm glow.

Look around as the sunset develops to see its effect on the surrounding landscape. Rippled water produces shimmering, abstract reflections. Here, the framing has produced a nice color contrast between golden tones and the last remnants of blue in the sky.

Wait until the sun has moved below the horizon, and capture the way its light continues to create colorful displays in the sky. The strong silhouette of the rooftops has been used to balance the picture and provide context.

Don't forget to turn away from the sunset to see the effect of the dying light on the scene behind you. Cityscapes can be particularly striking as the buildings take on an extraordinary range of colors.

See also: Purple twilight pp.42–43, Snowy sunsets pp.60–61, Changing skies pp.106–07, Golden sunrise pp.322–33

Farmers market

Market tables, with their vibrant arrays of fresh produce are a real treasure trove for photographers. The fruit and vegetables are beautifully displayed and there are often interesting characters to see. It's best to arrive as early as possible, to avoid the crowds and catch the displays at their very best. Some markets are partially covered, so keep an eye on exposure and frame your shots to avoid really strong contrasts of light and shade.

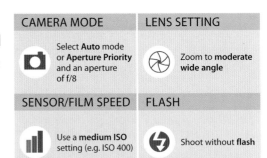

CAMERA MODE	LENS SETTING
Select **Auto** mode or **Aperture Priority** and an aperture of f/8	Zoom to **moderate wide angle**
SENSOR/FILM SPEED	**FLASH**
Use a **medium ISO** setting (e.g. ISO 400)	Shoot without **flash**

FOR THIS SHOT

This fruit stand is exploding with color. Shot early in the morning before most customers arrive, it's piled high and pretty as a picture.

1 Composition
Look at the produce as if it were a still life, to decide how to frame your pictures. Here, shooting square-on creates structure and keeps everything sharp.

2 White balance
If the stand has an awning that creates a color cast, be prepared to adjust your images on a computer later. Alternatively, use the white balance feature on your camera.

3 Human interest
Including the farmer or customers adds character and local color to the shot. It's courteous to ask permission before taking any pictures of people.

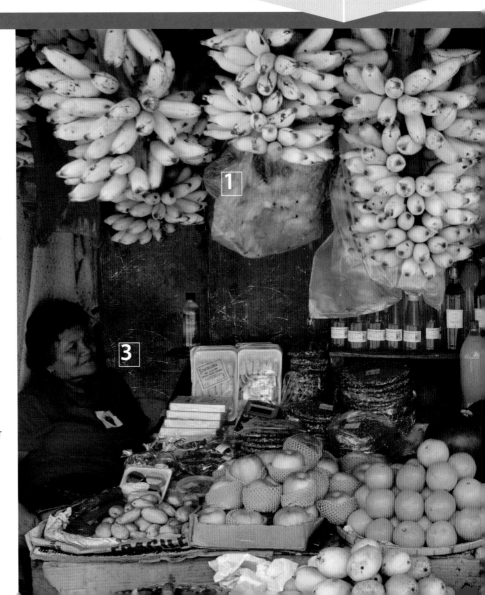

TRY THIS

Close-up overhead shots of fruit and vegetables will give you the chance to create a collection of more abstract images focusing on the diverse shapes and colors of the produce. Experiment with different zoom settings to find out what works best: use wide for whole piles or baskets of wares and long for more abstract close-ups.

ALTERNATIVE APPROACHES

The character of a farmers market varies from one location to another. Try to capture each market's idiosyncrasies by shooting as many quirky details as you can.

Close-up shots of homemade labels are a lovely way to convey the rustic charm of a market. They will also help to remind you where that particular market was.

You can make your pictures less abstact and more personal by including customers in your shots. Impromptu shots of children and their reactions can be very entertaining.

See also: Eating al fresco pp.154–55, On the tourist trail pp.226–27, Using color pp.232–33, Spirit of place pp.238–39

Shades of gray

Although most photographers shoot in color, gray is a more commonplace feature of pictures than we imagine, even though it's often tinged with color. When shooting scenes where gray—or pale, washed-out colors—predominate, think in terms of monochrome photography. Put aside considerations about color and consider instead how form and texture work together.

CAMERA MODE	LENS SETTING
Select **Landscape** mode or **Aperture Priority** and an aperture of f/4	Zoom to **telephoto**

SENSOR/FILM SPEED	FLASH
Use a **low ISO** setting (e.g. ISO 100)	Shoot without **flash**

FOR THIS SHOT

From a distance a refined oil storage tank hardly appears photogenic. Up close it has strong pictorial forms as regular lines juxtapose with curved surfaces.

1 Shadows
Because they can overextend the range of brightness, shadows can cause colors to appear washed out. Take advantage of a lack of color to feature shadows prominently.

2 Emphasize form
Without the distraction of color, form becomes the dominant feature. Here, the elegant lines of the lamp, staircase, and even the curve of the shadow, are all given room to breathe.

3 Color balance
When shooting a neutral tone like gray, experiment with different color balance settings. Each one will imbue the shadows (and darker grays) with a slightly different hue.

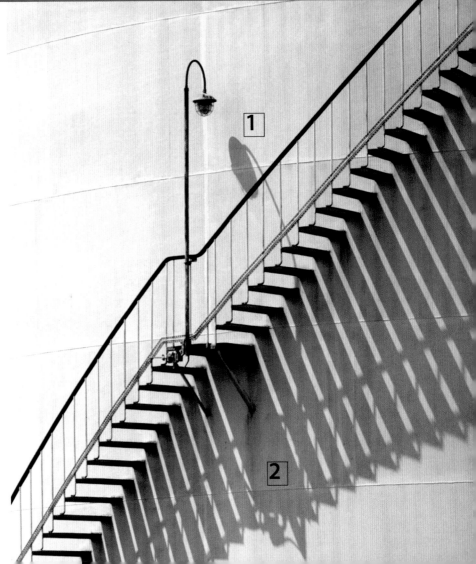

ON YOUR PHONE
GRAIN FILTER

Applying a grain filter is a simple—and very effective—way to add grit and texture to an image. This atmospheric black-and-white shot of a moonlit shore wouldn't have anywhere near as much impact if it was silky smooth.

ALTERNATIVE APPROACHES

Foggy or hazy conditions are perfect for seeking out gray-toned scenes with diminished contrast and desaturated color. Notice the way different shades of gray work together, and look out for occasional splashes of color too.

With minimal color to catch the eye, strong geometric shapes become the principal focus of this composition. Prevent convergence by holding the camera level, keeping vertical lines straight.

In any landscape view, a haze of mist creates depth. On extremely murky days this effect is further exaggerated, even over shorter distances. Waiting for a flock of passing birds to appear in the middle distance of this scene has enhanced the eerie, otherworldly atmosphere.

Photographing a misty gray scene is a good way to draw attention to the beauty found in fine details. Just a small highlight—such as the rising sun glinting off these distant buildings—can transform the atmosphere of a scene entirely.

See also: Wintry cityscapes pp.50–51, Industrial landscapes pp.84–85, Skeleton trees pp.312–13, Silvery moon pp.314–15

Café life

The perfect vantage point from which to watch the world go by, a café is a hive of activity, with customers eating, drinking, and chatting and waiters hurrying between tables. It's a great place to sharpen your candid photography skills, but turn your camera on the café itself too, and record the changes of atmosphere and mood that occur throughout the day.

FOR THIS SHOT

Reflections are a creative way of increasing the potential of a scene. Here we can see the café itself, some customers outside, and its surroundings—a quiet Spanish square.

1 Depth of field
For reflected shots like this, an extensive depth of field ensures that the whole image appears sharp.

2 Composition
The impression of an image within an image is enhanced by the framing device of the frosted glass, the wall on the right, and the top of the window frame.

3 Creating intrigue
The unusual arrangement of this image encourages the viewer to look at it more closely—was the shot taken from inside, or outside, the café?

CAMERA MODE

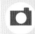 Select **Landscape** mode or **Aperture Priority** and an aperture of f/11

SENSOR/FILM SPEED

 Use a **low ISO** setting (e.g. ISO 100)

LENS SETTING

 Zoom to **maximum wide angle**

FLASH

 Shoot without **flash**

ON YOUR PHONE
RETRO COLORS

Rest your camera phone casually on a table and set it to camera mode to capture unselfconscious shots of your companions. You can add a retro twist with apps that imitate film-processing effects such as transparency cross-processing.

ALTERNATIVE APPROACHES

Some cafés are aesthetically interesting but photographing them is usually about capturing their ambience and customers, rather than the buildings they're situated in. Every new customer presents a new photo opportunity—spend some time sitting in the café, working out what makes it unique.

Cafés provide scope for a variety of portraits. Group shots can be lively and energetic but individual portraits tend to have a more introspective feel. Shoot candidly to capture genuine expressions. To avoid being intrusive, try shooting blind: set up your camera, then shoot without using the viewfinder or LCD panel.

Focusing on the menu board in this shot draws the viewer into the scene. The blurring of the scene beyond creates a sense of the world hurrying by.

TAKE IT FURTHER
A DAY IN THE LIFE

Shooting at different times of the day has a major impact on the feel of a scene. In the case of a café, as well as obvious changes such as varying weather conditions and the aspect of the sun, there will also be a change to the clientele. Cafés appeal to different people at different times of the day. Create a portrait of a day in the life of a café by shooting from morning through to night, either from a single viewpoint or from different positions. Notice how the lighting—natural or artificial—changes the feel of the shot.

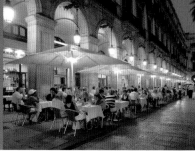

See also: Character portraits pp.82–83, Eating al fresco pp.154–55, Street photography pp.160–61, Window-lit portraits pp.300–01

Heritage architecture

In addition to its social and historical value, heritage architecture—from prehistoric monuments through to 20th-century public buildings—is usually also highly photogenic. Structures of this type are much-photographed, so strive to create images that reach beyond the obvious. Work with the available light, look for interesting shapes, patterns, and details, and consider the unique appeal of the building.

CAMERA MODE	LENS SETTING
Select **Auto** mode or **Aperture Priority** and an aperture of f/8	Zoom to **maximum wide angle**

SENSOR/FILM SPEED	FLASH
Use a **low ISO** setting (e.g. ISO 100)	Shoot without **flash**

FOR THIS SHOT

The low viewpoint and slightly skewed angle of this shot perfectly captures the dizzying effect of this cavernous, opulent interior.

1 **Wide angle**
To capture the full glory of a sumptuously decorated ceiling, zoom out as far as you can to emphasize its scale.

2 **ISO setting**
To capture as much detail as possible, set a low ISO sensitivity. For a shake-free shot, you'll need to use a tripod or find a firm support for your camera. If you don't have a tripod, try placing your camera on the ground and use the self timer.

3 **Framing**
Including the converging verticals of the soaring columns accentuates the height of the building.

TRY THIS

It's can be tricky to illustrate the scale of unusual landmarks, such as this Indian stepwell, especially when only part of the structure is visible. Including people in the scene instantly conveys size and scale. Against a monochrome backdrop, this woman's bright clothes stand out and inject energy into the scene.

ALTERNATIVE APPROACHES

There's more to heritage architecture than monumental scale. Most historic buildings have distinctive forms and features and are packed with texture and detail. Look beyond conventional wide-angle views for perspectives that breathe new life into ancient structures.

Use contrasts in your images to highlight the different characteristics of buildings and structures. The juxtaposition of the imposing and intricate facade of this medieval cathedral and the bold, dynamic bridge emphasizes the unique properties of both.

It's possible to convey the character of a building without shooting it in its entirety. In fact, the power of large structures is often lost in a wide-angle view. Seek out architectural features and details that are characteristic of the period or style, and frame tightly.

The profiles of some buildings are so strong that their silhouette or shadow can describe, and even identify, them. Use the landscape or cityscape upon which that shadow falls as a canvas. In high contrast conditions, experiment with the exposure settings to find the right balance between brightness and shadow.

See also: *Modern architecture pp.74–75, Architectural details pp.78–79, Romantic ruins pp.144–45, On the tourist trail pp.226–27*

3

Picture composition

The impact of any picture depends on the way that different subject elements are positioned within the frame. Strong compositions use bold structural forms to create lines, shapes, and rhythms that can give meaning or context to picture subjects. Start by thinking about a scene's general structure, and experiment with the methods outlined here to create compositions that really engage the viewer.

▶ FRAMING SUBJECTS

Prized photographs are often displayed in frames to enhance their impact. The frame creates the general illusion of a window—one that we look through to the scene beyond. When composing photos we can do something very similar, by creating a contextual frame around the principal subject as part of the image.

Using this framing technique gives the photo a sense of place and enhances or introduces depth in a scene. In terms of the context, you might frame a garden scene by using overhanging branches that also make best use of the otherwise empty area at the sides and top of the frame. A shot through a doorway or window that's made up of straight lines or regular shapes can provide a more formal and very effective frame for the subject beyond.

Framing devices like these also add depth to a scene by introducing an additional plane in front of the plane of focus, on which the subject lies. They may also be used to lead the viewer's eye through to a subject—again, like a conventional frame or window, you're drawn to look through at what is beyond.

FRAME CREATED BY A DOORWAY

FOLIAGE USED AS A FRAME

 SHAPES WITHIN IMAGES

Shapes and lines within images are effective compositional tools. You can use them to direct the gaze of the viewer, add drama, and create balance.

Diagonal lines lead the eye from one part of the scene to another. They tend to impart more energy than horizontals, and encourage the eye to explore and linger on the image. In radial compositions the key elements spread out from the middle of the frame, giving a lively feeling even to static subjects. Symmetrical compositions are particularly bold and suggest solidity, strength, and even formality.

DIAGONAL

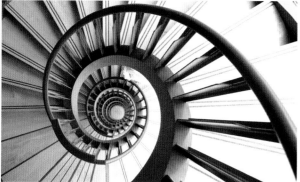

RADIAL

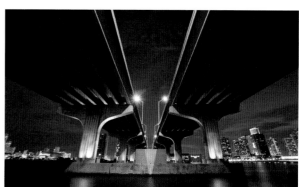

SYMMETRICAL

 PERSPECTIVE AND MOVEMENT

There are many ways to strengthen the sense and dynamic energy of receding space in your pictures.

Including parallel lines that appear to converge at a distant point is a useful way of adding depth to a scene and leading the eye to a subject at the point of convergence.

Look out for lead-in lines that can encourage the viewer's eye to make a journey around an image, from the foreground, through the scene, and on to the subject.

CONVERGING PARALLELS

LEAD-IN LINE

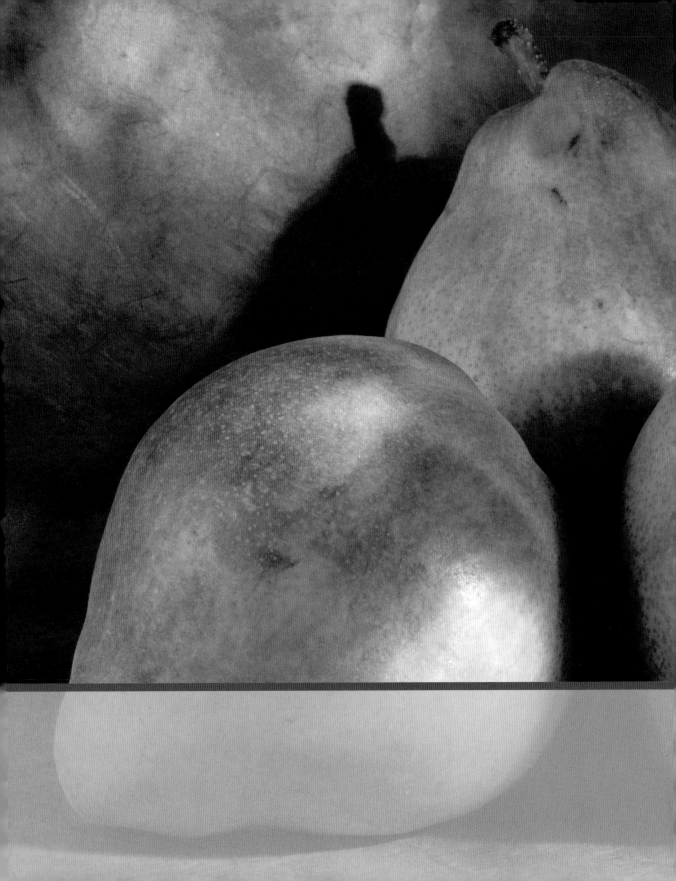

Mid-Fall

pale and pearly sunlight

"
Season of mists and **mellow fruitfulness,**
Close bosom-friend of the **maturing sun**
"

John Keats

foggy **woodland walks**

copper, bronze, and ruby-red

melancholy moments

splashes of vibrant color

Colors of fall

In temperate climates, nature has a final flourish of color as summer draws to a close. Autumnal weather can be changeable, bringing a variety of photographic results. Overcast skies provide soft light, while bright sunlight infuses leaves with a translucent, dappled glow. For the most vibrant color, head out just before sunset or after sunrise when the lighting is at its warmest.

FOR THIS SHOT

Rather than relying solely on the bright foliage for impact, this image uses it as a component to enhance an already strong composition.

1 **Contrasts**
The bold framing places the tree trunk in the foreground to emphasize the contrasts in form and color in the scene.

2 **Exposure time**
An exposure time of 1/2 sec gives the water a soft silky look, providing a foil for the sharp outlines of the leaves and branches.

3 **Color saturation**
Vary your exposure settings to alter the color saturation. If your camera has Vivid or Sunset exposure modes, experiment with those too.

CAMERA MODE

Select **Landscape** mode or **Aperture Priority** and an aperture of f/11

SENSOR/FILM SPEED

Use a **low ISO** setting (e.g. ISO 100)

LENS SETTING

Zoom to **moderate wide angle**

FLASH

Try shots with and without **fill-in flash**

TRY THIS

Use backlighting to enhance the luminance of fall leaves. For the most brilliant colors, shoot toward the canopy into a bright sky, or even into the sun. The light will cause your camera to underexpose the shot, so increase your exposure by 1 stop.

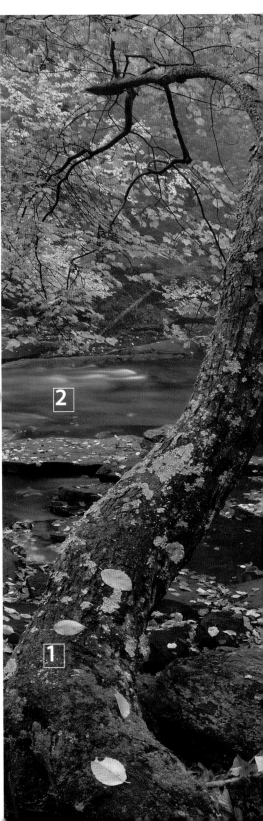

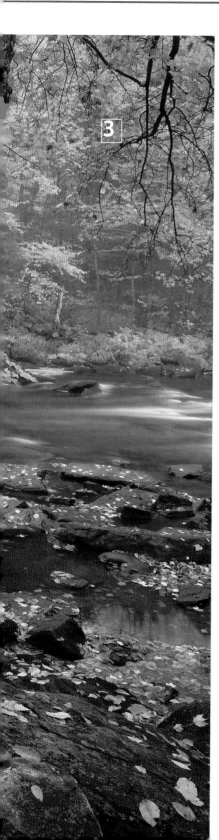

ALTERNATIVE APPROACHES

From wide-angle landscape images to close-up shots of a leaf-covered forest floor, fall tones can be photographed in many different ways. Broad views place the colors in context and contrast them with the stark forms of the trees while images of leaves reflected in water result in more abstract compositions.

The fall color palette consists of an astonishing range of vibrant hues. Look for the appearance of colored bands as foliage from tall shrubs and undergrowth turn their own distinctive colors.

Reflected in ponds or lakes, and shot through a fine rain or mist, fall colors take on an abstract look. Catch the moment when a breeze shivers across the water or create your own ripples by skipping a pebble.

TAKE IT FURTHER
COLOR SATURATION

Give an otherworldly brightness to fall scenes by using image manipulation software to boost the color saturation. Experiment with the effect this has on your images but don't increase the saturation too much. A 15 percent boost is usually sufficient—any more, and the colors may end up looking lurid rather than intense.

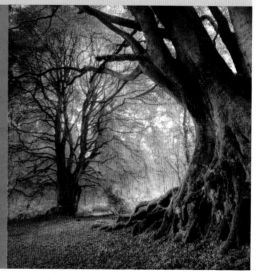

See also: In the forest pp.270–71, Using color pp.232–33, Playing in leaves pp.272–73, Indoor still life pp.274–75, Fallen leaves pp.306–07

Fall pets

Most of us who have pets enjoy making pictures of them all through the year, but in the fall, when the landscape is flushed with russet tones and the sun is lower in the sky, your pet portraits can take on a whole new visual vocabulary. Take advantage of the bond that you have with your pet to get up close and capture its character, and exploit the wonderful light and autumn colors to create some really gorgeous seasonal portraits.

CAMERA MODE	LENS SETTING
Select **Portrait** mode or **Aperture Priority** and an aperture of f/2.8	Zoom to **maximum telephoto**
SENSOR/FILM SPEED	**FLASH**
Use a **medium ISO** setting (e.g. ISO 400)	Try shots with and without **fill-in flash**

FOR THIS SHOT

This photograph of a cat turning in surprise perfectly captures its inquisitive nature and quick reactions.

1 Backlighting
Shoot toward the sun to produce a bright halo around part of your pet. Here, fill-in flash has been used to make sure that the cat isn't lost in shadow.

2 Eye contact
Portraits work best if there's eye contact. Call to your pet a moment before you press the shutter-release, to encourage it to look at the camera.

3 Depth of field
Use Portrait mode to ensure that you have a relatively narrow depth of field. Here, the cat is in sharp focus, while the leafy background is softly blurred.

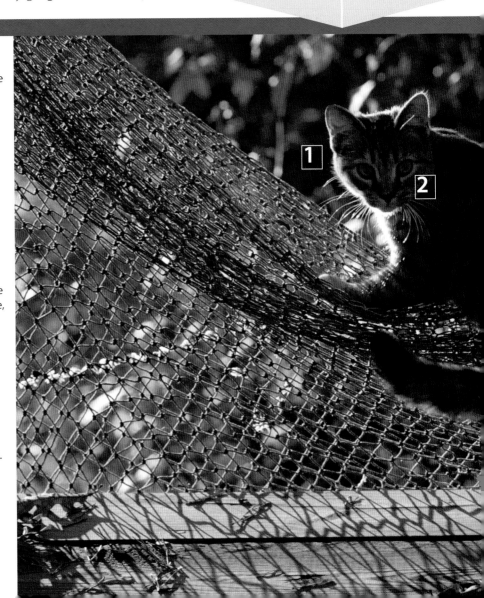

TRY THIS

More docile pets will allow you to set up shots that would be almost impossible to achieve if you were shooting spontaneously. This sleepy rabbit is well camouflaged among the fallen leaves, so you'd need to get down to his level and frame tightly.

ALTERNATIVE APPROACHES

Try shots with a different emphasis—shooting from your pet's perspective, juxtaposing his colors with those of the landscape, or making a feature of the raking fall light.

Including people in your animal photographs can reveal the nature of their relationship with their owners. Shoot from a low viewpoint to reduce the proportion of the image taken up by foreground that doesn't contribute to the pictorial value.

Use the fall colors to create a vibrant background for your portraits. Here, the slightly blurred scarlet and yellow leaves emphasize the cat's striking black and white markings. Always expose for your subject when using bright backgrounds.

TAKE IT FURTHER
SELECTIVE FOCUSING

Use selective focusing to make your pet stand out from its environment. Select a wide aperture and zoom in. As your subject lies behind blurred elements, autofocus will be confused. Focus manually or autofocus first on the subject without anything in the way, then hold the focus and recompose the shot.

See also: Pets in snow pp.28–29, Cats and dogs pp.136–37, Pets in action pp.194–95, Fall wildlife pp.280–81

In the forest

From thick vegetation to sudden clearings in the undergrowth, the forest is a place of contrasts. Lighting varies dramatically too, not only with changes in the weather but also according to the height and density of the canopy above. Explore the forest with your camera looking for interesting patterns and compositions created by the trees, plants, and fungi that flourish on the autumnal forest floor.

CAMERA MODE	LENS SETTING
Select **Landscape** mode or **Aperture Priority** and an aperture of f/16	Zoom to **moderate wide angle**

SENSOR/FILM SPEED	FLASH
Use a low **ISO setting** (e.g. ISO 100)	Shoot without **flash**

FOR THIS SHOT

This lush forest is an intriguing ecosystem of plants that thrive in damp conditions. A fern has taken root among moss-covered fallen trees producing an image that shows a broad range of forest textures.

1 Composition
Use any diagonal lines you can find, such as fallen branches and patterns in foliage, to lead the eye to a focal point such as the beautifully lit fern in this picture.

2 Wide angle
To create a feeling of being almost overwhelmed by the density of the undergrowth, zoom out for a wide view, then get in low and close.

3 Even lighting
Exploit the way in which foliage can filter daylight to produce soft, even lighting. Experiment with white balance settings until you get vivid greens.

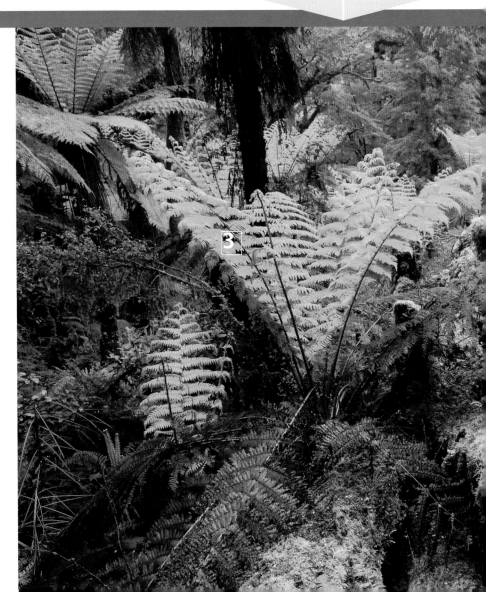

ON YOUR PHONE
FISHEYE VIEW

Fit a fisheye lens adaptor to your camera phone and place it on the ground to produce a distorted view. Alternatively, a similar effect can be achieved with a fisheye app that will simulate the look on standard images.

ALTERNATIVE APPROACHES

Where the overhead cover is less dense, shafts of sunlight can pick out individual plants and fungi. Get in close to shoot some of the details of the forest landscape, and always look out for interesting shapes and textures.

Mushrooms and toadstools have a magical, fairytale quality when in their natural environment. Get down to their level, and move in close with your lens at a wide-angle setting—but do tread very carefully. Try to find a subject that's backlit, as this will highlight the delicate structure and colors.

Fallen trees can make fascinating photographic subjects, their massive exposed and decaying roots radiating outward, creating a dramatic starburst effect. Explore them in close-up, or go for a wider view to show them in the context of the forest.

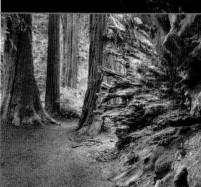

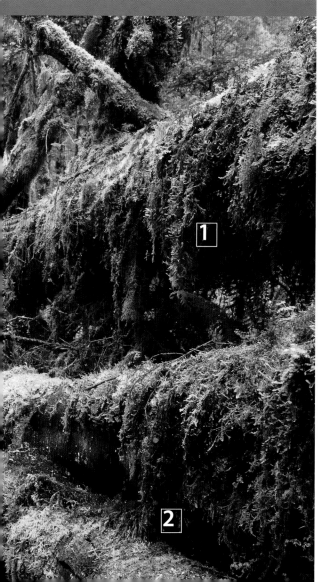

1

2

TRY THIS

Even some ostensibly natural forests need to be managed to stop them becoming too dense. Look out for felled trees and harvested timber, and use the patterns and textures created by the sawn surfaces to make graphically interesting images.

See also: Woodland shadows pp.34–35, New growth pp.90–91, Lush greenery pp.138–39, Fallen leaves pp.306–07

Playing in leaves

Whether they're kicking them, throwing them, or rolling around in them, children find the potential for fun in a big pile of leaves almost impossible to resist. Their enthusiasm and enjoyment is complemented by the rich russet colors, creating a quintessential portrait of the season. Get as close to the action as possible, and try to make best use of the soft, warm light produced by the low sun at this time of year.

CAMERA MODE	LENS SETTING
Select **Portrait** mode or **Aperture Priority** and an aperture of f/8	Zoom to **moderate telephoto**

SENSOR/FILM SPEED	FLASH
Use a **medium ISO** setting (e.g. ISO 400)	Try shots with and without **fill-in flash**

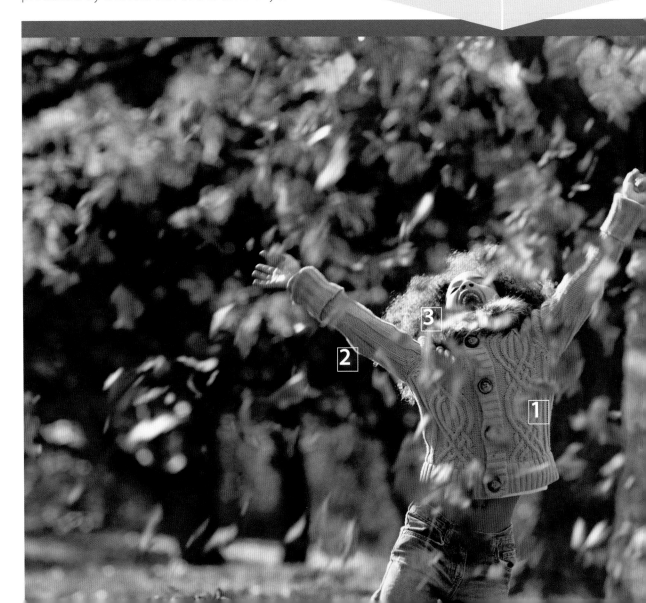

TAKE IT FURTHER
AUTUMNAL PORTRAIT

A portrait like this requires careful staging. The subject's hair has been teased and drawn outward and her clothing has been chosen to complement the fall colors. Even the leaves in her hair have been specially selected for their shape and color.

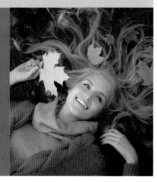

FOR THIS SHOT

Although carefully composed, this shot feels spontaneous and energetic thanks to the subject's expressive face and the movement of the leaves.

1 Composition
If possible, match the color of your subject's clothes to the natural colors of the image. A more satisfying composition can be achieved by tailoring their pose to echo other shapes in the picture.

2 Aperture
Use a medium aperture (f/8, for example) and moderate telephoto setting to keep the subject sharp while blurring the background slightly.

3 Exposure
Use a medium ISO sensitivity (ISO 400) to allow for short exposures of around 1/250 sec to freeze motion and keep your subject sharp.

ALTERNATIVE APPROACHES

Scenes of children playing in fallen leaves don't have to be full of frenetic movement and energy—the reds and golds of autumn lend themselves to more reflective images, too. Experiment with angle and perspective—get in close to show the beauty of an individual leaf, for example.

The light from a low autumn sun adds warmth and enriches the color of these leaves. Keeping the sun behind your subject produces beautiful rim lighting and makes the leaves glow. A little overexposure helps to keep the tones airy.

Children can bring chaos to the most tranquil situation. This shot exploits that dynamism to good effect. The neatness of the piled leaves contrasts with the energy of the boy hurling himself toward them. Try experimenting with exposure times to capture a slight motion blur.

To capture a scene from a child's perspective, get down low and shoot upward. In this picture, we appreciate the size of the tree through the eyes of the child. Shooting into the sky has resulted in some lens flare, which lends a dreamlike, nostalgic quality to the image.

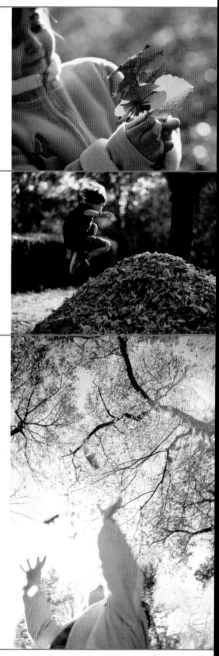

See also: Ice formations pp.14–15, Children outdoors pp.126–27 Colors of fall pp.266–67, Fallen leaves pp.306–07, Fun in the snow pp.336–37

Indoor still life

On chilly, damp days, when you don't feel like venturing out with your camera, experimenting with some still-life photography is a very rewarding alternative. It doesn't need to be anything elaborate. Look for objects around the home with varied shapes, textures, and colors, then try out different arrangements and various sources of lighting—a simple desk light can be very useful.

FOR THIS SHOT

Kitchen utensils—especially those that are well-used and have acquired a patina—create an attractive combination of shapes and textures.

 Composition
Set your camera on a tripod so that you can leave it in position while you make adjustments. You have total control over a still life, so take time to get your composition right.

 Lighting
Set up by a window and use natural daylight as your main light source. Leave the interior lights on to add highlights to reflective surfaces.

 Depth of field
Experiment with aperture settings and observe how varying the depth of field changes the feel of the image.

CAMERA MODE

Select **Portrait** mode or **Aperture Priority** and an aperture of f/8

SENSOR/FILM SPEED

Use a **low ISO** setting (e.g. ISO 100)

LENS SETTING

Zoom to **moderate telephoto**

FLASH

Try shots with and without **flash**

TAKE IT FURTHER
RECREATING AN OLD MASTER

Study still-life paintings by great artists and try to recreate them, or give them a new twist. Imitate the artist's use of color and light to give your picture a seasonal feel. You could even apply a software filter to create the impression of brushstrokes.

ALTERNATIVE APPROACHES

Often interesting still-life compositions will present themselves to you—an assortment of ornaments on a shelf or items placed casually on a dining table, for example. Even objects that are not conventionally beautiful can be recruited to make intriguing images. All you need to do is recognize the potential.

Grouping objects that have shape, texture, or material in common, such as these bottles, can form a striking composition. Try out both regular and random arrangements to see which shapes look good together. With transparent objects it's worth experimenting with backlighting to delineate the shapes.

Color can be used to give a still life unity. Here, a coppery setting has been used to complement the autumnal tones of the pears. Experiment with different materials to diffuse the light from the window to create a dappled light and shade, similar to that produced by leafy branches.

Even with inanimate objects, you can create an impression of movement. These ballet shoes hanging from their ribbons suggest a line of dancers caught en pointe. Make small adjustments to the position of the shoes to find which pattern is most rhythmic.

See also: Outdoor still life pp.46–47, Farmers market pp.252–53, Picture composition pp.260–61, In the kitchen pp.282–83

Forlorn gardens

In the autumn, the garden changes character as the leaves fall and plants die back. It is still, however, a magical place. As flower and seed heads dry out, they take on a stark, sculptural quality that's very photogenic, particularly against the low sunlight of October days. The flowers may have faded, but there are still touches of vivid color to be found.

FOR THIS SHOT

Hydrangea heads cling to vestiges of brilliant color as they fade to autumnal brown. Here, their fragile beauty is enhanced by a delicate edging of frost.

1 Lighting
Shoot the main subject under shade or shadow to reduce contrasts of light and shade and bring out subtle colors.

2 Focus
Use Portrait mode (or Macro mode for smaller subjects) to blur the background, so that the subject stands out sharply.

3 Enhanced color
If your camera has a Vivid Color mode, try using it to enhance the colors—brighter colors will be affected more than paler, neutral shades.

CAMERA MODE

 Select **Portrait** mode or **Aperture Priority** and an aperture of f/4

SENSOR/FILM SPEED

 Use a **low to medium ISO** setting (e.g. ISO 100 to 400)

LENS SETTING

 Zoom to **moderate telephoto**

FLASH

 Shoot without **flash**

TRY THIS

Translucent subjects, such as these honesty "coins" or skeleton leaves, look gorgeous when backlit. Use a macro setting and shoot them in front of a window. If necessary, soften the light by placing thin paper or translucent gauze over the glass.

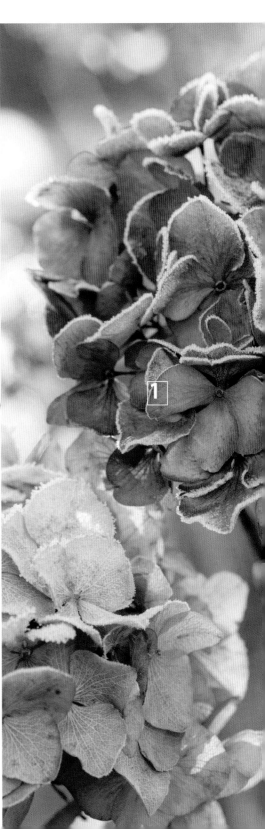

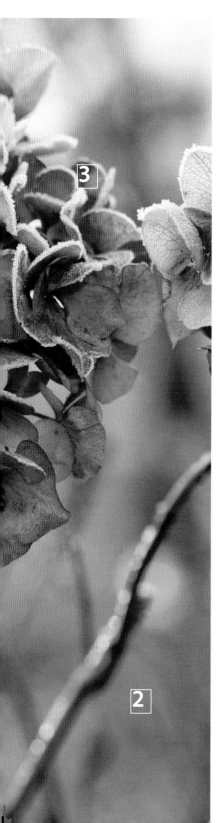

3

2

ALTERNATIVE APPROACHES

As fall draws on, structural elements, such as fences and sheds, become more prominent. Use them as a backdrop for some seasonal still-life arrangements, and look for neglected corners that might harbor interesting objects or textures. And, of course, enjoy taking the last pictures of plants before they finally disappear.

The low angle has foreshortened the bleached forms of these garden tools propped against wooden garden chairs, creating a strong sense of perspective. The dappled light filtering through the almost bare trees adds interest and texture to the autumnal scene.

The regular pattern created by these stacked flowerpots is emphasized by the bright green moss and dark shadows inside them. The cobwebs and the small sedum growing on one pot evoke the sense of time passing.

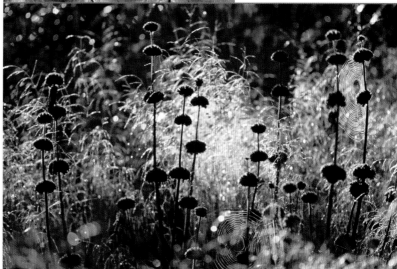

Seed heads left for the birds to feast on have a strongly architectural quality, especially when shot in silhouette against the low sun of a fall afternoon and a golden backdrop of feathery grasses. Note the filigree effect of the cobwebs.

See also: In the winter garden pp.30–31, Flowers in close-up pp.190–91, Lost and abandoned pp.244–45, Out of season pp.284–85

Striking contrasts

Making contrasts the theme of photographs often relies upon chance—something intriguing may catch your eye when you are out and about—so it's a good idea to carry your camera with you wherever you go. Creating a striking image depends largely on how you compose it. Think carefully about how to frame your shot, to make the most of the contrast you want to emphasize.

FOR THIS SHOT

This image contrasts not just the little girl with the graffiti artist, but also the colorful graffiti in the background with the gray city street in front.

1 **Composition**
A strong diagonal from a subject in the foreground to another in the background creates a bold composition that leads your eye into the scene.

2 **Depth of field**
Where it's important to keep two focal points in equally sharp focus, use as small an aperture as possible.

3 **Lighting**
You can give contrasting subjects equal prominence by making sure that the lighting picks out both of them in the same way.

CAMERA MODE

 Select **Landscape** mode or **Aperture Priority** and an aperture of f/5.6

SENSOR/FILM SPEED

 Use a **medium ISO** setting (e.g. ISO 400)

LENS SETTING

 Zoom to **medium telephoto**

FLASH

 Shoot without **flash**

TAKE IT FURTHER
SIMPLE COMPOSITES

Use your image-editing software to cut out an object, then place the object on different backgrounds to create a composite. Here, the background image has been desaturated to emphasize the vibrant color of the rose.

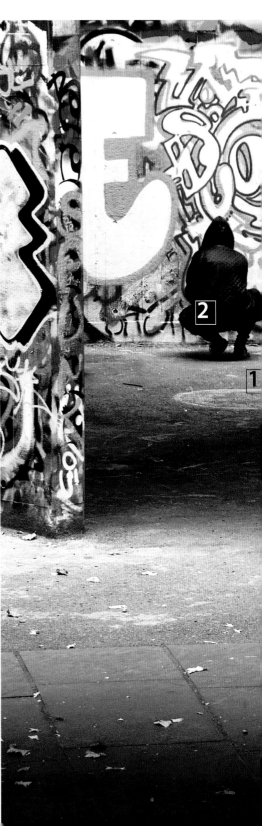

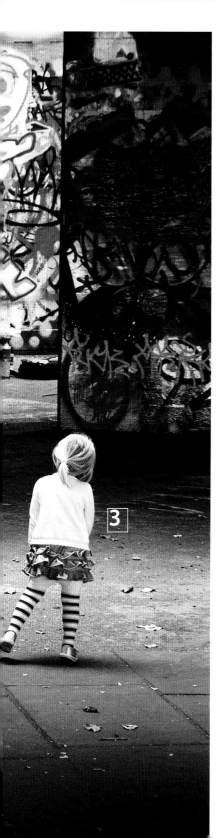

ALTERNATIVE APPROACHES

Like a photojournalist, keep a constant look-out for thought-provoking images. These might take the form of visual contrasts in whole landscapes, or tiny details that could pass unnoticed. They might reflect shifts in nature, changes in the environment or our culture, or simply the passing of time.

A graphic contrast of form, color, and texture, this study of a delicate petal balancing like a gondola on the edge of a gnarled leaf is a haunting image symbolic of the beauty of youth versus age. A narrow depth of field has been used to bring the fine details into sharp focus, accentuating the contrasting textures.

Viewing a heavy industrial site from a wheatfield highlights the contrast between the two. This is emphasized by the half-and-half composition of the image and the different color casts of each—the blue of the belching chimneys and the gold of the ripening wheat.

City centers are a rich source of interesting material. This shot of a city square in China reveals multiple contrasts—in scale, texture, dimension, color, and, most strikingly, in traditional and modern culture.

See also: Exploring textures pp.114–15, Street photography pp.160–61
Using color pp.232–33, Picture composition pp.260–61

Fall wildlife

Fall is a busy time of year for many animals, as they prepare for winter. This creates an opportunity for shots that are not only portraits of the animals themselves, but also show their relationship with their environment. From morning mist to low afternoon sun, fall provides an abundance of natural effects that can be used to add texture and atmosphere.

FOR THIS SHOT

Shooting into the sun highlights the fine mist in this woodland scene, while the wild boar is neatly framed by the tall trees on either side.

1 **Exposure**
To preserve detail in the background of your shot, expose for a dark area of the scene.

2 **Composition**
It's tempting to place animals at the center of any wildlife picture. Here, however, a more interesting shot has been created by positioning the boar in the bottom third of the frame.

3 **Timing**
Waiting for the boar to move into a patch of sun has been rewarded in a shot in which the animal's profile is picked out by gentle rays of light.

CAMERA MODE

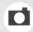 Select **Landscape** mode or **Aperture Priority** and an aperture of f/4

SENSOR/FILM SPEED

 Zoom to **maximum telephoto**

LENS SETTING

 Use a **low ISO** setting (e.g. ISO 100)

FLASH

 Shoot without **flash**

TRY THIS

After a warm summer, fall often brings a profusion of insects. Here, a ladybug is surrounded by water droplets of a similar size and shape to the insect itself. The speed of movement of most insects makes a tripod redundant, so shoot handheld, setting your camera to Macro mode with a high ISO setting. Pick a still day, to avoid wind disturbance.

ALTERNATIVE APPROACHES

Of course wildlife doesn't appear on demand or pose on cue. However, if you spend a little time studying animals' habits—favored habitats and feeding times—you'll increase your chances of success. You won't always have to venture far from home, either—gardens and parks are host to many types of wildlife.

Take advantage of animals rummaging for scarce food supplies to get in closer than you otherwise might. For an eye-to-eye shot like this you'll need to get down on the damp ground, so you might want to take something with you to lie on.

As many birds migrate for the winter, lakes and rivers can seem lifeless. Turn this into an opportunity to create ethereal images in the early morning, such as this solitary bird set against a pastel-tinted landscape. Overexpose by around 2/3 stop to preserve brightness.

TAKE IT FURTHER
GETTING CLOSER

Super-zoom cameras with long focal lengths will enable you to get close-up images of animals while keeping your distance. Even if you can't get a clear view, a glimpse through foliage can make a very effective image—especially if you can see the eyes.

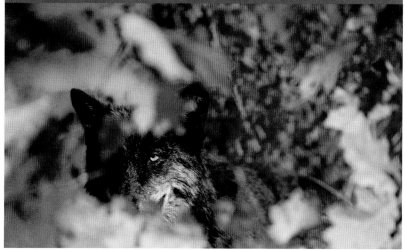

See also: Winter wildlife pp.48–49, At the animal park pp.80–81, Garden safari pp.172–73, Colors of fall pp.266–67

In the kitchen

The hub of the home, the kitchen is far more than just a place to prepare food. It's often the place where children do their homework or "help" with the cooking, and where friends and neighbors gather when they drop by. So it's an ideal setting for relaxed, informal portraits. The kitchen is also a rich source of material for interesting still-life shots—brightly colored ingredients, gleaming utensils, and gadgets are all worth exploring with your camera.

CAMERA MODE	LENS SETTING
Select **Portrait** mode or **Aperture Priority** and an aperture of f/2.8	Zoom to **medium telephoto**

SENSOR/FILM SPEED	FLASH
Use a **low to medium ISO** setting (e.g. ISO 100 to 400)	Shoot with **fill-in flash**

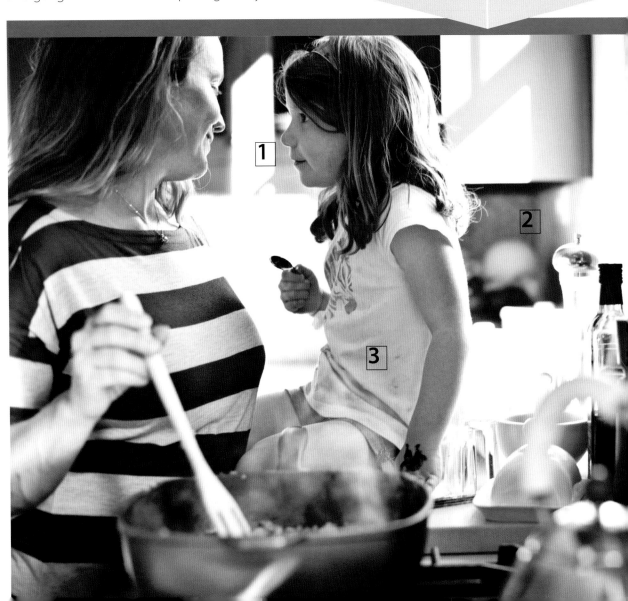

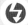

TRY THIS

Make a mini photo story by taking a series of images recording the activities taking place in your kitchen over a period of time. Children tend to make the most amusing subjects, but the preparations for a party or a special meal would make a fun sequence too.

FOR THIS SHOT

This charming shot depicts a mother and daughter having a tasting session. The natural lighting, reinforced by a little fill-in flash, creates an informal mood that suits the subject.

1 Composition
Placing the mother and daughter in the corner of the image brings the otherwise negative spaces of the kitchen into the fore.

2 Portrait mode
Use Portrait mode because the limited depth of field ensures that, in a cluttered setting like this, the subjects stand out sharply while the background is slightly blurred.

3 Balance the lighting
Use very small amounts of fill-in flash (and set an underexposure for the flash) to overcome the high contrast effects created by sunlight and shadows.

ALTERNATIVE APPROACHES

Look in your cupboards for interesting objects or ingredients to photograph, or, for a more challenging project, try setting up a reportage-style shoot at a restaurant.

Ask if you can photograph the kitchen of a local restaurant (promise not to get in the way). The pace and setting will be very different from at home and it will give you the chance to take some character shots of the staff as they go about their business.

Eye-catching arrangements of spices, vegetables, and fruits can make vibrant still-life shots. Think about the role of color, shape, and pattern, and explore different angles for different effects.

See also: Birthday parties pp.108–09, People at work pp.186–87, Around the house pp.296–97, Using flash pp.344–45

Out of season

In high season parks, fairgrounds, and coastal resorts provide a backdrop for lively pictures of friends and families having fun. Out of season, however, the absence of people in these usually vibrant environments can be exploited to create images that have a distinctly melancholy feel. Look for compositions that play on the contrast between an object or area's normal function and its current neglected state.

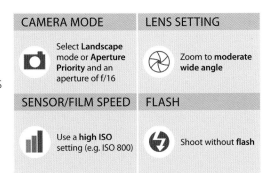

CAMERA MODE	LENS SETTING
Select **Landscape** mode or **Aperture Priority** and an aperture of f/16	Zoom to **moderate wide angle**

SENSOR/FILM SPEED	FLASH
Use a **high ISO** setting (e.g. ISO 800)	Shoot without **flash**

FOR THIS SHOT

Devoid of people, this children's playground feels bleak and abandoned. By concentrating on just one item of equipment, the sense of loneliness is compounded.

1 **Color**
Choose an overcast day for flat lighting that suppresses bright colors. Try experimenting with the white balance or color saturation settings on your camera to produce even more muted tones.

2 **Conditions**
Make the most of less favorable weather conditions to create atmosphere in your pictures. Here, the fog obscures any distant signs of life, isolating the play park and providing a ghostly backdrop.

3 **Composition**
Positioning the slide to one side—leaving a space in the shot that would usually be occupied by action—enhances the feeling that something is missing.

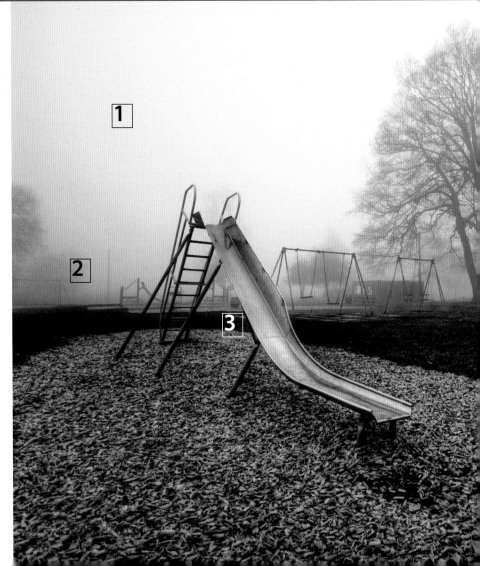

ON YOUR PHONE
ISOLATING OBJECTS

A selective focus app can be used to create an exaggerated depth of field effect, thowing the background out of focus. Here, it concentrates attention on the foreground detail—a swing that has clearly not been used for many weeks.

ALTERNATIVE APPROACHES

Without the distraction of the crowds, you're free to focus on form and color. Set against a desolate landscape the gaudy colors and quirky shapes characteristic of recreational areas really stand out, so make a feature of them in your shots.

Use the playful, temporary architecture of fairground stalls, beach huts, and souvenir shops to create colorful compositions. Frame your shots to contrast them against empty spaces in the scene, such as the sky or a deserted promenade.

In harsh weather, when gray skies combine with frost or snow to create a monochrome landscape, look out for any splashes of color. They'll stand out and add an extra dimension to your image.

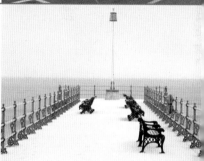

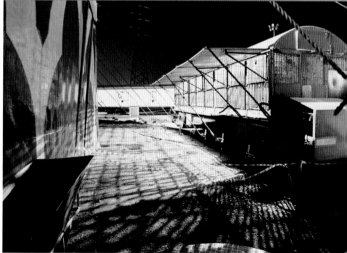

At closing time, fairgrounds have a haunted atmosphere: the scene is bereft of people, but the memory of activity remains. In situations like this, exploit the eerie patterns formed by the interplay of light and shadow.

See also: A walk in the park pp.22–23, Lost and abandoned pp.244–45, Shades of gray pp.254–55, Mist and fog pp.326–27

Bonfire

Once night falls, fall celebrations are often focused around a bonfire—a wonderful opportunity for dramatic shots exploring the contrast between the fire and the inky darkness of the sky. Experiment with abstracts of the flames and smoke, and take advantage of the fire's warm glow to create some striking shots of the spectators enjoying the blaze.

FOR THIS SHOT

In this shot, the orange glow of the smoke and the building beyond create a painterly effect, forming a vivid contrast with the dark blues and black of the rest of the scene.

1 **Focusing**
Cameras struggle to focus in low light. Focus manually or point the camera at the brightest part of the scene and use that to lock focus.

2 **Exposure**
It can be tricky to get the exposure right for dimly lit scenes. Start by underexposing by 1 stop, then vary this by 1/3 stop increments above and below.

3 **Sensitivity**
Set the ISO sensitivity high—any noise will add to the atmosphere and you'll be able to shoot without a tripod.

CAMERA MODE

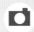 Select **Auto** mode or **Aperture Priority** and an aperture of f/5.6

SENSOR/FILM SPEED

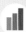 Use a **very high ISO** setting (e.g. ISO 1600 to 6400)

LENS SETTING

 Zoom to **moderate telephoto**

FLASH

 Shoot without **flash**

ON YOUR PHONE
BOLD SILHOUETTES

Camera phones may have trouble producing images that are true to color in the high-contrast lighting around a bonfire, so try shooting strong images then converting them to black and white. Any overexposure will create interesting silhouettes.

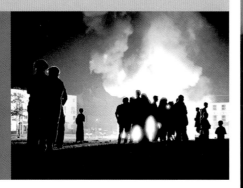

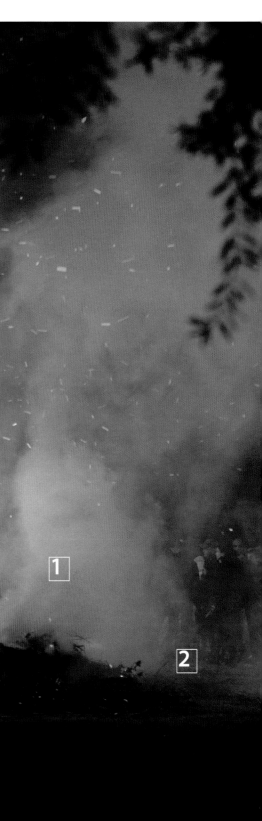

ALTERNATIVE APPROACHES

Your approach to photographing bonfires may vary, depending on the size of the fire and the crowd around it. Make use of the light from the fire to create chiaroscuro images of the revelers, focus on the flickering flames, or experiment with exposures to take intriguing shots of light trails in the sky.

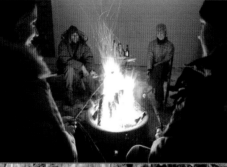

Bonfires cast a theatrical orange glow up onto the faces of people sitting around them, rather like footlights on a stage. Move up close to your subjects and take the time to find a strong composition. Here, the two people at the sides of the shot have been used to frame the fire and other onlookers.

Zoom in for some close-ups of the heart of the fire. Even though the flames are bright, it's worth experimenting with flash. Light from the flash will illuminate the charred logs and wood that would otherwise appear in silhouette, creating a more textured image.

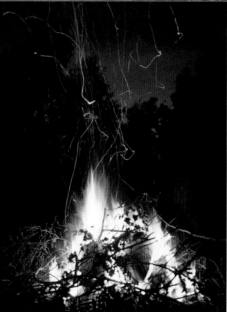

Try different exposures when photographing the bonfire. Rather like flowing water, flames appear to merge into silken rivulets when shot using exposure times of 1 or 2 sec. Leaping sparks become jagged trails of light against the dark sky.

See also: Cozy Interiors pp.26–27, Light trails pp.90–91, Working in low light pp.288–89, Fireworks pp.340–41

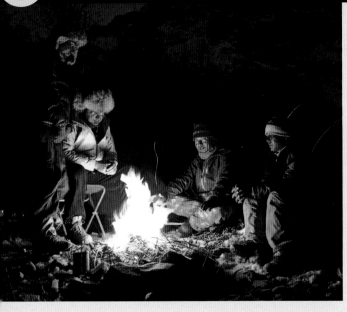

Working in low light

With large aperture lenses and sensitivity settings reaching up to ISO 200,000, modern digital cameras are capable of producing impressive images in even the lowest light. Cameras reveal colors and details in the dark that, to us, are almost invisible, and scenes that appear dull in the day can be transformed when the sun goes down. Take your camera out after dark and discover a new way of seeing the world.

▶ NIGHT VISION

In low light conditions, there is a great difference between what the human eye can see and what the electronic eye of a camera's sensor can detect. By using a long exposure or a high ISO sensitivity setting in the dark, your camera is able to accumulate enough light to deliver colors and tonal richness that are impossible for our eyes to perceive. In fact, colors remain just as bright and vivid in low light as they are in daylight—the colors themselves haven't changed. While high-sensitivity film suffered from obtrusive grain and poor color and contrast, modern sensors produce excellent images even at very high ISO settings.

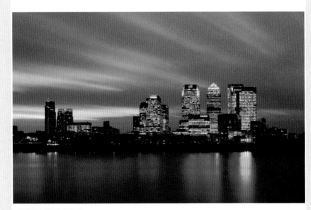

RICH COLORS

▶ TAKING BETTER PHOTOS

There are endless subjects for you to explore with low-light photography, but wherever you point your camera, the following tips will help you to get the best results:
• Set a high ISO sensitivity to limit blurring from camera shake; any extra noise this produces can be reduced later in post processing on your computer.
• Use wide apertures (such as f/2.8) and long exposures to let in more light, but keep to exposure times of 1/60 sec or shorter if hand-holding the camera.
• Focus on a detailed or high-contrast area to help your camera's focusing system lock on.
• Shoot in RAW format for flexibility in post-processing.
• Try underexposing by 1 or 2 stops to preserve the dark tone of your night photos.
• If possible, bracket your shots to ensure that you get a satisfactory exposure (see pp.316–17).
• If using flash, invest in an off-camera unit that you can direct at the subject at an angle, or bounce off a surface, for better lighting effects (see pp.344–45).
• If your camera or lens has image stabilization, make sure it's switched on.
• Shoot cityscapes at twilight, for a mix of ambient and artificial light, with the white balance set to Tungsten.
• If you have an SLR, buy the fastest lens (widest maximum aperture) you can afford.

▶ MOONLIT LANDSCAPES

One of the possibilities created by the digital camera's mastery of darkness is photographing landscapes by moonlight. Although the moon can appear very bright, it provides a very small fraction of the light of the sun. This means that to capture landscapes you'll still need to use long exposures and high ISO settings. Try to shoot on clear nights around the full moon. Start by taking shots at ISO 800 or 1000, with an aperture of f/4 and an exposure time of 4 sec, then experiment with longer exposures and smaller apertures.

The results are well worth the effort. You'll get magical, eerie landscapes and luminscent skies studded with bright stars.

LIGHT OF THE MOON

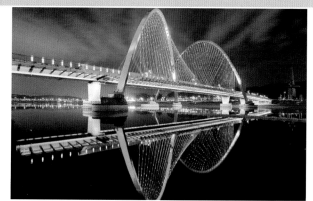

REFLECTIONS AMPLIFY THE EFFECT OF LIGHTS

POOLS OF LIGHT CREATE DEPTH

BLACK AND WHITE EMPHASIZES CONTRAST

FILL-IN FLASH COMPLEMENTS AMBIENT LIGHT

Late Fall

bare **branches** reaching to the sky

“ Autumn's… **golden richness** speaks not of the innocence of spring, nor the power of summer, but of the **mellowness** and **kindly wisdom** of approaching age ”

Lin Yutang

wild **weather**

dark and light, moody and bright

haunting **landscapes**

lavish illuminations

Festival of light

Many different societies celebrate the approach of winter. Historically, some were an occasion to banish the dark, albeit for a short time, while others had—and still have—religious meaning. Whatever their function, festivals invariably involve light displays and colorful decorations, and these are a gift for photographers. To capture the true spirit of the festivities get as close as you can the action and shoot freely.

CAMERA MODE	LENS SETTING
Select **Portrait** mode or **Aperture Priority** and an aperture of f/2.8	Zoom to **moderate telephoto**

SENSOR/FILM SPEED	FLASH
Use a **high ISO** setting (e.g. ISO 1000)	Shoot without **flash**

FOR THIS SHOT

This picture depicting crowds of people celebrating Diwali captures a tender moment of interaction amidst the throng.

1 Lighting
Using only ambient candlelight gives a scene a warm glow. Here, the swathe of candles in the foreground has captured the people at the front in soft light, but left those toward the back in shadow.

2 Composition
The horizontal arrangement of the candles and rows of people across the full width of the image has produced a nicely balanced composition.

3 ISO setting
When shooting scenes in low light, turn up your camera's ISO setting. This enables you to use exposure times short enough to reduce motion blur.

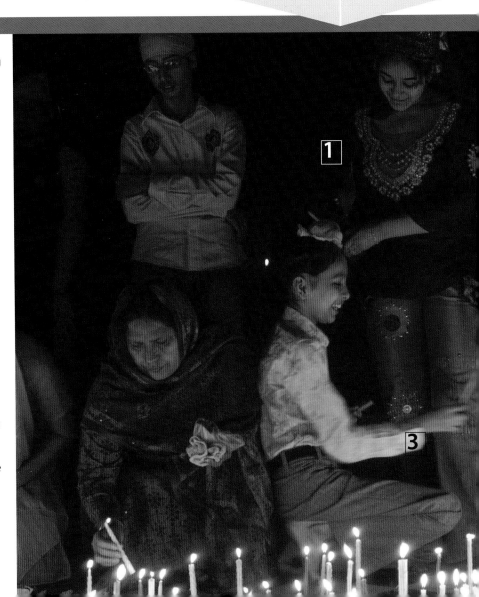

TAKE IT FURTHER
ZOOM BLUR

This arresting shot of a festive light display was captured by zooming out while the picture was being exposed. To achieve this, you'll need an SLR with a zoom lens. Set the shutter time to 1/2 sec and zoom out steadily after pressing the shutter button.

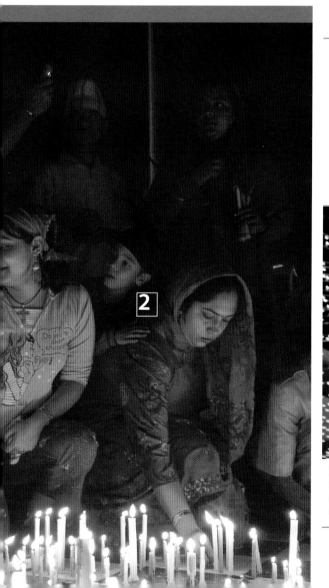

ALTERNATIVE APPROACHES

For a rounded portrait of an event, try to focus on intimate moments as well as sweeping overviews. If a festival is unfamiliar to you, spend time exploring or do some research to ensure that you successfully capture all the key elements.

For many, festivals are simply entertaining, but some have a more solemn purpose, and involve important symbolism. Zoom in to capture details and use a large aperture to produce a narrow depth of field in order to emphasize the point of focus.

Use lines of streamers and decorations decking the streets to create striking compositions. These paper flags, shot against the sober backdrop of a church in shadow, are nicely backlit by the high sun, which is positioned just out of shot.

Look for ways that you can capture childrens' sense of wonder at this type of event. Catch them lit by the festive lights or gazing in awe at displays. Add drama by getting down low and shooting upward, which will isolate the child against the lights.

See also: *At the carnival pp.158–59, Working in low light pp.288–89, Winter markets pp.332–33, Fireworks pp.340–41*

Around the house

When searching for photogenic locations, it's easy to overlook your own home. But if you spend some time observing your everyday surroundings with a photographer's eye, possibilities for images will soon occur—from straightforward compositions that showcase your DIY or interior design skills to more abstract shots focusing on details. Look for ways to exploit both natural and artificial light sources.

CAMERA MODE	LENS SETTING
Select **Landscape** mode or **Aperture Priority** and an aperture of f/16	Zoom to **moderate wide angle**

SENSOR/FILM SPEED	FLASH
Use a **low ISO** setting (e.g. ISO 100)	Try shots with and without **fill-in flash**

FOR THIS SHOT

This striking composition, divided into two halves with light pouring in from the top of stairs and the back door, encourages you to explore.

1 Lighting
Faced with a combination of daylight and artificial lighting, set your camera's white balance to auto or—if you want a warmer appearance— select the sunlight setting.

2 Straight lines
Use a tripod to ensure your camera is level. Tilting it even slightly will create distortions—the proliferation of straight lines in this image would expose any flaws.

3 Using flash
A touch of fill-in flash— but not full flash—will help lift and lighten dense shadows in interior shots. Experiment both with and without flash.

For 360 degree panoramas of your home interior, use a camera phone and a panorama app, which allows you to take consecutive shots and then stitches them together for you. To minimize distortion, ensure that you keep your phone level throughout.

ALTERNATIVE APPROACHES

Whatever the size or style of your home, on those dark fall days when you just don't feel like venturing out, it can offer you plenty of scope for a photography project or two.

All manner of domestic articles, from crockery and cutlery to cushions and fabrics, can be arranged to create interesting images. For maximum impact, stick to a theme, such as shape or color.

A simple minimal interior can be used to create an equally minimalist image. Adjust the position of furniture or accessories, and make use of, spotlighting for a stronger composition.

Use an open window to frame the view outside. The offbeat angle used here allows the viewer to see both the interior and exterior of the home and captures the light falling onto the table.

See also: *Indoor abstracts pp.24–25, Cozy interiors pp.26–27, Modern interiors pp.220–21, Using flash pp.344–45*

Outdoor sports

Sports photography tends to be all about action-packed shots filled with color and movement. However, late fall weather conditions—from low, pale sunlight to torrential downpours—add an extra dimension to the subject. Experiment with a variety of approaches, from long-distance pictures that capture both the activity and its setting, to shots that put you in the thick of things.

CAMERA MODE	LENS SETTING
Select **Sports** mode or **Shutter Priority** set to 1/250 sec	Zoom to **moderate wide angle**

SENSOR/FILM SPEED	FLASH
Use a **high ISO** setting (e.g. ISO 1600)	Try shots with and without **fill-in flash**

FOR THIS SHOT

This picture of an amateur soccer game, captured under the soft golden glow of a pale sun, says more about the atmosphere than the action.

1 Composition
An unusual composition, with the subjects grouped in the upper third of the frame, allows the low sun to be out of shot and the players' long shadows to stretch toward the foreground.

2 Exposure
Set your exposure carefully to prevent the subjects from being too dark and shaded. Don't worry if the sky is a little overexposed; it simply emphasizes the glare of the low sun.

3 Depth of field
Shooting at a small aperture setting has created an extensive depth of field. Almost every part of this image, from the grass in the foreground to the trees in the distance, is sharp.

TAKE IT FURTHER
PURSUING PASSION

For close-up sports shots you'll need a super-zoom or an SLR camera and lenses that let you zoom in tight on the action. Those lenses will also need to have wide maximum apertures – essential for delivering action-freezing short exposure times.

ALTERNATIVE APPROACHES

When choosing your approach, think about the way you can best communicate the essence and the atmosphere of the sport. As well as taking documentary-style pictures, experiment with different angles and perspectives.

Although wet conditions present a challenge for the players, they can result in evocative, characterful images. The framing of this picture concentrates our attention on the mud, and tells us all we need to know about the game.

Accentuate dreadful weather conditions by increasing the ISO sensitivity—any image noise will only add to the atmosphere. Here, backlighting also focuses the attention on the rain. Zoom in tight to give a sense of what it's like to be in the middle of the action.

Adjust your approach to reflect the nature of the sport. Your viewpoint will give distinctly different results. For example, zooming in on rowers from the riverbank will result in a shot that communicates effort and exertion. Shooting from a raised vantage point gives an impression of order and effortlessness.

See also: Watersports pp.182–83, On two wheels pp.188–89, Marathon runners pp.246–47, Winter sports pp.330–31

Window-lit portraits

The soft, diffused light from a window can be used for natural, flattering portraits and many photographers exploit it as a simple and cost-effective alternative to expensive studio lighting. It's easy to position yourself so that the window is out of view—making your subject the sole focus of your image—but incorporating the window in the shot can add interest and give a sense of place.

CAMERA MODE	LENS SETTING
Select **Portrait** mode or **Aperture Priority** and an aperture of f/8	Zoom to **moderate telephoto**

SENSOR/FILM SPEED	FLASH
Use a **low ISO** setting (e.g. ISO 100)	Try shots with and without **fill-in flash**

FOR THIS SHOT

Regardless of whether your image is candid or posed, take plenty of pictures. The quality of the light may change while you work, giving each image a different feel.

1 **Candid or posed**
Although candid portraits have an authentic feel, the subject's ignorance of the camera doesn't have to be genuine. Spend some time working on a pose that looks informal—your subject may feel more relaxed if he or she has something to hold.

2 **Exposure**
Overexpose your image by 1 stop to burn out the view through the window and keep your subject's face well lit.

3 **Rim lighting**
The light from the window rim lights elements of the subject rather than bathing him in light, giving the picture a mellow feel.

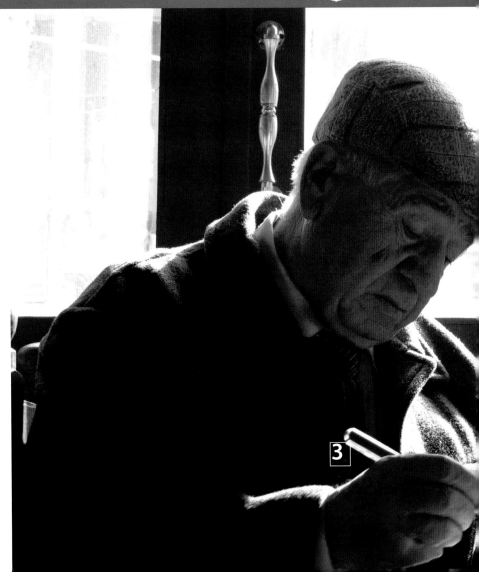

TRY THIS

For an unusual portrait, position your subject so that you catch his or her reflection in the window. Try a letterbox crop with the subject at the edges for even less orthodox results.

2

1

ALTERNATIVE APPROACHES

When the sun is shining directly through a window, the resulting light—though softened by the glass—is harsher, brighter, and more focused than indirect light. Exploit the varying levels and intensities of light to make portraits with a markedly different aesthetic and mood.

You can turn your window into a feature by having your subject face the view beyond. This results in an unconventional portrait in which body language plays a key role. In this shot, by exposing on the bright outside, the boy is thrown into silhouette.

Lens flare, caused by light reflecting around and within the camera lens, is usually something to be avoided. Used sparingly, however, the lightening and softening it produces can be used to impart a dreamlike or romantic feel.

The shadow from a decorative window can be used to add interest and symmetry to your portrait. Experiment with the position of your subject to obtain the lighting effect you desire. To cast a strong light directly onto your subject's face, position her face-on to the window and shoot from the side.

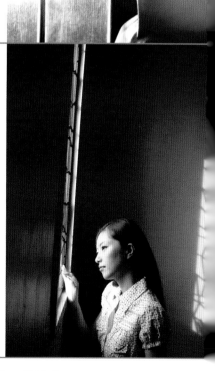

See also: Indoor child portraits pp.32–33, Character portraits pp.82–83, Backlighting and silhouettes pp.204–05, Picture composition pp.260–61

At the aquarium

Aquariums offer the chance to photograph spectacular marine creatures that you might never have the opportunity—or perhaps the nerve—to see in the wild. The aquarium can be a testing environment for photographers: the light levels are low and the glass tanks and water create a color cast. However, armed with a few simple techniques to counteract these limitations, you can capture some great images.

CAMERA MODE	LENS SETTING
Select **Landscape** mode or **Aperture Priority** and an aperture of f/4	Zoom to **moderate telephoto**

SENSOR/FILM SPEED	FLASH
Use a **high ISO** setting (e.g. ISO 1600)	Shoot without **flash**

FOR THIS SHOT

Many of the fish and other sea creatures in aquariums will respond favorably to the presence of people up close, resulting in touching moments like this one.

1 Focusing
Aquarium plexiglass is very thick, which may confuse some focusing systems. Try prefocusing on an object at an appropriate distance outside the tank, then recompose your image.

2 Keep it steady
It is unlikely that you'll be permitted to use a tripod, so brace yourself against a wall, or keep your camera strap taut to steady your camera.

3 Exposure
Aim for an exposure time of at least 1/60 second. Increasing the ISO sensitivity and using a wide aperture (f/4) will compensate for the low light levels.

TAKE IT FURTHER
COLOR CORRECTION

The optical properties of water can result in a green color cast that's exaggerated by the thick glass of an aquarium (right). With an SLR or enthusiast compact you can shoot in RAW mode to produce an unprocessed replica of the data from your camera's sensor. This gives you more control when you come to correct the image with manipulation software (far right).

ALTERNATIVE APPROACHES

Aquariums are excellent sources of photo ideas. In addition to close-up shots of sea life, visitors to the aquarium, and the aquarium itself, make good subjects for pictures.

Make the most of crowds of people at the aquarium. Stand back and include a group of visitors—silhouetted against the blue of the water—to convey the scale of the tanks and the creatures inside them.

You'll need to be patient to capture a dramatic portrait like this. Instead of moving around trying to follow your subject, watch its behavior, position yourself, and wait for it to come to you.

Shots like this are all about perspective and symmetry, but the wide angle of the shot and the position of the sharks are key to its effectiveness.

See also: Pond life pp.132–33, People under water pp.174–75, Reflected city pp.184–85, Working in low light pp.288–89

Street lights

Midwinter street scenes, thick with mist or fog and bathed in moody light, possess an enigmatic glamour. Make the most of the partial illumination offered by street lighting to create pictures that suggest more than they reveal. You can choose to feature the light source itself, or simply capture its effect. Try shooting into and away from the light, and use falling rain, wet surfaces, and reflections to evoke a sense of mystery.

CAMERA MODE	LENS SETTING
Select **Auto** mode or **Aperture Priority** and an aperture of f/8	Zoom to **moderate wide angle**

SENSOR/FILM SPEED	FLASH
Use a **medium to high ISO** setting (e.g. ISO 400 to 800)	Shoot without **flash**

FOR THIS SHOT

The presence of fog on an early winter evening has transformed this scene by concealing the background and softening the harsh street light.

1 Exposure
Set your exposure on the residual light in the sky, rather than the artificial light source. This will capture the scene clearly, while adding a atmospheric flare to the street lamps.

2 Depth
Shoot before the sky becomes totally dark. Any remaining light will create silhouettes in the more distant elements of the scene.

3 White balance
The color temperature of streetlighting can be unpredictable, but start with the Tungsten white balance setting, which cools down the warm tones. Experiment with different settings for warmer or cooler results.

TAKE IT FURTHER
A GRITTY WINTER SCENE

Enhance or exaggerate the gritty, noir-like look of a brightly lit blizzard by using image manipulation filters. Use the Add Grain filter to give the scene a coarseness in keeping with the weather. Use the Colorize feature (or a photo filter effect) to add a cool, blue tone to the image.

ALTERNATIVE APPROACHES

Think of street lights as more than just street furniture or a source of light. Try using them as an intrinsic part of the composition, in which they can play a large part in defining the atmosphere and feel of a scene.

In this picture, different colored street lights have been used to draw the eye down the backstreet. By getting down low and zooming out wide, the slick sheen on the cobbles and the reflection in the puddle have been included to add depth and foreground interest.

Streetlights tend to throw pools of light in their immediate vicinity. Compared to our eyes, digital cameras are very good at picking up on these, so look for the interesting compositions that these pools create.

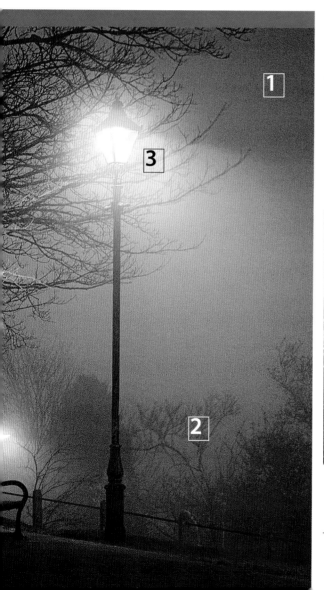

Street lighting can boost scenes that are still bathed in residual daylight. Here, a lamp casts a golden shaft of light across the wet road, producing a very striking foreground to the scene.

See also: Street shadows pp.52–53, City lights pp.62–63, Working in low light pp.288–89, Exposure pp.316–17

Fallen leaves

The riot of color that characterizes autumn might seem to come to an end when the leaves fall from the trees. However, you still have a chance to capture those glorious colors before they take their final curtain call, albeit from a rather different perspective. Make the most of the brief time when fallen leaves carpet the ground in a final flourish of russet and gold.

FOR THIS SHOT

The natural arrangement of fallen leaves over bare branches reflected in a roadside puddle creates a beautiful mixed-media collage of a tree.

1 Underexpose
To preserve the leaf colors and the reflection of the blue sky on the water, underexpose by 1/3 or 2/3 stop.

2 Format
To accommodate as many leaves as possible and increase the sense of depth, zoom out to a moderate wide angle and shoot in portrait format.

3 Timing
A passing cloud has allowed a burst of sunlight to lift the scene without burning out the reflection of the branches.

CAMERA MODE

Select **Landscape** mode or **Aperture Priority** and an aperture of f/16

SENSOR/FILM SPEED

Use a **low ISO** setting (e.g. ISO 100)

LENS SETTING

Zoom to **moderate wide angle**

FLASH

Shoot without **flash**

TRY THIS

Create an artwork from fallen leaves. Collect specimens based on a theme, such as shape, pattern, or color, and arrange them on a plain surface. Here, the dark trunk of a fallen tree gives the background texture without distracting from the leaves.

ALTERNATIVE APPROACHES

Floating on a pond or strewn across a sidewalk, fallen leaves can look spectacular en masse, creating a gorgeous mosaic that brightens even the gloomiest of settings. However, detailed and delicate images can be made using a single leaf, or just a handful of leaves.

With its harmonious combination of colors, a confetti-like carpet of fallen leaves makes a colorful picture, but can be lacking in focus. Look out for situations like this, where the landscape imposes patterns and structure on the leaves.

Leaf colors appear at their most vivid—and luminous—when backlit. Rather than searching for perfectly positioned leaves, select one with a pleasing shape and color and place it as required. Notice the way that shadows fall on the leaves and the impact this has on your composition.

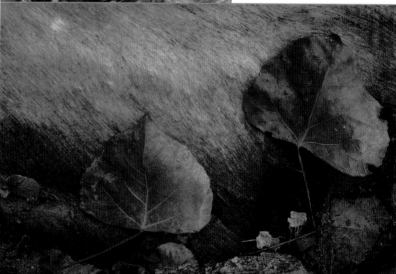

Less vibrantly colored leaves can be used to create more mellow, atmospheric images. Choose your leaves and background carefully for a harmonious composition, then select Macro mode to maximize texture.

See also: *232–33 Using color pp.232–33, Colors of fall pp.266–67, In the forest pp.270–71, Playing in leaves pp.272–73*

Wild outdoors

Braving extreme weather conditions can be exhilarating and will reward you with dramatic images, as long as you heed safety warnings and remember to keep your camera dry. Unusual light conditions, both before and after a storm, combined with strong winds and lashing rain set the stage for some wonderfully atmospheric pictures. Where possible, take cover and shoot fast, as conditions can change from one moment to the next.

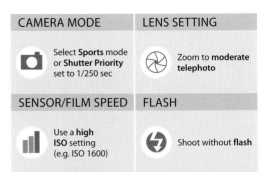

CAMERA MODE	LENS SETTING
Select **Sports** mode or **Shutter Priority** set to 1/250 sec	Zoom to **moderate telephoto**

SENSOR/FILM SPEED	FLASH
Use a **high ISO** setting (e.g. ISO 1600)	Shoot without **flash**

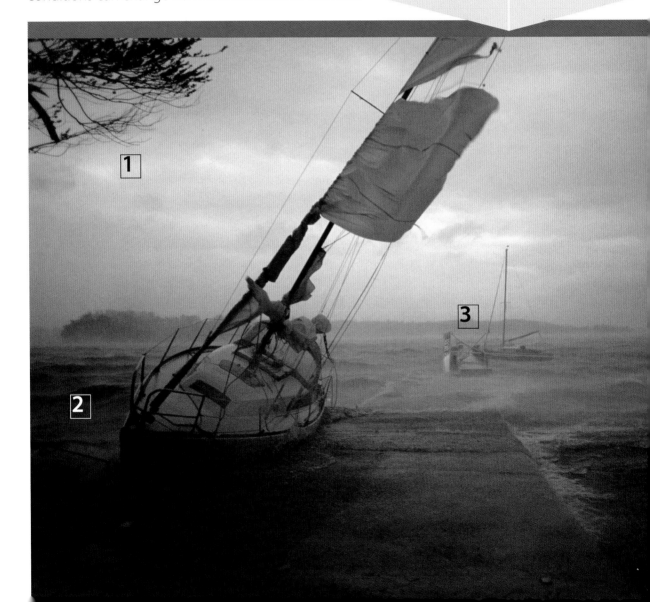

ON YOUR PHONE
THE COMING STORM

Many camera phone apps can be used to accentuate bad weather shots. Use filters that exaggerate contrast, add vignettes, or suppress color. Each produces different results that will make your images look as if they were taken in extreme conditions.

ALTERNATIVE APPROACHES

In stormy weather, normally static scenes are set in motion by the whipping wind and the rain has a softening effect on the landscape. Look for strong shapes and splashes of color to give your images an interesting focal point.

This view from an interstate bridge successfully exploits the contrast between the solid shapes of the trucks, the pinpricks of oncoming headlights, and the pale clouds of spray.

FOR THIS SHOT

Steely grays and slate blue dominate this striking shot of a yacht keeling over in the wind. Waiting for a crack in the heavy cloud cover to illuminate the stormy sky has added a touch of melodrama to the scene.

1 Exposure
Underexposing by 2/3 stop intensifies the blue tones and revealed detail in the clouds that might otherwise appear featureless.

2 ISO setting
Use short shutter times to keep the stormy waves well defined. You may need to increase the ISO sensitivity to 1000, or even higher.

3 Zoom in
Bad weather can be treacherous and change quickly, so use your zoom to get in close to details, rather than risk your safety.

Take cover in a dry place to catch some candid, fun shots of people battling against the weather. Look out for fleeting moments that capture its effects in a new way. This woman's crumpled red umbrella looks like a giant flower that's about to swallow her up.

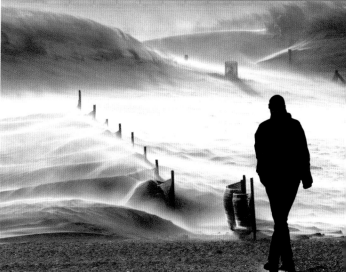

Strong winds can create unusual effects in the landscape. Here the sand resembles a tempestuous seascape. In situations like this use a tripod to steady the camera, and keep it protected.

See also: Snowstorms pp.44–45, Rainy days pp.98–99, Changing skies pp.106–07, Mist and fog pp.326–27

Romantic portrait

Portraits of the person you love are not just about capturing a true likeness, but also about the feelings you have for them. Unlike quick, informal shots, these images are carefully set up to capture a characteristic, particular look, or quality that you find attractive. As with all portraits, you'll obtain the best results if your subject feels comfortable and relaxed.

FOR THIS SHOT

In this portrait, the lighting creates a striking contrast between shadows and highlights focusing attention on the woman's eye, lips, and hand.

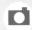 **Lighting**
Warm lighting, reminiscent of the light from a fire, casts an amber glow and helps to establish a relaxed, intimate mood.

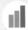 **Eyes**
Eye contact is vital for creating a sense of shared intimacy, so make sure the eyes are in sharp focus. Once you're happy with a pose, take several shots to capture the best expression.

 Framing
Zoom in close to the face. Here, the shot has been tightly framed to create a more dynamic image.

CAMERA MODE

Select **Portrait** mode or **Aperture Priority** and an aperture of f/2 or f/2.8

SENSOR/FILM SPEED

Use a **high ISO** setting (e.g. ISO 1000)

LENS SETTING

Zoom to **moderate wide angle**

FLASH

Shoot without **flash**

TRY THIS

Use a mirror to help create intriguing shots. The mirror image will show the side of the face you can't see, producing a double image of your subject. Cropping in closely so that you can't see the whole head adds to the impact of the portrait.

ALTERNATIVE APPROACHES

Because you know your partner well, you can try out both informal shots and more staged poses. Lighting and props play an important role in setting the mood for romantic portraits, so experiment with different locations and try out various light sources and exposures to see how they change things.

Take the time to compose your images carefully. Think about where to place your subject and ask her to try out different poses, to see what looks best. Here, strong lighting from the left highlights the model's arms and legs, as well as her face, creating some interesting shapes.

Informal shots can evoke tender memories. This unusual shot has been taken from a low viewpoint above the model's head, so that her body is foreshortened. Making the image black and white accentuates the the curves and planes of her shoulders and back, which are thrown into relief by strong light from the right.

Clever choice of location can make portraits more interesting. Here, the bare corner of a warehouse provides a rugged setting for a man working out. He has been positioned in front of a bright window so that he is backlit and partially in silhouette. The light picks out the contours of his back and torso, enhancing his physique.

See also: Character portraits pp.82–83, Window-lit portraits pp.300–01, Dimly lit interiors pp.338–38, Posed portraits pp.342–43

Skeleton trees

As winter sets in, deciduous trees shed the last of their leaves and reveal their intricate skeletal shapes. It's almost as if the essence of the trees is revealed through their beautiful filigree silhouettes. Get out with your camera and explore the eerie atmospheric effect that bare trees have on rural landscapes, or try juxtaposing their intricate, organic forms against the geometry of the urban environment.

CAMERA MODE	LENS SETTING
Select **Landscape** mode or **Aperture Priority** and an aperture of f/11	Zoom to **moderate wide angle**

SENSOR/FILM SPEED	FLASH
Use a **medium ISO setting** (e.g. ISO 400)	Shoot without **flash**

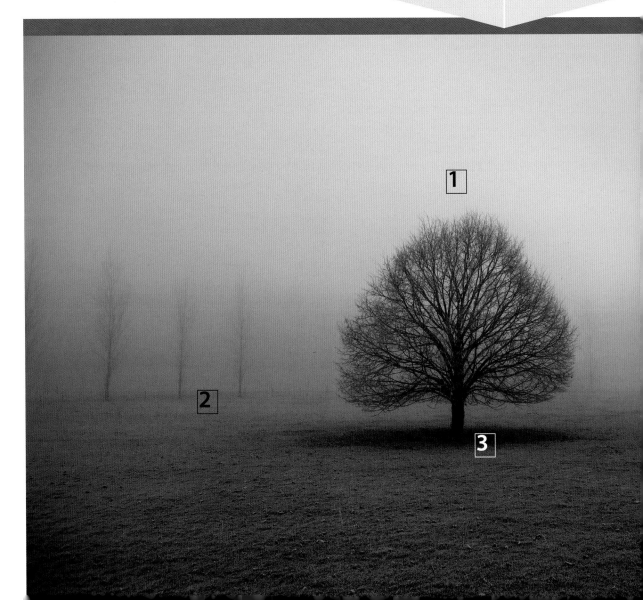

TRY THIS

To capture a ghostly image of a tree at night, mount your camera on a tripod, setting the ISO sensitivity to 100 and the aperture to f/5.6. Open the shutter, and use a flashlight to cast an ethereal light across the tree. As an alternative, experiment by using your flash at different intensities, if possible.

ALTERNATIVE APPROACHES

An image of a solitary tree set in a muted landscape has a timeless feel, evoking a sense of strength and permanence. But look out too for opportunities to capture dramatic images of leafless trees in more intriguing contexts.

Seek out trees in urban settings and capture the uneasy relationship between the organic architecture of the tree and that of the surrounding buildings. Shooting upward from a low angle emphasizes the vertical thrust of both.

Keep your eyes open for compositional tools and framing devices. Here, for example, the tree and field is glimpsed through a small window in the wall of a barn, creating an image within an image. Use a small aperture to ensure the whole of the image remains sharp.

FOR THIS SHOT

This picture of a lone tree standing in a misty landscape inspires feelings of isolation and detachment in the viewer.

1 Symmetry
When stripped of their leaves, some trees display a near-perfect symmetry. Highlight this by positioning the line of symmetry at the center of your shot and, where possible, exploiting any symmetry in the background.

2 Composition
To emphasize the feeling of its quiet solitude, the tree has been shot from a distance, is fairly small in the frame, and is surrounded by lots of empty space.

3 Creative exposure
In murky conditions, overexpose by up to 1 stop to keep the image as bright as possible. The tree will be rendered as a virtual silhouette.

TAKE IT FURTHER
YEAR-ROUND PROJECT

For a year-round project, shoot a single tree from the same place during each season. Make sure you take the exact position and use the same framing each time, and try to match the skies and the direction of the sunlight as much as possible.

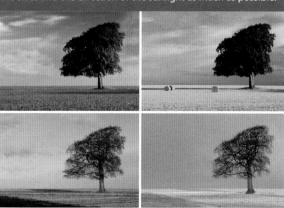

See also: Woodland shadows pp.34–35, Snow-laden trees pp.54–55, Colors of fall pp.266–67, Out of season pp.284–85

Silvery moon

Attempting to photograph the moon can be frustrating. Finding the right exposure is difficult, especially if you're trying to include the landscape, and you need to bear in mind that the moon appears much larger to your eye than it does to your camera (in fact, many of the most stunning shots of the moon that you see are actually composites). One way around both these problems is to shoot on a cloudy night.

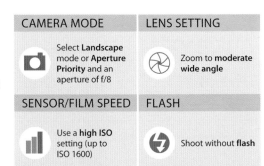

CAMERA MODE	LENS SETTING
Select **Landscape** mode or **Aperture Priority** and an aperture of f/8	Zoom to **moderate wide angle**

SENSOR/FILM SPEED	FLASH
Use a **high ISO** setting (up to ISO 1600)	Shoot without **flash**

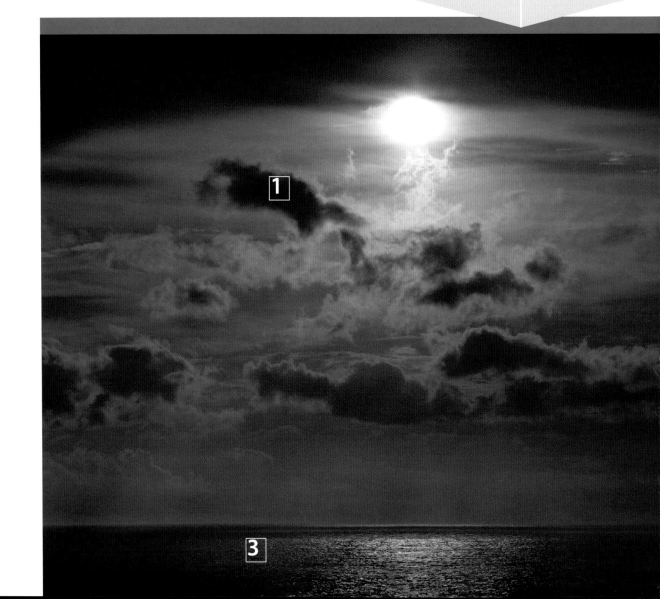

TAKE IT FURTHER
A CLOSER LOOK

For frame-filling images of the moon, you can get an adaptor that allows you to shoot through a telescope. Set the exposure control to automatic. Avoid shooting when the moon is full, as this can result in flat, shadowless lighting.

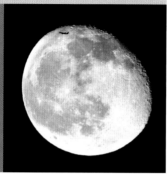

ALTERNATIVE APPROACHES

Although we usually associate it with nighttime pictures, the moon is often visible during the day too. Try photographing it at different times of day for images with a markedly different feel.

Shooting the moon during the day solves the problem of exposure, as its contrast with the sky is negligible. This is ostensibly a picture of a dramatic cloud formation, but the inclusion of the moon is what makes the shot stand out.

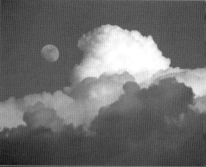

FOR THIS SHOT

The power of this seascape lies in the way the moonlight defines the outline of the clouds. The soft reflection of the moon balances the composition.

1 Exposure
For moonlit landscapes, underexpose by up to 2 stops from your camera's suggested reading to retain the dark tones.

2 Cloud cover
The moon can appear over-bright in a pitch-black sky, so choose a cloudy night when the light is diffused. Use a tripod so you don't have to hold the camera in position while you wait for a good cloud formation.

3 ISO sensitivity
Clouds—and the sea— will move while the shutter of your camera is open. To prevent any motion blur, set a high ISO sensitivity of up to 1600.

Without a telescope, it's difficult to make successful pictures in which the moon is the sole subject. For dramatic, eerily beautiful moon portraits, keep an eye out for those times when ice crystals in the atmosphere produce a white or rainbow halo effect.

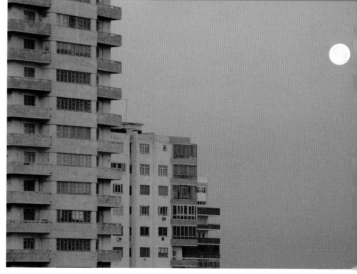

In this shot a long focal length has been used to capture the moon, set against a clear twilight sky, as an effective counterpoint to the tightly framed apartment blocks.

See also: *Purple twilight pp.42–43, Snowy sunsets pp.60–61, Changing skies pp.106–07, Working in low light pp.288–89*

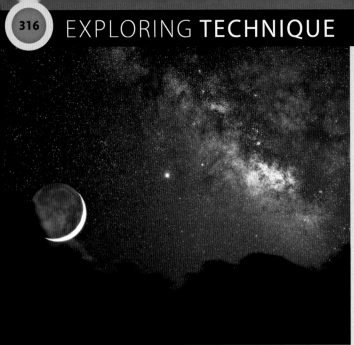

Exposure

Of all the factors that contribute to a good photograph, exposure is often the one that even experienced photographers can misjudge. Few modern cameras struggle to deliver acceptable exposures in the most common situations. However, when you start to push the boundaries of your photography, you might find your camera's autoexposure system wanting. When you've learned how to control your camera's exposure, you'll have mastered a powerful and creative tool.

▶ MAKING THE "CORRECT" EXPOSURE

A camera's autoexposure system aims to balance the lens aperture size, shutter time, and ISO setting to ensure that the light falling on the sensor captures adequate detail in the shadows, mid-tones, and highlights of an image. Given this strategy for achieving a "correct" exposure, we can broadly judge the exposure of any image. If its shadows and mid-tones appear too light, and its highlights are burned out, we deem an image to be overexposed. Conversely, if its highlights seem too dim, and its mid-tones and shadows are too dark, we consider an image to be underexposed.

If difficult conditions have caused your camera to produce a poor exposure, you can remedy this by using its Exposure Compensation control. This lets you override the camera's suggested exposure settings by adjusting the aperture size or shutter speed, or both.

If you anticipate exposure problems, and your camera has the feature, bracketing is useful. This works by making three, five, or more separate pictures with one press of the shutter button: one or more either side of the metered setting. From these you can then select the most satisfactory image.

−1 STOP

ORIGINAL EXPOSURE

+1 STOP

▶ METERING SYSTEMS

Even basic modern cameras have accurate metering systems. Most have center-weighted systems and some have more advanced metering.

Center-weighted metering systems calculate image exposure from the central part of the scene, where your subject is most likely to be placed. Multi-zone or evaluative metering is a more sophisticated system that breaks up the scene—especially the central area—into smaller segments and uses the readings to calculate the best exposure. Spot metering calculates an exposure from a small area of the frame, which is particularly useful when lighting conditions are difficult.

MULTI-ZONE OR EVALUATIVE METERING

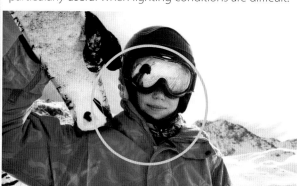

CENTER-WEIGHTED METERING

SPOT METERING

▶ CREATIVE EXPOSURE CONTROL

The "correct" exposure of an image will always be the one that best conveys your intentions. In fact, underexposure and overexposure can improve the look of your images in various ways. Try reducing exposure to combat glare in bright areas, create stronger silhouettes, and make mid-tone colors appear richer. By giving extra exposure you can create a light, dreamy atmosphere or blow out detail for artistic effect.

−1²/₃ STOP COMPENSATION

+2 STOPS COMPENSATION

Early Winter

burst of brilliance

> Winter **dawn** is the **color of metal**, The trees stiffen into place like **burnt** nerves

Sylvia Plath

a **cacophony** of color

opalescent **dawn light**

snow on snow on snow

dashing through the snow

Golden sunrise

Photographers often talk about the golden hour: the 60 minutes or so after sunrise and then again before sunset, when scenes are suffused with a warm golden light. A wondrous spectacle at any time of year, the winter sunrise, with its long shadows, is well worth getting up for, and offers the added bonus that it arrives much later than sunrise during the summer.

FOR THIS SHOT

Golden light combined with the contrast-reducing effect of mist, has created very special shooting conditions. The soft, almost sepia, tones are a perfect fit for the nostalgic feel of this shot of a deserted country road.

1 **Lighting**
Shooting into the sun lights up the icy tracks. The mist has diffused the light and reduced the lens flare that's often a feature of this technique

2 **Perspective**
Use a series of converging lines—here, the warm light reflecting off the road—to create perspective.

3 **Exposure**
In misty conditions, when the light is soft, modest overexposure (around 1/3 stop) stops the scene becoming dull and accentuates the highlights.

CAMERA MODE

Select **Landscape** mode or **Aperture Priority** and an aperture of f/8

SENSOR/FILM SPEED

Use a **low ISO** setting (e.g. ISO 100)

LENS SETTING

Zoom to **moderate telephoto**

FLASH

Shoot without **flash**

TRY THIS

The rising sun bathes melting ice in beautiful, if somewhat incongruous, warm amber light. Switch your camera to Macro mode to focus on the small details of the ice and shoot with a fast exposure time.

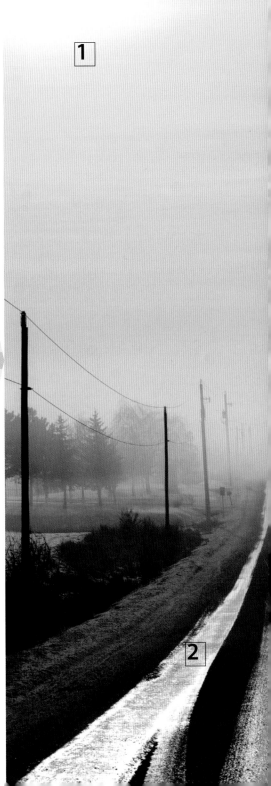

ALTERNATIVE APPROACHES

Trust your camera for early morning sunrise images—it can see more colors than you can. Notice the way the light changes, from strong reddish-gold at sunrise through to a softer, more pallid yellow later. Each tone will alter different scenes in various subtle ways.

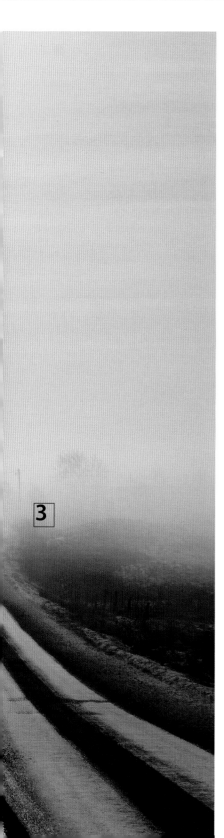

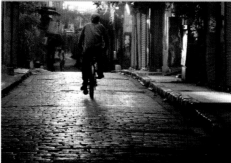

Use the glow from the rising sun to imbue street scenes with gorgeous opalescent colors. Here, the lone cyclist heading toward the brightness of the coming day, captures the tranquility of early mornings. For a wide depth of field in low light, you'll need to use a tripod to avoid camera shake.

Photographing a sunrise over water increases the overall light level of your pictures, and helps to bring out details and increase depth. This image of a jagged coastline and choppy sea is full of texture. Fill-in flash has been used to balance the sunlight and bring out detail in the foreground rocks.

3

Try using a sunrise to backlight a cityscape. Here, the soft yellow sky provides a simple and elegant backdrop for the elaborate buildings. Together with the glowing windows, the effect is stunning. Expose the scene for the foreground to retain shadow details.

See also: Snowy sunsets pp.60–61, Dazzling sunlight pp.222–23, Glorious sunsets pp.250–51, Exposure pp.316–17

Shops and shoppers

A shopping mall, or any busy retail street, with its crowds of people, modern architectural features, and imaginative window displays, is bursting with energy and life. In addition, at this time of year, they are often festooned with lavish decorations. There's plenty to photograph, but remember—for safety (and to avoid unwanted attention) try to be as discreet as possible.

FOR THIS SHOT

This photograph of a shopping mall atrium captures the activity, and gaudy splendor of these cathedrals of consumerism.

 Elevated position
Find a high vantage point and zoom out as far as possible to capture a sense of scale. Try to feature any seasonal displays—these are a gift for photographers.

 Color balance
With many different and unusual light sources, set your camera's white balance to auto—or experiment with different settings for unusual effects.

 Sensitivity
Since tripods are not allowed in most shopping malls set the ISO sensitivity to medium or high (ISO 400 to 800) for handheld shots.

CAMERA MODE

Select **Landscape mode** or **Aperture Priority** and an aperture of f/5.6

SENSOR/FILM SPEED

Use a **high ISO** setting (e.g. ISO 1000)

LENS SETTING

Zoom to **maximum wide angle**

FLASH

Shoot without **flash**

TRY THIS

Try your hand at street photography and you might find that some of your pictures take you into the realm of social commentary. For example, images of rich and poor, side by side, can create powerful and poignant contrasts.

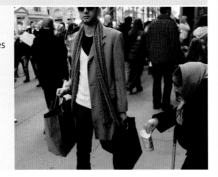

ALTERNATIVE APPROACHES

December is one of the busiest shopping months, providing endless opportunities to capture photos of people hurriedly, sometimes frantically, seeking out gifts for the holiday season. Look for opportunities to capture this lively atmosphere, but be alert for telling moments of stillness too.

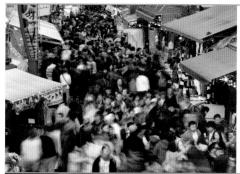

From a raised position, such as a walkway or second floor window, you can photograph the organized chaos of a street market or main street. Experiment with exposure times to capture different levels of motion blur.

Store window displays are designed to catch the attention of passersby and draw them into the store. If you spot an intriguing composition, don't be afraid to stop people and ask them if you can take a picture.

TAKE IT FURTHER
A MOMENT OF STILLNESS

Using an ultra wide-angle lens, ask your subject to stand still (reading a shopping list or using a phone) in a busy street. With a long (1/2 to 1 sec) exposure time, your subject will appear motionless while other shoppers hurry past in a blur.

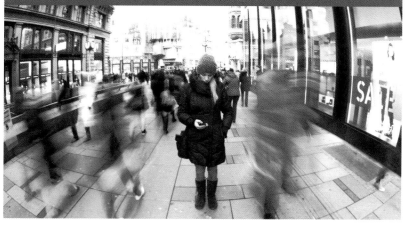

See also: *City lights pp.62–63, On the move pp.86–87, Street photography pp.160–61, Marathon runners pp.246–47*

Mist and fog

On a foggy winter's day it can be tempting to hunker down at home rather than head off in search of photographic inspiration. Fog and mist, however, create magical, atmospheric scenes, so it's well worth getting up early (but not too early at this time of year) to catch them. In fog, the distances between objects appear greater, altering your sense of perspective. Look out for viewpoints where you can best capture this effect.

CAMERA MODE	LENS SETTING
Select **Landscape** mode or **Aperture Priority** and an aperture of f/5.6	Zoom to **telephoto**
SENSOR/FILM SPEED	**FLASH**
Use a **medium ISO** setting (e.g. ISO 400)	Shoot without **flash**

FOR THIS SHOT

Swathes of mist envelop the landscape in this early morning shot, veiling the valleys and lakes below. Note the striking contrasts between light and dark.

1 Perspective
Zoom in to frame the shot, flatten perspective, and further compress the planes of the scene.

2 Light levels
A modest amount of underexposure (around 1/3 to 2/3 stop) helps to define detail in the mist itself and avoid bleached-out highlights.

3 Exposure
Experiment with different exposure times: longer exposures will make the bands of mist look like smooth rivers of silk. Brief exposure times will give sharper definition and more structure.

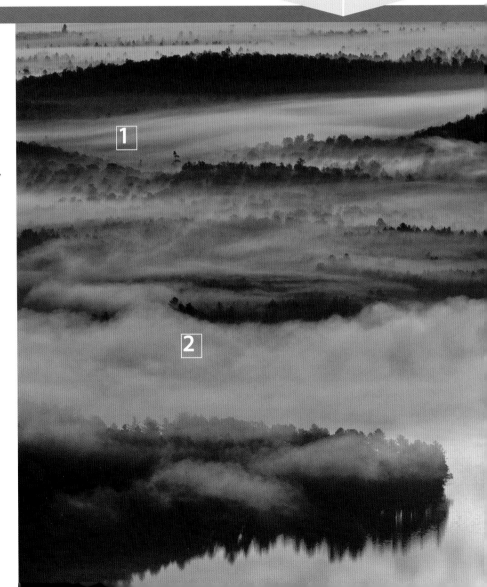

TRY THIS

Like mist and fog, low cloud also distorts perspective, increasing the sense of distance from the camera. Tall buildings look even taller when their upper floors vanish into the clouds. You can emphasize the sense of height by using a wide-angle lens setting.

ALTERNATIVE APPROACHES

Dense fog transforms the appearance of familiar places, obscuring some things and making others appear more prominent. It also creates ghostly light conditions that you can exploit to make some really atmospheric images.

Although fog reduces visibility, it can create the illusion of increased depth, as in this avenue of trees. Those in the foreground stand out clearly, whereas those in the background disappear. The presence of the cyclist and his dog provide a sense of scale.

When the sun breaks through fog, the warmth makes it swirl, creating striking patterns. Try to focus on an area of fog in the middle distance to create a painterly, smudgy image of subtle light and color.

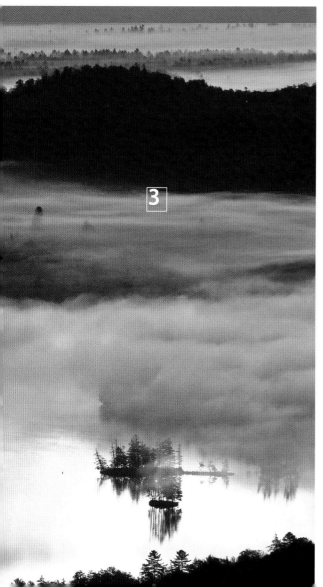

Streetlights cast an orange glow in fog, giving ordinary scenes an oddly theatrical appearance. Try different exposures to capture the light effects. Here, blurring the image slightly and tilting the camera creates an eerie sense of disorientation.

See also: Rainy day pp.98–99, Changing skies pp.106–07, Out of season pp.284–85, Street lights pp.304–05, White on white pp.334–35

Abstract lights

A neon-lit city center on a wet night is the perfect hunting ground for some colorful abstract images. Neon signs alone can produce bold, graphic images, albeit with a commercial message, but when scattered and reflected in rainy windows or puddles, they take on a less figurative form. As well as images in which color and pattern alone take precedence, look for compositions that include visual references to recognizable objects.

CAMERA MODE	LENS SETTING
Select **Macro** mode or **Aperture Priority** and an aperture of f/4	Zoom to **moderate telephoto**

SENSOR/FILM SPEED	FLASH
Use a **high ISO** setting (e.g. ISO 800)	Shoot without **flash**

FOR THIS SHOT

This psychedelic image is all about color, pattern, and texture. It would be entirely abstract, but for the sharpness of the raindrops, which tells us that we're looking through a window at a view of a city street.

1 Sharpness
For shots like this, sharpness is more important than absolute color fidelity. For short exposure times you may need to increase the ISO sensitivity.

2 Focus
Focus on the raindrops, using the Close-up or Macro mode, if necessary—to give the most abstract view of the lights beyond.

3 Composition
Different apertures alter the shape of out-of-focus lights, so decrease aperture to around f/8 to make lights sharper and smaller or increase aperture up to about f/2.8 to render them softer and larger, while keeping raindrops sharp.

TRY THIS

You can create dreamy abstract effects by shooting lights out of focus. In Aperture Priority mode, open the lens to at least medium aperture and set the focus to Macro, or lock the focus at the closest focusing distance.

ALTERNATIVE APPROACHES

Explore the possibilities offered by reflections. In fluid or shaped surfaces light is distorted, producing intriguing textures and patterns. Try including areas of darkness too, to lend contrast and structure to your composition.

Look for surfaces that are arranged on different levels. Here the steps form a series of dark geometric shapes set against the random splashes of color.

Ripples in water fragments reflections and produces a softly linear pattern of intersecting colors. Get close to the water—the more oblique your angle, the more abstract your image will be. Experiment by zooming in and out for different effects.

Lights don't have to be blurred out of recognition to produce an interesting abstract. Sharp reflections in curved surfaces can turn a regular shape into something rather more surreal. Remember to focus on the reflection, rather than the surface.

See also: City lights pp.62–63, Close-up and macro pp.92–93, Rainy days pp.98–99, Fireworks pp.340–41

Winter sports

Most winter sports are all about speed and motion and, whether you're freezing the action or blurring it, even the most basic modern cameras are capable of capturing this. But not all sports shots have to be dynamic or energetic—a moment of tranquility in the midst of a frenzy of activity can make an equally engaging image. Remember to protect your camera from the cold in really freezing conditions.

CAMERA MODE	LENS SETTING
Select **Sports** mode or **Shutter Priority** set to 1/250 sec	Zoom to **moderate wide angle**

SENSOR/FILM SPEED	FLASH
Use a **low ISO** setting (e.g. ISO 100)	Shoot without **flash**

FOR THIS SHOT

While you'd expect to see photos of skiers in action or picturesque snow scenes, a different perspective results in a more personal, and interesting, image.

1 **Shadows**
A stretch of snow has been used like a screen on which a shadow, formed partly by the person taking the shot, is projected.

2 **Texture**
A small aperture of around f/16 keeps everything looking sharp while an overexposure of 2/3 to 1 stop retains the texture and detail of the snow.

3 **Lead-in lines**
The skis and ski-pole in this shot don't just add to the interest of this quirky self-portrait. They lead the eye toward the focal point of the image—the shadow of the ski lift and its passengers.

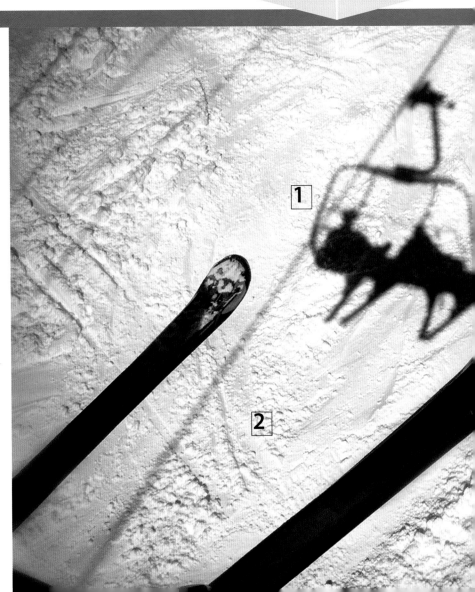

TRY THIS

Using a short exposure time to freeze motion isn't the only way to depict speed. Controlled blurring blurs a subject at the edges, imitating the feel of a Futurist painting. Use a longer shutter time—say 1/4 to 1/2 sec—to capture movement during exposure. Use a tripod or rest your camera on a stable surface to keep it steady.

ALTERNATIVE APPROACHES

From the colorful clothing worn by skiers and snowboarders to the impact of their activities on the mountain landscape, winter sports offer a huge variety of subjects for photography.

Look out for interesting perspectives and ways of shooting people in the landscape. Here, a reflective snow visor acts like a wide-angle lens. Adjust your position to get a good balance between the subject and the reflection.

Skiers slaloming their way down snow fields leave lines in their wake. Include skiers in the shot to give the scene a sense of scale and overexpose by up to 1 2/3 stops to keep the snow bright, while retaining the all-important texture.

To capture fast action you need to find a good position, prefocus, and set your camera to Sports mode (or select a very brief exposure time). Pan the camera to follow the action and if your model has a multi-shot mode, use it. For midair shots it's usually best to include some of the surrounding landscape.

See also: Mountain scenery pp.162–63, On two wheels pp.188–89, Outdoor sports pp.298–99, Fun in the snow pp.336–37

Winter market

Outdoor markets take place at all times of year, but during the festive season they have a magical atmosphere that's a gift for photographers. On gloomy winter days they're an oasis of warmth, light, and color. Visit at different times of day to capture the changing atmosphere—the glowing hustle and bustle of the evening contrasts with quieter, early morning scenes that have an altogether chillier feel.

CAMERA MODE	LENS SETTING
Select **Auto** mode or **Aperture Priority** and an aperture of f/11	Zoom to **maximum wide angle**

SENSOR/FILM SPEED	FLASH
Use a **medium ISO** setting (e.g. ISO 400)	Shoot without **flash**

TRY THIS

Get up close and shoot details of the people who work at the winter markets. Concentrate on their work, whether it's producing crafts or preparing food and drinks. Making a purchase can help develop a rapport with the stall holder and could lead to some extra special shots.

ALTERNATIVE APPROACHES

Winter markets are as varied as the stalls found in them. Seek out different viewpoints, capturing close-ups of the stallholders and visitors as well as moving farther away to photograph the whole scene laid out before you.

Take advantage of the lovely light and upbeat mood of a winter market to make some seasonal portraits of friends and family. Look for moments when people's faces are illuminated by the glow of candles and colored lights.

FOR THIS SHOT

A stall decked in glass baubles, figurines, and candle-lit trinkets is the staple of winter markets.

1 **Composition**
Filling half the image with a close-up of a painted glass ball sets the scene and leads the eye into the image.

2 **Wide angle**
The wide and off-beat angle shows as much of the light and color of the scene as possible. The wide-angle view has distorted the nearest bauble, but in this scene it's perhaps even an advantage.

3 **Exposure**
Autoexposure mode gives good results for shots of stall gifts, but try using Macro mode too for some really close shots of small objects.

Not all winter markets are about bright lights and color. Year-round weekly markets can have a very different feel. On cold mornings, when there are fewer customers around, and especially if there's fog in the air, they can have a slightly melancholy feel.

The seasonal appearance of a winter market has a transforming effect on the landscape. Large open squares and parks become a congested mass of color and lights. Shoot in early evening to contrast bluish daylight with the warm glow of incandescent lights.

See also: Camera modes pp.64–65, Street photography pp.160–61, People at work pp.186–87, Farmers market pp.252–53

White on white

Photographing white objects against a white background—such as after heavy snowfall—presents an interesting challenge. When an image has no color, subjects can be defined only by variations in shades of gray. This means that you have to pay extra attention to composition and focus on shapes and the spaces between them to create a really strong image.

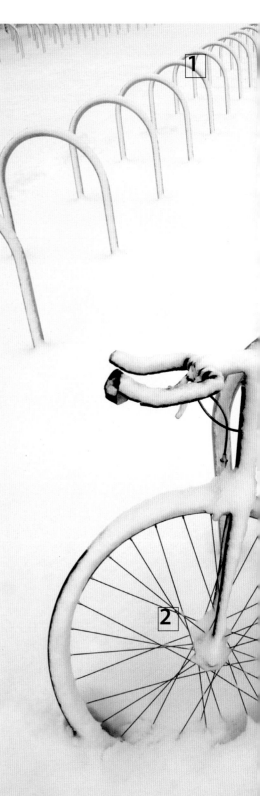

FOR THIS SHOT

A thick blanket of snow has settled on a lone bicycle and a set of bike racks, completely transforming the appearance of an everyday scene.

1 **Depth**
Snow conceals the ground and flattens perspective. Elements such as these bike racks help give the image a sense of depth.

2 **Exposure**
Snow turns murky gray if shot using auto-exposure settings. To preserve its brilliant white, it's best to overexpose by at least 1 stop.

3 **ISO setting**
Use the best quality settings (and the lowest ISO sensitivity) to pick up detail in the texture of the snow.

CAMERA MODE

 Select **Landscape** mode or **Aperture Priority** and an aperture of f/8

SENSOR/FILM SPEED

 Use a **low ISO** setting (e.g. ISO 100)

LENS SETTING

 Zoom to **maximum wide angle**

FLASH

 Shoot without **flash**

TRY THIS

Look for repeating patterns that have been enhanced by snow. The graphic quality of these roof tiles and wire fencing has been greatly increased by the strong contrast between light and dark.

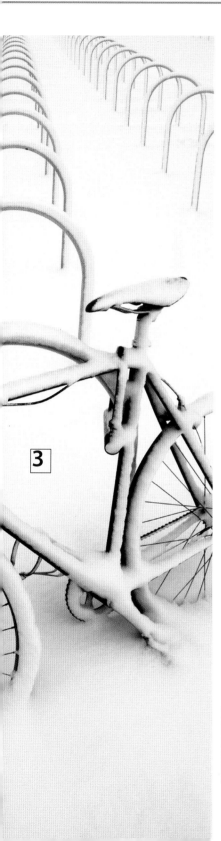

3

ALTERNATIVE APPROACHES

Explore the effect that modest to heavy snowfall has on the landscape: all but the most prominent features will have been reduced to gentle undulations. Look at the way in which variations of light and shade give form and imply a sense of depth in your image.

When color and contrast is minimal, perspective is flattened because the usual clues that show distance are absent. Instead, the sense of depth is created by aerial perspective, which is based on the experience that more distant objects are paler and less distinct. Use falling snow, mist, or low cloud when you encounter them, as they increase the sense of depth.

Even a modest covering of snow makes things unrecognizable. Rows of similar objects, such as the cars in this image, simply look like ripples or waves, particularly when they are shot obliquely. The effects will vary according to the direction of the light, so it's worth revisiting the scene at different times of day.

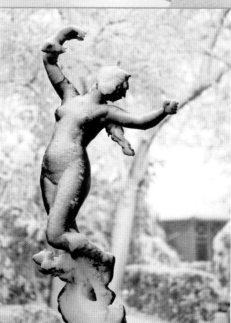

On snowy, overcast days, contrasts in tone and color are much lower than normal so it's a good idea to make the most of any tonal or color differences you can find. Set the camera's white balance to Cloudy to ensure results are not too blue. Here, correct balance helps the tiny patch of green to carry its proper weight; if the tone had a bluish cast, the door would disappear into the overall tint.

See also: A walk in the park pp.22–23, Pets in snow pp.28–29, Snowstorms pp.44–45, Shades of gray pp.254–55

Fun in the snow

Shooting in the snow doesn't have to be just about tranquil snowscapes or howling blizzards—snowy days are an opportunity to capture informal portraits and action shots. Experiment with different types of image, and try to express the spontaneous joy of messing around in the snow. But don't get too carried away if your camera isn't waterproof.

FOR THIS SHOT

The tight framing of this photograph, which all but crops out one of the protagonists in the snowball fight, pulls the viewer into the action.

1 Timing
Timing is crucial for capturing an action shot like this. Allow for the short delay between pressing the shutter release and the camera taking the shot.

2 Framing
The explosion of snow dominates the shot—with a wider view, much of the energy and exuberance of the scene would be lost.

3 Focusing
Your autofocus system will struggle to work for this scenario, so prefocus on the subject then turn off the autofocus before shooting.

CAMERA MODE

 Select **Portrait** mode or **Aperture Priority** and an aperture of f/8

SENSOR/FILM SPEED

 Use a **medium ISO** setting (e.g. ISO 400)

LENS SETTING

 Zoom to **moderate telephoto**

FLASH

 Shoot without **flash**

3

TRY THIS

If a subject is moving quickly past you, your auto focus may struggle to pick it up. Counteract this problem by prefocusing the camera on a predetermined point—be sure to press the shutter just before your subject reaches that point.

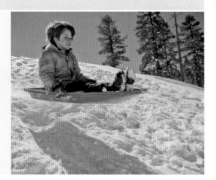

2

1

ALTERNATIVE APPROACHES

As well as altering the landscape, snow transforms mood so make the most of the situation. Try to capture the spirit of informality and freedom that snow encourages, be inspired and, most importantly, have fun.

Images of snow don't have to be muted in tone. Parks and open spaces become playgrounds for children and adults alike, and offer opportunities for surprisingly colorful compositions. As well as taking those close-up action shots, take a step back to show the setting. The people playing in the snow will look like bright splashes of color on a white canvas.

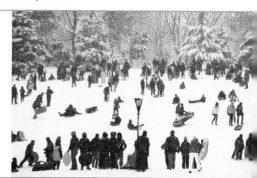

Drawing pictures in the snow is a playful alternative to building snowmen. For the best results, wait until the sun is low in the sky and take the shot as shadows begin to fall. The humor of this image is given poignancy by the knowledge that its subject will disappear with the next dusting of snow.

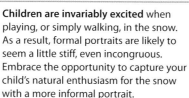

Children are invariably excited when playing, or simply walking, in the snow. As a result, formal portraits are likely to seem a little stiff, even incongruous. Embrace the opportunity to capture your child's natural enthusiasm for the snow with a more informal portrait.

Using an elevated camera angle tends to reduce a subject's status in the eyes of the viewer. However, when the subject is a child, it can imply affection. A high camera angle is also useful when you want to concentrate on the subject—or subjects—and isolate them from any potentially distracting elements in the background.

See also: *Outdoor portraits pp.16–17, A walk in the park pp.22–23, Birthday parties pp.108–09, Children outdoors pp.126–27*

Dimly lit interior

Reminiscent of 17th-century Dutch paintings, subtly lit interior scenes can be strongly atmospheric. Don't be tempted to use Auto mode because your camera will automatically compensate for the lack of light with an extended exposure time, resulting in an artificially bright image that may also be blurred. Mastering exposure control is important when the light is low and will usually require the use of a tripod.

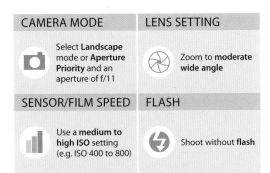

CAMERA MODE	LENS SETTING
Select **Landscape** mode or **Aperture Priority** and an aperture of f/11	Zoom to **moderate wide angle**
SENSOR/FILM SPEED	FLASH
Use a **medium to high ISO** setting (e.g. ISO 400 to 800)	Shoot without **flash**

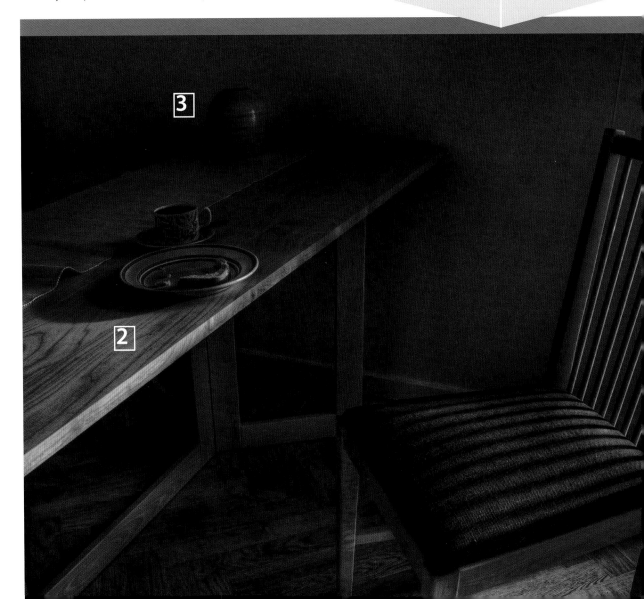

TRY THIS

Shooting through
patterned voile not only produces an intriguing effect, but also softens the scene, reducing the levels of contrast and brightness. You could also try using colored translucent fabrics to give an image a delicate, overall wash of color.

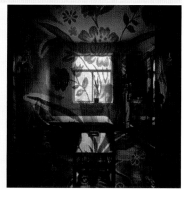

ALTERNATIVE APPROACHES

Working with interiors is your chance to be a lighting director: you can control every element of light by pulling curtains or positioning candles. Measure exposures from lit areas to keep shadows deep and mysterious.

Still-life arrangements make it easy for you to control the lighting and the position of any props. Look at where the light falls in this image, and note how touches of color and pattern add interest.

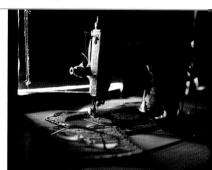

Candles emit a soft, warm light that's perfect for romantic portraits. Check your shots for a color cast and adjust the white balance setting to Tungsten if your pictures appear too orange.

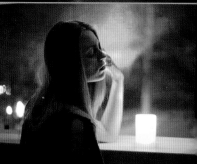

FOR THIS SHOT

Taken in an historic building, this quiet domestic scene, lit only by daylight from a small window, evokes the feel of a bygone age.

1 Exposure
To preserve muted tones, take an exposure reading using the multi-zone setting, if possible, then underexpose the shot by around 1 stop or more, adjusting as necessary.

2 Contrast
You can create moody, atmospheric images by avoiding strong contrasts. This will also help you retain shadow detail and subtle differences in tone.

3 Depth of field
In low lighting, your camera will tend to select a wide aperture, resulting in a narrow depth of field. Select a small aperture to keep the whole image sharp, but use a tripod as this will require a longer exposure.

Interior shots with windows can be tricky. If you expose for the window, the interior will be too dark, but if you expose for the interior, the window will be overexposed. Avoid direct sunlight and underexpose by 1 to 2 stops below what the camera suggests.

See also: Cozy interiors pp.26–27, Silhouettes pp.202–03, Shafts of light pp.240–41, Exposure 316–17

Fireworks

You might imagine that firework displays, with their profusion of light and color, are difficult to photograph, but modern digital cameras are able to cope very effectively with the challenge. It's worth experimenting with exposure times for the different types of firework you're shooting. To capture the trail of an aerial firework, use longer exposure times. For exploding rockets, a briefer exposure time is required.

CAMERA MODE	LENS SETTING
Select **Manual** mode and set to f/8, 1/2 sec	Zoom to **moderate wide angle**

SENSOR/FILM SPEED	FLASH
Use a **low to medium ISO** setting (e.g. ISO 100 to 400)	Shoot without **flash**

FOR THIS SHOT

The inclusion of figures in the foreground of this picture gives a sense of scale and helps to make the viewer feel part of the scene.

1 Exposure
A low ISO setting and medium aperture setting, with exposure times of around 1/2 to 1 sec, will preserve the color and detail of the fireworks.

2 Focus manually
Autofocusing systems will struggle to focus on fireworks until the display is well underway. If possible, focus manually instead.

3 Tripod
Use a tripod to assist with accurate framing and to make it possible to use longer exposure times while avoiding camera movement.

ON YOUR PHONE
AN ABSTRACT LIGHT SHOW

Fast changing light levels and movement can confuse the exposure and focusing systems of camera phones. For colorful abstract pictures, shoot away and then, using an app, adjust the color and contrast of your images.

ALTERNATIVE APPROACHES

From enormous public extravaganzas to more modest backyard celebrations, firework displays are always joyful occasions. As well as explosions set against the night sky, look out for the dramatic way in which fireworks illuminate their surroundings. Your viewpoint is crucial to making the most of these events, so arrive early and set up in advance.

A firework display in an urban setting can act as a spectacular—and unusual—backdrop to floodlit buildings. Setting the exposure for the floodlighting normally results in the correct exposure for the fireworks too. Try underexposing by 1 stop for richer colors.

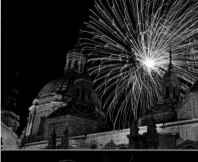

Unlike other fireworks, sparklers give you some degree of control over the content of your image. Get your subjects to draw patterns in the air at different speeds and then experiment with exposure times up to 2 sec. Try shots with and without flash.

Public firework displays often take place near rivers or over the sea, so make the most of the opportunity to use reflections to add even more light and color to your composition. Frame widely to ensure the whole display is captured and crop afterward, if necessary.

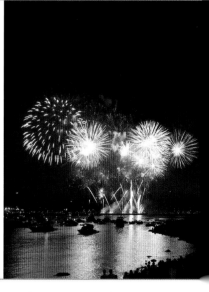

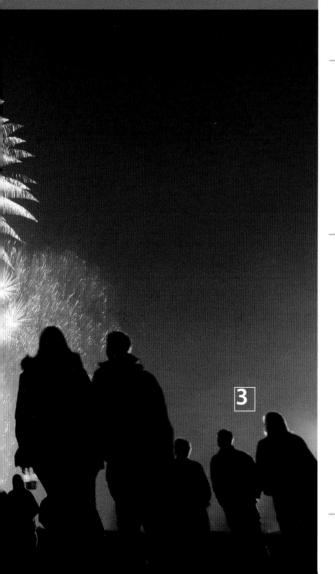

3

See also: Camera modes pp.64–65, Light trails pp.88–89, Silhouettes pp.202–03, Bonfires pp.286–87, Exposure pp.316–17

Posed portrait

Many people leave posed portraits to professional photographers, believing that they're too difficult to attempt at home. However, they're worth trying as a good portrait is rewarding for both the photographer and the sitter. Also, when the subjects are either your friends or family, the resulting images are sometimes more revealing and personal—and therefore more special—than professional portraits.

CAMERA MODE	LENS SETTING
Select **Portrait** mode or **Aperture Priority** and an aperture of f/2 or f/2.8	Zoom to **moderate telephoto**
SENSOR/FILM SPEED	FLASH
Use a **low ISO** setting (e.g. ISO 100)	Shoot without **flash**

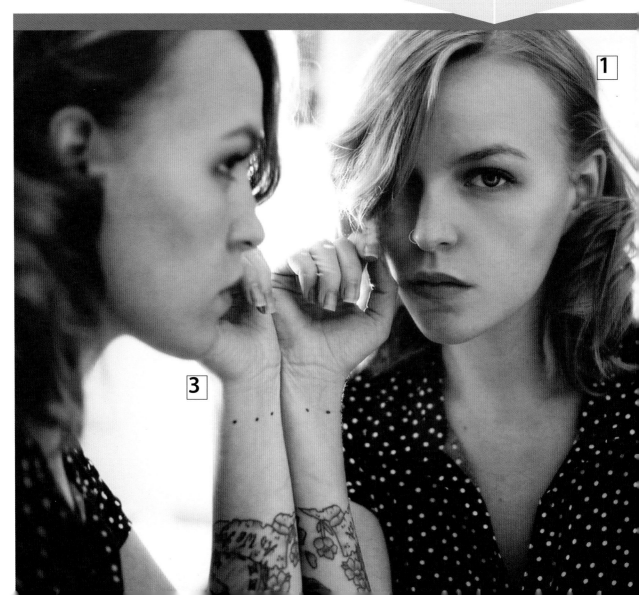

TRY THIS

Set up a group portrait with a few friends. Try to find a simple, uncluttered location with good natural light. Pose your friends so they're lit from the side, and move them away from the wall to avoid shadows. Leave room to include yourself and use your camera's self-timer mode. When shooting from closer-in, use fill-in flash to balance the lighting.

FOR THIS SHOT

This striking portrait combines strong eye contact with the inventive use of the subject's reflection. The woman appears to be looking at us and herself at the same time.

1 Reflection
Try to match your approach to your subject. Here, a strong pose and intense gaze are complemented by the unconventional use of a mirror. The result is a multidimensional portrait that may reflect something of the subject's character.

2 Location
Find a location with good light and a background that isn't too loud or busy. Move around your subject to find the best angle.

3 Engage your subject
Involve your sitters in what you're doing and show them your try-out shots so they know what you're trying to achieve. Try to work quickly and encourage them to experiment with poses.

ALTERNATIVE APPROACHES

A posed portrait needn't be formal, but it should be constructed in a way that suggests some forethought and that sets it apart from spontaneous snapshots.

If you can't find a sitter, shoot a self portrait. Arrange your lighting and visualize the shot before setting up your camera. Use the self timer or, if you have one, a remote control shutter release.

A plain, simple background is often the best option for portraits. However, a busy background can add context and interest. Here, even though the picture has a boldly patterned backdrop, the strong natural side lighting and clear modeling of the subject's face ensures that this isn't a distraction.

See also: Indoor child portraits pp.32–33, Character portraits pp.82–83, Window-lit portraits pp.300–01, Romantic portraits pp.310–11

Using flash

Although digital cameras work very well in low-light conditions (see pp.288–89), there will be times when you need some additional illumination. All compact cameras feature a small built-in flash unit that may be sufficient for general use. However, for more challenging subjects, or for more accomplished lighting results, a variety of accessory flash units is available. Learning to use flash effectively will enable you to broaden the scope of your photography and boost your creativity.

WHEN TO USE FLASH

Using flash is a convenient way of taking photographs when the available light isn't sufficient to make a satisfactory exposure. By reducing the necessary exposure time it prevents the effects of camera shake (when you're using the camera hand-held), and also enables you to freeze motion. However, you can also use flash to complement the ambient lighting in a scene. For example, one of the best uses of flash is to balance the variation between foreground and background light levels when you are photographing a back-lit subject.

A MOMENT CAPTURED

FLASH LIGHTING TECHNIQUES

The standard flash unit built into many cameras is adequate but usually produces rather harsh and directional lighting. For more effective flash lighting it's better to use a separate flash unit. This is normally attached to the accessory shoe on top of the camera (where available) but can also be mounted separately, using a flash bracket, or positioned away from the camera. An accessory flash unit will enable you to experiment with the following techniques:

• **Fill-in flash**: ideal when a subject is back-lit, this balances the ambient light—but doesn't overpower it—and fills in shadows. You can do this, in a less controlled way, using an on-camera flash (see above, right).

• **Diffused flash**: to create gentler shadows and soft, uniform lighting, the flash gun is aimed at the subject—therefore providing maximum illumination—but has a diffuser placed over it.

• **Bounced flash**: for a more even and less harsh light, the flash is directed at the ceiling or a wall to diffuse the light before it hits the subjects. The light can also take on color tones from the surface.

• **Mulitiple flash**: using two or more flash units that trigger simultaneously, it is possible to provide lighting that specifically lights parts of the scene and gives you more control over the general effect.

 ## COMPACT CAMERA FLASH MODES

Many digital cameras have several flash modes to choose from. The following are the most common in compact cameras using the built-in flash unit:

- **Auto flash**: triggers automatically when your camera calculates that extra light is needed in a scene.
- **Fill-in (forced) flash**: activates the flash unit even when your camera determines that there is sufficient light to make an exposure. When set to fill-in flash, most cameras will reduce the intensity of the flash produced to create a more subtle effect.
- **Red-eye reduction**: helps to prevent eyes turning red in portraits by firing a series of flashes before the exposure to make the subject's pupils dilate.

RED-EYE REDUCTION

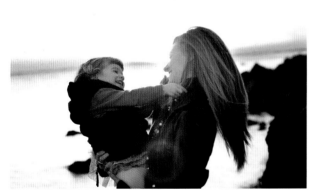

FILL-IN FLASH

DIFFUSED FLASH

BOUNCED FLASH

MULITIPLE FLASH

Glossary

ambient light Existing light arising from natural sources.

aperture Opening behind the lens through which light passes.

aperture priority An automatic exposure mode that varies the shutter time as required.

app A contraction of application. Downloadable software used on mobile devices.

autofocus Default automated system of camera focus.

AWB (auto-white balance) Automatic setting of white balance to correct color cast.

backlighting Lighting the subject from behind with the light source facing the camera.

black An area that has no color or hue due to its absorption of most or all light.

brightness Quality of visual perception that varies with the amount or intensity of light.

camera exposure Quantity of light reaching the camera sensor: depends on the effective aperture of the lens and the duration of the exposure to light.

center-weighted metering A type of metering that gives more importance to the central areas of an image.

color Quality of visual perception characterized by hue, saturation, and lightness.

color balance The relative strengths of colors in an image.

color cast Tint or hint of color evenly covering an image.

contrast Measure of a scene's subject brightness range.

crop To use part of an image for the purpose of, for example, improving composition, fitting an image to an available space or format, or squaring up an image to correct a tilted horizon.

depth of field Measure of zone or distance over which any object in front of a lens appears acceptably sharp; lies in front of, and behind, plane of best focus.

digital manipulation The process of changing the characteristics of a digital image using a computer and software.

direct vision finder Type of viewfinder in which the subject is observed directly, through a hole or optical device.

display Device that provides temporary visual representation of data such as a monitor screen, an LCD projector, or the information panel on a camera.

distortion Inaccurate representation of lines or shape of objects in image causing bending of lines or change of shape.

dynamic range Measure of the difference between the highest and lowest energy of significant areas in a scene.

enhancement Change in one or more qualities of an image in order to improve its visual properties, such as an increase in color saturation, sharpness, and so on.

EV (exposure value) A measure relating exposure time and f/number to brightness: high EV indicates bright light. A change of one EV is equivalent to a change in one stop.

evaluative metering A type of metering system which divides a scene into a number of sections and measures the brightness in each in order to determine the final exposure.

EVF (electronic viewfinder) LCD camera screen, viewed under an eyepiece, showing the view through the lens.

exposure Process of allowing light to reach light-sensitive sensor to create an image.

exposure compensation Control over autoexposure which increases or decreases exposure in accordance with the setting.

f/number (f/stop) Setting of the lens aperture that determines the amount of light passing into the lens.

fill-in To illuminate shadows cast by the main light source, by using another light source or reflector to bounce light from the main source into the shadows.

filter (1) Glass or plastic attachment placed in front of lens to alter color or other quality of image. (2) Software that applies effects to the image.

flare A nonimage forming light caused by internal reflections within the lens.

flash (1) To provide illumination with a very brief burst of light. (2) Equipment used to provide a brief burst or flash of light. (3) Type of electronic memory used in digital cameras.

focal length Distance between the lens and a sharp image of an object at infinity projected by it. Usually measured in millimeters.

focus To make an image look sharp by bringing the focal plane of an optical system into coincidence with the sensor plane.

follow focus Autofocus method which adjusts continuously to follow changing position of the subject. Also called servo focus.

foregrounding The practice of making an object stand out among surrounding imagery.

full-frame Sensor size: approximately 36mm x 24mm.

grayscale Measure of the number of distinct steps between black and white in an image.

highlights The brightest or lightest parts of an image.

histogram Graphical representation showing the relative numbers of something over a range of values.

hue The visual perception of color.

ISO Name of the International Organization for Standardization: in digital photography, usually applied as the measure of sensor sensitivity, though other ISO standards are used.

image stabilization An in-built feature that serves to reduce blurring associated with the motion of a camera during exposure.

intelligent auto Autoexposure mode in which camera sets sensitivity (ISO setting) as well as exposure time and aperture.

JPEG (Joint Photographic Expert Group) Data compression protocol for reducing file sizes.

K (1) Binary thousand: 1,024, or 1,024 bytes is abbreviated to 1 KB. **(2)** Degrees Kelvin, measuring color temperature.

key tone The principal or most important tone in an image, usually the mid-tone between white and black.

landscape Image orientation in which the longest side is horizontal.

lead-in line A line that a viewer's eye can follow through an image.

levels Display of the distribution of pixel brightness in an image as a histogram—the height of the column is proportional to the number of pixels that are the indicated value.

light meter A device used to calculate camera settings in response to light.

macro Focusing in the close-up range but with the subject not magnified.

manual exposure Setting the camera exposure by hand rather than automatically.

metadata Information about the image—its location, time, creator, and more.

moiré Pattern of alternating light and dark bands, or colors, caused by the interference between two or more superimposed arrays or patterns that differ in phase, orientation, or frequency.

monochrome Photograph or image made up of black, white, and grays that may or may not be tinted.

multi-shot Camera setting that enables many exposures to be made in a short time, e.g. six framers per second. Also called series exposure.

multiple exposure Camera mode that allows exposures to be made one on top of another, resulting in blending of the images.

noise Irregularities in an image that reduce information content.

OLED Organic Light-Emitting Diode: type of display screen used to show preview images and menus.

opacity Measure of how much can be "seen" through a layer.

optical viewfinder Type of viewfinder that shows the subject through an optical system, rather than via a monitor screen.

overexposure A loss of highlight detail in an image.

paint Use light source such as torch or flash to illuminate large scenes.

palette (1) Set of tools, colors, or shapes. **(2)** Range or selection of colors available to a printer, a monitor, or other device.

panoramic A view obtained by rotating a lens to see a wide area.

partial metering Metering that measures from a part of the image, usually in the center.

perspective The way in which a three-dimensional scene is projected or seen on the two-dimensional surface of a screen or paper.

photomontage A single photographic image made by digitally combining several other photographic images.

pixel Picture element: the smallest unit of digital imaging.

pixelated Appearance of a digital image in which the individual pixels are clearly discernible.

portrait Image orientation in which the longest side is vertical. Compare with "landscape."

prefocusing A technique of setting focus first before recomposing a photograph to take the shot.

program exposure A type of autoexposure control in which the camera sets both shutter time and aperture.

RAW format Image file output from the camera with minimal in-camera processing, in a format specific to the camera model or range.

red-eye Bright red spot appearing in one or more eyes of subject in dark illuminated by flash.

resizing Changing file size or output size of an image.

resolution Measure of how much detail can be seen or has been recorded, and of how clearly it can be seen.

rim lighting Lighting technique that illuminates the outline or edge of an object from the rear.

RGB (Red Green Blue) Color model that defines colors in terms of relative amounts of red, green, and blue.

rule of thirds A guideline that proposes that an image should be imagined as divided into nine equal parts and that important compositional elements should be placed along these lines or their intersections.

saturation The vividness or intensity of hue.

scanning Process of turning an original into a digital facsimile—a digital file of a specified size.

scene mode Automatic modes that set up several camera functions to suit specific scenes or subjects.

sepia Brown tint applied to images to give antique look.

series exposure Camera setting that enables many exposures to be made in a short time, e.g. six frames per second. Also called multi-shot.

shutter priority A type of autoexposure in which the user sets the shutter while the camera sets the aperture automatically.

silhouette Subject rendered in black outline by exposing for a bright background.

single-shot Autofocus mode in which exposure is made only when focus is achieved.

SLR (single-lens reflex) Camera that views and takes photos through the same lens, using a mirror to control the light-path for viewing and shooting.

stop A change in brightness or exposure: reducing by one stop halves the amount of light and so reduces exposure, while adding a stop doubles the light and increases exposure.

telephoto Lens or zoom setting of greater-than-normal focal length, producing magnified view of the subject.

thumbnail Representation of an image as a small, low-resolution version of the original image.

TIFF Widely used image file format, based on tags.

tint Overall pale color affecting the whole image.

tonal range The numerous shades of gray between absolute black and absolute white.

underexposure A loss of shadow detail in an image.

wide-angle Lens or zoom setting of shorter-than-normal focal length which gives a wider-than-normal field of view.

zoom lens A type of lens in which the focal length can be altered without changing focus.

Index

Acknowledgments

From the author
This book is more of a team effort than many, and I couldn't have done it without the fantastic team at DK, led by Nicky Munro and Jo Clark with the able assistance of David Summers and Simon Murrell. Thanks to a sterling picture research effort from the whole team the book is a time-slice of today's inspiring images.

From the publisher
Dorling Kindersley would like to thank the following for their invaluable support: Peter Cope, Ed Wilson, Angela Wilkes, and Nicola Hodgson for editorial assistance; Simon Murrell and Katie Cavanagh for design assistance; Margaret McCormack for compiling the index; and Susie Peachey for compiling the picture credits.

Picture credits

The publisher would like to thank the following for their kind permission to reproduce their photographs:

(Key: a-above; b-below/bottom; c-centre; f-far; l-left; r-right; t-top)

1 Getty Images: Mitchell Funk / Photographer's Choice (fcl). 2 3 Corbis: Darrell Gulin. 4 5 Getty Images: EschCollection / Photonica. 6 Corbis: Bloomimage (fbl); Richard Hamilton Smith (ftl); Rob Casey (tr). Getty Images: Jenny de Groot / Flickr (ftr); Rainer Martini / LOOK (bc); Diane Cook and Len Jenshel / Stone+ (fbr). 7 Corbis: Alaska Stock (tr); Katsuhiko Kato / amanaimages (ftl); Don Mason (ftr); George H.H. Huey (fbl); John Conrad (bc). Getty Images: Dave Zubraski (tc). 10-11 Corbis: Radius Images. 12 Corbis: John Gillmoure (cr); Image Plan (tl); Serge Kozak (tc); KidStock / Blend Images (bc). 12-13 Corbis: Frank Lukasseck (c). Getty Images: Gert Tabak The Netherlands (bc); Photograph by Dr. Andreas Zachmann (bc). 13 Corbis: Richard Hamilton Smith (br). Getty Images: Daniel J Cox (tr); Riccardo Savi (tl); Keiichi Tsuji (fcr). 14-15 Getty Images: Photograph by Dr. Andreas Zachmann. 15 Corbis: Alaska Stock (tr); Image Plan (tr); Keith Douglas / All Canada Photos (fcr). Getty Images: Patricia Granlund (tc). 16-17 Getty Images: Adam Hester / Photographer's Choice RF. 17 Corbis: Darren Greenwood / Design Pics (tl); Christoph Jorda (tr). Getty Images: Jonathan Kirn / The Image Bank (br); Paul Viant / Photodisc (fbr). 18-19 Corbis: Richard Hamilton Smith. 19 Corbis: John Gillmoure (tl); Odilon Dimier / ZenShui (fcrb). Dorling Kindersley: Barrie Watts (fbr). Getty Images: Ernest Manewal (fcr); Kevin Summers (fra). 20-21 Corbis: Serge Kozak. 20 Corbis: Bruno Ehrs (bc). 21 Getty Images: Fuse (ca); Adam Hester (c); Javier Pierini (br). 22-23 Corbis: Mouton Laurence / ès. 23 Corbis: Frank Lukasseck (tl); Ocean (br). Getty Images: Cristina Pedrazzini (tc). 24-25 Tom Ang. 25 Getty Images: Foodcollection RF (bc); Alfred Schauhuber (fra); Marser (fra). 26-27 Getty Images: Franky De Meyer. 27 Getty Images: Tim Tadder (br). Getty Images: Danielle D. Hughson (tra); Keiichi Tsuji (tl); Ryan McVay (fcr). 28 Getty Images: John Churchman (tl). 28-29 Corbis: Michael Prince. 29 Corbis: Fotofeeling / Westend61 (fbr); Ken Gillespie / First Light (tr); Patrick Pleul / dpa (tr). Getty Images: Daniel J Cox (fcrb). 30-31 Corbis: Image Source. 31 Corbis: Harpur Garden Library (fcr); Andrew Parkinson (br). Getty Images: Gerard Soury (tl); Gert Tabak The Netherlands (fcra). 32-33 Corbis: David Shopper. 33 Corbis: Heide Benser (tl); KidStock / Blend Images (fcra); Nick Dolding / cultura (fcr); Yang Liu (fcr). 34-35 Getty Images: Riccardo Savi. 34 Corbis: Scott Barrow (tl). 35 Corbis: Radius Images (ca); Sayaka / amanaimages (c). Getty Images: James Wellner (c). 36 Getty Images: Doug Berry (tl); Bruno Ehrs (bl); Oliver Rossi (br). 37 Corbis: Christian Guy / Hemis (cb); Radius Images (tr). 38-39 Getty Images: Steve Prezant. 40 Corbis: The Brett Weston Archive (br); Rob Casey (tl); Ken Gillespie / All Canada Photos (cra); Richard T. Nowitz (c); Timothy Fadek (crb). Getty Images: James A. Guilliam / Photolibrary (fcl); Darrell Gulin / Photodisc (tl); Ragnar Schmuck (bl). 40-41 Alamy Images: Justin Kase zsixz (bc). 41 Alamy Images: Robert Adrian Hillman (tl); Romeo Koitmäe (tc). Corbis: George Hammerstein (cra). Getty Images: abbietabbie / Flickr Open (ftr); Mitchell Funk / Steve Satushek (cla); Image by Ivo Berg (Crazy-Ivory) (fbra); Philip and Karen Smith (br). Jef Poskanzer: (clb). 42-43 Corbis: George Hammerstein. 43 Corbis: Ken Gillespie / All Canada Photos (fcra); Arthur Morris (tc). Getty Images: Steve Satushek (br). 44-45 Getty Images: Mitchell Funk. 45 Alamy Images: Justin Kase zsixz (tl). Corbis: Steve Prezant (br). Getty Images: Andrew Errington (fcr); Peter Essick (fcra). 46-47 Tiina Honka. 47 Getty Images: Greg Wright (tl). Getty Images: James A. Guilliam / Garden Picture Library (br); James A. Guilliam / Photolibrary (fcra); Kathy Quirk-Syvertsen / Photodisc (tr). 48-49 Getty Images: Flaatten Photo / Flickr. 49 FLPA:

Konrad Wothe / Minden Pictures (fcr). Getty Images: abbietabbie / Flickr Open (tl); Darrell Gulin / Photodisc (fcra); Paul Tessier / Vetta (br). 50-51 Corbis: Al Francekevich. 51 Corbis: Rob Casey (tl); David Pollack (tr); Karl-Josef Hildenbrand / dpa (br). Getty Images: Jeff Hutchens (tr). 52-53 Getty Images: Jacques LOIC. 52 Getty Images: D. Sharon Pruitt Pink Sherbet Photography (cb). 53 Alamy Images: Robert Adrian Hillman (ca). Corbis: David H. Wells (cb). Getty Images: Image by Ivo Berg (Crazy-Ivory) (c). 54-55 Corbis: The Brett Weston Archive. 54 Corbis: David Buffington / Spaces Images (cl). 55 Corbis: Richard T. Nowitz (ca); Paul C. Pet (cb). Getty Images: Philip and Karen Smith (c). 56-57 Jef Poskanzer. 57 Corbis: Timothy Fadek (fcr); John-Patrick Morarescu / Westend61 (tl); Ross Hillier (fca). Getty Images: Monzino (br). 58-59 Corbis: Henryk Sadura / Tetra Images. 59 Corbis: Michael Macor / San Francisco Chronicle (br). Getty Images: Dawn D. Hanna (tl); Ragnar Schmuck (fcra); Wilson Santinelli (fcr). 60-61 Alamy Images: Romeo Koitmäe. 61 Corbis: Ocean (br); Radius Images (tl, tr). Getty Images: Cavan Images / Photographer's Choice (fcr). 62-63 Corbis: Jon Hicks. 63 Corbis: Radius Images (fcr); José Fuste Raga (br). Getty Images: Giorgio Fochesato (fcra); Photo by Neil Ta (tl). 64 Corbis: Arild Heitmann / Stocktrek Images (tl); David Spurdens / www.ExtremeSportsPhoto.com (cr); KidStock / Blend Images (bl). 65 Corbis: Anthony Asael / Art in All of Us (tc); Frank Krahmer (cra); Ben Welsh (ca); Robert Postma / First Light (fcra); Sylvain Sonnet (c); Kevin Steele / Aurora Photos (fcr). 66-67 Getty Images: Kaz Chiba. 68 Corbis: Franck Guiziou / Hemis (tc); Alan Schein Photography (br). Getty Images: John Warburton-Lee / JAI (fcr). Getty Images: Angelo Cesare Amboldi (bl); Rob Kints / Flickr (tl); John W Banagan (cb). 68-69 Getty Images: Eightfish (tc). 69 Corbis: Fernando Alda / Arcaid (bl); Keith Levit / Design Pics (tc); Judith Haeusler / cultura (tr); Ant Strack (c); Corey Hochachka / Design Pics (fcrb); Benelux (cb); Neil Emmerson / Robert Harding World Imagery (bc). Getty Images: Ulrich Kerth (fbr); Adam Jones / Stone (c); John Warden (tl). 70-71 Corbis: Deddeda / Design Pics. 71 Corbis: Benelux (cr); Roy McMahon (crb). Getty Images: eyetwist / kevin balluff (tl); Anthony Lee (fcra). 72-73 Getty Images: Mark Hannaford / AWL Images. 72 Alamy Images: Alex Segre (cb). 73 Corbis: Jeremy Woodhouse / Spaces Images (ca). Getty Images: Paul Edmondson / Stone (c); (crb). 74-75 Corbis: Franck Guiziou / Hemis. 75 Corbis: Fernando Alda / Arcaid (br); Judith Haeusler / cultura (fcra); John Warburton-Lee / JAI (fcr). Getty Images: Con Ryan / Flickr Select (tl). 76-77 Corbis: Jeremy Woodhouse / Blend Images. 77 Corbis: Jeremy Horner (c); Gong Lei / Xinhua Press (tl). Getty Images: Rob Kints (br). 78-79 Corbis: Lee Frost / Robert Harding World Imagery. 78 Getty Images: Diane Bos (bc). 79 Corbis: Neil Emmerson / Robert Harding World Imagery (c); Corey Hochachka / Design Pics (c); Keith Levit / Design Pics (cr). 80-81 Corbis: Klaus - Dietmar Gabbert / epa. 81 Getty Images: Grant Faint (tl, fcra); Adam Jones (br); John Warden (br). 82-83 Getty Images: Mitchell Kanashkevich. 83 Corbis: Ant Strack (br); Tim Tadder (tl). Getty Images: Dan Burn-Forti (fcr); Emmanuel Faure (fcra). 84-85 Corbis: Christian Hager / dpa. 85 Corbis: Marshall Sokoloff (fcrb). Getty Images: Eightfish (bl); Silvia Otten-Nattkamp Photography (tl); Arthur Meyerson (fcr). 86-87 Getty Images: John W Meyerson (fcr). 86-87 Getty Images: John W Banagan. 87 Tom Ang: (br). Getty Images: Angelo Cesare Amboldi (tl); Scott Barbour (fcra); John Churchman (br). 88-89 Corbis: Dick Reed. 89 Corbis: (ca, c); Paul A. Souders (br). 90-91 Getty Images: James A. Guilliam. 90 Getty Images: Ulrich Kerth (bc). 91 Getty Images: Amana images (cr); Kaz Chiba (c); Photography by Simon Bond (br). 92 Corbis: John Beedle/http://www.flowerphotos.com/Eye Ubiquitous/Corbis (br); Robert Postma / All Canada Photos (bl); Ken Gillespie / All Canada Photos (tl). 93 Corbis: David Harrigan / ableimages (bc); Ocean (tr, br, bl); Antonio M. Rosario / Tetra Images (tr). 94-95 Corbis: Luo Xiaoguang / Xinhua Press. 96 Corbis: Heide Benser (ca); TongRo / TongRo Image Stock (ftl); Seb Oliver / cultura (fcla); Tim Pannell (br); Juice Images

(fcr). Getty Images: AT Photography / Flickr (tr); Edwin Remsberg / Stone (c); Eriko Koga / Stone+ (bl). Nicky Munro: (tl). 96-97 Corbis: Roger Tidman (c); WB-Images / Westend61 (br). 97 Corbis: Karen Kasmauski / National Geographic Society (bc); Michael Wheatley / All Canada Photos (fcl); Tetra Images (cla); Seb Oliver / cultura (br). Getty Images: altrendo nature (bl); sodapix sodapix (tr). 98-99 Corbis: David Jay Zimmerman / Terra. 98 Corbis: Jed Share / Kaoru Share / SuperStock (bc). 99 Corbis: Bohemian Nomad Picturemakers (c); Luo Xiaoguang / Xinhua Press (ca). Getty Images: Dennie Cody / Photographer's Choice (br). 100-101 Corbis: Robert McGouey / All Canada Photos. 101 Corbis: Roger Tidman (tl); Michael Wheatley / All Canada Photos (fcl). Getty Images: altrendo nature (fcr); sodapix sodapix (fcra). 102-103 Getty Images: tancrediphoto.com. 103 Corbis: Ocean (fcra); TongRo / TongRo Image Stock (tl); Ross Woodhall / cultura (fcr); Jeremy Woodhouse / Blend Images (br). 104-105 Corbis: Birgid Allig. 105 Corbis: Arctic-Images (fcr); Seb Oliver / cultura (fcr); Jason Hosking (fbr). Getty Images: Boston Thek Imagery / Flickr (tl). 106-107 Corbis: Dave & Les Jacobs / Spaces Images. 107 Corbis: Warren Faidley (tl); Beat Glanzmann (ca); Radius Images (fcr); Seb Oliver / cultura (br). 108-109 Getty Images: Cultura / Nick Daly / StockImage. 109 Corbis: Tim Pannell (br). Getty Images: AT Photography / Flickr (fcr); Brand New Images / The Image Bank (tl); Huy Lam / First Light. 110-111 Corbis: Martin Siepmann / Westend61. 111 Corbis: Fabio Muzzi / cultura (fcr). Getty Images: altrendo nature (tr); Universal Stopping Point Photography / Flickr (fcra); altrendo travel (br). 112-113 Corbis: Heide Benser. 113 Corbis: Reg Charity (fcra); Juice Images (br); David Deas / DK Stock (fcr); Greg Dale / Horizontal International Photo Group Society (br). 114-115 Nicky Munro. 115 Corbis: WB-Images / Westend61 (br). Getty Images: Rune Johansen (tl); Rune Johansen / Photolibrary (tr); Edwin Remsberg / Stone (fcr). 116-117 Getty Images: Duncan Shaw / Britain on View. 117 Getty Images: Aaron Foster / Photographer's Choice (br); David Mathies / Vetta (fcra); Image Source (fcr); Dale Wilson / Photographer's Choice (cb). 118-119 Corbis: Tetra Images. 119 Corbis: Chaoimages / amanaimages (fcra); Claudia Rehm / Westend61 / Alloy (tl); Ocean (br). Getty Images: Eriko Koga / Stone+ (fcr). 120 Corbis: Imagemore Co., Ltd. (tl) Getty Images: Haakon Nygård / Flickr (bl). 121 Corbis: Karine Aigner / National Geographic Society (cb); Tim Hall / cultura (fcr); Ocean (crb); Desgrieux / SoFood (c); Sylvain Sonnet (fbr). David Summers: (fcla, ca, fcra). 122-123 Corbis: Ghislain & Marie David de Lossy / cultura. 124 Corbis: Bloomimage (bl); Andreas Kunert (tl). Getty Images: Olena Chernenko / Vetta (fbl); Blend Images / John Fedele / the Agency Collection (cb); Nevena Uzurov / Flickr Open (tr); ImagesBazaar; Petteri Löppönen / Flickr Open (br); OGphoto / Vetta (fbr). 125 Corbis: Dan Jurak / First Light (bc). Getty Images: Joe Cornish (cl); Kevin Dutton / Garden Picture Library (tl); Victoria Pearson / Stone (tr); Tomasz Pietryszek / Vetta (cra); Ed Freeman / Stone (ftr); Cal Vornberger / Peter Arnold (fbr). 126-127 Getty Images: Photos by Carol / Flickr. 127 Corbis: Anthony Asael / Art in All of Us (fcr). Getty Images: Ju Fumero / Flickr (fcra); Image Source (tr); Kohei Hara / Photodisc (fcrb). 128-129 Corbis: Dan Jurak / First Light. 129 Alamy Images: John Insull (br). Corbis: Laurence Mouton / PhotoAlto (tr). Getty Images: Nevena Uzurov / Flickr Open (tr); Tomasz Pietryszek / Vetta (tl). 130-131 Corbis: Yu Xiangquan / Xinhua Press. 131 Corbis: Jim Cummins (br); Max Wanger (tl); Pete Mcbride / National Geographic Society (fcra); Owen Franken / Documentary Value (fcrb). 132-133 Corbis: Andreas Kunert. 133 Corbis: Gary Bell (br); Ocean (cla); Radius Images (br). Getty Images: Victoria Pearson / Stone (cr); Cal Vornberger / Peter Arnold (fcr). 134-135 Corbis: Darrell Gulin. 135 Corbis: Les and Dave Jacobs / cultura (br). Getty Images: Peter Blahut / All Canada Photos (tr); OGphoto / Vetta (tl); SambaPhoto / Edu Lyra (fcr). 136 Getty Images: Petteri Löppönen / Flickr Open (bc). 136-137 Getty Images: jnmmr / Flickr. 137 Corbis: Image Source (ca). Getty Images: ens (cb);

Blend Images / John Fedele / the Agency Collection (c). 138-139 Corbis: Ghislain & Marie David de Lossy / cultura. 139 Corbis: amanaimages (br); Bloomimage (tl); Carol Sharp / Eye Ubiquitous / Eye Ubiquitous (fcr). Getty Images: Christopher Hope-Fitch / Flickr (fcra). 140-141 Getty Images: Bryce Pincham. 140 Getty Images: Evan Kafka / Stone (bc). 141 Corbis: John Kroetch / Design Pics (c); Dann Tardif / LWA (ca). Getty Images: by Nada Stankova Photography (br). 142-143 Getty Images: Ben Pipe Photography / Photolibrary. 143 Corbis: Marnie Burkhart (br); Clive Nichols / Arcaid (fcr). Getty Images: Olena Chernenko / Vetta (tl); Kevin Dutton / Garden Picture Library (fcr). 144-145 Getty Images: Ed Freeman / Stone. 145 Getty Images: photography by Spencer Bowman (fcra); David Sacks / Photonica (tl); Tim Graham Photo Library (fcr); Joe Cornish (br). 146-147 Getty Images: TAO Images Limited. 147 Corbis: Jack Hollingsworth (fcr). Getty Images: Keith Alstrin (tl); ImagesBazaar (fcr); Joe Klamar / AFP Creative (br). 148 Tom Ang: (tl, bl). Corbis: Redlink (br). 149 Corbis: Frank Krahmer (cl); Zero Creatives / cultura (tr); Robert Niedring / Westend61 (br). 150-151 Corbis: moodboard. 152 Alamy Images: Limor Sidi (crb). Tom Ang: (b). Corbis: Robert van der Hilst (ftl); John Nakata (tl); Lynda Richardson (tr); Tom & Dee Ann McCarthy (ftr). Getty Images: Sylvain Grandadam / Stone (fcla); Dave Zubraski (bl); Dave Porter Peterborough Uk (fcr). 152-153 Corbis: Ron Watts / All Canada Photos (bc). 153 Corbis: Ralph A. Clevenger (bl); Mauricio Handler / National Geographic Society (cla); Don Mason (tr); Will Gray / JAI (fcr); Imageshop (br). Getty Images: Peter Lilja (clb); Westend61 (c). 154-155 Getty Images: John Lamb / Stone. 155 Corbis: Kenneth Bengtsson / Naturbild (tc); Roy Botterell (fcr). Getty Images: Ian Cumming / Axiom Photographic Agency (fcr); Suri Sun / Flickr (br). 156-157 Corbis: Radius Images. 157 Corbis: Rudy Sulgan (tl). Getty Images: David Dixon / Garden Picture Library (tr); Tohoku Color Agency / Japan Images (tr); Image Source (ftr); Sylvain Grandadam / Stone (br). 158-159 Corbis: Tom & Dee Ann McCarthy. 159 Alamy Images: Roger Bamber (tl); Rosemary Harris (tr). Tom Ang: (fbr). Getty Images: Rob Brimson / Taxi (fcrb); Dave Porter Peterborough Uk (fcr). 160-161 Corbis: Randy Olson / National Geographic Society. 161 Alamy Images: philipjbigg (fcra); Limor Sidi (fcrb). Corbis: hamideddine Bouali / Demotix / Demotix (tl); Anna Larsson / Etsa (tr). 162-163 Corbis: Erin Butler / Flickr. 163 Corbis: Imageshop (tl); Kazuyoshi Nomachi / Terra (fcra); Ron Watts / All Canada Photos (fcr); Ocean (br). 164-165 Corbis: Lynda Richardson. 165 Getty Images: Nathan Griffith (br). Getty Images: Wolfgang Bayer / Discovery Channel Images (tl); Duncan Usher / Foto Natura (fcra); Westend61. 166-167 Corbis: Hemis. 167 Corbis: John Nakata (fcr); Murat Taner (tl); Getty Images: Gary Conner (tl); Maremagnum / Photographer's Choice (br). 168-169 Corbis: Martin Puddy. 169 Corbis: Lee Frost / Robert Harding World Imagery (fcr); Robert van der Hilst (tl); Will Gray / JAI (fcra); Andrew Watson / JAI (br). 170-171 Corbis: Owen Franken. 171 Corbis: Mark Hannaford / JAI (br). Getty Images: Tony Anderson / Taxi (fcra); WIN-Initiative (tl). 172-173 Getty Images: Darrell Gulin / Photographer's Choice. 173 Corbis: Ralph A. Clevenger (tl). Getty Images: Peter Lilja (tr); Dave Zubraski (fcr); Nature Picture Library (br). 174-175 Corbis: Don Mason. 175 Corbis: Kevin Dodge (fcra); Zac Macaulay / cultura (tl); Tracy Kahn (fcr); moodboard (br). 176 Corbis: Mauricio Handler / National Geographic Society; Radius Images (bl). 177 Corbis: Hello Lovely (cl); Amos Nachoum (tr); Birgitte Wilms / Minden Pictures (br). Getty Images: Georgette Douwma / Photographer's Choice RF (bl); Monica and Michael Sweet / Flickr (br). 178-179 Getty Images: Jeremy Woodhouse / Blend Images. 180 Corbis: Clive Nichols (bl); Charles O'Rear (tl); Ocean (cl); Holger Winkler / A.B. Getty Images: Santiago Bañón / Flickr (tc); Justin Charles / Stone; Jenny de Groot / Flickr (fcla); (c); emmabradshaw (cr); Gary John Norman / Iconica (fcr). 180-181 Getty Images: Buena Vista Images. 181 Corbis: Adie Bush / cultura (ca); Mark Karrass (tl); Jacobs Stock Photography / Spaces

ACKNOWLEDGMENTS

Images (tc); Katsuhiko Kato / amanaimages (ftr); Anahelena Natera / Ppsop (fclb); Lisbeth Hjort / cultura. Getty Images: Chase Jarvis (br); RunPhoto / Taxi Japan (fcra). 182-183 Getty Images: Martin Sundberg / Workbook Stock. 182 Getty Images: Erik Isakson (bc). 183 Corbis: Carson Ganci / Design Pics (cb). Getty Images: Justin Charles / Stone (c); Gary John Norman / Iconica (ca). 184-185 Corbis: Richard Hamilton Smith. 185 Corbis: Jacobs Stock Photography / Spaces Images (br); Anahelena Natera / Ppsop (br). Getty Images: EschCollection / Photonica (tc); Wayne Levin / Photographer's Choice (fcr). 186-187 Corbis: Ian Taylor / First Light. 186 Getty Images: Diverse Images / UIG (bc). 187 Corbis: Holger Winkler / A.B. (fcra). Getty Images: Betsie Van Der Meer / RedChopsticks (tl); Adalberto Roque / AFP Creative (fcrb). 189 Getty Images: Santiago Bañon / Flickr (fcr); Chase Jarvis / Digital Vision (tc); Rick Hyman / Vetta (tr); TAO Images Limited (fclb). 190-191 Getty Images. 191 Corbis: Susie Cushner / Graphistock (tl); Martin Meyer (fcr); Lisbeth Hjort / cultura (fcrb). Getty Images: Jenny de Groot / Flickr (fcra). 192-193 Corbis: Douglas Pearson. 192 Corbis: Ocean (bc). 193 Corbis: Charles O'Rear (ca); Ocean (c). Getty Images: Fernand Ivaldi / The Image Bank (crb). 194 Corbis: Ocean (bc). 194-195 Alamy Images: Juniors Bildarchiv. 195 Getty Images: Felipe Rodriguez Fernandez (tc); Martin Ruegner / Age Fotostock (cb); Will & Deni McIntyre / Stone (bc). 196-197 Getty Images: Ty Milford / Radius Images. 197 Getty Images: Buena Vista Images (fcrb); Gena Hayward is a photographer in Chicago, IL. / Flickr (tc); emmabradshaw (tr); Chase Jarvis (tr); Geir Pettersen / Digital Vision (br). 198-199 Getty Images: John Eastcott And Yva Momatiuk. 198 Corbis: Gary Braasch (c). 199 Corbis: Katsuhiko Kato / amanaimages (c). Getty Images: Jeremy Woodhouse / Blend Images (bc); Thomas Jackson / Stone (c). 200-201 Corbis: Adie Bush / cultura. 201 Corbis: B.S.P.I. (fcr); Clive Nichols (tl); Halfdark / fstop (fbr). Nicky Munro: (fcra). 202-203 Getty Images: Alain Daussin / The Image Bank. 203 Corbis: Mark Karrass (br); Scott T. Smith (ch). Getty Images: Getty Images News (fcra); RunPhoto / Taxi Japan (fcr). 204 Corbis: Mitsuaki Iwago / Minden Pictures (bl); Stoyan Nenov / Reuters (tl). Getty Images: Simon Potter / Cultura (br). 205 Corbis: Helene Cyr / Design Pics (br); Martin Gerten (fcr). Getty Images: B. Blue (fbr). 206-207 Corbis: Pete Mcbride / National Geographic Society. 208-209 Getty Images: Stephen Simpson / Taxi. 208 Corbis: Image Source (fcrb); Gregor Schuster (c); Sporrer / Rupp / cultura (br). Getty Images: Joel Carillet / Vetta (fbl); Photolife / Amanaimagesrf (ftl); Diane Cook and Len Jenshel / Stone+ (cfr). 209 Alamy Images: Rosie Collins (b). Corbis: David Harrigan / ableimages (fcra); George H.H. Huey (cla); Transtock; Ocean (fbr). Getty Images: Ian Cumming / Axiom Photographic Agency (ca); Rainer Martini / LOOK (ftr); Aurelie and Morgan David de Lossy (fclb); Miles Ertman (b). 210-211 Getty Images: Paul Harris / AWL Images. 211 Corbis: Farrell Grehan (fcr); James Horner (tl). Getty Images: Ian Cumming / Axiom Photographic Agency (br); Joel Carillet / Vetta (tr). 212-213 Getty Images: Sporrer / Rupp / Cultura. 212 Getty Images: Imgorthand / Vetta (bc). 213 Corbis: Sporrer / Rupp / cultura (bc). Getty Images: Cavan Images / Taxi (ca); Monkman / Digital Vision (c). 214-215 Corbis: Bertrand Gardel / Hemis. 215 Tom Ang: (fcr). Corbis: Image Source (crb). 216-217 Tom Ang. 217 Alamy Images: Johner Images (fcrb). Corbis: Adie Bush / cultura (fcl); Matthias Ritzmann (fcra). Getty Images: Aurelie and Morgan David de Lossy (fcr); Stephen Simpson / Taxi (tl). 218-219 Corbis: Fraser Hall / Robert Harding World Imagery. 218 Getty Images: Andrew C Mace / Flickr Select (br). 219 Corbis: Neale Clarke / Robert Harding World Imagery (ca). Getty Images: Andrew Holt / Photographer's Choice (bc); Rainer Martini / LOOK (c). 220-221 Tom Ang. 221 Corbis: Image Source (tl); G. Jackson / Arcaid (fcra); Gregor Schuster (ca). Getty Images: Diane Cook and Len Jenshel / Stone+ (cfr). 222-223 Getty Images: SuperStock. 222 Corbis: David Harrigan / ableimages (bc). 223 Corbis: Ed Darack / Science Faction (c). Getty Images: Gerard Hermand / Flickr (cb); Adrian Samson / Stone (ca). 224-225 Getty

Images. 225 Alamy Images: Rosie Collins (tr). Corbis: Julian Smith (br). Getty Images: AFP (fcr); Redferns (tl). Andy Mitchell: (fcrb). 226-227 Getty Images: Miles Ertman. 227 Corbis: Atlantide Phototravel (ftr); Ian Lishman / Juice Images (fcr); Ryan Pyle (fcrb). Getty Images: (fbr); Suzanne and Nick Geary (tc); Mitchell Funk / Photographer's Choice (fcr). 228-229 Corbis: Micha Pawlitzki. 228 Corbis: George H.H. Huey (cb). 229 Corbis: Pete Mcbride / National Geographic Society (c); Ocean (cb). Getty Images: Robert C Nunnington (ca). 230-231 Corbis: Ocean. 230 Corbis: Bernhard Kuh / Sodapix (br); Transtock (bc). 231 Corbis: Jeff Spielman (c); Jim Vecchi (ca); Jeremy Woodhouse / Spaces Images (c). 232 Corbis: Matt Brandon / Design Pics (bc); Hemis (br); Jon Hicks (tl). 233 Corbis: Peter Adams (tl); Ocean (tr); Mark A. Johnson (c); Jens Rydell / Johnér Images (fcr); Xu Xiaolin (c); Richard Hamilton Smith (fcrb); Dermot Conlan / PPSOP (bc); Dave Reede / All Canada Photos (br). 234-235 Corbis: Alan Copson / Photolibrary. 236 Tom Ang: (fcl). Corbis: Angela Drury (ftl); Radius Images (tr); Sudres / photocuisine (fbl); Tetra Images (crb); Karen Kasmauski / Science Faction (bfr). Getty Images: Fotosearch (fcla); Steven Puetzer / Photographer's Choice (c). 236-237 Corbis: Johan Alp / Etsa. 237 Tom Ang: (tc, fcra). Corbis: Adrianko (ca); Christian Bullinger / ès (ftl); Mimmo Jodice (br); Vladimir Godnik / moodboard (fclb). Getty Images: Dan Gair / Photolibrary (clb); Mitch Kezar / The Image Bank (fbr). 238-239 Corbis: Marcel Malherbe / Arcaid. 239 Corbis: Mimmo Jodice (br). Stephanie Farrow: (tr). Getty Images: Donald G. Jean / Flickr (tl). 240-241 Getty Images: Gavin Gough / Lonely Planet Images. 241 Corbis: Benoit Jeanneton / ès (tc). Getty Images: Dan Gair / Photolibrary (fcrb); Sunny / Riser (tl); Adam Jones / Photographer's Choice (fcr). 242-243 Corbis: Kevin R Morris / Bohemian Nomad Picturemakers. 243 Corbis: Karen Kasmauski / Science Faction (br); Raimund Koch (fr). Getty Images: Andreas Strauss / LOOK (ca). 244-245 Getty Images: Paul D. Van Hoy II / age fotostock. 245 Corbis: Johan Alp / Etsa (ca); Dave & Les Jacobs / Spaces Images (bfr); Konstantin Kokoshkin / Global Look (fcrb). Getty Images: Daniel Grizelj / Stone (tc). 246-247 Tom Ang. 246 Tom Ang: (bc). 247 Tom Ang: (ca, c, cb). 248-249 Getty Images: Mike Powles / Oxford Scientific. 249 Corbis: Wang Jianwei / Xinhua Press (tl); Bill Stormont (fcr). Getty Images: Grant Faint / The Image Bank (fcrb); Mitch Kezar / The Image Bank (fcra). 250-251 Getty Images: Santiago Bañon / Flickr. 251 Corbis: Seb Oliver / cultura (br). Getty Images: Fotosearch (fcra); Steven Puetzer / Photographer's Choice (tl); Alan Copson / Photolibrary (br). 252-253 Corbis: Luca Tettoni. 253 Tom Ang: (tl, ca, ftr). Corbis: Angela Drury (tr). Getty Images: Ken Wramton / Photodisc (fcrb). 254-255 Corbis: Christian Bullinger / ès. 255 Corbis: Vladimir Godnik / moodboard (br); Shun Sasabuchi / First Light (tl); Peter Johnson (fcr). Getty Images: WIN-Initiative (br). 256-257 Tom Ang. 256 Corbis: Dex Image (bc). 257 Corbis: Adrianko (ca); Jean-Pierre Lescourret (fbr); O. Alamany & E. Vicens (bc). Getty Images: David Hannah / Photolibrary (c). 258-259 Corbis: Tetra Images. 259 Corbis: Fly Fernandez (tl); Radius Images (fcr); Jeremy Woodhouse / Spaces Images (br). Getty Images: Chris Warren / age fotostock (fcra). 260 Corbis: Tim Graham (bl); Ron Watts (tl). Getty Images: Paul Nicklen / National Geographic (br). 261 Corbis: Oliver Eltinger (tr); Ocean (fcl); Tim Kiusalaas (fcr); RG Images / Stock4B (bc). 262-263 Corbis: Dieterlen / photocuisine. 264 Corbis: Jay Dickman (tr); Don Paulson / SuperStock; Michael Hanson / Aurora Photos (br). FLPA: DBN,Imagebroker / Imagebroker (cl). Getty Images: Keiji Iwai (tc); Heath Korvola (ftl); sodapix sodapix (c). 264-265 Corbis: Andrew McLachlan / All Canada Photos (cb). Getty Images: copyright Alex Arnaoudov / Flickr; Don Johnston (bc). 265 Corbis: Penny Adams / SuperStock (fbr); Dan Sherwood / Design Pics (bc); Dex Images (fr); Marnie Burkhart / Momatiuk - Eastcott (bl). Getty Images: British Modern Photography / Flickr (cra); Southern Stock / Digital Vision (fcl); Andy Farrer Photography / Flickr (c); juanjofotos / Flickr

(clb). 266-267 Corbis: Ocean. 266 Getty Images: mymonobrow / Flickr (bc). 267 Corbis: Momatiuk - Eastcott (ca). Getty Images: Angus Clyne / Flickr (br); Don Johnston (c). 268-269 Getty Images: Medford Taylor / National Geographic. 269 Corbis: Penny Adams / SuperStock (tr); Marnie Burkhart (tr); Dan Sherwood / Design Pics (br). Getty Images: sodapix sodapix (tl). 270-271 Getty Images: Ben Pipe Photography. 271 Corbis: William Manning (fcr); Peter Van Rhijn / All Canada Photos (fcra); Andrew McLachlan / All Canada Photos (br); Radius Images (c). Getty Images: Josef F. Stuefer (tl). 272-273 Corbis: LWA / Dann Tardif / Blend Images. 273 Corbis: Dex Images (fcra); Eyecandy Images (tl). Getty Images: Keiji Iwai (br); Stephen Simpson / Taxi (fcr). 274-275 Corbis: James Ross / The Image Bank. 274 Getty Images: Rachel Slepekis / Flickr (bc). 275 Corbis: Dieterlen / photocuisine (c). Getty Images: daitoZen / Flickr (ca); Southern Stock / Digital Vision (cb). 276-277 Corbis: Clive Nichols. 276 Getty Images: Mikel Bilbao / age fotostock (bc). 277 Corbis: Clive Nichols (cb); Jacqui Hurst / Garden Picture Library (c); Francesca Yorke / Garden Picture Library (c). 278-279 Getty Images: British Modern Photography / Flickr. 278 Getty Images: joSon (br); Renee Keith / Vetta (bc). 279 Getty Images: Nacivet / Photographer's Choice (tr); David Nunuk / First Light (c); TAO Images Limited (crb). 280-281 FLPA: DBN,Imagebroker / Imagebroker. 280 Corbis: Don Paulson / SuperStock (bc). 281 Corbis: John Conrad (br); Jay Dickman (c). Getty Images: Cornelia Doerr (ca). 282-283 Corbis: Patrick Molnar. 283 Alamy Images: AA World Travel Library (br). Corbis: Michael Hanson / Aurora Photos (tl, tc, tr). 284-285 Getty Images: Leon Hawley / Flickr. 285 Corbis: Jim Vecchi (fcra). Getty Images: copyright Alex Arnaoudov / Flickr (tl); Andy Farrer Photography / Flickr (fcr); Luciano Leonotti / Photonica (crb). 286-287 Alamy Images: CuboImages srl. 287 Getty Images: juanjofotos / Flickr (c); Heath Korvola (ca); Henrik Sorensen (bc). 288 Corbis: Katie Garrod / JAI (tl); Alex Holland / cultura (bc). 289 Corbis: Im ChanKyung / Topic Photo Agency (cl); Paul Souders (tr); Jeremy Woodhouse / Blend Images (fcr); Toby Melville / Reuters (br); Ocean (bl). 290-291 Getty Images: Alex Gumerov / Vetta. 292 Corbis: Guntmar Fritz (tr); Tony Hallas / Science Faction / Eureka Premium (bc); Bernd Wuestneck / epa (fcrb). Getty Images: Alija / Vetta (tc); Giorgio Fochesato (fbl); Ulli Seer / LOOK (br). 292-293 Corbis: Ron Chapple Stock (tc). 293 Corbis: (tl); Kamaran Najm / Metrography (fcla); Alex Mares-Manton / Asia Images (ftr); Michael Bader / Westend61 (bl). Getty Images: Craig van der Lende / Photographer's Choice (clb); Steve Thomson / WOWstockfootage (tl); Paul Mansfield photography / Flickr Open (br); John Churchman / Photolibrary (fbr). 294-295 Corbis: Tom Pietrasik. 295 Corbis: Alex Mares-Manton / Asia Images (fcra). Getty Images: Paul Mansfield photography / Flickr Open (fcrb); Stuart McCall / Photographer's Choice (tl); John & Lisa Merrill / The Image Bank (fcr). 296-297 Corbis: Justin Horrocks / Vetta. 297 Getty Images: Panoramic Images (tc); Victoria Pearson / Stone (fcr); William Howard / Stone+ (fcrb); Andrea Pistolesi / The Image Bank (fbr). 298-299 Getty Images: Dylan Lloyd / UpperCut Images. 299 Alamy Images: AF archive (fcr). Corbis: Nice One Productions (tl). Getty Images: Marcus Lyon / Photographer's Choice; Purestock (br). 300-301 Corbis: Kamaran Najm / Metrography. 301 Corbis: (fcra, fcr); Julian Winslow (cla). Getty Images: QxQ IMAGES / Datacraft (bc). 302-303 Getty Images: Craig van der Lende / Photographer's Choice. 303 Tom Ang: (tc). Corbis: Norbert Wu / Science Faction (fcrb). Getty Images: Yagi Studio / The Image Bank (fcr). Andy Mitchell: (br). 304-305 Corbis: Louis du Mont / Flickr. 305 Corbis: Owaki / Kulla (fcr). Getty Images: Giorgio Fochesato (fcr); Copyright Mikko Lagerstedt / Flickr Select (tl); David Pexton Photography, Contact david.pexton@gmail.com / Flickr (fcrb). 306-3-7 Getty Images: John Churchman / Photolibrary. 306 Getty Images: Wonderlust Industries / Photonica (bc). 307 Corbis: Odilon Dimier / PhotoAlto (c); Image Werks (ca);

Scott T. Smith (br). 308-309 Getty Images: Ulli Seer / LOOK. 309 Corbis: Erin Trieb / VII Mentor Program (tl); Janusz Wrobel / All Canada Photos (fcra); Emily Wabitsch / dpa (fcr); Bernd Wuestneck / epa (br). 310-311 Getty Images: ILina S / Flickr. 310 Getty Images: Alija / Vetta (bc). 311 Corbis: John Fedele / Blend Images (cb). Getty Images: Alex Gumerov / Vetta (ca); Darrell Marriott / Flickr Select (c). 312-313 Getty Images: Steve Thomson / WOWstockfootage. 313 Corbis: Ron Chapple Stock (fcra); Noah Kalina (tl); Guntmar Fritz (fcr). Getty Images: Peter Adams / The Image Bank (br). 314-315 Getty Images: Christoph Martin. 315 Corbis: Michael Bader / Westend61 (br); Douglas R. Clifford / ZUMA Press / Corbis Wire (tl); Tony Hallas / Science Faction / Eureka Premium (bc). Getty Images: Anthony Ise / Photodisc (fcra). 316 Corbis: Bengt Hedberg / Johnér Images (bc); David Nunuk / Visuals Unlimited (tl). 317 Corbis: Axiom Photographic / * / Design Pics (fcr); Ron Watts (ftr); Frank Krahmer (br); Alain Keler / Sygma (bc). 318-319 Getty Images: Stephen Simpson / Iconica. 320 Corbis: Alaska Stock (ftl); David Spurdens (fcla); Radius Images (tl); Tibor Bognár (fbl). Getty Images: AFP / DDP (fcr); Lisa Stokes / Flickr Open (tr); ~skye.gazer / Flickr Open (fcl); Elliot, Elliot (c); Kerrick James Photog / Photographer's Choice (br). 320-321 Corbis: Patrick Ward (cl). 321 Tom Ang: (fcl). Corbis: Paul Burns (fbl); Mika (tl); Michaela Rehle / Reuters (c). Getty Images: (br); Taken by Ali Bazzi / Flickr (cla); Ursula Sander / Flickr (ftr); Rekha Garton / Flickr (fcr); Andreas Strauss / LOOK (clb); Image Source (bl). 322-323 Getty Images: Lisa Stokes / Flickr Open. 322 Getty Images: Ursula Sander / Flickr (bc). 323 Corbis: David DuChemin / Design Pics (c). Getty Images: Taken by Ali Bazzi / Flickr (ca); Frank Chmura / Photodisc (crb). 324-325 Corbis: Tibor Bognár. 324 Corbis: Andrew Lichtenstein (tl). 325 Corbis: B.S.P.I. (ca); Mika (c). Getty Images: Christoph Hetzmannseder / Flickr (br). 326-327 Getty Images: Michael Melford / National Geographic. 327 Getty Images: by dio5 / Flickr Open (fcr); Alan Shortall / The Image Bank (tl); Photo by Ira Heuvelman-Dobrolyubova / Flickr (fcra); Robert Van Der Hilst / Photonica (crb). 328-329 Tom Ang. 329 Getty Images: Michel Tcherevkoff / The Image Bank (br); Elliot, Elliot (tl); Kerrick James Photog / Photographer's Choice (fcr). 330-331 Getty Images: Keith Barraclough / National Geographic. 331 Corbis: David Spurdens (fcrb); Patrick Ward (fcr). Getty Images: (tl, fcra). 332-333 Getty Images: AFP / DDP. 333 Alamy Images: nick baylis (cla); LatitudeStock (fcr). Getty Images: Andreas Strauss / LOOK (fcra); Richard Nebesky / Robert Harding World Imagery (br). 334-335 Getty Images: Andy Linden / Flickr Select. 334 Getty Images: Image Source (bl); Luigi Masella / Flickr Open (br). 335 Corbis: Michaela Rehle / Reuters (c). Getty Images: Moirenc Camille / Hemis. fr (cb); Marlene Ford / Flickr (ca). 336-337 Corbis: Paul Burns. 336 Getty Images: Stephen Simpson / Iconica (bc). 337 Corbis: Alaska Stock (ca); Kim Jongbeom / TongRo Image Stock (fcrb). Getty Images: Comstock Images (fbr). 338-339 Getty Images: Hannes Runelöf / Flickr. 339 Getty Images: Robert Van Der Hilst / Photonica (tl); stephengovel / Flickr (fcra); ~skye.gazer / Flickr Open (bc); Thomas Müller www.rotweiss.tv / Flickr (fcrb). 340-341 Alamy Images: Adam van Bunnens. 341 Corbis: Stefan Feldmann / Demotix / Demotix (br); Ocean (tl); Radius Images (bc). Getty Images: Pauline Cutler / Stone (fcr). 342-343 Getty Images: Rekha Garton / Flickr. 343 Corbis: Jorge Cruz (fcr). Getty Images: Rob Lewine (tc, ftr); Andy Smith / Photolibrary (br). 344 Corbis: Awilli (bc); Yanti May (tl). 345 Corbis: Michael Hanson / National Geographic Society (br); KidStock / Blend Images (fcr). Getty Images: Fursov Aleksey / Flickr (fbr); Uwe Umstatter / Radius Images (fcra); mauro grigollo / Vetta (cl)

All other images © Dorling Kindersley
For further information see: www.dkimages.com